100 YEARS OF HARLEY-DAVIDSON
BY WILLIE G. DAVIDSON

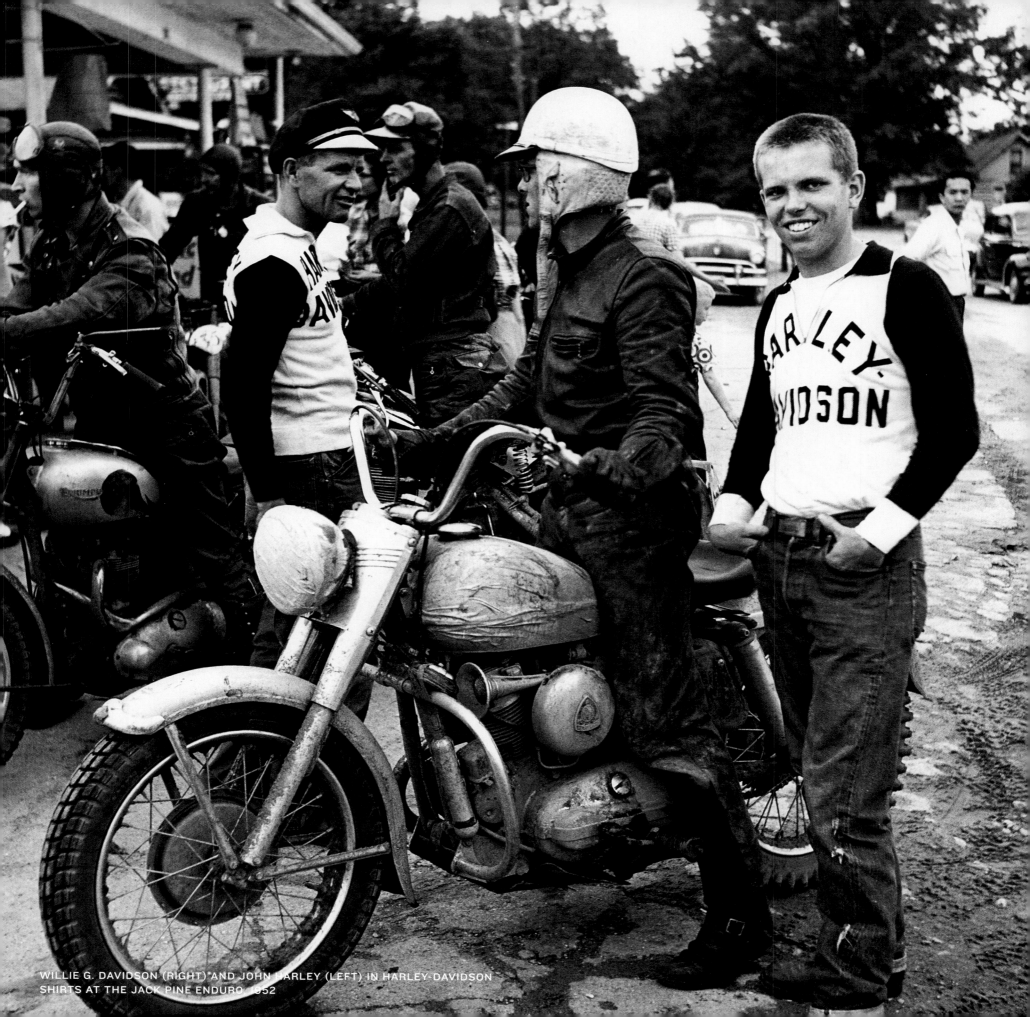

WILLIE G. DAVIDSON (RIGHT) AND JOHN HARLEY (LEFT) IN HARLEY-DAVIDSON
SHIRTS AT THE JACK PINE ENDURO, 1952

100 YEARS OF
HARLEY-DAVIDSON
BY WILLIE G. DAVIDSON

Produced by MELCHER MEDIA, INC. *for*

HARLEY-DAVIDSON MOTOR COMPANY

Bulfinch Press
AOL TIME WARNER BOOK GROUP
BOSTON · NEW YORK · LONDON

This book is dedicated with love and respect to my wife, Nancy.

Writing Consultant: Ken Schmidt

This book was produced by Melcher Media, Inc.
55 Vandam Street, New York, NY 10013
under the editorial direction of Charles Melcher.

Project Editor: John Meils
Assistant Editor: Megan Worman
Production Director: Andrea Hirsh

Harley-Davidson Motor Company
3700 W. Juneau Ave.
Milwaukee, WI 53208
www.harley-davidson.com

Project Manager: Cheri Radovančević
Captions: Herbert Wagner and Dr. Martin Jack Rosenblum

Designed by Pentagram

First Edition
ISBN 0-8212-2819-6
Library of Congress Control Number: 2002106062

Bulfinch Press is a division of AOL Time Warner Book Group.

PRINTED IN THE UNITED STATES OF AMERICA

CONTENTS

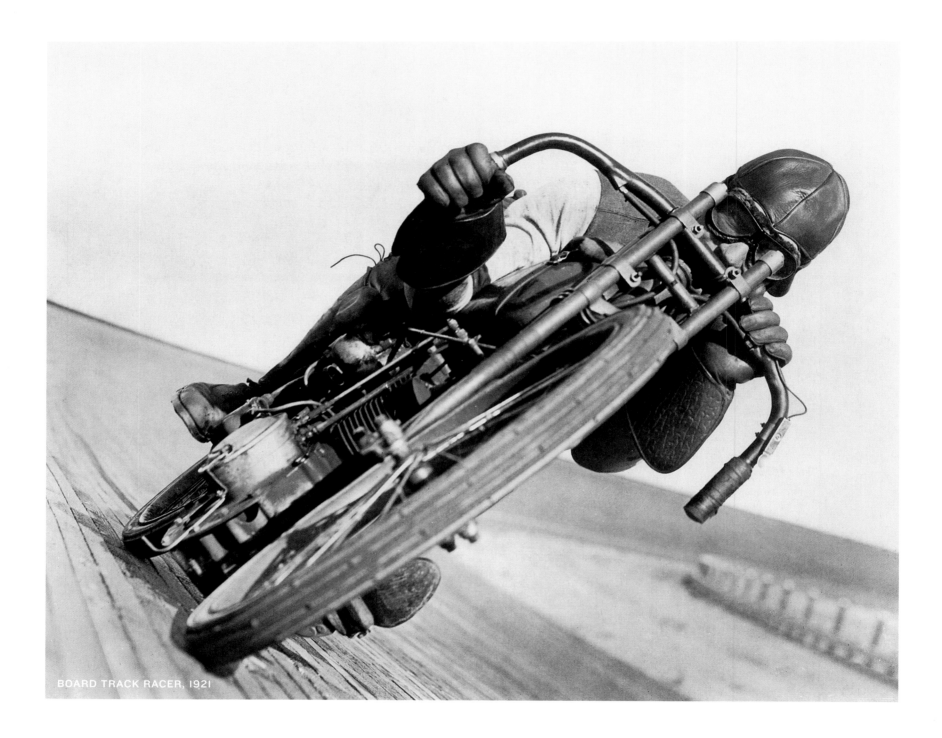

BOARD TRACK RACER, 1921

The role that I have lived throughout

my life as a contributor to this great company has been a fortunate one. My predecessors were here to protect and promote the brand, and I have tried to keep that flame burning through my design and by being involved with the sport of motorcycling.

In fact, I truly believe that our brand belongs to everyone involved with our company—the riders, dealers, employees, and enthusiasts throughout the world. And it is our job to carefully manage and protect our great trademark and everything that it implies. We do this with respect.

In the fast-moving world we live in, you don't always have the luxury of time to consider the elements that have shaped your life and those around you. But while working on this book, I've had an opportunity to reflect. I feel I'm a lucky individual to be able to talk about our history and my life as a designer and rider. The book is non-technical by intent, because it is meant to appeal to a general audience. The frustrating part of doing a book is not being able to mention all the people—dealers, enthusiasts, designers, engineers, suppliers, buddies, acquaintances—who have touched my life and my family's life in a very meaningful way over all these years in our history. For all of you whom I've had fun with on rides and at events or working on special projects, you are not forgotten.

I was able to chase my dream over the years, and I've been able to do it through the support of my wife, Nancy, and my children, Bill, Karen, and Michael, who are now very active in the company. I think for a parent to see his children become successful in any field is extremely satisfying, but to have them join Harley-Davidson is frosting on the cake. In his product development role in the marketing department, Bill is the voice of the customer. Karen works with the General Merchandise group, providing creative direction, which is used to inspire the creation and development of MotorClothes fine leather garments and apparel. Michael's interest in company history suits his job perfectly, because in his role as design liaison he is now assembling many of the items that will be showcased in the Harley-Davidson Museum. Not only are my children avid riders, they also share my love of art and design.

I would like to thank Harley-Davidson for the opportunity to enjoy a very exciting lifestyle—people, places, and great products. One hundred years is a major milestone for the Motor Company, and celebrating this is really a thrilling time for my family and me. The 100 years ahead will truly be an exciting road.

Enjoy the pleasures of motorcycling as I have, and ride free always!

Willie

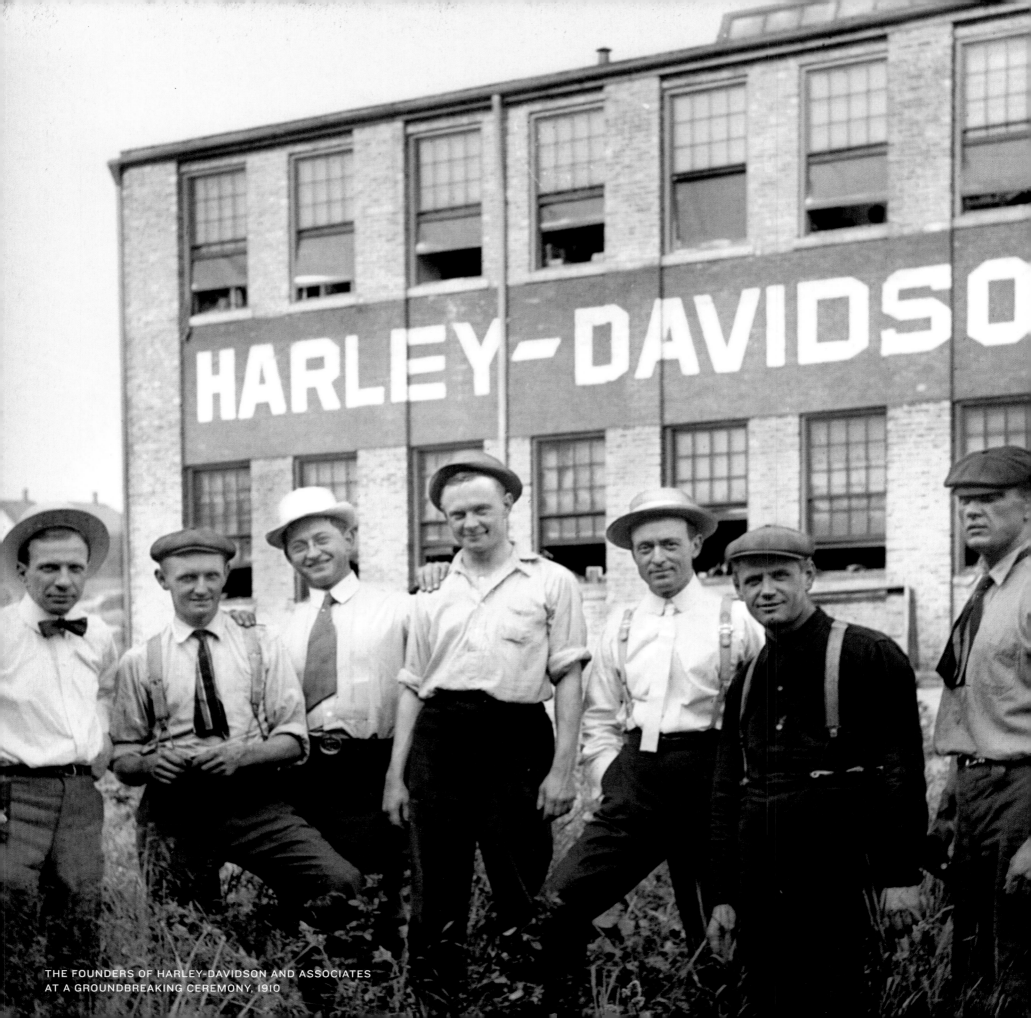

THE FOUNDERS OF HARLEY-DAVIDSON AND ASSOCIATES
AT A GROUNDBREAKING CEREMONY, 1910

1903

A LEGEND IS BORN

1927

WHILE WORKING IN THAT SMALL SHED

DURING NIGHTS AND WEEKENDS,

COULD THESE

YOUNG INVENTORS

HAVE ENVISIONED WHAT WAS TO COME?

I TRULY BELIEVE THE ANSWER IS NO.

THE FOUNDERS NEVER COULD HAVE IMAGINED THAT THEIR ENTERPRISE

WOULD TURN INTO A

TREASURE

RESPECTED BY ENTHUSIASTS AROUND THE WORLD.

M

OST STORIES ABOUT THE EARLIEST DAYS OF Harley-Davidson focus foremost on the hardware—that first engine, the bicycle frame, and so on—then the narrative builds from there. That's fine, but I don't think they begin to scrape the surface of how difficult it was for Harley-Davidson's founders to actually build a motorized bicycle in 1903, or for anyone to build any kind of motorized machine in the early 1900s. To me, the context for the company's history begins before the idea for that first motorcycle even took hold.

Transport yourself back in time to what Milwaukee, Wisconsin, must have looked like a hundred years ago. Imagine how tough people of that era had to be just to survive. If you were fortunate, your home had electricity, but you certainly would have known people who weren't so blessed. Outside the city, lots of people didn't even have indoor plumbing. The strong, icy winds blowing off Lake Michigan made for brutal winters. Journeys to school or work could be very tough.

The Industrial Revolution brought technology and wealth that earlier generations couldn't have imagined. But for most people life just after the turn of the century involved considerable struggle. Men and women could expect to live only about fifty years. Children died from incurable diseases. Most of the creature comforts we take for granted today simply didn't exist.

Milwaukee had an active manufacturing economy then, with mills forging and bending tons of metal

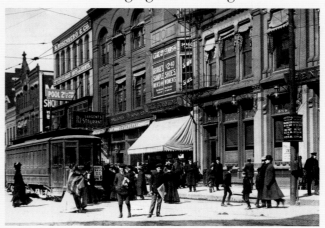

Transportation in late 19th-century Milwaukee was dominated by streetcars, horse-drawn buggies, and shoe leather.

every day. Factories were humming, while many of the first- or second-generation immigrants like my Scottish ancestors worked hard on dangerous shop floors.

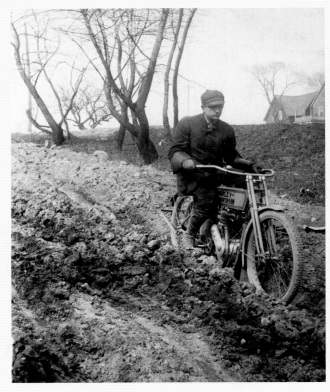

Horse-drawn carriages dominated the busy city streets, but electric-powered trolleys, considered the epitome of progress, had started to appear. Still, for the average person, the primary mode of transportation was honest-to-goodness horsepower. Those who didn't have horses walked or rode bicycles.

There were no highways to speak of, and coast-to-coast travel was extremely challenging. Most city streets were cobblestone. The remaining thoroughfares were gravel and dirt. And you can imagine the harsh road conditions after a pounding by hooves or heavy rains.

The primary method of travel between cities was rail. It must have been a major production for a family to board a train in Milwaukee and steam south to Chicago before heading east or west. But people wanted to go places. There was a desire to see and experience what this country was all about. That historic need served as an impetus for Harley-Davidson.

Inventors of the era were trying to make it easier to get from point A to point B. Steam engines were widely used by railroads and ships. But their offspring, gasoline-burning internal combustion engines developed in the late 1800s, were starting to become more popular. Inventors saw tremendous potential in these crude machines, notably used in powering carriages, which were the precursors to modern automobiles. In turn-of-the-century Milwaukee, the occasional gas-powered carriage—a rickety, spindly, slow-moving thing—always drew a crowd. Ownership was strictly reserved for the rich or the inventors who built them.

An equally rare sight was a motorized bicycle. The first models featured a leather belt connecting the motor to the rear wheel. In Europe, these vehicles and the stories about them intrigued the creative imaginations of many early inventors. In Milwaukee, Harley-Davidson's founders began experimenting with a gasoline engine.

Two of the company's founders were my dad's uncle, Arthur Davidson, and his next-door neighbor Bill

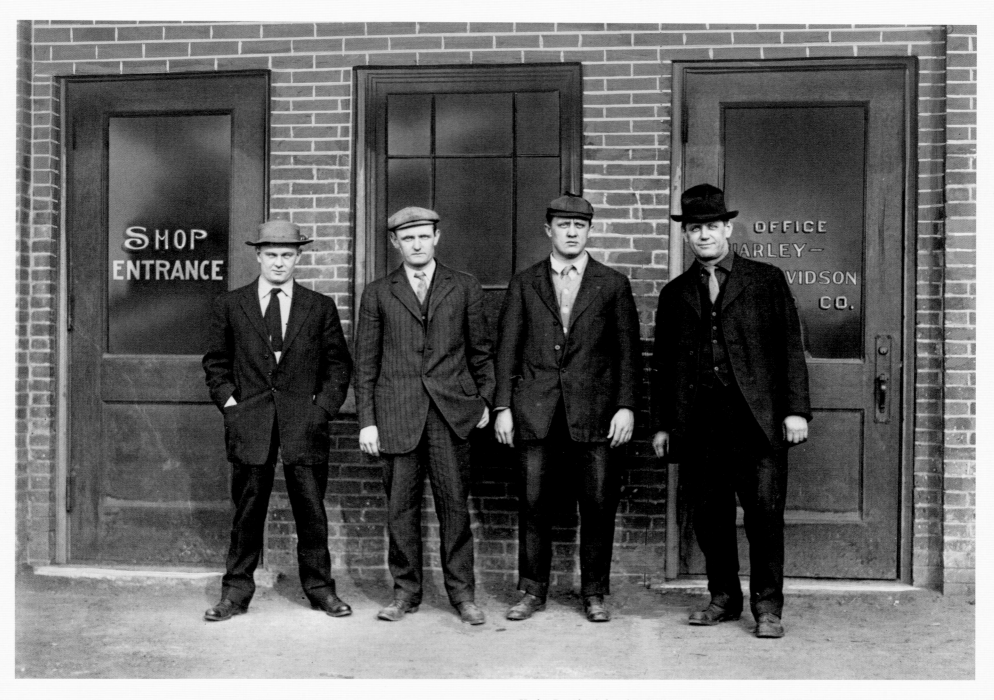

Harley-Davidson's founders (L-R) in 1912: Arthur Davidson, Walter Davidson, William S. Harley, and William A. Davidson.

Nearly a decade after it was built in 1912, one of the first Harley-Davidson motorcycles was still on the road, and by some accounts had run 100,000 miles.

Far right: Harley riders had a magazine of their own by 1916. Shown here is the premier issue of The Enthusiast, *the oldest continuously published motorcycle magazine in the world.*

Harley. They were lifelong pals and worked for the same Milwaukee metal fabricator when they were in their early twenties. Arthur was a pattern maker and the kind of person who was naturally liked, since he was very friendly. Bill Harley was an apprentice draftsman and an extremely bright guy. But most importantly, both were after-hours tinkerers. Hobbyists. Inventors. They were fascinated by the idea of building a motor-driven bicycle from the ground up. This was a major challenge: they had to design a gasoline engine from scratch.

At one time Bill Harley had been an employee of a local bicycle manufacturer, so he knew the hardware. Arthur had experience making patterns for gasoline engines. For additional help, they enlisted one of their coworkers, a German draftsman with a working knowledge of gasoline engines and some familiarity with European motorcycles. In those days, you couldn't run out and buy parts or order them from a catalog; every part of that first motorcycle had to be designed and fabricated by these men. (Think about that the next time you need a part!)

Evenings were spent experimenting and building

in the Davidson family basement at 315 North 37th Street, only a block away from the company's Juneau Avenue offices. Early on, the motorcycle development work moved into a shed behind the house.

After two years of experimentation, the founders were making headway but needed more expertise with the mechanics. They decided to approach Arthur's brother Walter, a railroad machinist living and working in Kansas. Walter was planning to visit Milwaukee to attend the wedding of their brother, my grandfather William A. Davidson, so the timing was right to solicit his help. Apparently, Arthur and Bill succeeded in capturing Walter's imagination. When Walter arrived back home, he familiarized himself with the blueprint and decided to remain in Milwaukee to help them finish that first bike.

Walter found a job with the Chicago, Milwaukee & St. Paul Railroad, where my grandfather worked along with my great-grandfather William C. Davidson, who also worked for the railroad after emigrating from Scotland in the 1850s. My grandfather was a toolmaker and toolroom foreman who was known for his skill and trustworthiness. He must have been excited by the motorcycle project at the family house.

Help with the project came from other sources as

well. One of Bill Harley's neighbors, Henry Melk, had a home machine shop and made his lathe available to the men. When they couldn't quite configure their first carburetor properly, Arthur consulted an inventor friend from childhood, Ole Evinrude. Ole later went on to great fame and fortune with the outboard boat motor company that bears his family's name.

The folklore that surrounds that first engine centers on the carburetor. Legend has it fashioned from a tomato can, and in my heart I'd like to believe that. But given the founders' seriousness and the efforts they put into developing exact drawings and patterns, I can't see them settling for something so primitive.

The makeshift operation in the family basement finally produced positive results, and the first engine was completed and mounted to a bicycle frame. However, it was too small to generate enough power. So they returned to the drawing board. If the engine had to be stronger, so did the bicycle frame that carried it. They determined that the traditional "diamond" bicycle frames lacked the necessary strength. They adopted a loop design that would become standard for their vehicles.

With their first prototype behind them and drawings and parts piling up, they found themselves in need of more space. With that in mind, my great-grandfather, an accomplished carpenter, built a small ten-by-fifteen-foot wooden shed in the backyard devoted exclusively to the project. HARLEY-DAVIDSON MOTOR CO. was painted on the front door. It was the first time those names were put together. I don't think they cared whose name came

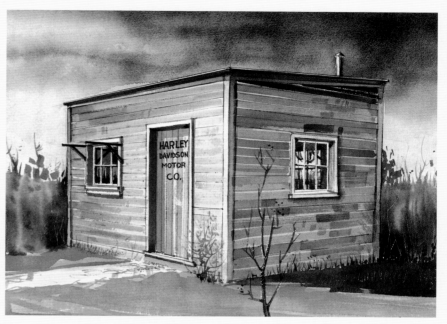

This watercolor painted by Willie G. portrays the original 1903 workplace. The shed, located in the Davidson family backyard, was built by William C. Davidson for his sons.

first. Sometimes things take on a life of their own, and the details of the real story will always be shrouded in mystery. I like it that way.

The question is this: While working in that small shed nights and weekends, could these young inventors have envisioned what was to come? I truly believe the answer is no. The founders never could have imagined that their enterprise would turn into a treasure respected by enthusiasts around the world. What they established was monumental, though probably hard to place in any real context because everything was yet to come. Put simply, it was the beginning.

1903/04 | SERIAL NUMBER ONE

This is the very first production Harley-Davidson motorcycle (though prototypes likely existed before it). It took a lot of experimentation to determine whether a truly viable form of transportation could be created. Performance back then was everything, and the founders achieved this through ingenuity, engineering knowledge, and entrepreneurial spirit.

The beauty of this motorcycle is its simplicity. Form follows function—the curvature of the front downtube follows the front wheel and then surrounds the circular crankcase. It is believed that the earliest model was probably used for some type of competition. It didn't have any fenders, and it was a minimal device—an engine and a set of wheels. It had a pedal system, by which the motorcycle was pedaled to get the engine started.

Serial Number One has been in our Archives Collection for a long time, and it now resides in the front lobby of Juneau Avenue. It was not always recognized as being the first Harley-Davidson. One day Ray Schlee, a member of the Harley-Davidson Archives restoration team, was restoring what we all thought was an early 1903/04 model. While disassembling some of the parts, Ray noticed that the original machinist had marked some of the castings with a small number "1." It was a monumental discovery. Ray called, and I came running down. He had the parts laid out on a cloth on the table. In my hand I was holding some of the very first machined parts ever used on our motorcycles. It was exciting to know that this was the earliest-known production Harley-Davidson motorcycle in the world.

POWERTRAIN

Engine: Single cylinder with atmospheric valve

Displacement: 26.84 cubic inches

Transmission: Direct drive

Primary drive: Leather belt

Secondary drive: None

Brakes: Back-pedaling, bicycle-style internal rear hub (rear only)

Ignition: Total-loss with three dry-cell batteries

CHASSIS

Frame: Single loop

Suspension: None

Wheelbase: 51 inches

Gas tank: 1 gallon

Oil: 1 quart

Tires: 28 inches (front and rear)

Color: Piano Black

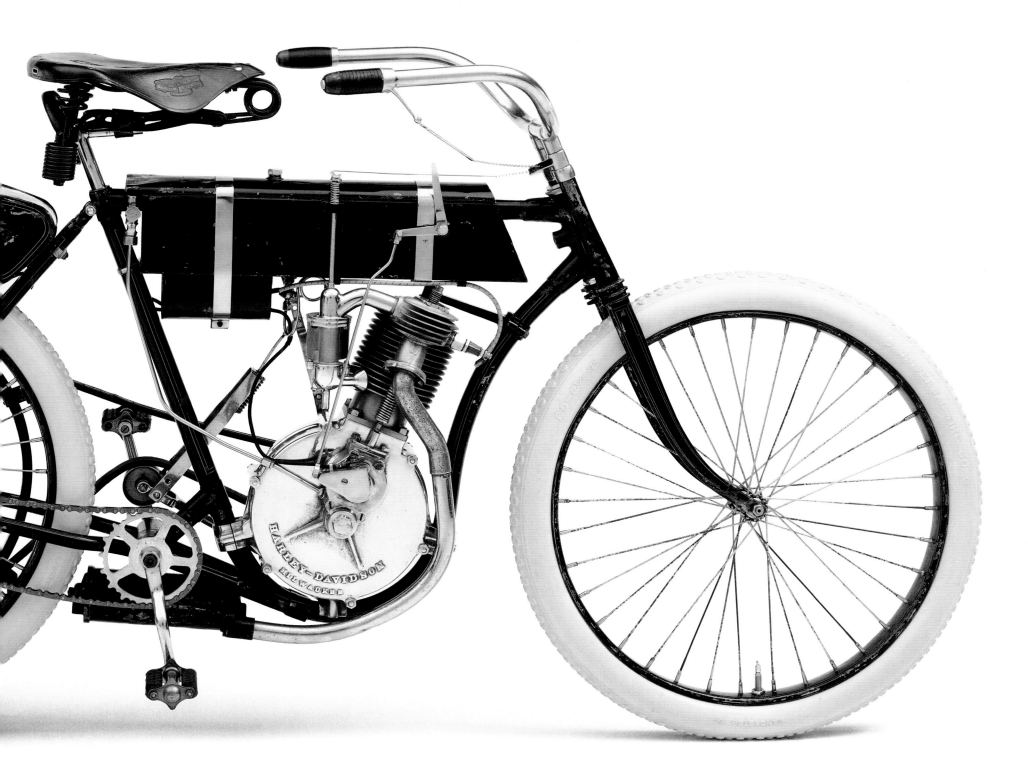

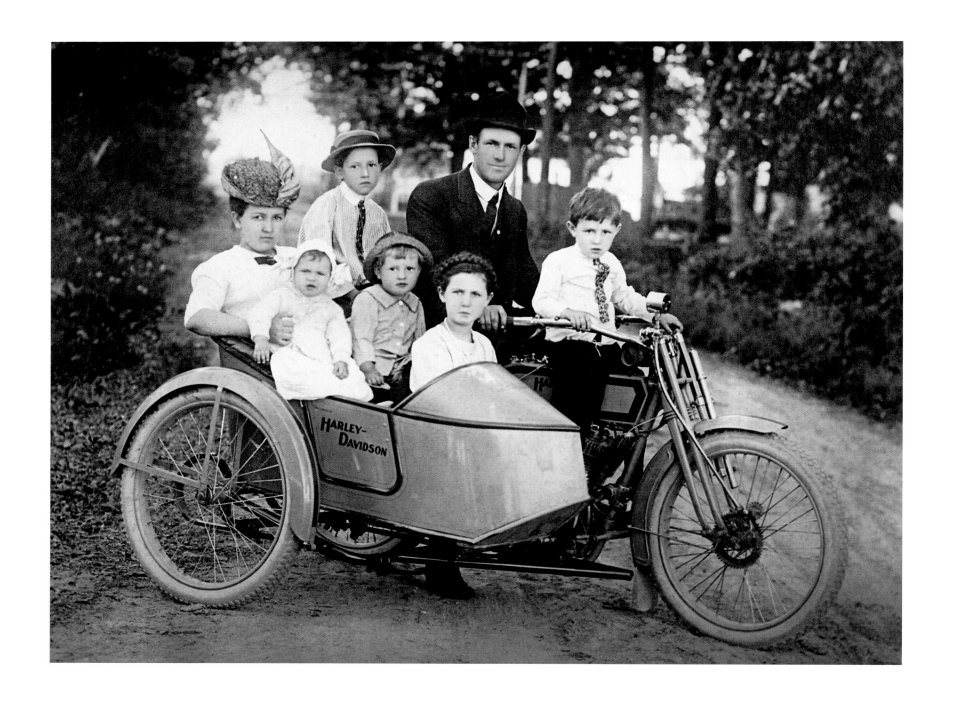

1914 | *The whole family could join the ride when a sidecar was attached.*

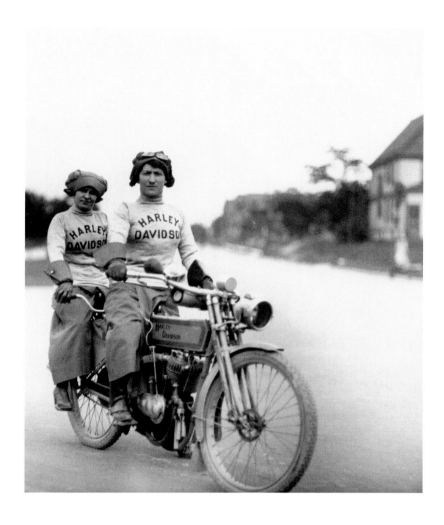

1912 These women are on a tandem-seat Harley-Davidson motorcycle with two sets of handlebars. The former Davidson family home is on the right.

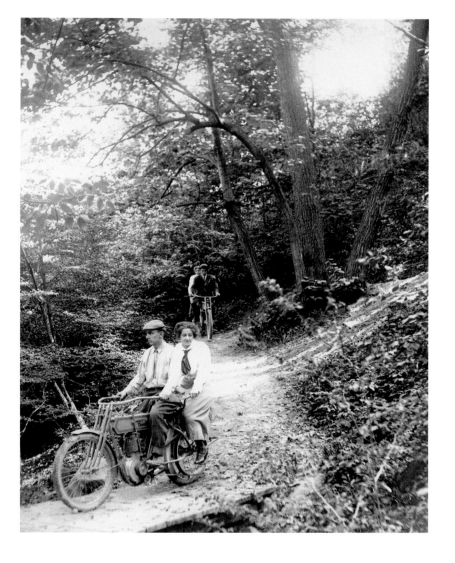

1911 Two couples ride through Milwaukee's Washington Park, a short distance from the original Harley-Davidson factory.

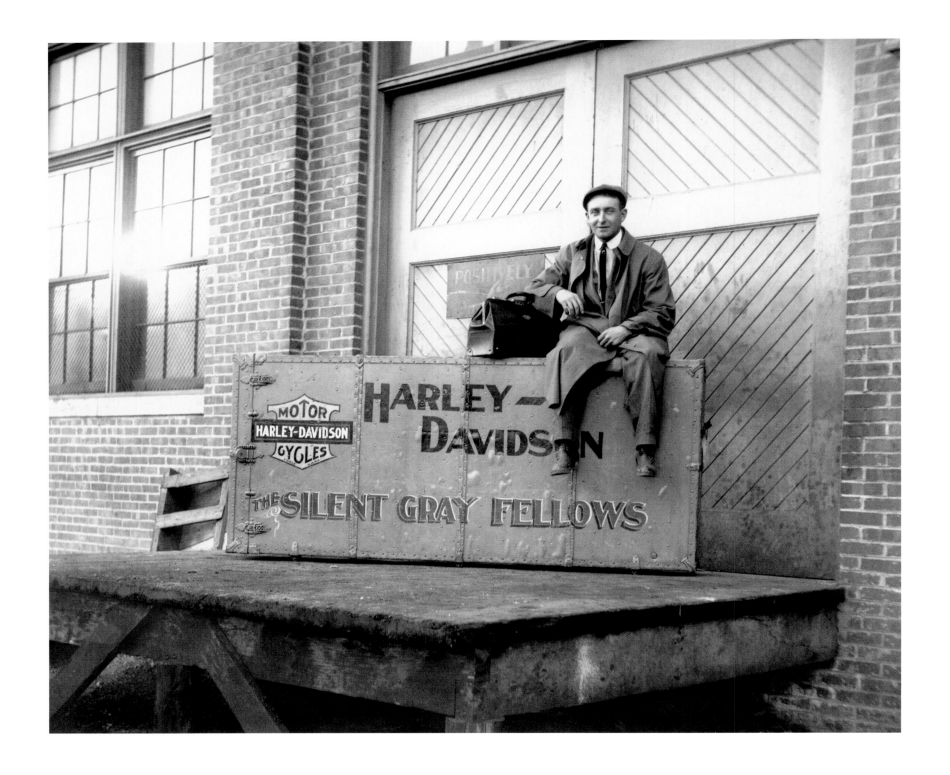

1912 Traveling salesman George Puls on a loading dock with a *Milwaukee original. The "Silent Gray Fellow" nickname for Harley-Davidson motorcycles was made popular around 1910.*

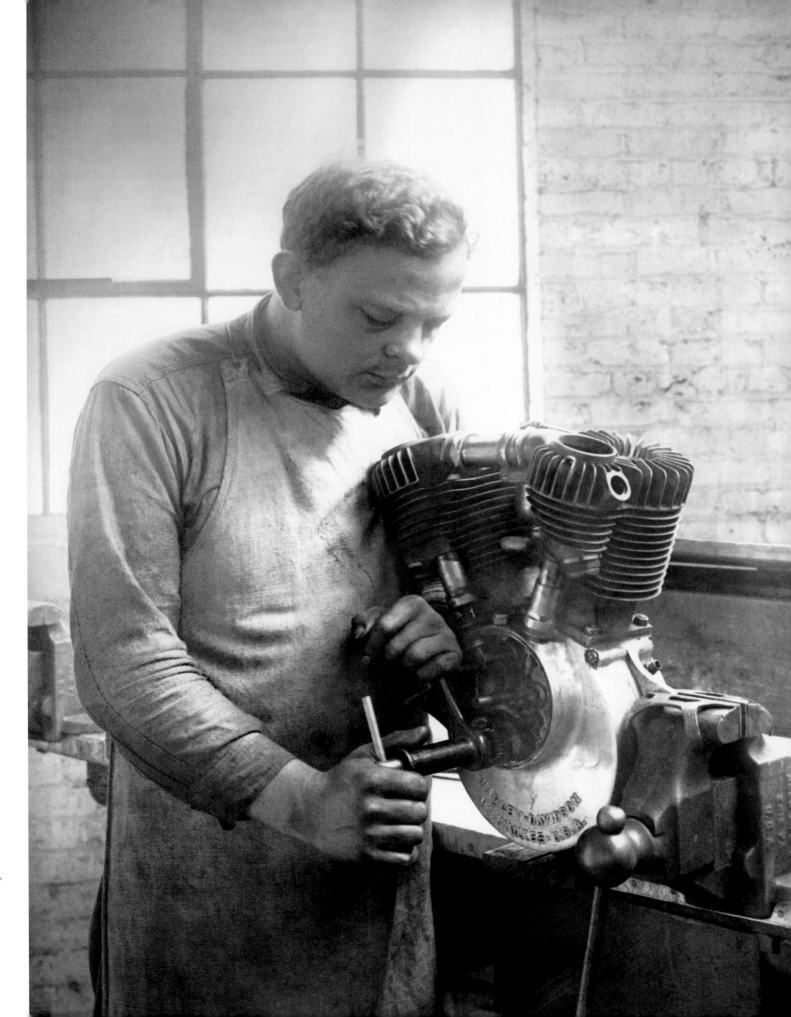

1916 An early Big Twin engine in the hands of a factory technician.

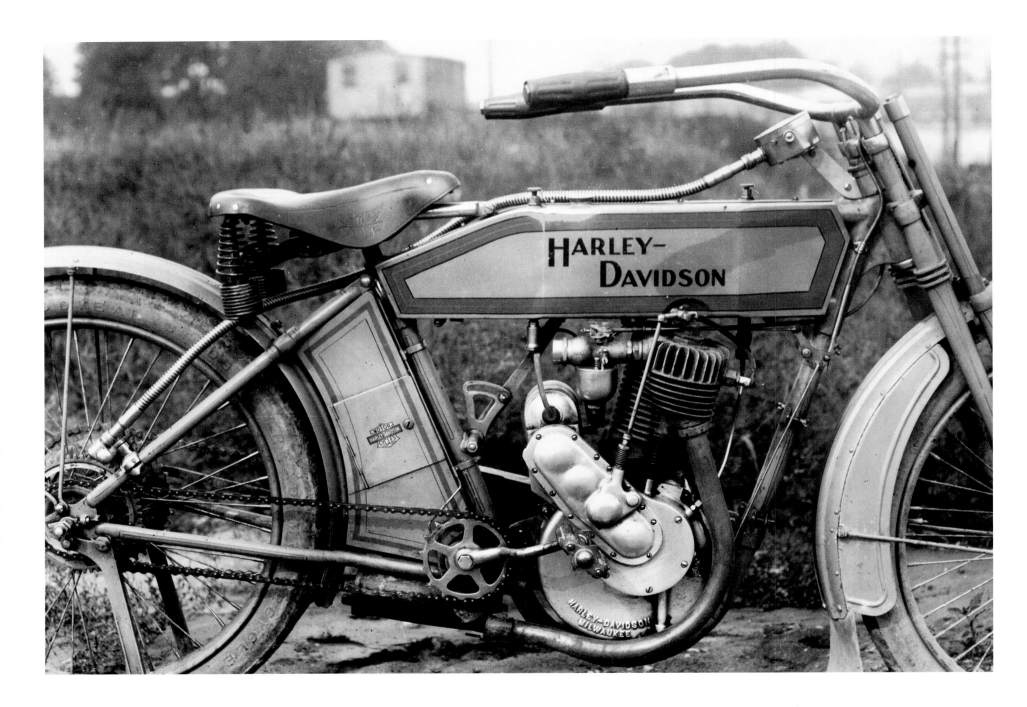

1913 | *A magneto-equipped, single-engine model.*

22

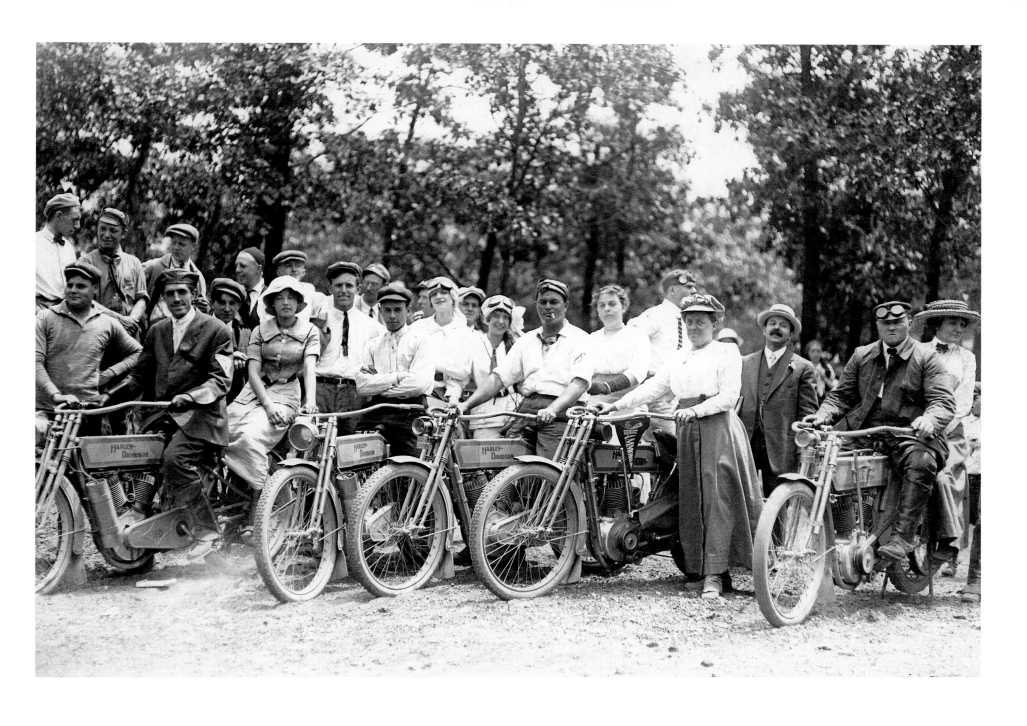

1912 | *Early motorcycle runs were social events in which women often participated—as both passengers and riders.*

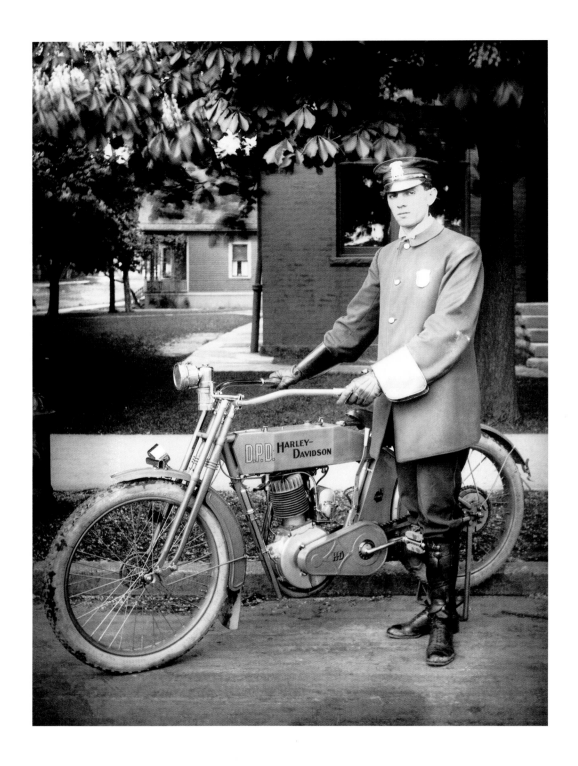

1912 | *By 1908, police departments were using Harley-Davidson motorcycles to nab speeders. This model has a fork-mounted speedometer.*

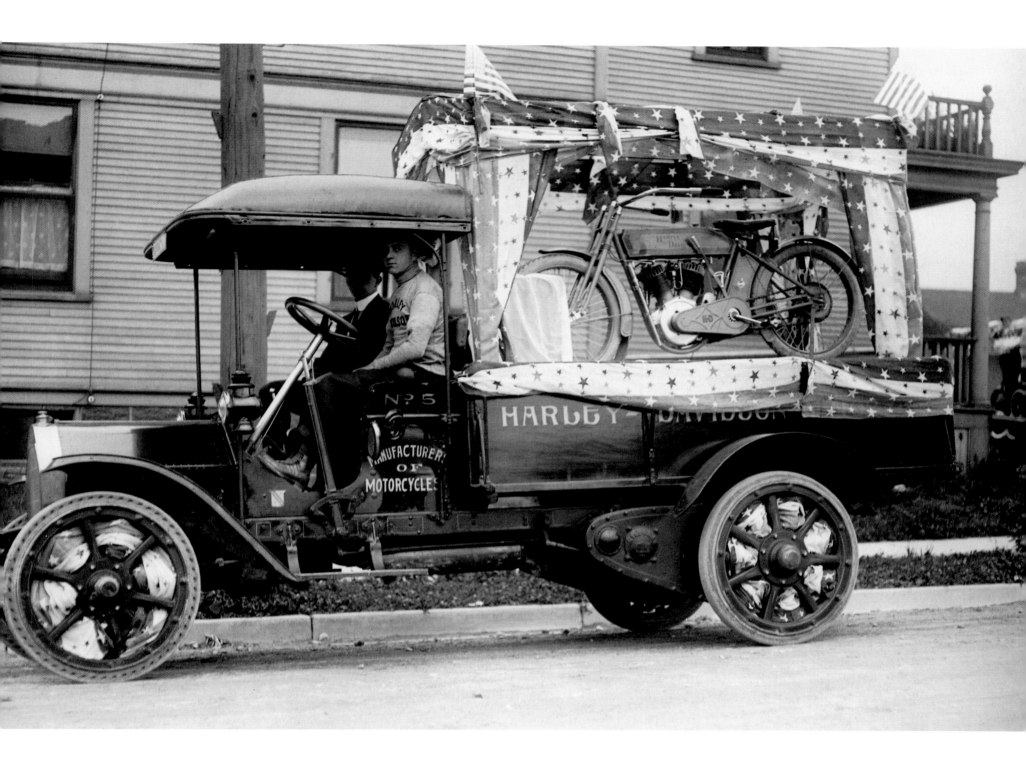

1912 | *A truck from Harley-Davidson's early fleet decorated for an Independence Day parade.*

1909 | MODEL 5-D (V-TWIN)

Harley-Davidson introduced its first production V-Twin engine in 1909. This was during the major growth years of the company. By this time sales volume was up to 1,149 bikes, and Harley-Davidson was becoming known.

The 45-degree V-Twin has a classic beauty that helped bring about the popularity of our motorcycles. The frame and engine shapes complement each other. The frame is wide at the top and has natural angles that correspond to the 45-degree V-Twin engine. It gives the observer a complete view of the engine.

The Model 5-D was designed in the era of gray paint, which is why a Harley-Davidson motorcycle at the time was referred to as the Silent Gray Fellow. Harley-Davidson has an interesting paint history. The first motorcycle Harley-Davidson produced was black, and our motorcycles remained that color until 1906; from 1907 to 1909, the colors were black or gray; and in model years 1910 through 1916, only gray was offered. Then in 1917 the company offered olive green for the first time and exclusively until 1932. In 1933, at the height of the Depression, a more dramatic two-tone paint scheme was introduced. In 1909, when this V-Twin was made, motorcycles were considered a form of transportation, and therefore had a more utilitarian paint scheme. There is a spindly handsomeness about them.

POWERTRAIN

Engine: 45-degree V-Twin with F-head cylinders

Displacement: 49.48 cubic inches

Transmission: Direct drive

Primary drive: Belt

Secondary drive: None

Brakes: Back-pedaling, bicycle-style internal hub brake (rear only)

Ignition: Magneto

CHASSIS

Frame: Single loop

Suspension: Leading link (front)

Wheelbase: 60 inches

Gas tank: 2 gallons

Oil: 1 gallon

Tires: 28 x 2.5 inches (front and rear)

Colors: Light Gray with Carmine striping; Piano Black

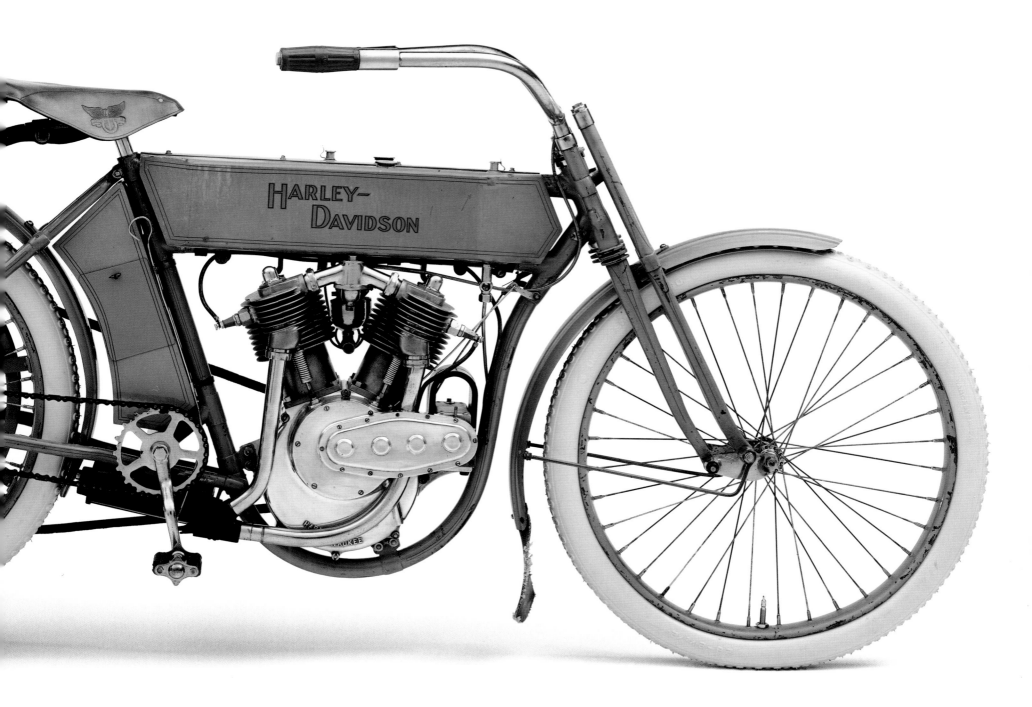

MOTORCYCLE RACING

IS IN MY BLOOD

AND

ALWAYS WILL BE.

WHEN I WAS A KID,

MY BEDROOM WALLS WERE

COVERED WITH POSTERS

OF MY

FAVORITE RACERS.

R

RACING IS A PASSION. JUST WATCH A MILE DIRT-TRACK race, and you'll understand. You'll see superior riders running at 130 mph, bunched so close that you could throw a blanket over them.

Sometimes one rider will touch another to make his presence known before passing. Then he'll throw his bike into a slide using his metal shoe as a sliding surface. This slows down the bike from high straightaway speeds. Upon leaving the corners, the riders tuck themselves in, minimizing wind resistance as they head down the backstretch. There are only a handful of motorcycle riders who have the riding talent to compete in these races. The lead changes and the sound of those XR750s keep you on your feet throughout the race and the hair on your neck standing straight up.

Motorcycle racing is in my blood and always will be. When I was a kid, my bedroom walls were covered with posters of my favorite racers. Trips to the Milwaukee Mile with my dad—seeing my heroes up close—are some of my best childhood memories. When Nancy and I married in 1957, we spent our honeymoon in Laconia, New Hampshire. There we watched one of my favorite racers, Joe Leonard, win the road race. Nancy and I still spend a lot of time at the racetracks.

Race bikes are simple and handsome machines. The older ones, from the board track era of the teens and early twenties, are especially stunning. I have an 8-Valve board-track racer in my personal collection. It sits in a special place that was created for it when I designed the room.

The 8-Valve has an uncomplicated frame. The engine is the major visual, along with the large-diameter wheels, tiny seat, fuel tank, and low bars. It's aggressive looking and projects power. The rider of this machine would have worn a leather helmet, goggles, puttees (leather lower-leg wraps that protected against oil shed from the total-loss oil system used in engines of that period), boots, and a jersey with "Harley-Davidson" embroidered across the front.

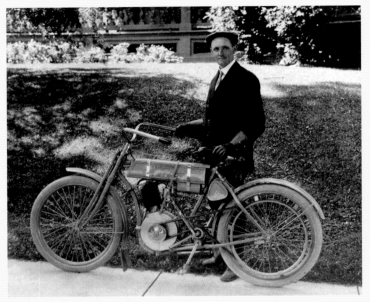

Walter Davidson after his Diamond Medal win in the 1908 National Endurance Run.

In 1908, Harley-Davidson's fifth year of production, our racing heritage began. Young motorcycle companies of that era had to go to great lengths to convince customers that two-wheeled machines were worth owning. Speed was one thing, but reliability was a much bigger issue. If a person was going to retire his horse or bicycle in favor of an expensive motorcycle, the last thing in the world he wanted to worry about was breaking down.

The need to prove dependability was the likely inspiration for the industry's first race events: endurance runs. These were long-distance affairs through and over woods, sand, steep inclines, river crossings, and all kinds of rugged terrain that tested both rider and machine.

At the start of an endurance run, participants were given 1,000 points, and then they rode to various checkpoints; judges would deduct points for early or late arrival. At the end of the run, the rider with the most points went home with a trophy, and the winning brand won some valuable marketing advantages.

It was an endurance run like this that helped to establish the young Harley-Davidson company, and its young president, as industry leaders.

In addition to being president of the company, Walter Davidson was a talented rider. In his and Harley-Davidson's major racing debut, an endurance event through the Catskill Mountains in New York, Walter excelled. He bested more than 60 competitors in the two-day, 365-mile race and not only finished first but did so with a perfect score. This achievement says a lot about the kind of person Walter was and the motorcycle his company built.

After the event Walter revealed that, unlike most of the other racers, he hadn't bothered to carry spare parts. This showed how much faith he placed in the vehicle. Remember, it was an unmodified stock motorcycle. Word spread far and wide about the sureness of Harley-Davidson's motorcycles—and about the endurance racer Walter Davidson.

Some might assume that the founding fathers would aggressively pursue endurance runs to build further awareness of the brand. But with the increases in horsepower that resulted from the introduction of twin-cylinder engines, such as our first V-Twin in the 1909 catalog, speed became the new focus. Motorcyclists and the general public were intrigued.

It must have been amazing in small-town America, where very few people owned motorized vehicles, to see racers on bikes hitting speeds in excess of 100 mph on special board tracks. The large oval-shaped tracks, lined with boards and banked steeply like bicycling velodromes, allowed for very high speeds. They also

increased the possibility of danger and accidents. The founders decided to steer clear.

Board track racers were the daredevils of their time and drew huge crowds. They rode on the high-banked tracks in very tight packs, on 61-cubic-inch, 8-Valve, V-Twin racing machines. No brakes. These racers had total-loss oil systems; once the oil flowed through the engine it wasn't recirculated, and the wooden tracks could get slippery. Maintaining the tracks was a challenge. Over time, the boards rotted or splintered. Injuries and deaths were all too frequent.

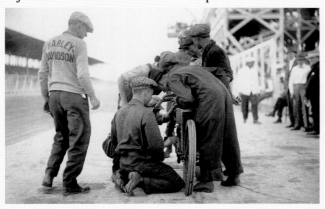

I remember talking to Jim Davis, a member of our famous early racing team, the Wrecking Crew. (Jim lived to be 104!) It was a thrill for me to hear firsthand stories of the early board tracks. The one that stands out in my mind was his pulling into the pits with a splinter that entered through the palm of his hand and extended up into his forearm. Board track racing was not for the fainthearted.

When the company stayed away, privateers took to the board tracks on Harley-Davidson motorcycles, so the name got good exposure anyway. The publicity or

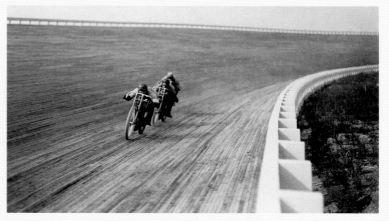

the fiercely competitive battles between company-sponsored teams convinced the founders to formally reenter the racing game in 1914. Under Bill Harley's direction, a new racing department sponsored teams that soon cleaned up in major events across the country.

By the late twenties, there was a movement to increase safety by reducing speeds. The company launched the Peashooter, a single-cylinder Harley-Davidson racer with a 21-cubic-inch (350cc) or 30.5-cubic-inch (500cc) engine: one of the most beautiful motorcycles we've ever created. By this point, board tracks were disappearing and dirt-track racing was becoming the dominant style. We were now the largest motorcycle producer in the world and had a reputation to uphold—which we did, on the tracks.

The 1929 introduction of the DL, a street model, signaled the beginning of the Peashooter's short but successful career and ushered in the era of Class C racing. This was racing for the everyday rider. Owners could ride standard machines—like our 45-cubic-inch side-valve WL models—to the track, remove the headlights, and race. My good friend Armando Magri (now deceased), who was a dealer in Sacramento, California, told stories of doing just that back in the forties. Our WLs and WRs, or Flatheads as they were called, were

Speeds on these banked board tracks broke the 100 mph barrier.

Far left: Pit stops were coordinated events with mechanics attending to refueling and adjustments.

the kings of the Class C circuit for many years. Flat-heads are also known as side-valve engines, which differ from overhead arrangement in that the valves are alongside the piston; thus, the head of the engine can be virtually flat.

Some of our engine names were derived from terminology commonly used in our engineering department, while others came from street lingo that described the upper parts of the engine. "Knucklehead," for example, is purely a street name. It describes the gnarly look of the rocker cover, which supports the valve mechanism at the top of the head. "Shovelhead" and "Pan-head" are also street names. We used the name "Evolution" internally for an engine, and then developed it as an official name; there were some other street names for this engine, but none of them really caught on. "Twin Cam" has clicked as the name for the variation of the Evolution engine, a combination of the internal and external term. It's tough to predict which nicknames will stick. Panhead and Shovelhead are used universally both here and abroad, while other names have come and gone.

It's worth mentioning that one of the most intriguing aspects of our early racing history is the lack of information about the hardware. Because these weren't standard machines, we didn't build a lot of them or keep detailed records. We know, of course, that the racers and race teams modified their bikes. There was a lot of trial and error. These were

experimental vehicles, and Harley-Davidson was open to innovation.

Racing is significant to engineering, but it is also important to marketing and brand support. The camaraderie among dealer, factory, customer, and competitor brings riders to a place where everyone enjoys the events. Racing does not exist only to support engine development. That would be a myopic view of racing, in my opinion.

Racing is engineering in the sense that you're learning every time you build a bike, whether it's for racing or the street. There are certain race features that can't be used on the street because they don't meet requirements for longevity. You tear apart a top-performance racer after every event. There are no noise or lighting or cost restrictions. Racing isn't always an easy path to the next street bike.

In 1930 a young man named Bill Davidson—otherwise known as William H., my dad—established an endurance-run legend similar to his uncle Walter's feat in 1908, when he won one of the industry's best-known endurance events, the Jack Pine Enduro. An endurance run is a time/distance event with a miles-per-hour average that must be maintained. The prescribed speed can differ depending on how the run is set up. You arrive at checkpoints where judges clock how long it took you to get there, and determine whether or not you maintained your average. At the start of the event, each racer is given a map that he tapes to the top of his tank. One challenge is not to get lost, given the roughness of the terrain and the fact that you ride as fast as you can. It's rare to be early at the checkpoints. You try

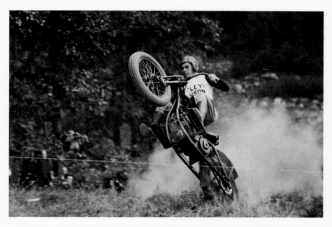

to make up as much time as possible. And you're always trying to combine the capabilities of the machine and your riding style with your ability to maintain the average speed. Riders can also get hopelessly bogged down. The mud, sand, and river crossings are difficult, and the terrain of endurance runs varies with the geography of the area.

Dad won that two-day Jack Pine Enduro event in 1930—which wound through the wilds of northern Michigan and was regarded as one of the most brutal of endurance runs—with a near perfect score of 997. He did this, as Walter had before him, on a stock motorcycle. This solidified Harley-Davidson's already firm reputation for building stock motorcycles capable of superior performance.

Hillclimbing—racing motorcycles directly up the face of steep inclines—became extremely popular in the early 1930s and established itself as one of the most colorful elements of the sport. Each racer individually attempts to gain the top of the hill in the fastest time. Successful hill climbers must be very skilled riders and their machines highly modified. Hillclimbing pits man against nature and marries man and machine in extreme circumstances.

It's human nature to seek situations that challenge our competence. The mere fact that motorcycles exist means they will be raced. It's like climbing mountains because they're there. Events such as hillclimbing and board track racing were the extreme sports of their respective eras. They became popular because people liked watching and talking about them. And the local Harley-Davidson dealers did a terrific job of supporting the riders and promoting the events, including hosting tie-in events at the dealerships. Hanging out with the dealers before a race has been going on forever.

There have been so many tremendous riders in Harley-Davidson's racing past that it would take a book to cover them all. But it's impossible to talk about racing without highlighting a rider like Joe Petrali, a man for whom the word "legendary" is an understatement. He would race anything—board tracks, dirt, the beach at Daytona, hill climbs—and set record after record wher-

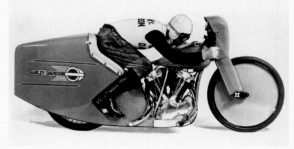

ever he competed. To promote our early Knucklehead, a one-off streamliner was created in 1937. Joe promptly set a record with that bike on Daytona Beach sand—where all land-based speed records occurred at the time—that stands to this day: 136 mph. (The shrouding that surrounds the upper fork area on that bike is actually the fuel-tank sheet metal turned on end.)

During the Flathead era, we introduced the KR (like the WR, based on a street model, the 1952 K Model). KRs quickly powered their way to national championships. The British brands—Triumph, BSA, and

The popularity of hillclimb competitions peaked in the early 1930s.

Bottom: Racer Joe Petrali is on a '61 OHV Streamliner that set a landspeed record at Daytona Beach in 1937.

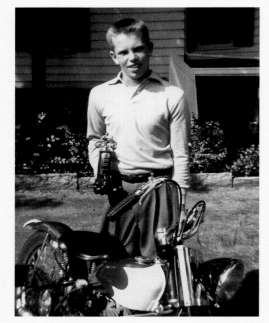

Young Willie G. stands in front of his 165 Model with a first-place trophy for his victory in a 50-mile race through the Kettle Moraine hill country near Milwaukee.

Norton—were our primary competitors, especially after the original Indian's demise in 1953, so victory on the tracks was important to ensure supremacy in the showroom. The KR, incidentally, had a peanut-shaped fuel tank borrowed from the 1948 125cc S Model. This peanut tank soon became synonymous with Harley-Davidson performance, and found its way to the overhead-valve Sportster XLCH Model in 1958. It continues to be a recognizable Sportster trademark.

I got involved in Enduros in the early fifties. I was riding a 165 (a later version of the 125cc S) and eventually a K Model. I won a few trophies in those days.

The Sportster, powered by a 55-cubic-inch overhead-valve engine, was introduced in 1957 and ushered in the era of muscle bikes. The new XL standard models were accompanied by a race-inspired brother, the XLCH (for "competition hot").

In 1961, Daytona racing moved from the beach to the new high-banked Daytona International Speedway. The use of fairings was permitted on road racers, and Harley-Davidson racers competed with numerous variations of our KR Model, including big front fairings, larger fuel tanks, different chassis, and suspension systems. Over the next several years, we presented a strong racing program with everything from our Aermacchi-built motorcycles and Sportsters to tried-and-true KRs.

One of the world's most famous race bikes, the XR750, debuted in 1972. The familiar orange and black XR has been the bike to beat on dirt tracks since its introduction. Some of the biggest names in dirt-track racing—Jay Springsteen, Chris Carr, and the most winning dirt-track racer of all time, Scott Parker—earned their fame on XRs.

I have great admiration for both the XR and its riders. I was presented with an XR750 from our racing department on my 30th anniversary with the company in February 1993. The people instrumental in giving it to me were Louie Netz, my longtime collaborator in styling, Trev Deeley, a former racer and long-time friend of the Motor Company, and Vaughn Beals, a former president of the company and a great leader. Louie told me that there was a meeting down the hall. When I entered the room, there was a motorcycle under a cover. I wasn't surprised to see it, because we always have meetings around motorcycles. I started looking around the room and noticed that Vaughn was there, and then more people walked in. They pulled the tarp off, and I was blown away! It was a current model XR750. I had both Scott Parker and Bill Werner, our legendary race mechanic, sign it.

During his racing career, Scott Parker set a record with nine Grand National championships. Two of the wins were at Del Mar, in 1997 and 1998. In 1998, his ninth Grand National win, Scotty came into the pit after winning the race. Of course, Nancy and I were all excited and gave him hugs like we always do. He then took the number plate off of his motorcycle and gave it to me. It's framed on a wall at my home. The next year,

the event organizers asked me to wave the checkered flag for the final race. Again, the winner was Scotty. I was thrilled, because this win determined the points for the championship. The winner always does a lap around the track with somebody on the back of the bike, and he took me, carrying the checkered flag.

My favorite type of racing is dirt track. Some of my favorite racers were Joe Leonard, Carroll Resweber, and Brad Andres, who raced during the early part of my life. Joe Leonard was unique in winning several AMA championships from 1958–61; he went on to win the Indianapolis 500 racing Indy cars. Leonard is the only racer to achieve both and is a hero to me. Carroll Resweber, who is from the Milwaukee area, was also a national champion from 1958–61, and at one time worked in our racing department. Brad Andres—the son of our dealer in San Diego, Leonard Andres—was a friend of mine when I was going to Art Center in Los Angeles. I would go to the races in nearby Ascott on Friday nights to watch Andres race. It was a wonderful diversion for me. These racers were friends and still are. They're all in the Dirt Track Hall of Fame.

I am proud to also be a member of the AMA Hall of Fame. The AMA Dirt Track Hall of Fame held a special event at the Springfield Mile to honor top racers several years ago. It was neat to be there and shake their hands. The setting of the Springfield Mile, a one-mile dirt track that goes way back in my memory, made the event even more special. My brother and I rode down there many years ago on our early K Models. It was always the high point of the year. It's a beautiful track, and to this day I look forward to attending the Springfield races.

Reflecting our dirt-track heritage, today's Sportster 883R brings the XR's look to a street-legal machine. The potent orange yoke sewn on our dirt-track team leathers, which I designed years ago, can be seen on jackets worn by Harley enthusiasts around the world. The orange and black colors are offset by a white pinstripe.

Our recognizable orange, white, and black paint scheme would also grace the tanks, fairing, and fenders of our 1994 entry into superbike racing, the VR 1000. When we designed the visual elements of the VR, we aimed to create a look that

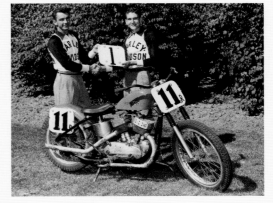

would be instantly recognized on the track. To achieve this, we painted one side black and the other orange, so the bike would look different depending on your view. The tail section's shape was inspired by our XRs, and the fairing had strong family ties to our earlier road racers.

The VR1000 provided inspiration for us when we designed the motorcycle that would help launch our second century: the VRSCA V-Rod. The V-Rod's successful development and introduction owe a lot to our rich history in racing. From Walter Davidson's legendary 1908 endurance run to now, the victories and losses on the racetrack have made us better at building motorcycles. And if you've seen the V-Rod, you'll understand what I'm talking about.

Three-time Grand National Champion Joe Leonard (left) hands the No. 1 plate to Brad Andres. A KR, the model they both raced, is in the foreground.

1921 | WJ (SPORT)

I'm intrigued with the 1921 WJ because of its unique engine. Harley-Davidson had been producing V-Twins, and suddenly the Motor Company introduced a "flat twin." Rather than forming a V, the two cylinders are opposed. The WJ and the XA army model are the only two Harley-Davidson motorcycles with flat twin engines, and only the WJ has a horizontal front-to-rear configuration.

Stylistically, this motorcycle was a departure for Harley-Davidson. The frame, the tank shape, the forks—everything on this motorcycle was new and different. Looking at the WJ engine, I don't see the beauty I see in the V-Twin. The cylinders and heads are lost under all of the covers, manifolds, and housings. Even so, it was a radical design for Harley-Davidson in its day.

Recently, I was in the Harley-Davidson Archives with my son Michael, our design consultant for the Harley-Davidson Museum. Michael showed me an early *Enthusiast* magazine cover with my father on a WJ. Bill Harley and another man are riding on either side, watching over him. Though there is no caption, Michael and I think the picture shows an early riding session; I know my father learned to ride on a WJ.

Motorcycle design for new riders has always been a part of product development at Harley-Davidson. To be viable and profitable, you have to appeal to various people at different levels of ridership. With the WJ, the company was looking for a smooth engine that would attract new riders. It was not as fast as the other models of its time and did not have their classical beauty. But it demonstrates the company's willingness to branch out, to keep many ideas on the drawing board.

POWERTRAIN
Engine: Fore and aft opposed twin
Displacement: 35.6 cubic inches
Transmission: 3-speed hand-shift
Primary drive: Gear
Secondary drive: Enclosed chain
Brakes: External contracting shoe (rear only)
Ignition: Battery and coil

CHASSIS
Frame: Keystone
Suspension: Coil spring leading link (front)
Wheelbase: 57 inches
Gas tank: 3 gallons
Oil: 2 quarts
Tires: 26 x 3 inches (front and rear)
Color: Olive Green

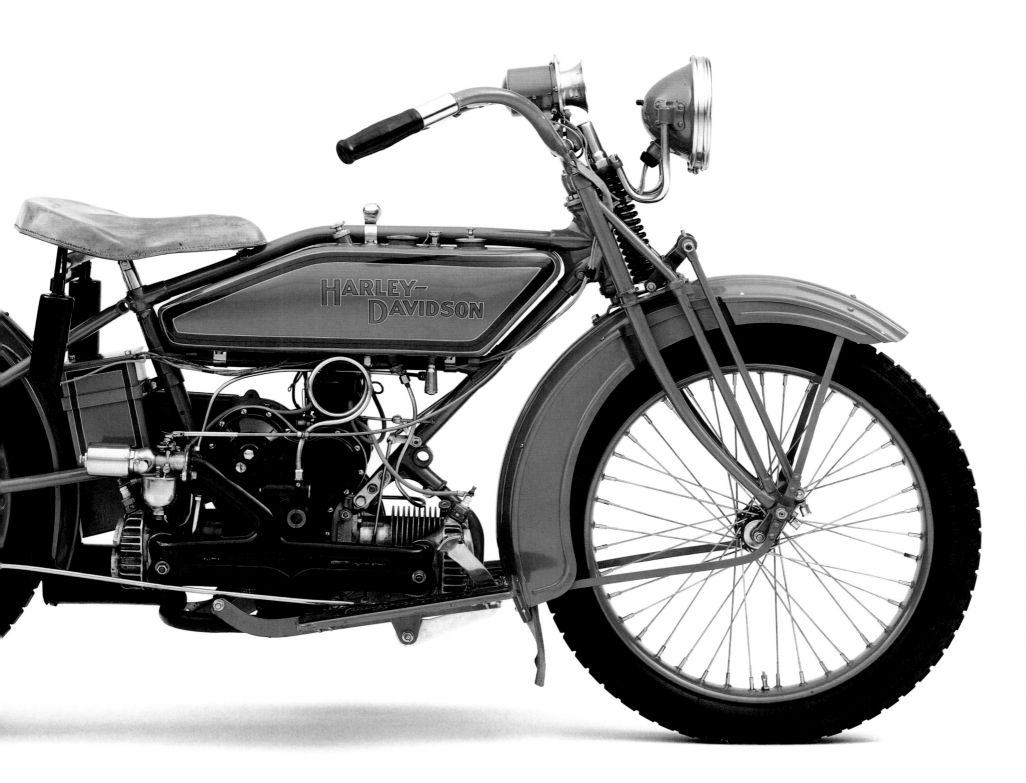

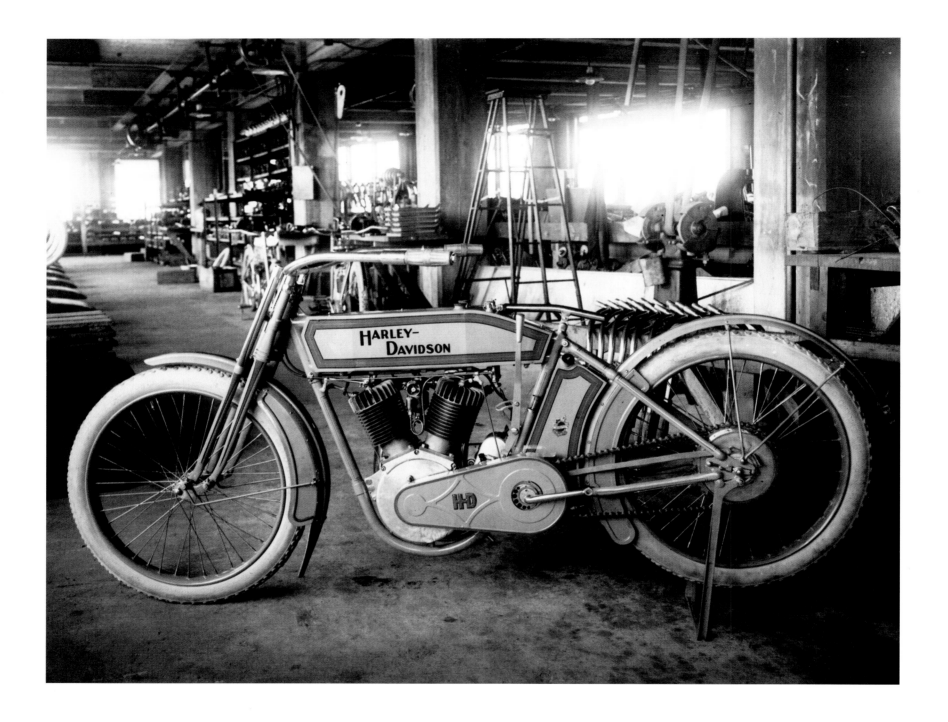

1913 | *This Twin shows the bold striping scheme for 1913 models. Great care was taken during the enameling process, with three hand-rubbed coats of paint followed by a protective varnish.*

1912–13 | *In the early years of the sport, Harley-Davidson motorcycles appealed to a wide variety of people—from urban commuters to farmers to delivery boys.*

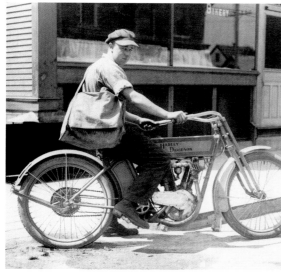

 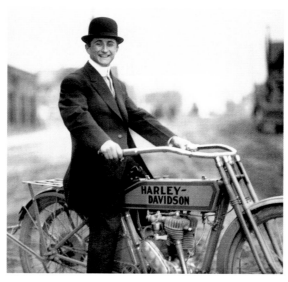 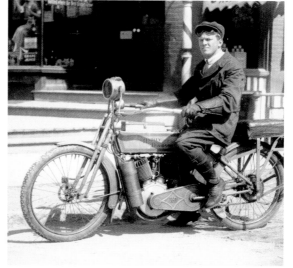

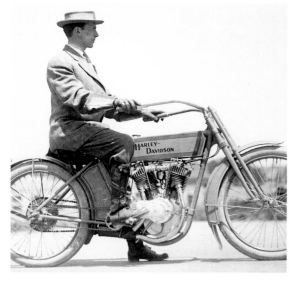 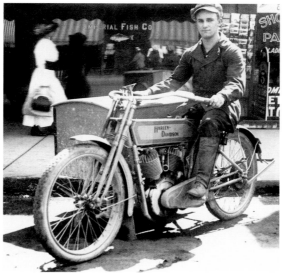 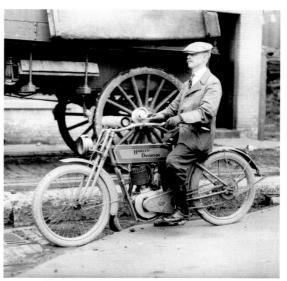

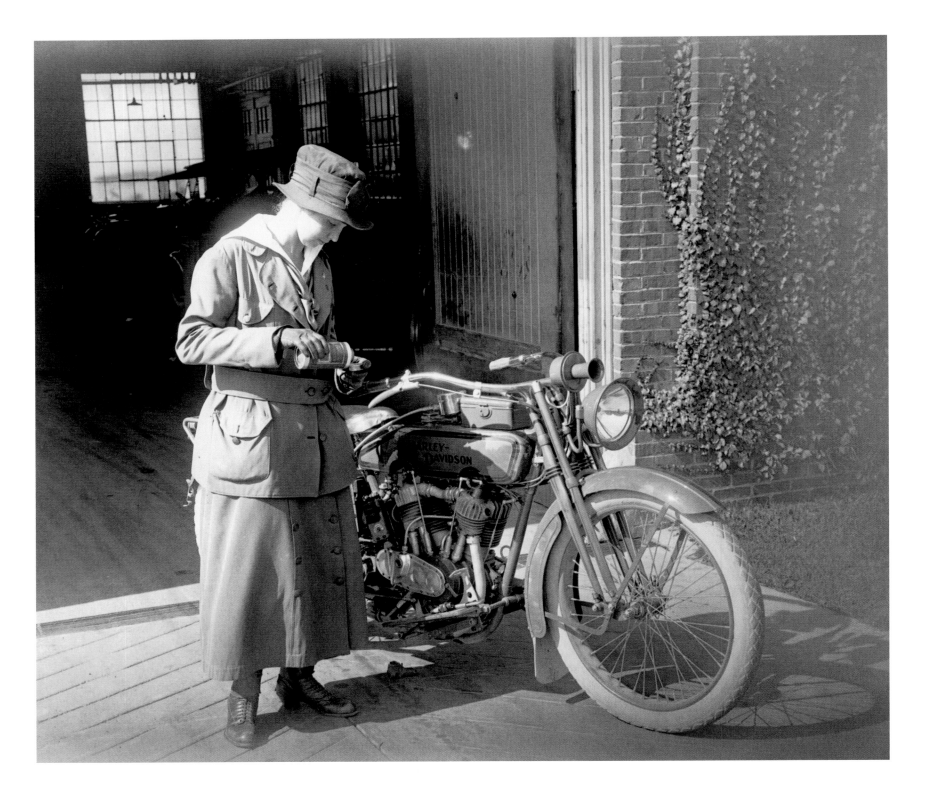

1917 | *Lillian Haver was a popular female rider from Milwaukee.*
She logged 65,000 miles by 1921.

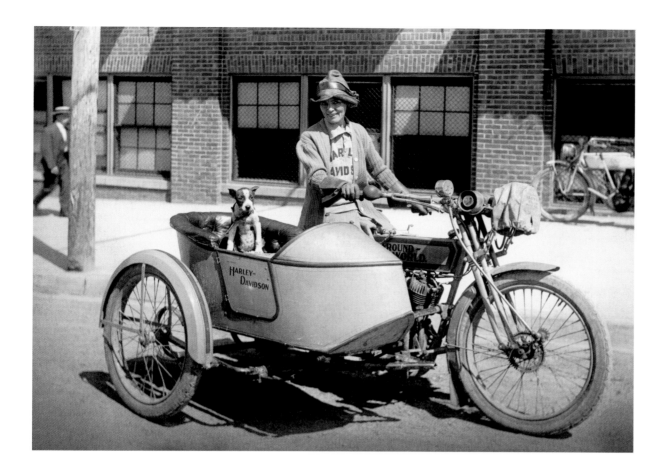

1914 | *A canine passenger sits in this Roger's-type sidecar pictured here in front of Harley-Davidson's Juneau Avenue factory.*

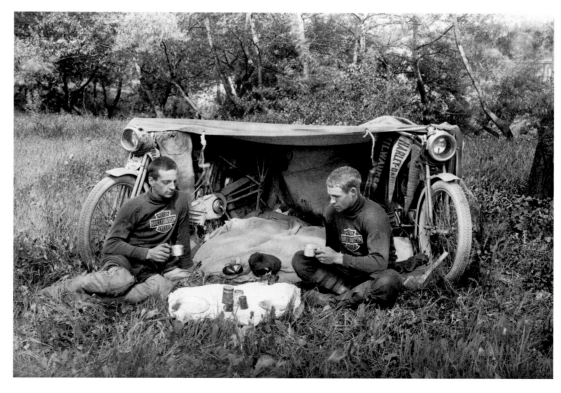

1915 | *These young men share a picnic and make a tent from a tarp and their Harley-Davidson motorcycles.*

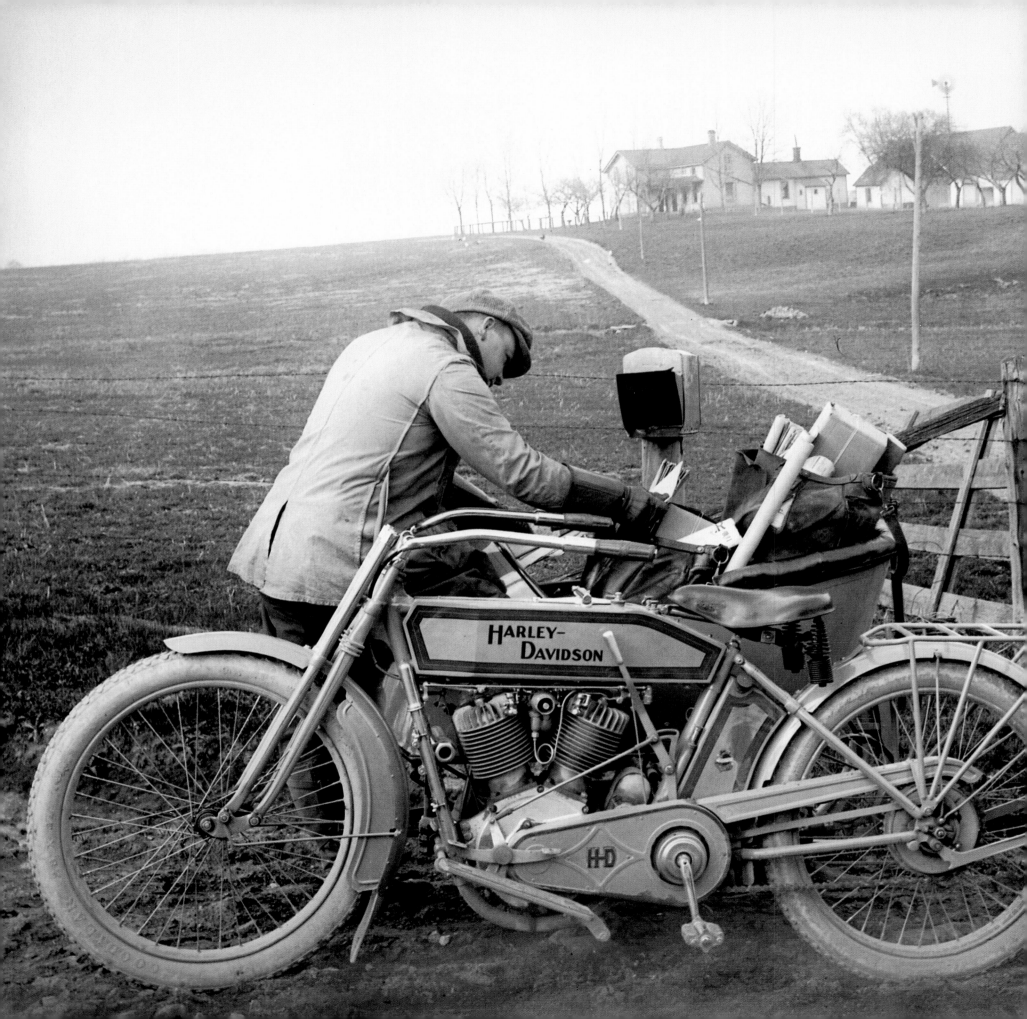

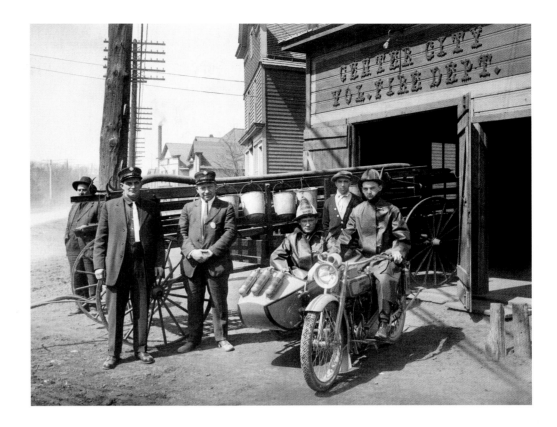

1915 | *Fire departments were early customers of the Harley-Davidson Motor Company because motorcycles could reach an emergency faster than horses.*

1914 | *Rural postal carriers were quick to adopt Harley-Davidson motorcycles, which eliminated the feeding, hitching, and stabling of horses, while also cutting delivery time in half.*

43

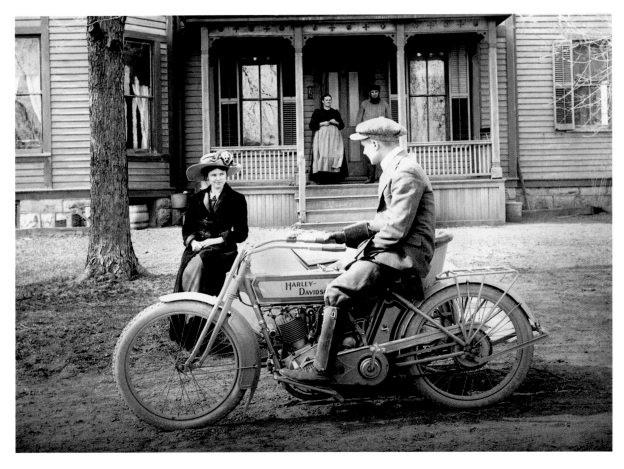

1914 | *For some young people in the early part of the twentieth century, having a motorcycle was a part of the courting ritual.*

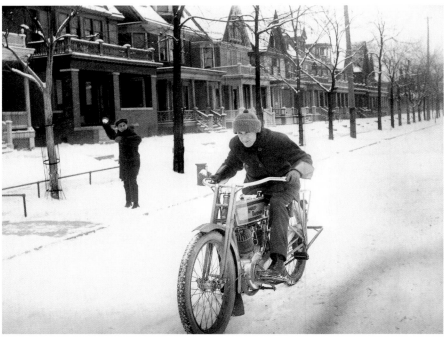

1915 | *For dedicated riders, a snowfall was no reason to put their Harley-Davidson motorcycles away for the winter.*

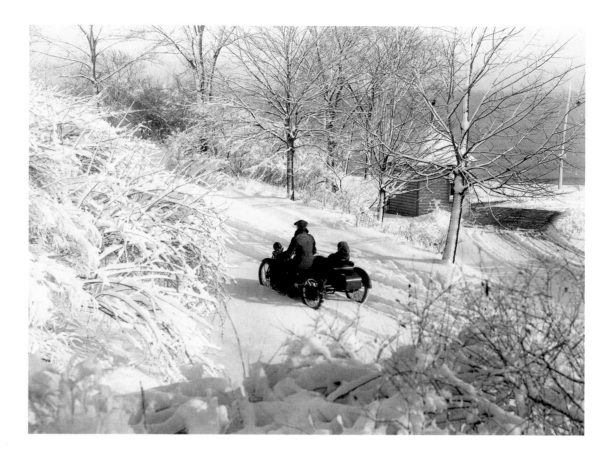

1921 *This motorcycle's drive wheel was equipped with tire chains to get through the snow.*

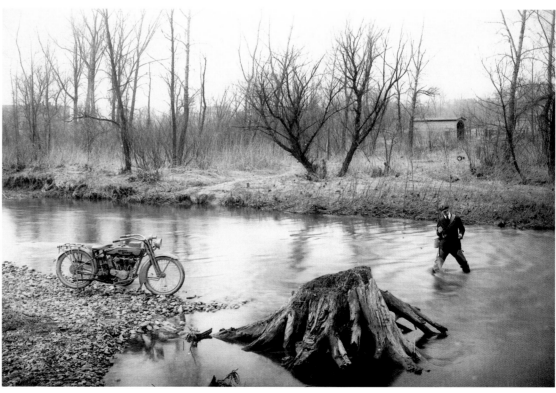

1917 *This scene, shot along the Milwaukee River, demonstrated a Harley-Davidson motorcycle's ability to reach an out-of-the-way fishing spot.*

Expansion

Harley-Davidson Motor Company headquarters has been in the same neighborhood for 100 years. The facilities can be traced from a wood shed at the Davidson home in 1903 to the red brick building that was built in 1913 and still stands today. I have fond memories of trips to Juneau with my dad during the forties and fifties, when Juneau Avenue was utilized for the manufacturing of finished products. The last completed motorcycle came off the line at Juneau in 1974.

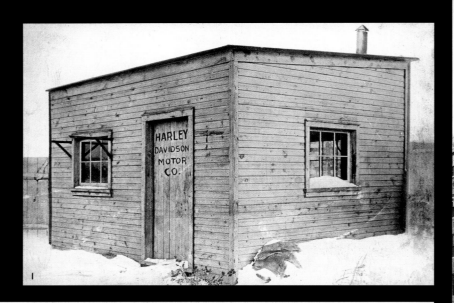

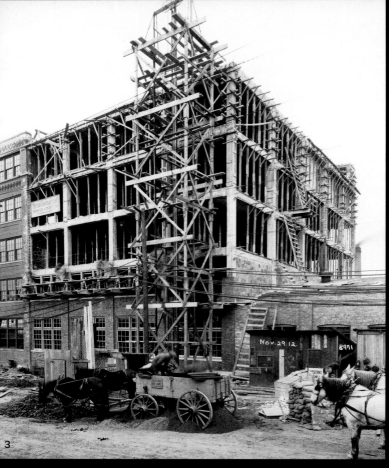

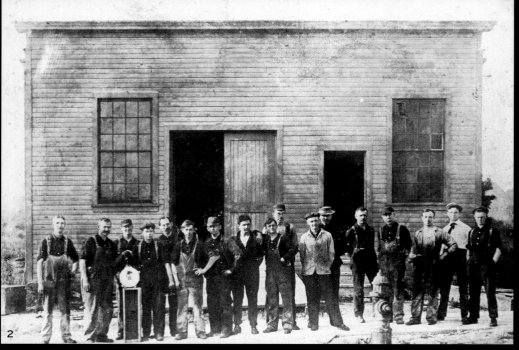

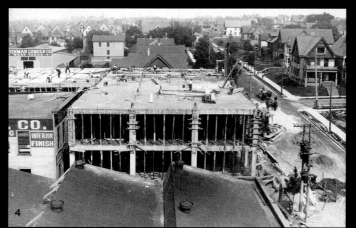

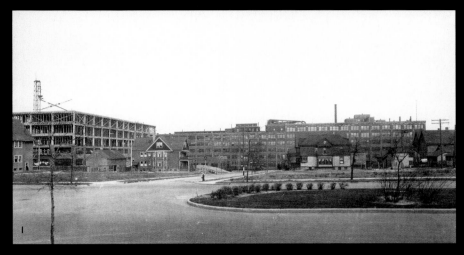

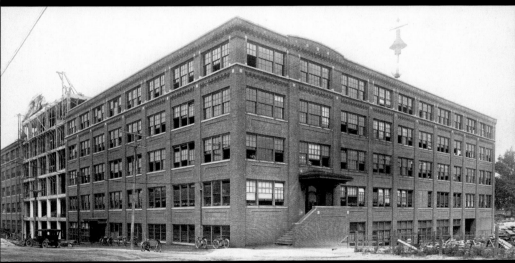

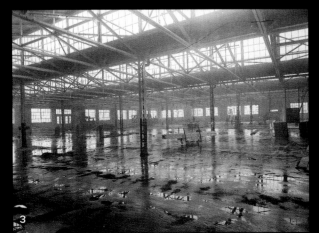

OPPOSITE PAGE

(1) Original shed, 1903 (2) First shed expansion, 1907 (3) Wooden scaffoldir the Juneau Avenue building site in 1912 (4) Addition at 37th and Juneau, 19

THIS PAGE

(1) The complex in 1919 (2) A connector between buildings being complete 1912 (3) Interior "sawtooth" building construction, 1918 (4) Harley-Davids world headquarters today.

IS THERE A BETTER FEELING

THAN ESCAPING FROM

EVERYDAY LIFE

FOR A WHILE

AND DOING SOMETHING

THAT'S JUST PLAIN

FUN?

'VE RIDDEN MOTORCYCLES HUNDREDS OF THOUSANDS OF miles on every kind of road: from the twisty blacktops of southern Wisconsin to the arid straightaways of Australia, from high above the tree line in the Austrian Alps to the Pacific coast of Hawaii, and just about everything in between. I logged those miles in all kinds of weather, and every minute has been memorable. There is no such thing as a bad motorcycle ride.

Even after all that saddle time, I can't adequately explain what it feels like to ride one of our motorcycles to someone who's never done it. Harder still is trying to explain Harley-Davidson's mystique and why so many people believe so powerfully in it.

When describing the ride, riders talk about the heightening of the senses on two wheels, the feeling of power during a roll-on, the exciting sensation of counteracting centrifugal force during cornering.

There's also the simple intrigue of our motorcycles. Whether they're kids staring out of school buses or truckers or rank-and-file commuters whose heads turn every time a motorcycle goes by, people are drawn to Harley-Davidson motorcycles.

Riders mention how much more in touch with our surroundings we can be on a bike as opposed to enclosed in a car. We are continually bombarded with sensations—the scent of evergreens, freshly cut grass, sea air. We hear the pulsing of the V-Twin and we feel the wind on our faces. The temperature changes with

The Flexible brand, shown here on a 1913 Harley-Davidson model, was developed to give the sidecar a distinctive feel.

every dip in the road. Everything we're seeing and feeling is right there, unfiltered and pure.

Riders also speak of freedom, one of the hardest concepts to get across because of its emotional value. Is there a better feeling than escaping from everyday life for awhile and doing something that's just plain fun? Or setting off on a journey, whether it's for fifteen minutes

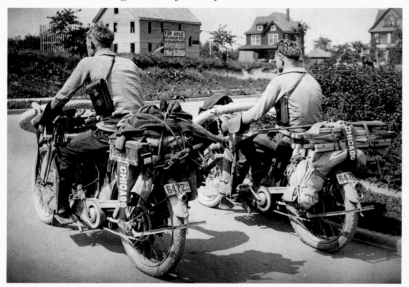

or fifteen days, where the destination is of secondary concern and the main objectives are exhilaration and pure adventure?

We might try to compare motorcycling to other thrill-seeking pursuits, like flying or sailing. But the comparisons are inadequate because the traveling environments are so vastly different. The rider will invariably wind up saying, "You'll just have to get on a motorcycle and ride."

If you think it's hard to communicate the riding experience today, think about how difficult it would have been back in its earliest days, when the majority of people had never experienced motor-powered transit of any kind.

While the founders were introducing Harley-Davidson vehicles as a means of transportation, they were also inadvertently providing a glimpse of the sheer fun of motorcycling. Folks in Milwaukee knew about bicycling, of course, and a few might have even seen a motorized bicycle or two, but only a handful had actually ridden one.

As Harley-Davidson and other manufacturers established themselves and grew, the public became more aware. It was as true then as it is today: motorcycling isn't for everybody. Only the adventurous souls followed through and fulfilled a dream.

And "adventure" was the key word. As alluring as seeing the countryside from a motorized vehicle was, surprises could pop up almost anywhere. Not only were most roads primitive and challenging to handle, but mechanical engineering was in the early phases of development. Things we take for granted on motorcycles today—like the engine running flawlessly and brakes working efficiently—were not guaranteed then. Riders needed a great deal of mechanical know-how, especially since breakdowns could occur far from home where assistance was unavailable.

As with any new device, though, once ease of use and soundness were established, the fascination spread to the non-mechanically inclined, just as it has with everything from cars to computers.

As the motorcycle began to gain acceptance as a useful and enjoyable means of personal and commer-

cial transportation, motorcycling also grew as a hobby. And hobbies have a way of attracting like-minded people. Within a few short years, small gatherings of riders naturally appeared and expanded over time. What better way to enjoy your new hobby than to share stories and experiences with others who enjoy it as much as you do?

By Harley-Davidson's fifth year in production, motorcycle companies were cropping up across America. Endurance runs and racing increased the visibility of stronger brands, and as we've seen over the decades, riders are attracted to a winning brand. In particular, they wanted a durable, reliable machine, along with power and speed.

Early indications that specific makes were becoming important to riders and spectators can be seen

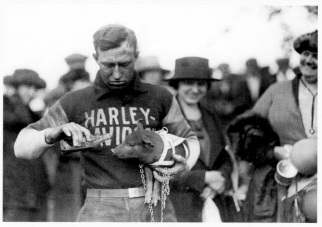

in photos of Walter Davidson in an early endurance run. Walter loved to ride and was a competitive person, both on our vehicles and in business. He and that 1908 Enduro helped to establish Harley-Davidson as a strong, trustworthy brand.

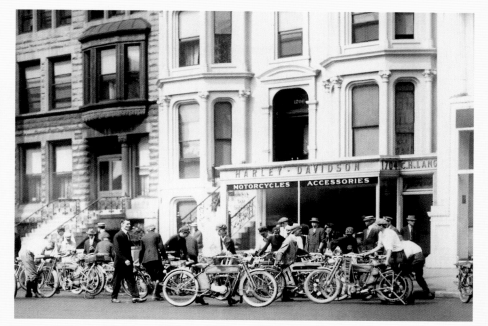

By the mid-teens, motorcycle racing had evolved into a popular spectator sport. With speed and performance being proved and publicized each weekend on tracks or endurance runs throughout the country, names like Harley-Davidson, Indian, and Excelsior-Henderson rose to the top as popular favorites.

In pictures from around that time, you can see riders wearing jerseys similar to those worn by our race teams, with "Harley-Davidson" embroidered across the front. It was evidence of a following, one that endures to this day. These were the first indications of people wanting to be associated with Harley-Davidson. Our brand was taking on emotional meaning.

Because the founders were so visibly involved with the motorcycle community and spent so much time with customers, they quickly realized the value of this camaraderie. Customers had a great time riding together. The founders, through their commitment to riding, instituted a spirit of shared experience that riders still appreciate today, 100 years later.

Motorcyclists gather outside C.H. Lang's Chicago dealership in 1912. Lang was Harley-Davidson's first dealer.

Far left: Racer Ray Weishaar rewards his hog mascot after the 1920 Marion Championship.

The Harley-Davidson Enthusiast

June, 1925

As cars gained favor in the 1920s, Harley-Davidson touted the joys of fresh air and the open road in a sidecar.

This philosophy of customer involvement thrives within our dealer network. Early riders would gather at dealerships to learn from the salespeople and meet with friends. Dealers recognized the value of this opportunity by sponsoring clubs and promoting events. The tradition of riders hanging out at dealerships still continues.

The founders also made it a priority to help dealers strengthen their ties with riders. By striving to ensure that what happened after the sale of a motorcycle was as important as the sale itself, and by keeping customers active and involved with the brand, our dealers have always played a crucial role in the ongoing success of our company.

By 1920, Harley-Davidson was the largest motorcycle manufacturer in the world and saw fit to advertise its leadership position widely. Arthur Davidson was a natural marketer and the driving force behind our sizable investments in advertising and promotional materials, which were always artistically designed and are highly collectible today. Advertising and promotion communicated our role as the industry leader with a brand that people aspire to own and feel good about being associated with.

We instill our pride in our product, which comes across loud and clear in our advertising and at the dealerships. Our motorcycles were not mere commodities. Harley-Davidson stands for something more powerful, something beyond hardware.

In the 1930s, Walter Davidson made a more concerted marketing push that probably had something to do with the diminishing practicality of owning a motorcycle for transportation purposes. Automobile mass production had become so efficient that cars were now becoming affordable. Understandably, many people preferred being protected from the elements.

But for those riders whose interest extended beyond basic transportation, the apparent logic of owning a car may have been precisely what kept them on their motorcycles. They preferred to ride. And they knew that a car could never give them as much pleasure as riding a Harley-Davidson motorcycle. The company's challenge, then, was to find new customers.

At the onset of the Great Depression, which posed a threat to our future and forced many smaller competitors into extinction, company management and the dealer network placed more emphasis on promoting rider gatherings. Club rides communicated the fun of motorcycling. The company also worked closely with dealers to build traffic in showrooms, increase owner satisfaction, fuel positive word of mouth, and expand parts and accessories offerings.

I have great respect for the founders' early philosophies and their flexibility in reacting to the ups and downs of this business. Their close-to-the-customer philosophy would not only protect the brand during

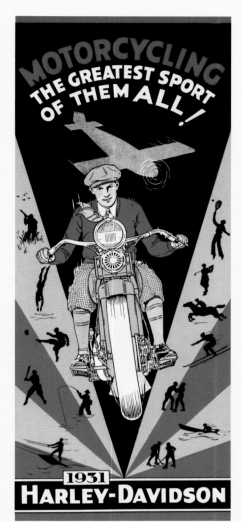

future market slowdowns but would serve us well through the Depression and World War II, our turnaround in the 1980s, and in our current success today. By keeping our riders excited and involved, dealers kept motorcycling alive and attracted new generations of riders.

When our riders had a positive experience at a dealership, race, or event, they told their friends about it, which created demand for motorcycles. Our mystique—that impossible-to-describe essence of the brand—grew stronger with each story, as did our customer base. Just saying the name "Harley-Davidson" practically guaranteed a positive reaction.

I believe that the extraordinary efforts of all the great people in this company to bring riders together is what has separated Harley-Davidson from its competitors. Our name generates passion, which is brought to life and perpetuated by our dealers and, ultimately, by everyone who owns and enjoys Harley-Davidson products.

I also believe that if our mystique could be put into words, it wouldn't be mysterious anymore. Feelings were never meant to be fully understood; that's their true beauty. And since emotions are essentially personal, it means simply that there are millions of reasons why people choose to ride Harley-Davidson motorcycles.

The more involved a person becomes with Harley-Davidson, the more he or she values the experience. We all have a limited time on this good earth, and we're blessed to have something like this in our lives that gives us such pleasure. So we owe it to ourselves to enjoy it to the fullest. Then, as generations of riders did before us, we'll share our stories and pass this wealth down to the next generation. They'll treasure it, too—and have just as much difficulty explaining why.

This advertisement from 1931 illustrates the concept of motorcycling as a sport, rather than merely a form of transportation.

1927 | 8-VALVE

When I think of the 8-Valve and the history of the board tracks, I visualize excitement we will never again witness. This was Harley-Davidson's first foray into serious racing. Only a handful of top racers could manage the 8-Valve. They ran these machines wide open around the boards—a steep, high-banked track made out of two-by-fours.

The boards were very difficult to maintain, because the wood deteriorated quickly. The bikes were total loss oil systems—as the engine used oil, it was eliminated onto the track surface. Just think of it—the riders went all out with virtually no suspension and no brakes on an oily, deteriorating surface.

We only made a handful of 8-Valves, and each was different. They had different styles of exhaust ports and pipes, and sometimes no pipes at all. Each model was tweaked to maximize horsepower. Not only did the factory make changes from one model to the next, but the riders would then tailor the bikes to their specific tastes.

Any kind of racing bike has two pronounced visual elements: the engine and the wheels. Racing bikes look aggressive because of the low engine and drop handlebars. The wheels dominate what you see because there is no sheet metal and no front fender. The large diameter of the wheels adds to their visual impact. Because it is extremely rare and beautiful, the 8-Valve is one of the most desired collector's models.

POWERTRAIN
Engine: 1927 V-Twin 8-Valve factory race engine
Displacement: 1000 ccs
Transmission: None
Primary drive: Direct single-row chain
Secondary drive: Direct single-row chain
Brakes: None
Ignition: Magneto

CHASSIS
Frame: Single loop
Suspension: None
Wheelbase: 52 inches
Tires: 28 x 2.25 inches (front and rear)
Color: Olive Green

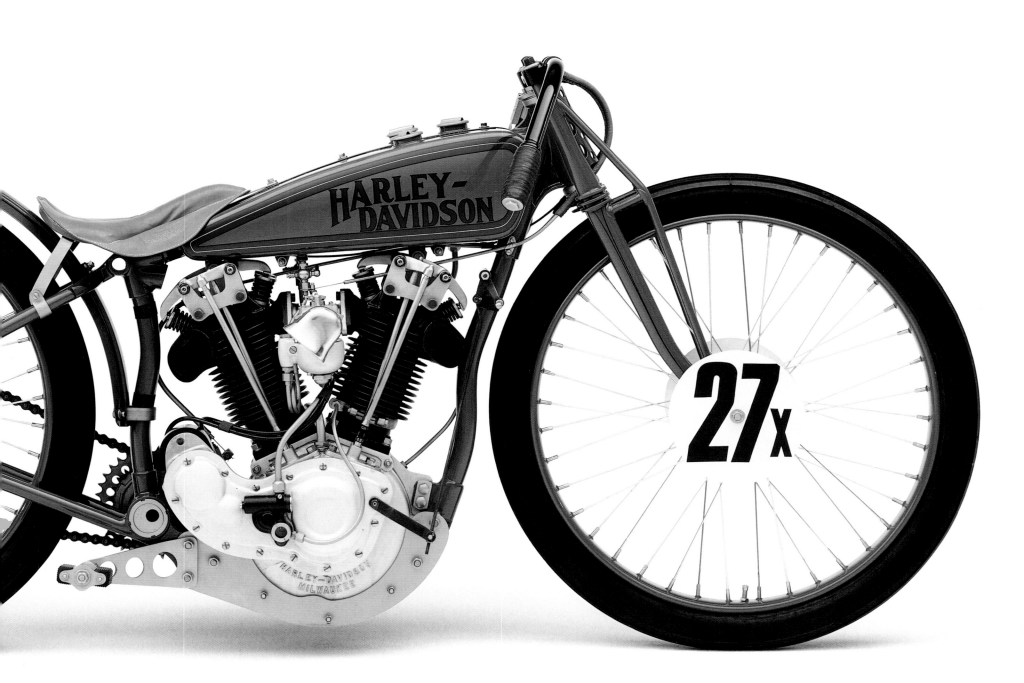

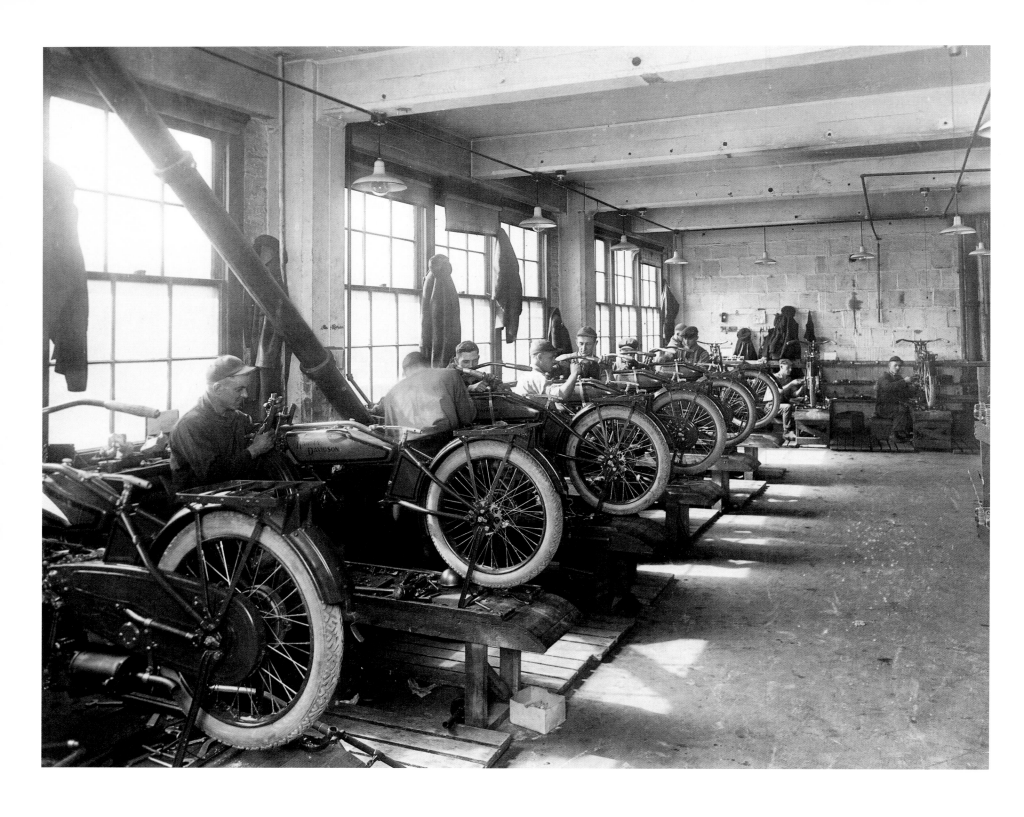

1923 | *Harley-Davidson motorcycles being assembled on the factory floor.*

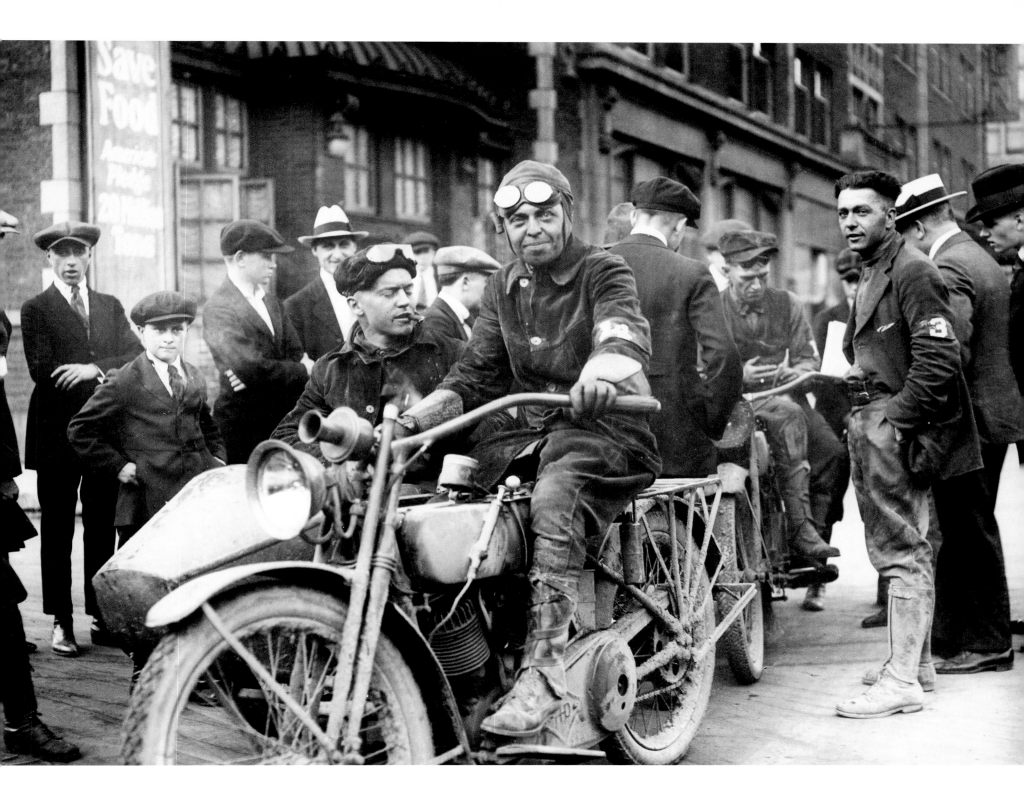

1919 Γ *George Connors and Bill Manz (in sidecar) took second place in the thousand mile U.S. Navy recruiting tour—a round-trip endurance run between Milwaukee and northern Michigan.*

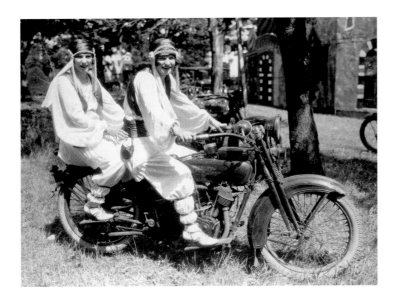

1924 | *Posing for the Arabian Nights Fete in Bayshore, Long Island, these women represent an aspect of motorcycle culture.*

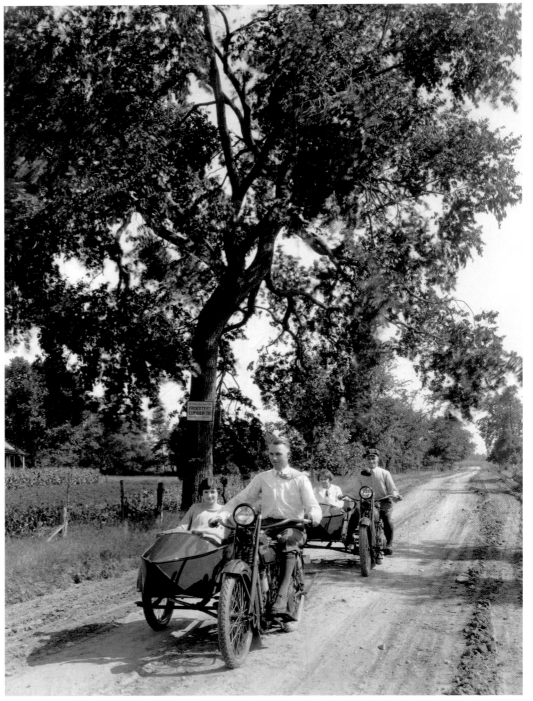

1921 | *Two couples enjoy the timeless pleasure of a summer jaunt along a country road.*

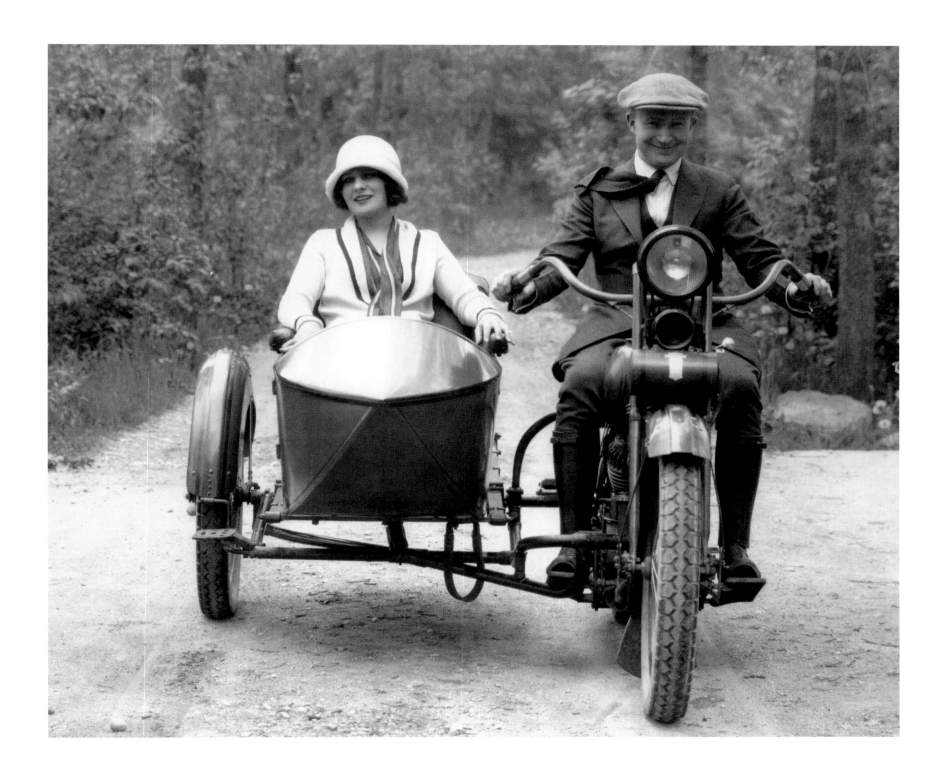

1926 | *"Hap" Jameson, an early editor of* The Enthusiast *magazine,*
and his passenger out for a ride in the country.

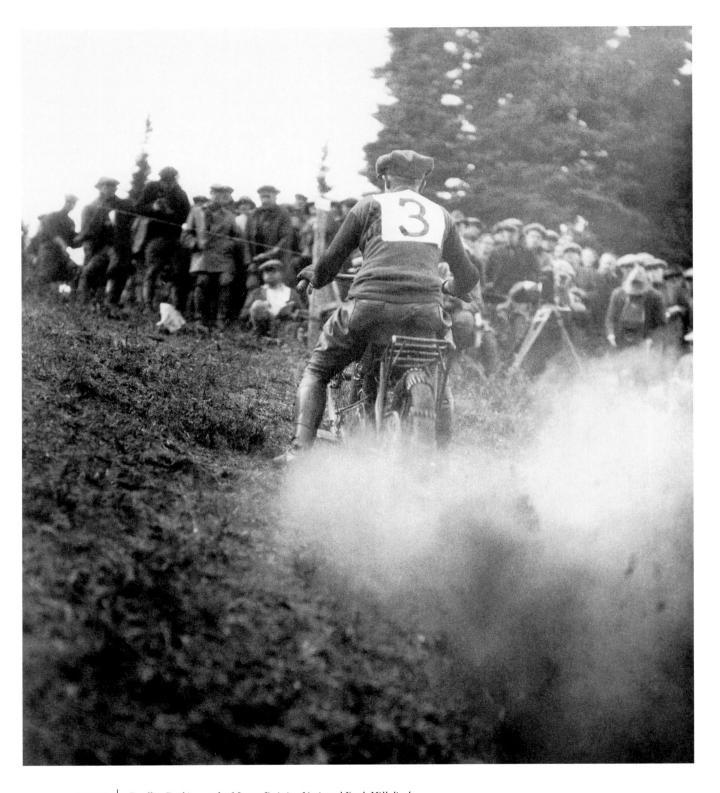

1923 | *Dudley Perkins at the Mount Rainier National Park Hillclimb.*

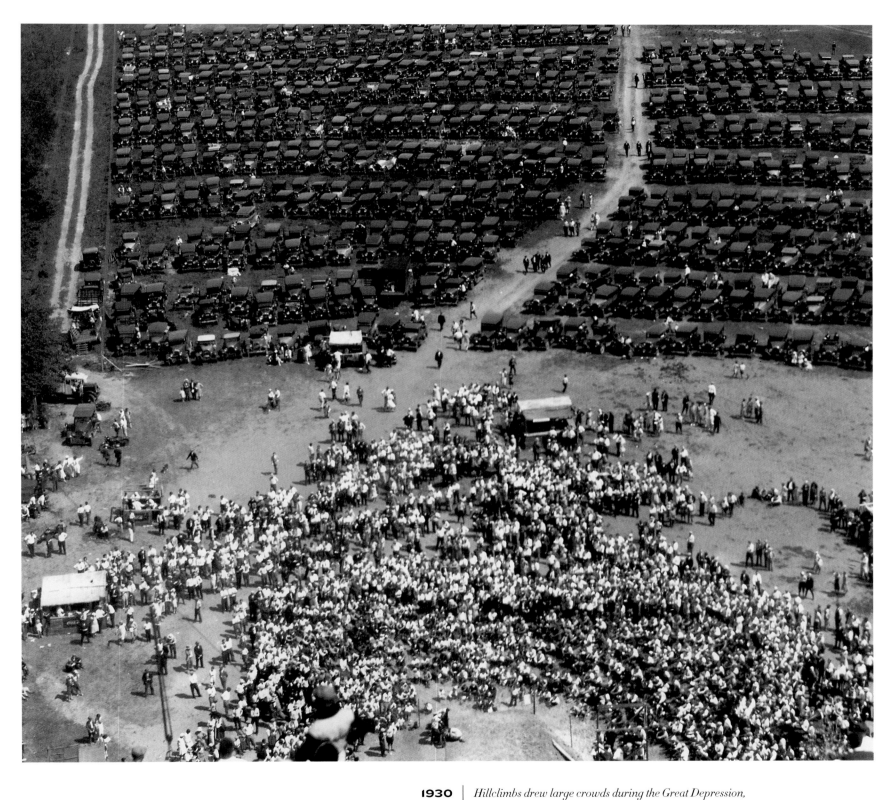

1930 *Hillclimbs drew large crowds during the Great Depression, especially when professional riders participated. Shown here is a view of the event from the finish line.*

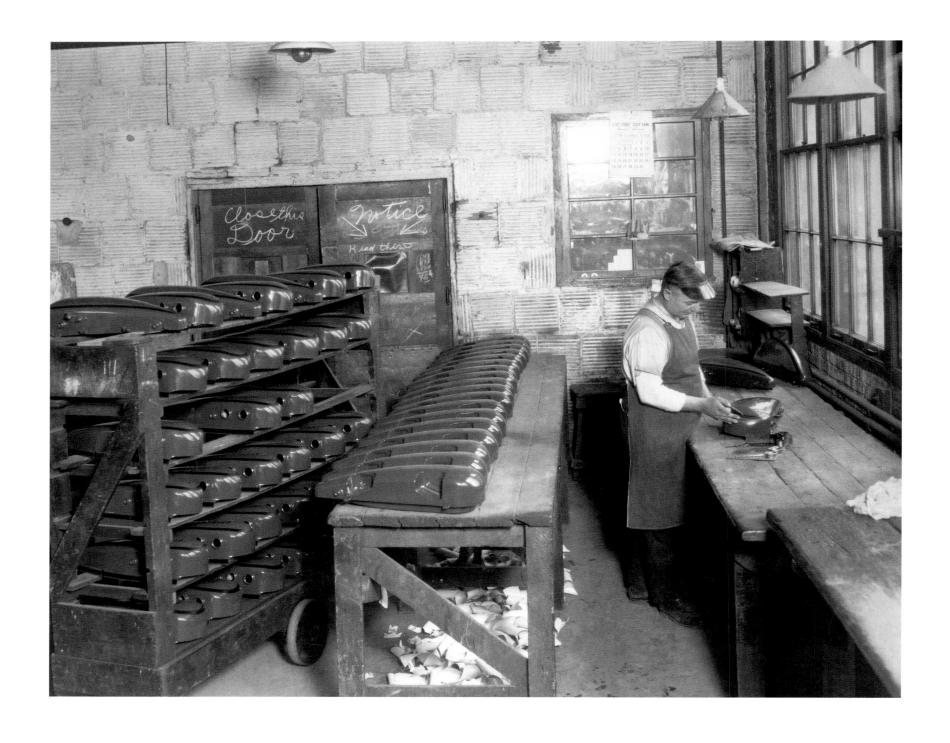

1929 | *This employee inside the Harley-Davidson factory is applying striping to fuel and oil tanks.*

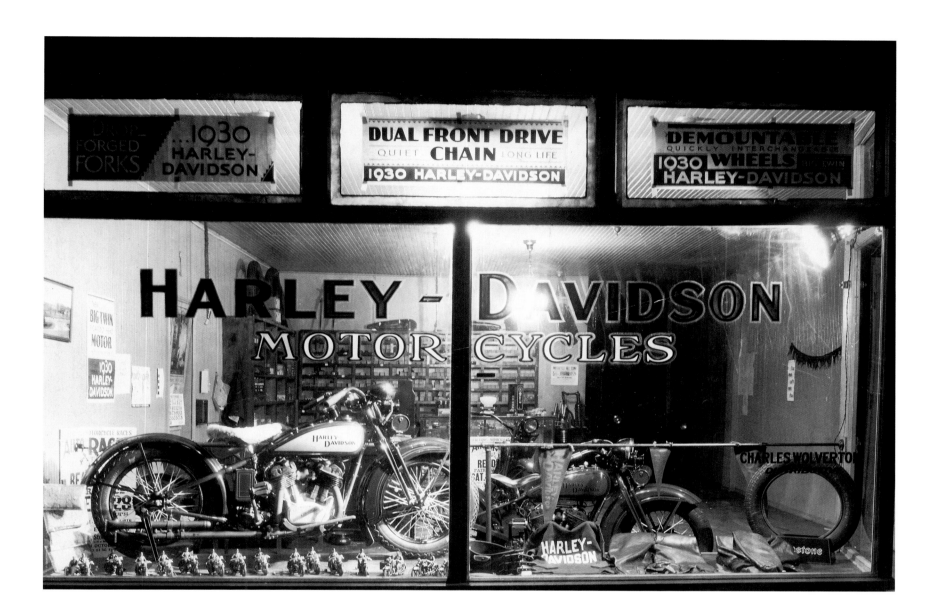

1930 | *The new VL side-valve model is on display in the window of*
Red Wolverton's Reading, Pennsylvania, dealership.

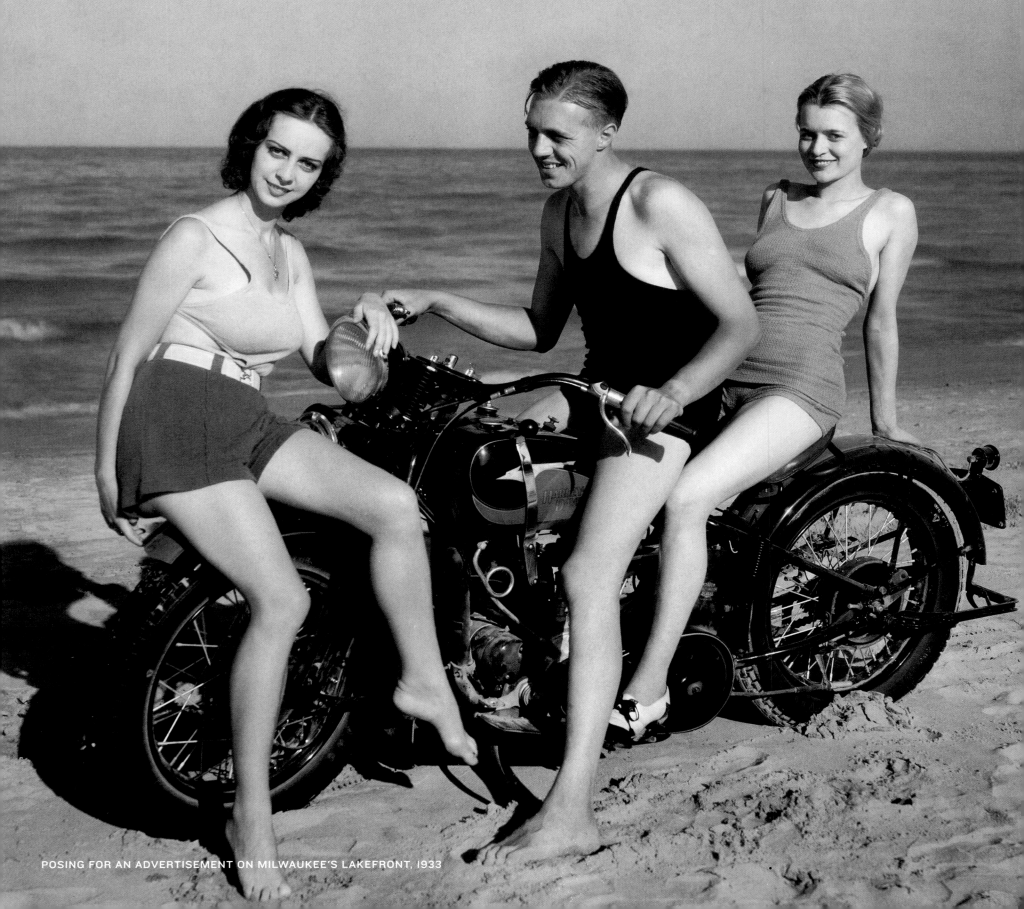

POSING FOR AN ADVERTISEMENT ON MILWAUKEE'S LAKEFRONT, 1933

1928

DEPRESSION AND DARK DAYS

1938

THROUGHOUT THE COURSE OF

THE TWENTIETH CENTURY

HARLEY-DAVIDSON MOTORCYCLES

WERE WOVEN INTO THE FABRIC

OF AMERICAN LIFE.

IN MANY WAYS,

HARLEY-DAVIDSON

CAME OF AGE AND MATURED

WITH AMERICA.

HARLEY-DAVIDSON OWNERS, MYSELF INCLUDED, WILL TELL you that their motorcycles are very close to the center of their lives. When we're not riding them, we're thinking about them. But it's not just enthusiasts whose lives have been impacted by Harley-Davidson. Throughout the course of the twentieth century Harley-Davidson motorcycles were woven into the fabric of American life. In many ways, Harley-Davidson came of age and matured with America.

For much of the first half of the century, groceries, mail, or laundry may have been delivered right to your front door by a Harley-Davidson vehicle, be it an early package truck or the later Servi-Car. You might also have seen a policeman on one of our motorcycles. These bikes had an aura of authority. We once did a great advertising poster for our police bikes with a headline that read THERE'S SOMETHING UNDENI-ABLY RIGHT ABOUT A COP ON A HARLEY-DAVID-SON. It's hard to imagine a presidential motorcade or a downtown parade, now or at any time in the last century, without a police escort on Harley-Davidson motorcycles. If you see a policeman on a motorcycle in an old black-and-white movie or newsreel, you can be pretty sure that vehicle was a Harley-Davidson.

Less visible in our home market but also vital were the more than 90,000 military Harley-Davidson models used during World War I. They were symbols of American ingenuity and strength around the globe and played recurring roles not only in the history of our company but in the history of the world.

As much as we enjoy talking about our motorcycles in the context of sport, fun, and leisure, we need to remember that, since nearly the beginning, there has been a key commercial element to our company. The utilitarian side of motorcycling—use of the bikes for work rather than pleasure—has allowed us to broaden our marketing base and generate additional volume. It has also provided some memorable products and vivid stories.

While I have no doubt that our reputation for quality

had a lot to do with the Detroit Police Department's decision to purchase some of our bikes in 1908, I've always imagined that even in the earliest days, people recognized that a police officer on a Harley-Davidson would command immediate attention and a large degree of respect.

As other police departments saw Detroit's success with our motorcycles, many of them purchased Harley-Davidson police models, and a new side of our business developed. Within a few years, police departments around the country were using our motorcycles, and our reputation as the vehicle of choice for law enforcement spread. The policemen on our motorcycles sent a message to potential motorcyclists and other commercial users that if Harley-Davidson motorcycles can stand up to continuous police use, they've got to be good.

There were other trade applications for our vehicles. The U.S. Postal Service started using Harley-Davidson vehicles to deliver mail in the early 1910s. A motorcycle's size and maneuverability offered distinct advantages over horses and horse-drawn wagons, especially for rural deliveries, and motorcycles were relatively inexpensive to operate.

The company realized it was time to further diversify. Certain businesses could gain a competitive edge by using motorcycles for their deliveries. So Harley-Davidson introduced its first delivery vehicle in 1915: a wooden container with a hinged lid mounted to the sidecar chassis. Soon our motorcycles were being used for a variety of commercial deliveries, from groceries to auto parts. Even some funeral homes used them. We had a department that painted signage for these delivery vehicles, so businesses could custom-order directly from the factory.

It's hard to determine how many of our motorcycles were used for commercial versus personal use during the early decades of our history. We do know, however, that Harley-Davidson motorcycles were widely favored among commercial users.

It was our growing reputation for quality that earned us our first contract to provide motorcycles to the military back in March 1916. A band of Mexican revolutionaries, led by Pancho Villa, had attacked and killed several Americans in the town of Columbus, New Mexico. Within days, Harley-Davidson received a telegram from the War Department, requesting motorcycles to help track down the rebels in the desert terrain. The motorcycles included sidecars developed by Bill Harley that could be used with mounted machine guns.

The War Department recognized our motorcycles'

Police use of Harley-Davidson motorcycles dates back to 1908 when the Detroit Police Department purchased police models. This officer poses with a 1913 chain-drive model.

Far right: By the late 1920s, Harley-Davidson police motorcycles were an important component of the Motor Company's business. Law enforcement sales and service would help carry the company through the Depression years.

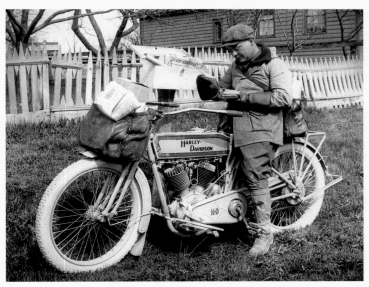

superior performance and was impressed by the speed with which we delivered the motorcycles to New Mexico. A few months later, during the first full year of U.S. involvement in World War I, they purchased nearly half of our production output—some 18,000 motorcycles—for the war effort in Europe. Harley-Davidson motorcycles proved their worth in scouting missions and in quickly transporting messages.

An unexpected benefit of shipping thousands of motorcycles to Europe was establishing a brand presence there. The majority of motorcycles we sent to Europe for the war stayed there, with some of them eventually reconfigured as pleasure vehicles.

World War I changed everything. By the early twenties, we had become the largest motorcycle manufacturer in the world, in no small part because of our production of military motorcycles. The end of the war, though, marked the beginning of some tough times for Harley-Davidson. The economy was rocky, and the explosive

growth of the automobile industry, especially in the twenties, lowered the demand for motorcycles. More and more people were choosing four- instead of two-wheeled vehicles.

The Great Depression delivered another devastating blow to the motorcycle industry. Ultimately, only two U.S. motorcycle manufacturers, Harley-Davidson and Indian, would live through it. Some 3,000 police departments were using our vehicles by this time, along with many businesses and, of course, many thousands more who bought strictly for pleasure. All these bikes would continue to need replacement parts and service, and their mere presence on the streets fortified our brand.

Around this time, we introduced our three-wheeled

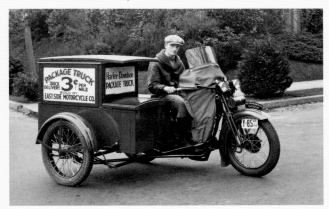

Servi-Car, which would become a mainstay for decades among police and commercial users. We even designed a special tow bar to allow a garage employee to ride the Servi-Car to a customer's house, hitch it to the bumper of the customer's car, and drive the car to the shop for maintenance work. The employee would then return the car, towing the Servi-Car, which was the employee's

By the mid-1910s, motorcycle use in rural mail delivery service was widespread.

Bottom: Motorcycle delivery vehicles with specially designed sidecars and custom graphics were used in the 1920s and beyond.

transportation back to the shop. Car shops across the country used this simple, effective idea.

The Servi-Car also caught on with police departments and became a great vehicle for tire checkers, who could comfortably patrol streets for parking violations.

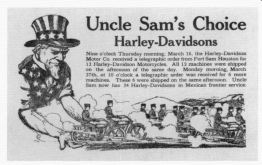

One of the most important chapters in our history opened during World War II, as America's allies increasingly relied upon motorcycles to shore up their defenses. Again, the conversion of some overseas motorcycle facilities into wartime manufacturing facilities created a need for Harley-Davidson motorcycles, and this time we responded with our new WLA, a military version of the 45 WLD. The Russian army, a U.S. ally at that time, purchased around 30,000 WLAs over the duration of the war. Our motorcycles were used for everything from scouting missions to overall reconnaissance and were highly regarded for their ability to negotiate rough terrain. By the time America was directly involved in the fighting, virtually every Harley-Davidson motorcycle being built was for use in the war effort, and more than 90,000 of our military motorcycles would see action around the globe.

Shortages of raw materials meant civilian motorcyclists often had to wait for replacement parts. A lack of metal forced us to ship oil in glass jars, which a few civilian riders have kept to this day to remind them of Harley-Davidson's involvement in the war effort. These rare items are highly desirable in the collector market.

Harley-Davidson contributed to U.S. Army efforts in 1916 when specially equipped sidecars mounted with machine guns were used for Mexican border duty.

Far right: An officer mounted on a Harley-Davidson motorcycle led the way in 1951 for the return of General Douglas MacArthur to his boyhood home of Milwaukee.

Letters from soldiers flowed into Harley-Davidson headquarters praising the performance of the WLAs. The American motorcycle was proving its mettle under the most brutal circumstances, and Harley-Davidson owners followed the stories of brave Americans and their motorcycles in our magazine, *The Enthusiast*.

As soldiers returned home, many who had learned to ride in the military were now eager to continue their love affair with motorcycles. So they turned to the brand they knew and respected from their time in the war: Harley-Davidson.

A few years later, in 1953, our largest domestic competitor, Indian, shut its doors and left Harley-Davidson as the only American motorcycle manufacturer. Indian redesigned their motorcycles to become more competitive in the market, but I believe they hadn't allocated enough test time. They were anxious to release an all-new lineup to the public, but inadequate testing marked the beginning of their downfall. From a field

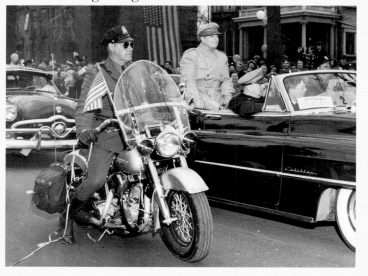

that once held over 155 American-based competitors, we were the last survivor.

In the postwar era, Americans felt relieved and secure, and they wanted to get out, have fun, and see the country. There's no better way to do that than on a motorcycle, so thousands of new or war-vet riders took to the road on Harley-Davidson vehicles. Pleasure-motorcycle sales at Harley-Davidson ramped up quickly.

To help spur Europe's postwar economy, import tariffs were lifted on many European products being shipped into the United States, and British bikes like Norton, BSA, and Triumph began to gain a degree of favor here. In the late fifties and throughout the sixties and beyond, the U.S. saw an influx of Japanese motorcycles. These non-domestic competitors met us head-on on the roads and on racetracks, but also solidified our position as "America's motorcycle." Our unique look had evolved. We had imprinted an imagery and a style of motorcycle in people's minds.

Decades later, after wide swings of great market growth, devastating declines, and growth again, Harley-Davidson's position as America's motorcycle has become even more firmly grounded. As we became more successful, many large foreign competitors, one

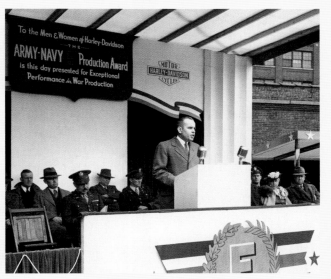

by one, began imitating the look of our motorcycles. They always claim they're not copying Harley-Davidson, simply evoking "American styling." That's actually a great compliment to us, since motorcyclists around the world associate American styling with Harley-Davidson. We've worked very hard over the past 100 years to earn this distinction. Producing America's motorcycle is something we do with a tremendous amount of pride and honor.

On a platform erected outside the Juneau Avenue plant in Milwaukee, company president William H. Davidson accepts an Army-Navy "E" Award for exceptional industrial performance during World War II.

Far left: World War II soldiers grew fond of their military Harley-Davidson motorcycles and wrote to The Enthusiast *telling of overseas adventures.*

1927 | S (PEASHOOTER)

The Peashooter appeared as the era of the board track and the 61-cubic-inch 8-Valves ended. Peashooters were equipped with either 21-cubic-inch (350cc) or 30.5-cubic-inch (500cc) engines. With these smaller engines, you would no longer see the tremendous speeds of the 8-Valves. Peashooters were used in several types of racing, from dirt track to cinder track. The cinder track is a very short track where a special variation of the S motorcycle raced.

Every piece on a racing bike is designed for a specific function. The 1927 Peashooter is a minimal machine. It has no lights or brakes; the fuel tank is sensuous; the rear fender is tiny; the exhaust pipe is short. The chain guard is a beautiful little teardrop. These extremely functional forms represent the combination of art and science.

I am fascinated by racing bikes because of their proportions. The 1927 S Peashooter has big, large-diameter wheels. The proportion of those wheels to the low seat and the drop handlebars—even the way the whole frame sits low—is handsome. The exposed valve springs at the top of the engine are mechanically handsome. I just love these motorcycles. That's why I have two iterations of the Peashooter in my personal collection—one restored and one "barn fresh."

POWERTRAIN

Engine: Single-cylinder overhead valve

Displacement: 350 cubic centimeters

Transmission: Direct drive

Primary drive: Chain

Secondary drive: Chain

Brakes: None

Ignition: Magneto

CHASSIS

Frame: Single loop

Suspension: Telescopic forks (front)

Wheelbase: 49.625 inches

Tires: 28 x 2.25 inches (front and rear)

Color: Olive Green

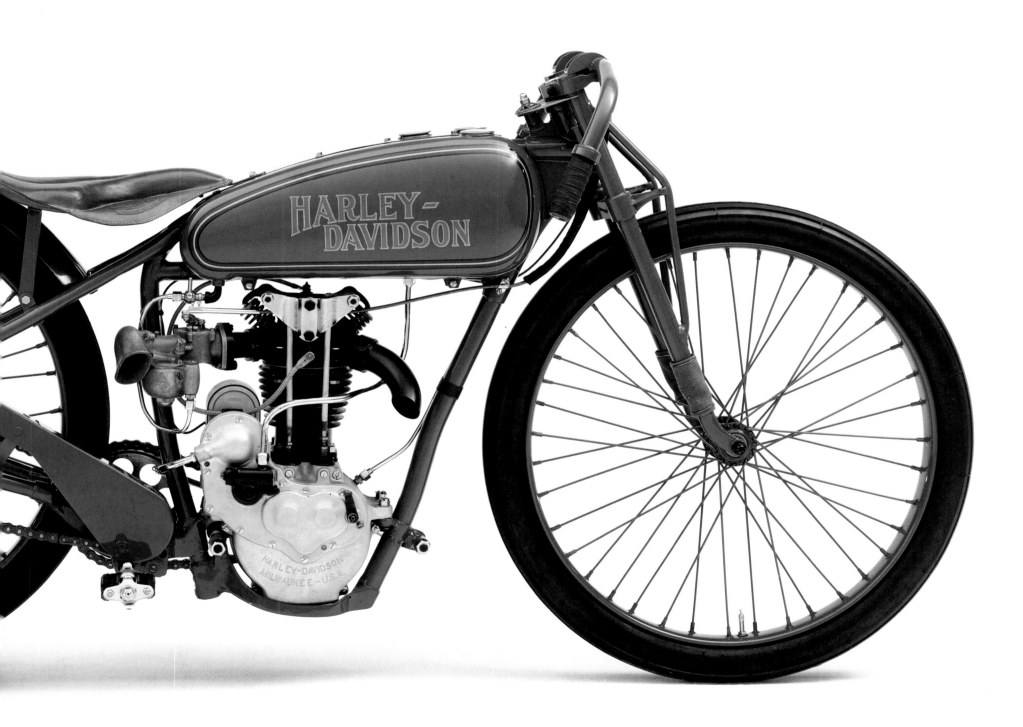

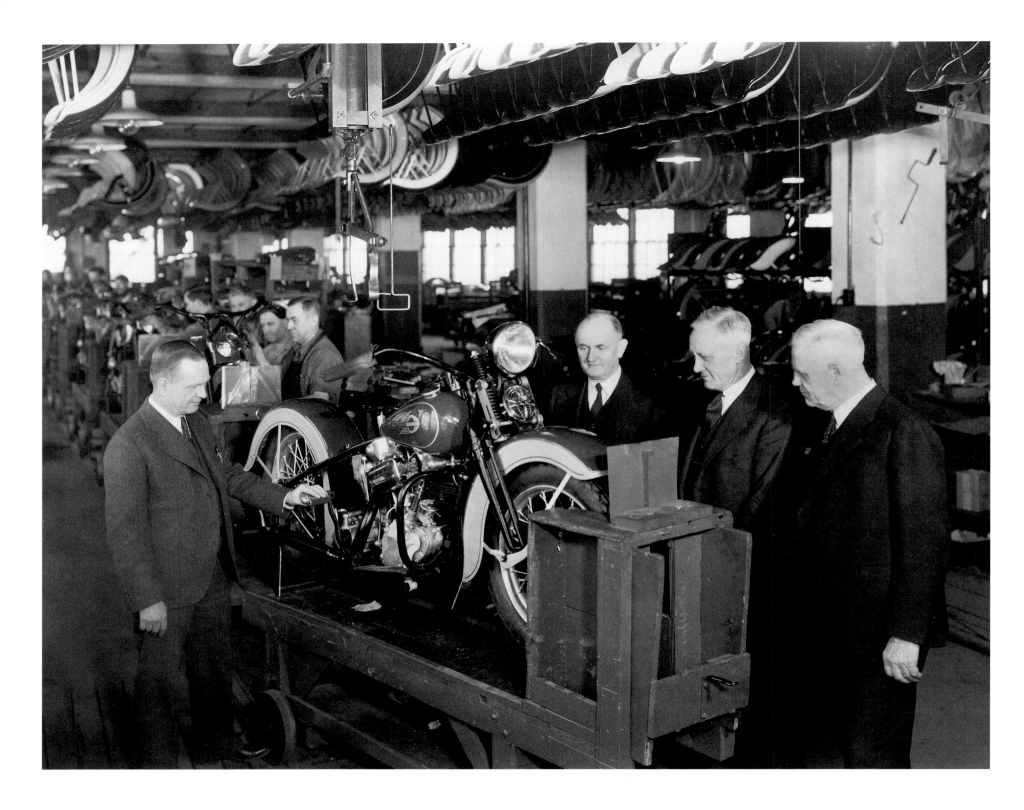

1936 | *Harley-Davidson founders, from left to right: Arthur Davidson, Walter Davidson, William S. Harley, and William A. Davidson. They are inspecting a prototype 61 OHV model, a motorcycle that would set styling and engineering standards for all subsequent Big Twins.*

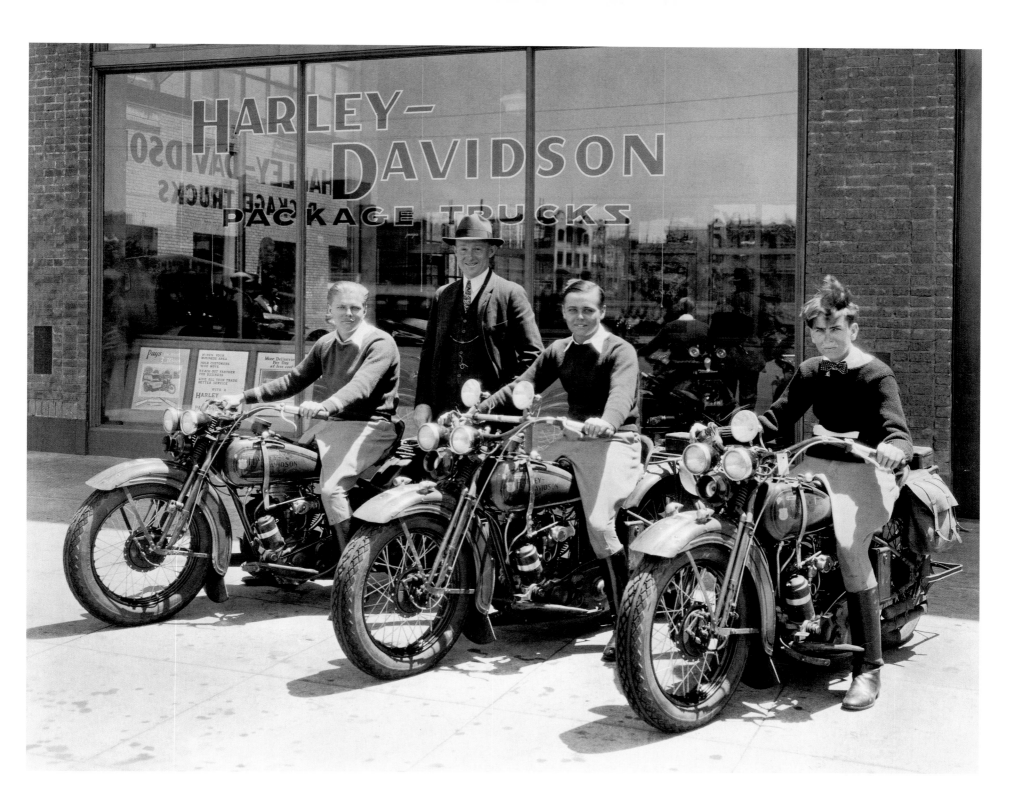

1929 Second generation Gordon, Walter Jr., and Allan Davidson in San Francisco with dealer Dudley Perkins. One stop on their 8,000-mile cross-continent motorcycle tour.

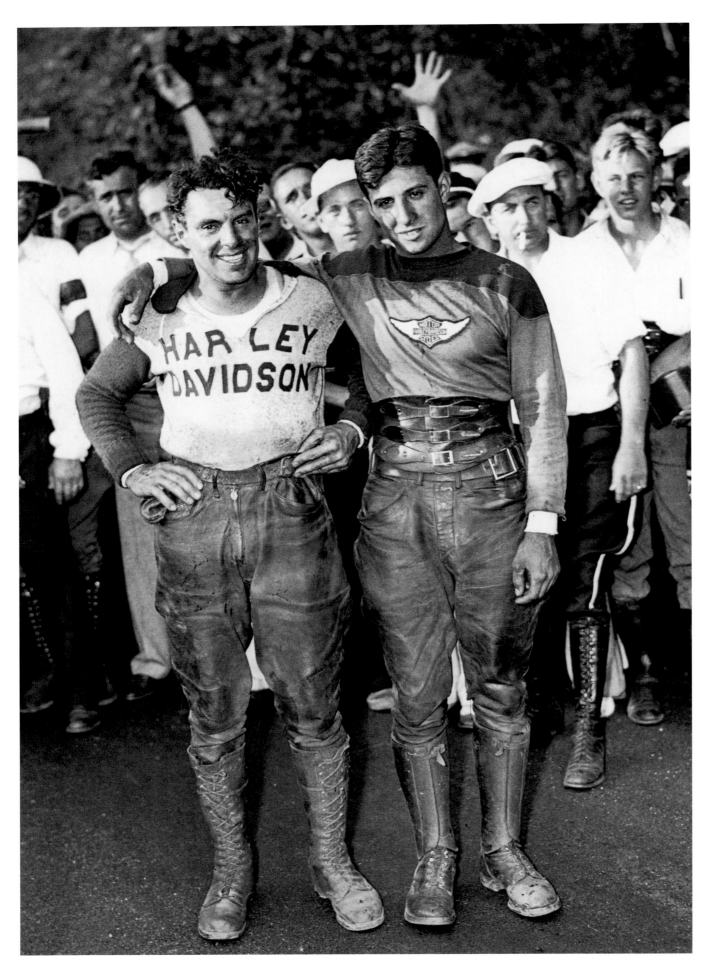

1935 | *Dirt track stars Babe Tancrede and Benny Campanale wearing stout boots, riding belts, leather pants, and Harley-Davidson jerseys.*

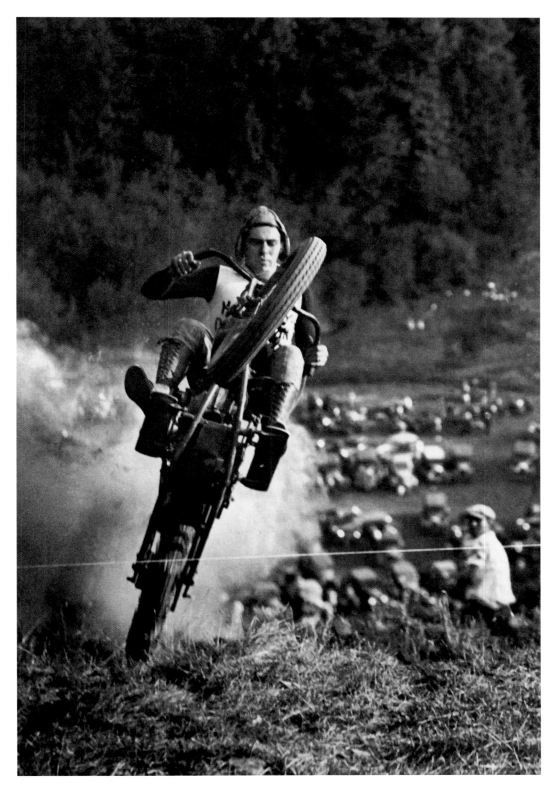

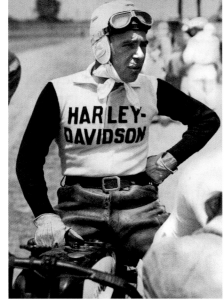

1937 Joe Petrali was one of the great names in 1930s racing and was dominant at both track and hillclimb events.

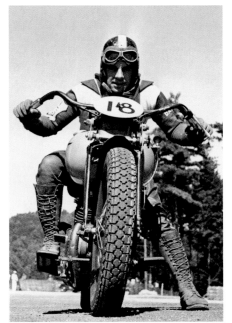

1938 Babe Tancrede at Laconia, New Hampshire, on a WLDR dirt track racer. This 45-inch side-valve model put out 29 horsepower at 5,500 rpm and could reach a speed of 90 mph.

1935 This finish line view at Hornell, New York, shows Joe Petrali doing what he did best.

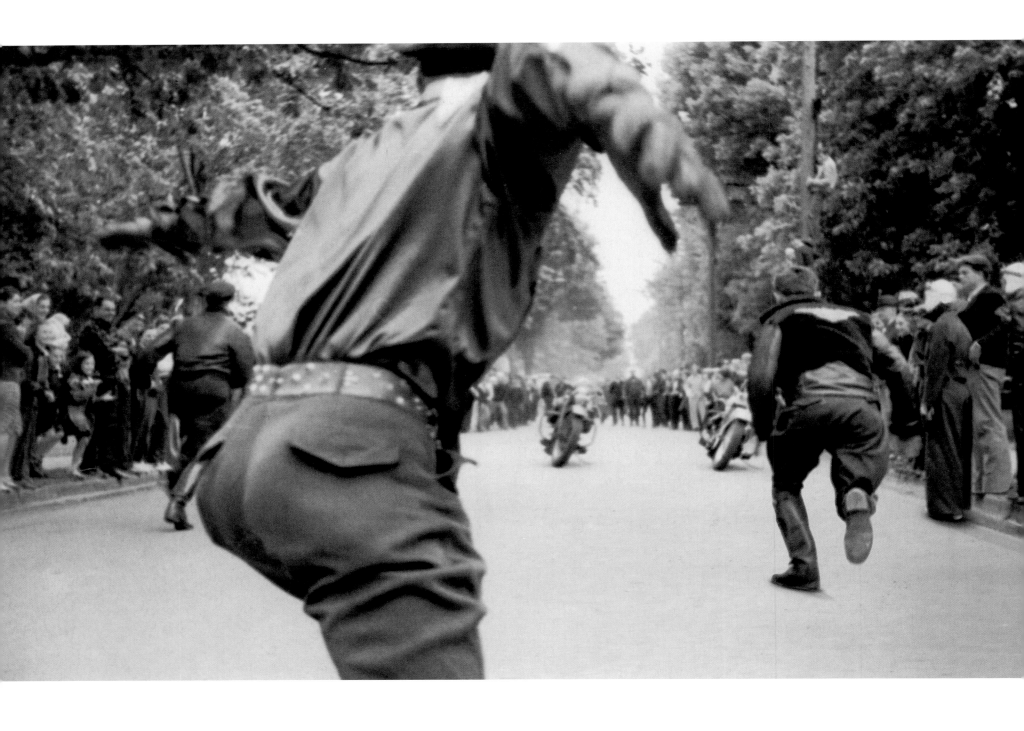

1938 | *In the motorcycle foot race, riders ran to their bikes,*
kick-started them, and vied to be the first to cross the finish line.

78

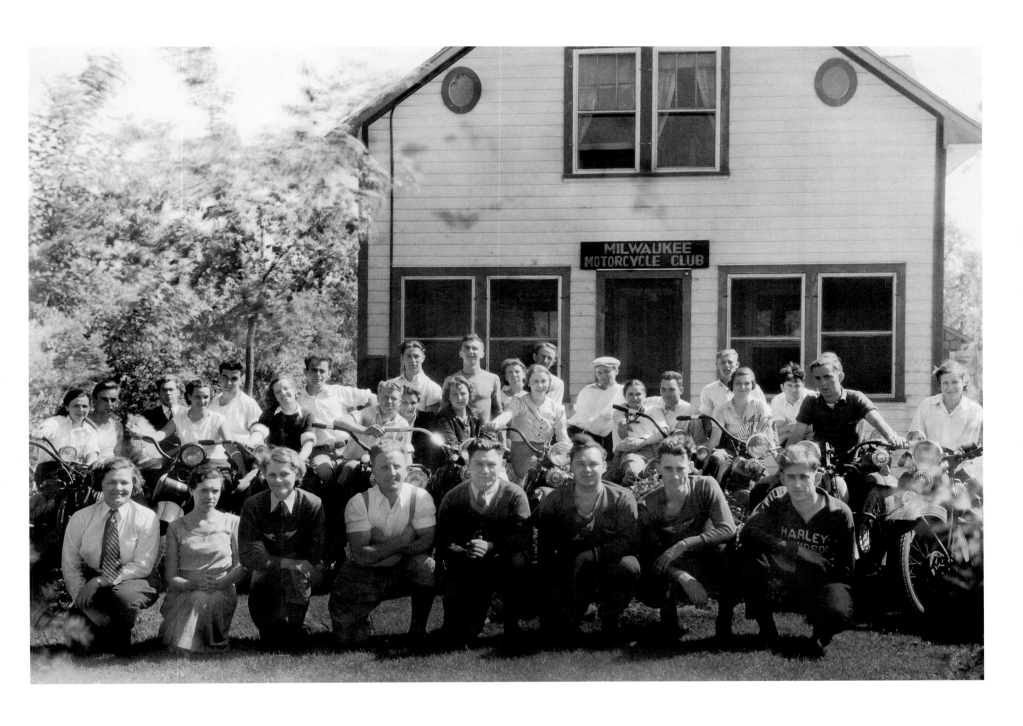

1932 The Milwaukee Motorcycle Club at their Friess Lake summer cottage west of the city. The club was established in 1926 and had nearly 100 members by the early 1930s.

1929 | DL

The 1929 DL marked the first appearance of the flathead engine, which uses side valves for both intake and exhaust. This engine had a remarkable lifetime. Harley-Davidson used it for forty-four years, from 1929 to 1973. Apart from the alternator, the engine had very few changes in that time period.

This motorcycle comes from the days when there were no design departments to beautify the shapes of functional parts. Engineers created the forms. Some ideas lasted, some were abandoned along the way. The DL, for example, has two headlights and four mufflers—more than any other Harley-Davidson model. We made motorcycles with twin headlights only in 1929 and 1930. The small bullet-shaped mufflers appear on both sides of the bike.

The look of these motorcycles makes them very collectible today. The DL's tank shape, for example, is absolutely beautiful. The first version of the teardrop-shaped tank appeared on the 1925 JD. From 1925 to 1936, the fuel tank wasn't completely rounded. It had a flat top and somewhat curved sides. Eventually, in 1936, the tank design evolved into the form seen to this day.

Back in 1929, everything was done by hand. The paint on the DL is olive green. There was maroon striping on the fuel tank, but that's as far as they went with color. The years of two-tones and bright colors were yet to come. If people then could see what we're doing today, they wouldn't believe it.

POWERTRAIN

Engine: 45-degree V-Twin flathead

Displacement: 45 cubic inches

Transmission: Three-speed, hand-shift

Primary drive: Double-row chain

Secondary drive: Chain

Brakes: Internal expanding (front), external contracting (rear)

Ignition: Battery and coil

CHASSIS

Frame: Single loop

Suspension: Coil spring leading link (front)

Wheelbase: 56.5 inches

Gas tank: 3 gallons

Oil: 3 quarts

Tires: 25 x 3.85 inches (front and rear)

Color: Olive Green

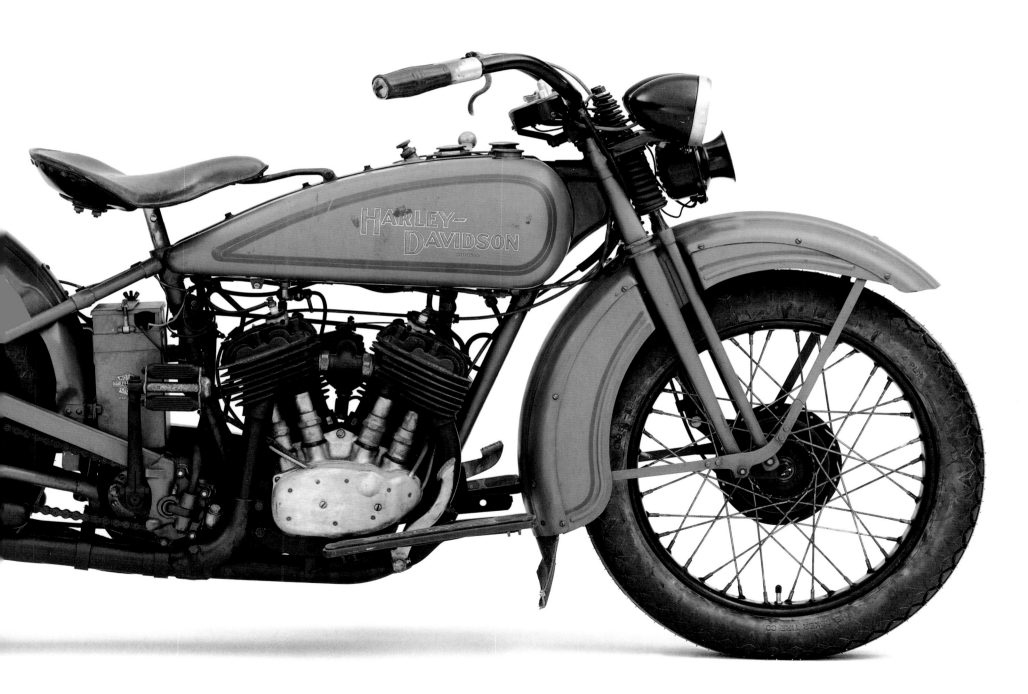

I HAD NO DESIRE

TO RADICALLY CHANGE THINGS

RIGHT OUT OF THE GATE

BECAUSE THE

PURITY AND SIMPLICITY

OF OUR BIKES WERE THEIR

GREATEST STRENGTHS.

But I had some new ideas.

WHEN YOU GET DOWN TO IT, AT THE END OF A DAY'S WORK at Harley-Davidson, motorcycles are as pure as they've always been: two wheels, a motor, a seat, and handlebars. But as simple as the product may seem, this is a difficult industry in which to compete. Ask anyone who's tried.

Each new company that has entered this business over the past 100 years has believed it could take this basic two-wheels-motor-seat-handlebars idea to new levels and improve the riding experience. Only a few succeeded. Harley-Davidson is the longest-standing motorcycle company in the world.

Motors were the obvious starting point. Since day one, better, faster, and more reliable motors have evolved. These improvements excited riders, generated sales, and motivated the entire industry. Over time, especially in the early decades of the century, those who had the resources to stay ahead of the motor-development and engineering-improvement curve—and the ability to profitably mass-produce new, improved products and get them to market—lived.

Each time the bar was raised, the surviving companies were forced to take greater leaps and dig deeper into their pockets to remain competitive and keep their customers loyal. But the stakes quickly grew too steep; many companies couldn't keep up with the pace and folded their tents.

Engineering reached levels of near-parity throughout the industry, and companies needed more ammunition to make their brands unique. Dealer training, racing, and event sponsorship became elemental to success. But during the periods of economic instability, like the Great Depression or the recession of the late seventies, declining demand meant motorcycle companies had to create or maintain greater brand differentiation. This is where styling comes into play.

The essence of a motorcycle is its function. What those of us in styling try to do is embellish the basic vehicle to give it character in support of the brand. We respect the Harley-Davidson heritage, and we aim to

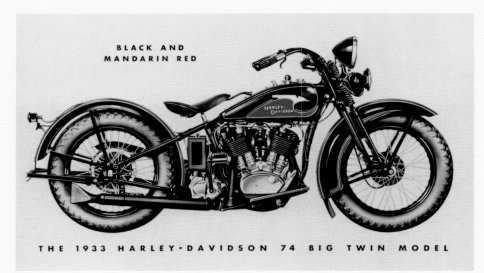

BLACK AND
MANDARIN RED

THE 1933 HARLEY-DAVIDSON 74 BIG TWIN MODEL

To revitalize the declining motorcycle market, new colors and tank graphics were introduced in 1933 to replace the long-running olive green paint and block typography.

Far right: With contoured surfaces, intriguing mechanical details, and chromed accents, the Knucklehead engine was a visual masterpiece that set the pattern for later Big Twin OHV engines.

preserve its spirit. The styling process creates a recognizable look by injecting some of our own inspiration and individuality through custom touches. This can work only when we have a group of talented people, with each contributing.

There were times when styling was the most vital aspect of new motorcycle development. When the company was financially unable to develop new engines and models, the focus was on styling to keep the bikes looking fresh and modern. The Great Depression, for example, wiped out many industries and came a whisker away from killing ours. People with no jobs and empty pockets were worried about covering the rent and feeding kids, not shopping for motorcycles.

By 1933, with the country's economy at its lowest ebb, Harley-Davidson and Indian were the two domestic motorcycle manufacturers still standing, from a field that once numbered more than 150 competitors. Many took their last breaths during the Depression. Our police and military contracts, plus the devotion of our dealers and riders, kept us alive in that period.

To create excitement and perhaps spark interest in this shriveling market, a decision was made to change the appearance of our motorcycles. It turned out to be a good strategy. Our traditional olive-green paint scheme and block-lettered tank graphics were replaced with vivid reds, blues, two-tones, and the hand-painted art deco eagle graphic. This was the earliest factory custom paint job, and custom paint would eventually become one of our core competencies. Our unique paint treatments became fundamental to the magic of our motorcycles, and this was the beginning of that trend.

The first motorcycle, Serial Number One, was black; then came the Silent Gray Fellow, followed by the greens. But the change to custom paint involved us more intimately in the relationship between the customer and styling. We were starting to see that styling has to do with emotions, and that riders have a deep emotional attachment to their vehicles.

The people behind this new effort weren't trained designers, and there was no styling department then. I don't think the term "industrial design" even existed. What Harley-Davidson had were some self-taught artistic people with a flair for proportions and creativity. The fact that these folks constructed such innovative machines, and that company leadership supported their efforts, boded well for our future.

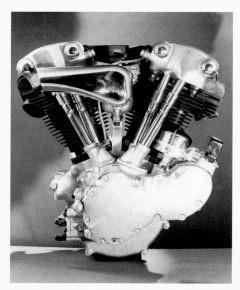

The revamped bikes were striking and riders liked what they saw. The sales numbers, though still small, inched upward through the rest of the thirties. Clearly, the lesson had been learned that introducing paint variations could add a considerable competitive advantage.

A few years later a landmark vehicle, a favorite of mine, was introduced: the 1936 EL. The EL featured a new and potent overhead-valve 61-inch motor, fondly nicknamed the "Knucklehead" because its rocker boxes (atop each cylinder head) resembled fists. In and of itself, the Knucklehead was big news, and it's the grandfather of our current overhead-valve V-Twins. But in addition to the motor, the EL had numerous industry-first design features. Its teardrop-shaped fuel tank was topped with an instrument panel (dubbed the "Cat's Eye") that bundled all the gauges into one graceful package. Our first-ever oil circulation system featured a wraparound oil tank. To this day, the wraparound oil tank is a key visual component, as noted in the Softail line.

The development of the oil circulation system was a major deal. The oil now circulated through the engine and returned to an oil tank, as opposed to a total-loss system, where the oil flows through the motor, lubricates it, and then is vented out of the motor. The new oil circulation system meant that oil would remain on board.

The EL is one of the most beautiful models we've ever produced. It established a look for Harley-Davidson and remains an influential motorcycle. The overall proportions of sheet metal to wheels to tires and the handsome engine are elements that make the EL stand out to me. I have five of them in my personal collection. Among my Knuckleheads are a '47 (last year of production) sidecar rig, a '36 (first year of production) white Knuckle that's a totally restored original, and an early Bobber. The Bobber is based on a 1946 Knuckle. It's a classic custom that demonstrates the way motorcycles were being customized after World War II, when fenders were changed or removed. The Bobber is prominent in my collection because customs have become a big part of our success story.

How the leadership and employees of Harley-Davidson were able to pull off the EL, given the market dynamics of that time, is as much a reflection of their passion and skill as their drive to achieve extraordinary things against very difficult odds. Followers of Harley-Davidson are quick to recognize that these traits are part of our roots and continue to exemplify the people who work here today.

As time went on, Harley-Davidson created a wide range of motorcycle accessories. We were always evolving and giving our riders the custom touches they came to expect from us. From

The 1936 EL Model introduced new features that have stood the test of time. The integrated "Cat's Eye" instrument panel combined the speedometer, warning lights, and ignition switch into a smart-looking console.

Bottom: Willie G. was featured on the October 1982 cover of Custom Bike with his Knucklehead bobber.

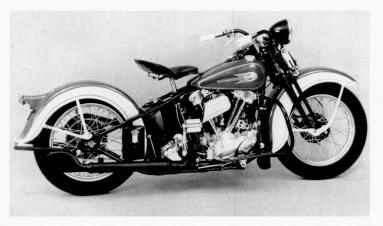

the thirties on, expert styling had taken hold and was gradually becoming synonymous with Harley-Davidson motorcycles.

Anytime I flip through our product brochures from the forties and fifties, my eye immediately picks up the subtle but attractive year-to-year changes in the overall style of the bike—fenders, tanks, seats, trim, paint. These enabled us to distinguish new bikes from prior models and helped us to keep our product offerings fresh, without the enormous tooling costs of entirely new motorcycles. As parts were being designed and created, they also helped fuel our rapidly

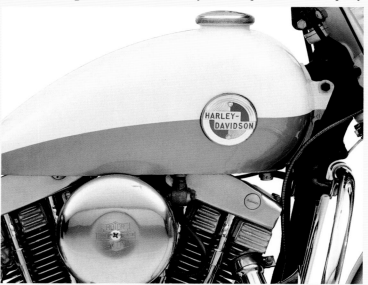

growing parts and accessories business.

One of the first things I ever designed for the company was the tank emblem in 1957. I wasn't an employee at the time, just moonlighting as a young designer, getting my feet wet. Badging is the main way to distinguish a model from one year to the next. It's also the place where we carry our most valuable asset, our name. I'm proud to have designed many of our fuel-tank logos over the years. The fuel tank is the first part of the motorcycle I look at to determine its year.

Another significant model in Harley-Davidson history is the 1952 flathead K Model. The K was a lean-looking motorcycle with barebones styling—an engine and two wheels. I appreciate its spare look. In 1954 a larger engine was added to the K, and the KH was born—for the boulevard. The racing version, the KR, was the undisputed king of the dirt track. It exemplifies everything I love about this era of motorcycling. My first big motorcycle was a K Model, and those were my formative years as a rider on a big bike. As a young man I was an avid follower of the AMA dirt-track championship (and still am), and here was this new KR. I was riding a K Model, and the KR was a derivative of it.

When you're young, there are certain things in your life that make strong impressions. In my case, it was the era of Joe Leonard, Carroll Resweber, and Brad Andres. They were my heroes when I was a young guy blasting around on my bike. The emotion from this era fires my psyche. It's indelible in my mind.

In 1957 the K Model was changed from a flathead to an overhead-valve engine design, which brought improved performance. As a result of this change, the

world now had its first muscle bike, and Harley-Davidson had a best-seller.

As important as styling and design had become

to Harley-Davidson, there was no formal styling department when I joined the company in 1963. Engineers and various design consultants (including me) had carried the ball. By then the company was involved with golf cars and Topper scooters. Harley-Davidson had also purchased the Tomahawk Boat Company for their plastic-forming expertise, which enabled us to design and manufacture saddlebags and tour boxes. There was also an Italian partner for a line of light-weight motorcycles, Aermacchi. These products were in addition to the existing line of Harley-Davidson motorcycles. My dad was company president then. He and I would have lunch together, and we started talking about the company's need for a stand-alone styling department.

At first the styling department consisted of me and a model maker, which made things challenging but exciting. Harley-Davidson was a small company and we had a lot of freedom, which is a huge plus to any designer. It was truly a dream world.

I had no desire to radically change things right out of the gate because the purity and simplicity of our bikes were their greatest strengths. But I had some new

ideas. We were not in the custom market, but that didn't mean we couldn't experiment a little. As the years passed, with the help of many loyal coworkers and friends, we started to stretch our design wings. We would end up styling some groundbreaking models (and even a few that didn't catch on). But our philosophy remains true to what brought Harley-Davidson success in hard times—to maintain the heritage of our styling past while always keeping an eye firmly trained on the future. It's what makes a Harley distinct from every other motorcycle on the road, and keeps us on the leading edge.

In this 1952 picture taken by future wife, Nancy, Willie G. stands next to his first big bike, a K Model.

Hillclimbs

These hillclimb photos bring back fond memories for me. As a child, I attended hillclimb events in the area around Milwaukee. There's drama in a two-wheeler climbing a very steep hill. It harks back to early motorcycling, and has been depicted in painting and sculpture. Of course, it was more popular back then than it is today. But there's just something about these guys in their football helmets, on these old Springer models, climbing these vertical hills that will always be fun to look at.

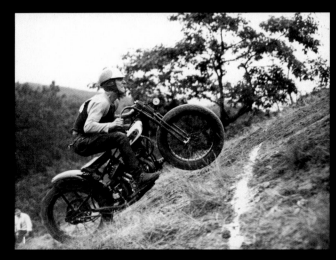

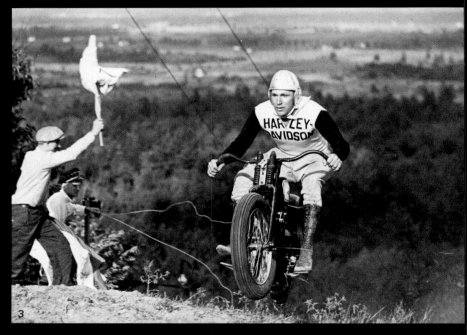

2

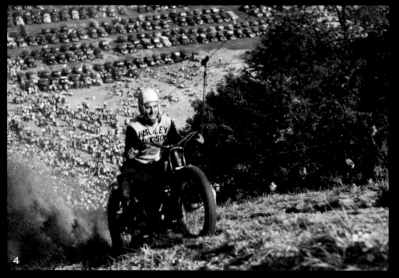

3

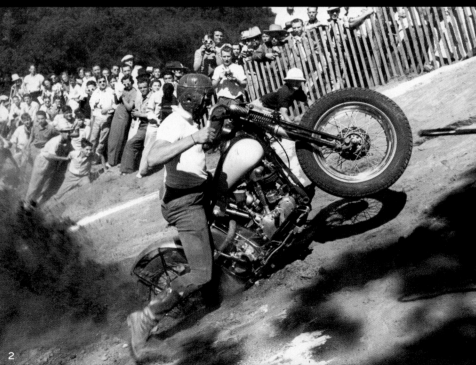

4

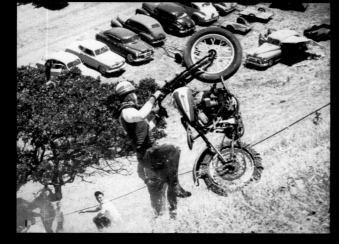

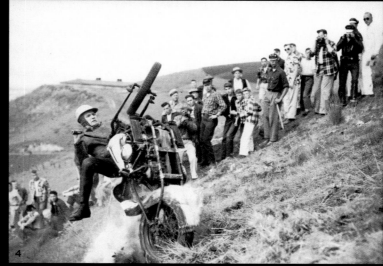

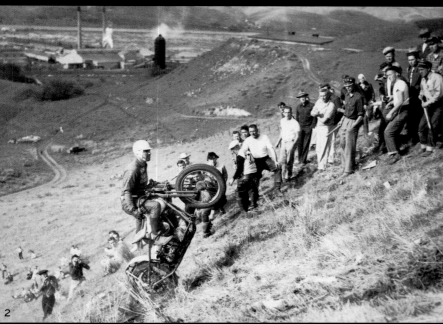

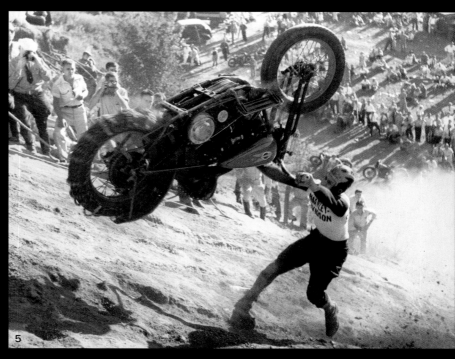

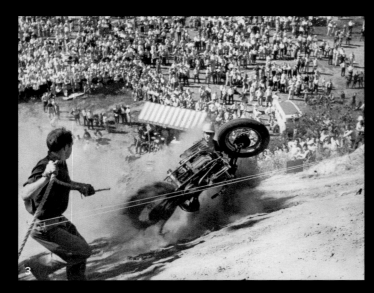

OPPOSITE PAGE

(1) Displaying determination in 1951 (2) Spraying dirt with the back wheel (3) A Harley-Davidson motorcycle at the finish line in 1940 (4) Powering up the hill in 1948.

THIS PAGE

(1) A spectacular mid-air loop in 1939 (2) Everyone watches an apprehensive moment at a 1952 competition (3) Top-hill view in 1947 (4) The drama intrigued the crowds (5) An uphill wheelie at a 1952 climb.

1936 | EL (KNUCKLEHEAD)

The EL (Knucklehead) is on anybody's list of Harley-Davidson milestones. The Knucklehead engine is the granddaddy of our air-cooled V-Twins. It defined a look—through the combination of engine style and small, defined shapes—that lives on in today's motorcycles.

The Knucklehead engine was the first overhead valve model, which meant better performance for Harley-Davidson motorcycles. It also marked the beginning of a tradition of names the street gave to the configuration of covers on the rocker boxes. In this case, the gnarly top area of the motor looks like a knuckle.

People talk about this motorcycle with reverence. Riders liked it then, and it is a major collectible now. Its shapes and forms mark a defining moment in Harley-Davidson history. The instrument console was the first one to be located at the top of the fuel tank. It's fondly known as the "Cat's Eye." The defining style element, which continues to this day, is the teardrop fuel tank. Other distinctive styling elements include the wraparound oil tank, the fenders, and the dramatic flying wheel on the fuel tank.

The paint scheme on the EL reflects the art deco era. Prior to 1933, Harley-Davidson paint colors were plain, almost dull: gray, green, black. But in 1933, the Motor Company used dramatic graphics in order to survive harsh economic times. The colors on this 1936 EL continued that trend.

I was a young kid when the 1936 EL was introduced. It has a fond place in my memory.

POWERTRAIN

Engine: 45-degree, overhead-valve V-Twin
Displacement: 61 cubic inches
Transmission: Four-speed, constant mesh, hand-shift
Primary drive: Double-row chain, oil-mist lubrication
Secondary drive: Chain
Brakes: Drum and shoe (front and rear)
Ignition: Battery and coil

CHASSIS

Frame: Steel, double downtube
Suspension: Coil-spring leading link Springer fork (front)
Wheelbase: 59.5 inches
Gas tank: 3.75 gallons
Oil: 1 gallon
Tires: 18 inches (front and rear)
Colors: Sherwood Green/Silver; Teak Red/Black; Dusk Gray/Buff; Venetian Blue/Cream; Maroon/Nile Green

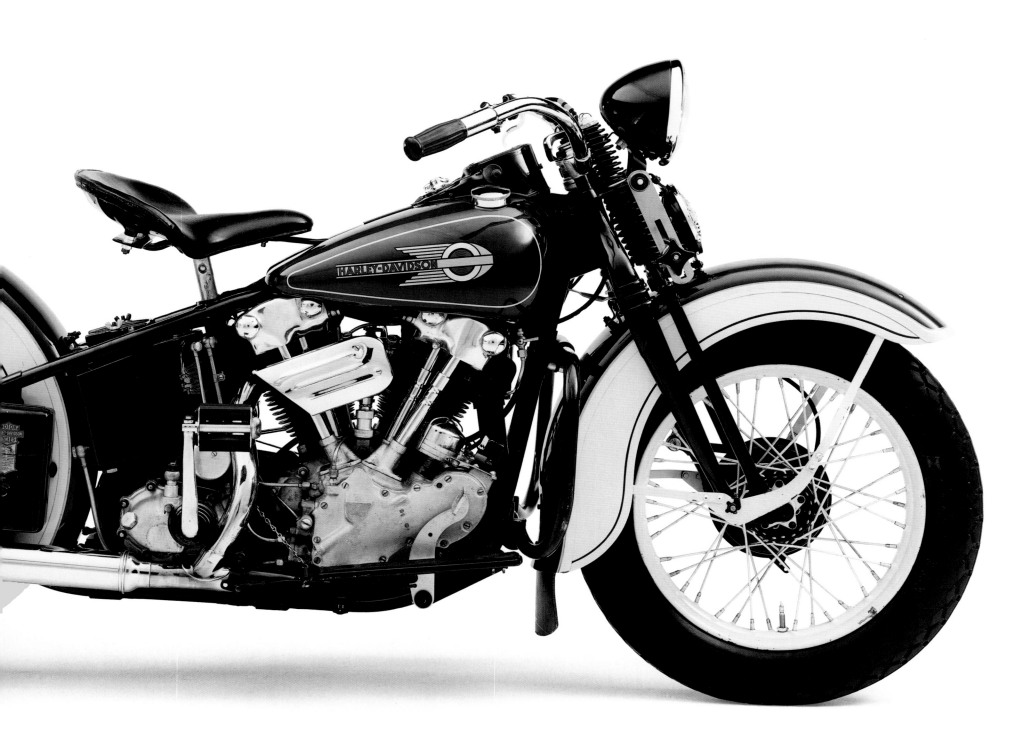

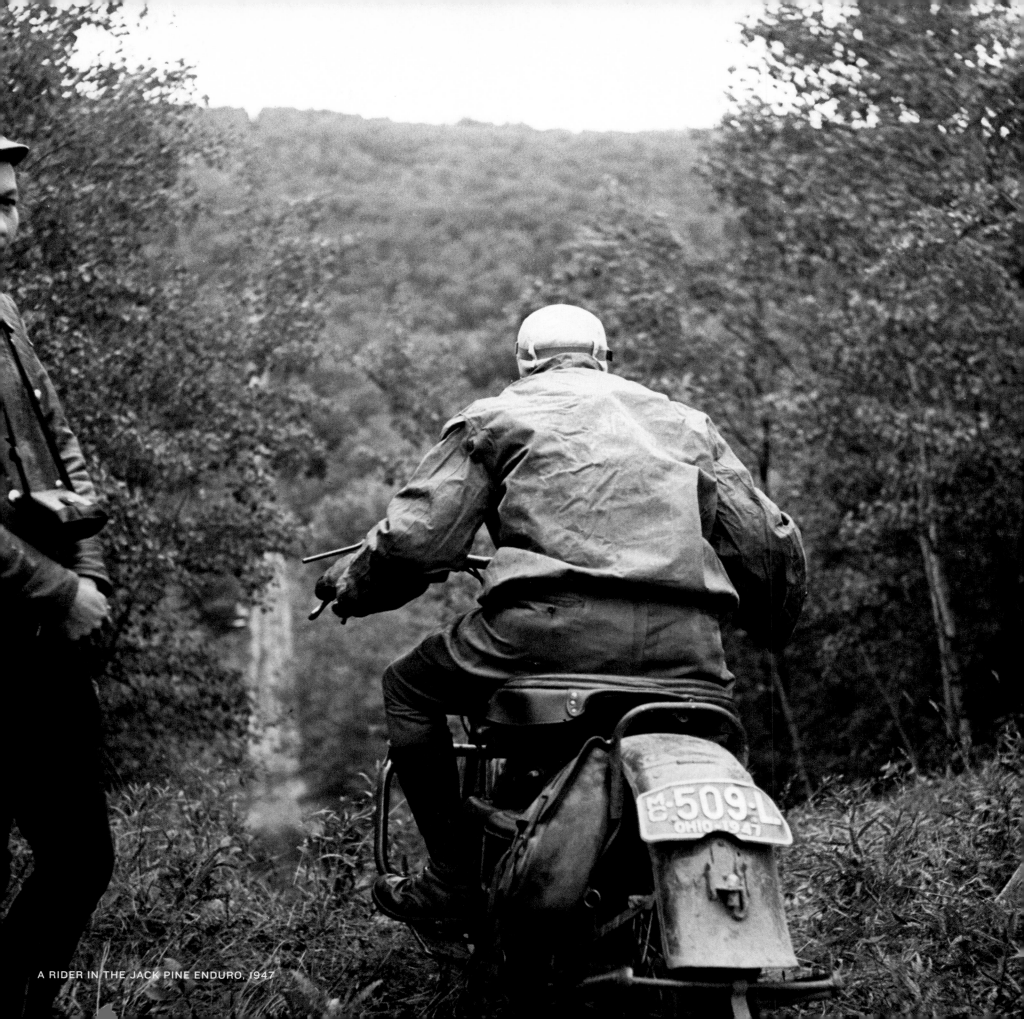

A RIDER IN THE JACK PINE ENDURO, 1947

1939

PATRIOTISM AND PASSION

1955

AFTER MANY VISITS TO THE PLANT,

IT BECAME CLEAR TO ME THAT

THE EMPLOYEES WERE THE PEOPLE

WHO MADE THE MAGIC.

THERE HAS ALWAYS BEEN

GREAT EMOTION

WITHIN THE WALLS OF

HARLEY-DAVIDSON.

W

HEN I WAS A BOY, MY BIGGEST THRILL WAS GOING down to the factory at 3700 West Juneau with my dad. It was a special treat. This was the magical place where raw metal entered through one door and finished motorcycles exited through another.

Back then, every Harley-Davidson motorcycle was assembled in that building (which is now our corporate headquarters). You could walk through the plant and observe every step in the creation of a motorcycle. A vast system of overhead belts powered the lathes and other machinery that performed the cutting, shaping, drilling, and grinding of parts.

After the chassis were welded together by workers in masks and leather smocks, they'd be loaded onto wooden supports and pushed to each workstation via a system of rollers. Employees manning these stations would add parts, assemble systems, and gradually create a finished motorcycle. Everywhere you looked there were racks of engines, wheels, tires, frames, tanks, seats, fenders, and headlights.

No trip was complete without a stop at the racing department, which, for a kid, was an incredibly cool place. It seemed sacred. The bikes, which represented experimental technology, looked much different from the standard models, and they had that simple, handsome look that I have always appreciated. Sometimes

Beginning in 1915, a motorcycle from each production year was placed into a special collection at the Juneau Avenue plant.

I'd hang around with the test riders. They rode in all kinds of weather, testing prototypes and generally ensuring the safety and stability of our motorcycles. I loved listening to their stories.

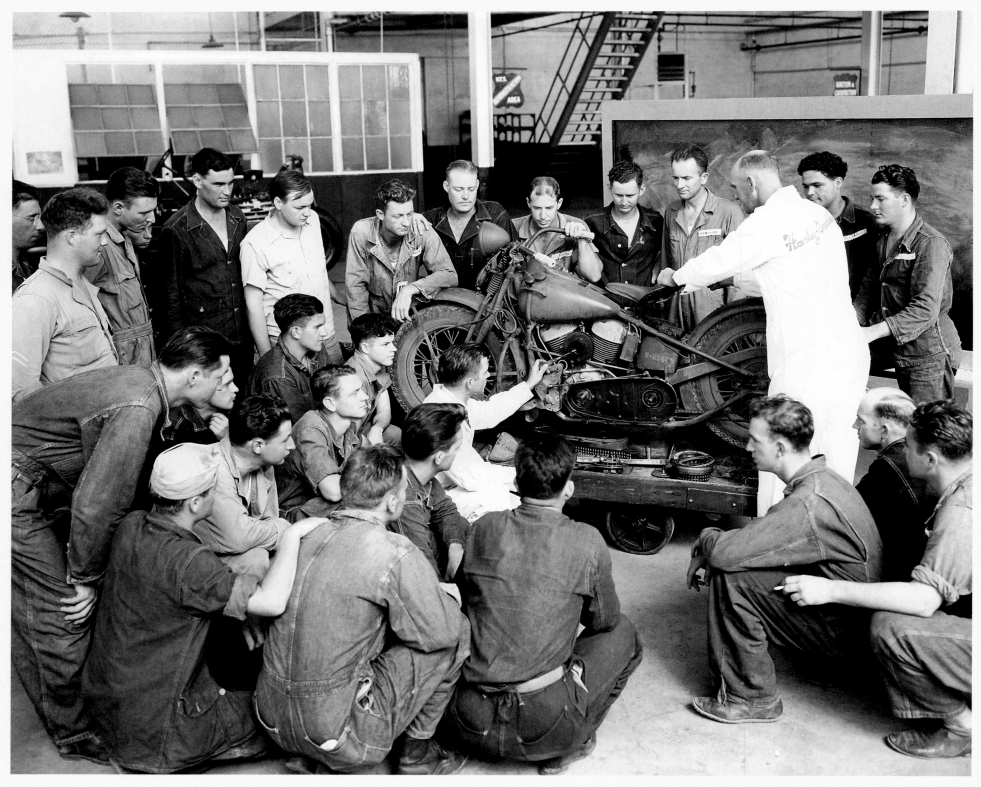

*Service department technician Johnny Powers (kneeling, in white)
instructs mechanics about the finer points of the Big Twin military
motorcycle in 1941.*

And then there was the bike collection, going all the way back to the oldest existing Harley-Davidson motorcycle, which resides today in the lobby of that same building I visited as a boy. The founders made it a rule to keep one model from each year. When I visited as a kid, the collection just looked like a roomful of great old bikes to me. But something must have sparked, because I have been an avid collector since.

I can distinctly remember how much I enjoyed watching my dad talking with employees. He made himself accessible. He got along well with everyone, just as his father had. I'm proud to say that this friendly relationship between employees and leadership at Harley-Davidson, established in the company's earliest years, continues today.

After many visits to the plant, it became clear to me that the employees were the people who made the magic. There has always been great emotion within the walls of Harley-Davidson. The original founders were true enthusiasts—they rode, raced, and ignited the passion in the company. I'm sure they tried to create a working environment in which employees could share in their excitement.

I have learned over the years that Harley-Davidson employees believe wholeheartedly in the brand and what it represents. In fact, many of our employees are avid riders themselves.

Of course, there are quite a few more Harley-Davidson employees now than the few hundred who worked at the plant I visited as a boy. In addition to our headquarters, we now have five facilities in Wisconsin—Powertrain Operations, Menomonee Falls,

which builds Big Twin engines and transmissions; Powertrain Operations, Wauwatosa, which manufactures Sportster and Buell engines and transmissions; Tomahawk Operations, in Tomahawk, a plastic-forming and painting facility (i.e., saddlebags, fairings, Tour Packs, sidecars, and windshields); and a parts-and-accessories distribution center in Franklin.

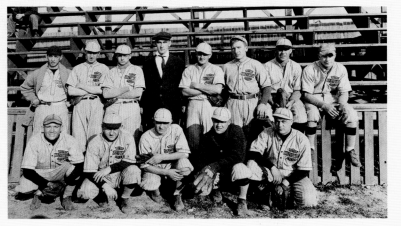

The newest Milwaukee-area facility is our Willie G. Davidson Product Development Center, which is home to our styling, engineering, and purchasing departments among others. I'm honored that our executive leadership named this facility after me.

Our largest plant, in York, Pennsylvania, produces the Softail and Touring motorcycle assembly. The plant in Kansas City, Missouri, assembles the Dyna, Sportster, and V-Rod models. We have other key business operations located in Chicago, Illinois; Franklin, Wisconsin; Talladega, Alabama; Highland Heights, Ohio; Ann Arbor, Michigan; Carson City, Nevada; and Plano, Texas. Harley-Davidson also maintains operations in strategic international markets throughout the

This photo of the Motor Company baseball team, made up of both office and factory personnel, was taken in 1916.

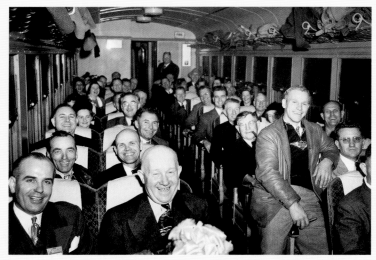

Harley-Davidson dealers and their Motor Company hosts ride on a private train to the new Capitol Drive facility in 1947. William H. Davidson (in front on left) is seated next to dealer Dudley Perkins.

continent of Europe, as well as in Japan, to support its worldwide dealer and distributor network.

More than 9,000 people around the world carry badges identifying themselves as Harley-Davidson employees. As remarkable as that is, it's even more impressive that we've maintained much of our small-company feeling. I still love to go into our manufacturing facilities and watch the magic happen. Visit any of our plants today (and I encourage everyone to take a tour or visit an annual open house) and you'll see a singular mixture of hands-on craftsmanship and state-of-the-art robotic technology.

Our machinery can produce parts that are nearly perfect, but only because there are people guiding the process, tweaking the equipment, measuring the results, and striving to reduce the possibility of defects. Our tools may have changed, but our philosophy and dedication to quality haven't.

Inside headquarters and in the Product Development Center, teams work behind the scenes to improve the ownership experience and to bring new customers into the fold. What people see in our plants and in the marketplace is the tangible evidence of all this hard work. Most people have no idea how complicated it is to bring a Harley-Davidson motorcycle to the showroom.

Harley-Davidson employee dedication extends far beyond our offices and factories. Formally through company initiatives and informally on their own time, employees are Harley-Davidson's eyes and ears in the riding community. In 1983 we launched our demo fleet program and the Harley Owners Group (H.O.G.). The feedback we get from this connection is very valuable. When employees, myself included, attend rallies, we feel in tune with the sport and hobby—and our customers.

As I've said, our founders introduced this philosophy, but its continuing success must be attributed to the quality and flexibility of our current leadership. The major changes implemented during our turnaround years and beyond have made Harley-Davidson a company respected around the world for its progressive approaches to managing and retaining good people.

The hard times we went through forced us to re-examine our approaches to our products, our customers, and, above all, our employees. When we were in survival mode, we believed that every bit of effort we gave contributed to keeping the company alive.

To take better advantage of our most valuable resource, we introduced the concept of employee involvement. We formalized processes for listening to our people and acting on their suggestions. We saw across-the-board improvements almost immediately. Who knows more about how to enhance the quality of a machined part than the person who's been running that machine? When employees realized that leadership

was genuinely interested in their input and willing to give them freedom to act on their suggestions, enthusiasm was rekindled and measurable advances resulted.

We introduced other innovative manufacturing philosophies as well; we were one of the first companies in America to institute "just-in-time inventory control," a monitoring system that eliminates large inventories of parts. This practice generated much-needed capital for us and is now commonly used by manufacturers the world over.

To identify and prevent defective parts or materials before they find their way into finished products, we introduced "statistical operator control," a sophisticated measurement system that gives employees direct accountability for everything they produce. This system formed a work culture in which continual refinement became standard procedure.

Our employees were proud to be among the very first people in America to use these highly innovative manufacturing, measurement, and improvement procedures. Their pride was evident not only in the quality of their work but in the way they made their voices heard. As word spread throughout the motorcycle and business communities about the great things our people were doing, more and more interested parties, including leadership from many of the world's best-known companies, started touring our plants to learn from our processes.

Designing, engineering, manufacturing, marketing, distributing, and servicing motorcycles, parts and accessories, and general merchandise—while providing unique ownership experiences that continue to evolve and exceed customer expectations—is a complicated task, with very little margin for error. It can't be done without knowledgeable and engaged employees.

When asked how it is that the people of Harley-Davidson receive so much obvious gratification from their work, I always say that if you are involved with your products and able to contribute to the company's success, you will be more productive and have a desire to exceed expectations. Your workday won't be drudgery; you'll be motivated to be more efficient and to strive for higher quality. And if your participation leads to a better understanding of the people who purchase and use what you make, there's no limit to what you can do.

Our company has grown dramatically, compared not just to our early years but to only a few years ago. But our roots have been preserved, and words like "family" and "heritage" still mean a lot to us. The marriage between the Harley-Davidson Motor Company and its employees is a century strong. We understand the value of the relationship and continue to do everything we can to make sure it thrives for another 100 years.

The Willie G. Davidson Product Development Center was dedicated on June 7, 1997.

Far left: Shown here is a 1940s era small-parts assembly area at the Juneau Avenue plant.

The War Years

Motorcycles have always been maneuverable in tight areas and on rough terrain. This attribute lends itself well to special needs during times of war. Harley-Davidson was eager and ready to modify vehicles to meet the rugged demands required by our armed services.

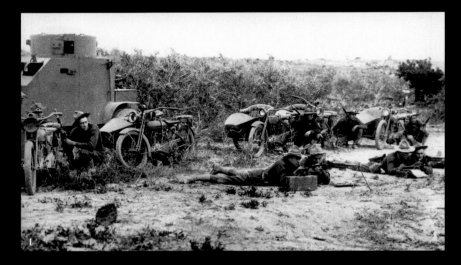

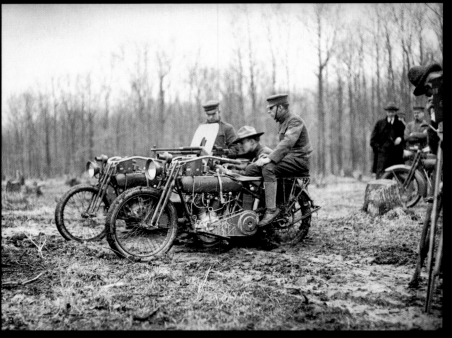

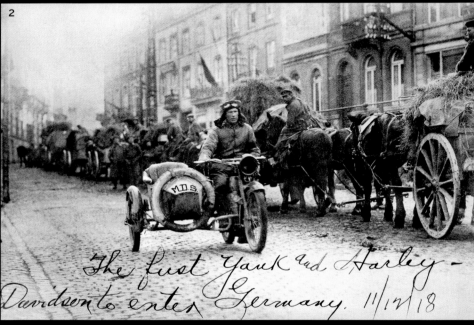

The first Yank and Harley-Davidson to enter Germany. 11/12/18

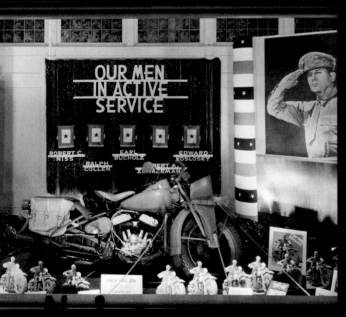

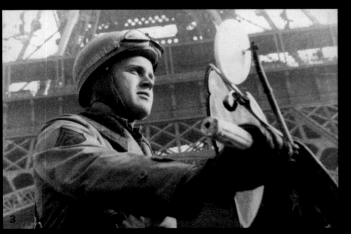

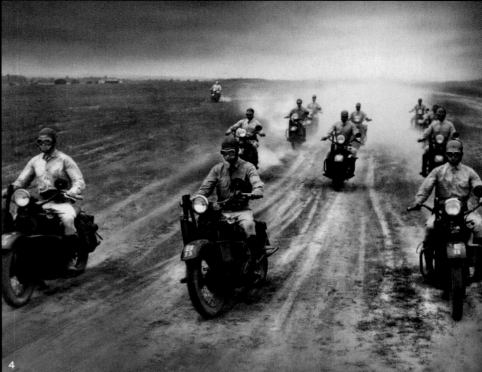

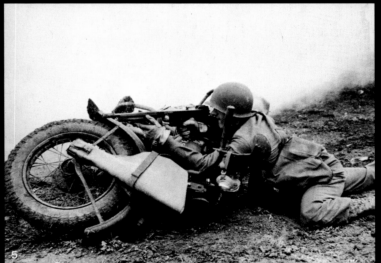

OPPOSITE PAGE
(1) Armed troops on Mexican border in 1916 (2) Corporal Roy Holtz enters
Germany in 1918 (3) Testing fighting motorcycles near Milwaukee in 1916
(4) Military motorcycles line up in camp, 1917.

THIS PAGE
(1) A rider shows the troops how it's done, 1942 (2) A dealership window honors
those who served, 1942 (3) American G.I. in Paris, 1945 (4) Training for desert
warfare, 1942 (5) U.S. soldier trains in England, 1943.

1942 | WLA

With the WLA, we helped win World War II and created some Harley-Davidson enthusiasts along the way. The motorcycles we shipped to different parts of the world stayed where they landed. We still hear about WLAs in remote places where American soldiers served.

The entire WLA trim has a military purpose. The U.S. military spec'd the motorcycle, and we manufactured it to their specifications. At the heart of the WLA is the Flathead, Harley-Davidson's longest-serving engine. An obvious military feature is the Thompson submachine gun and scabbard. The headlights are less obvious—blackout lights with unique lenses that only appear on Army models. The rider could only see directly in front of him, and his light could not easily be seen by the enemy except head-on.

These vehicles were often used in off-road situations, hence the metal leg shields and high-clearance fenders. If you are in deep mud, the mud builds up on the tire and doesn't contact the fender. A skid plate underneath the bike protects the engine from rocks.

Every detail on the WLA is highly functional. The three seat studs keep the rider's gun and holster from wearing through the seat leather. Some WLAs have an Army star on the fuel tank. This model has a decal with instructions. The name Harley-Davidson would never appear on the fuel tank. You'll find a small Bar & Shield on the speedometer, and our name on the spark plugs.

In the past people would take off the military accessories and repaint the sheet metal to make the WLA look like a street bike. Today, an unrestored model is a highly desired collectible.

POWERTRAIN

Engine: 45-degree, side-valve V-Twin with
 aluminum heads
Displacement: 45 cubic inches
Transmission: Three-speed, hand-shift
Primary drive: Double-row chain, oil-mist lubricated
Secondary drive: Single-row chain
Brakes: Drum and shoe (front and rear)

CHASSIS

Frame: Rigid
Suspension: Springer leading-link, with exposed
 springs (front)
Wheelbase: 57.5 inches
Gas tank: 3.35 gallons
Oil: 1.2 gallons
Tires: 18 inches (front and rear)
Color: Olive Drab

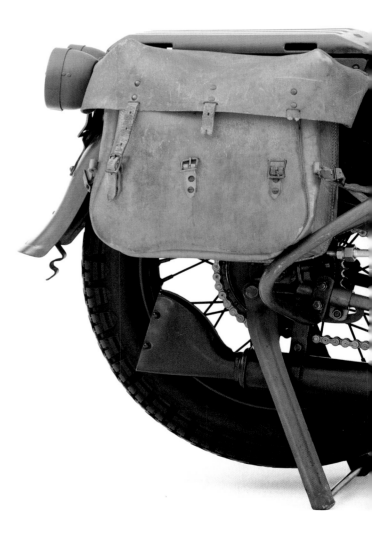

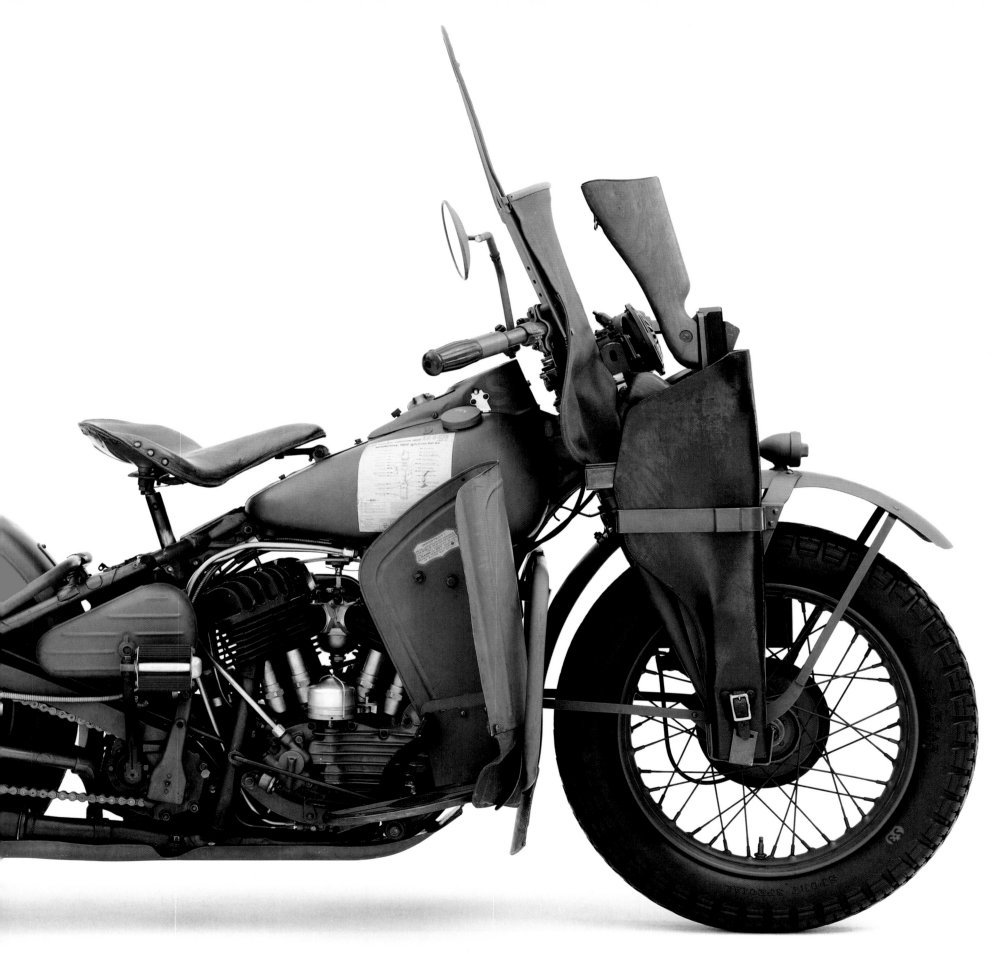

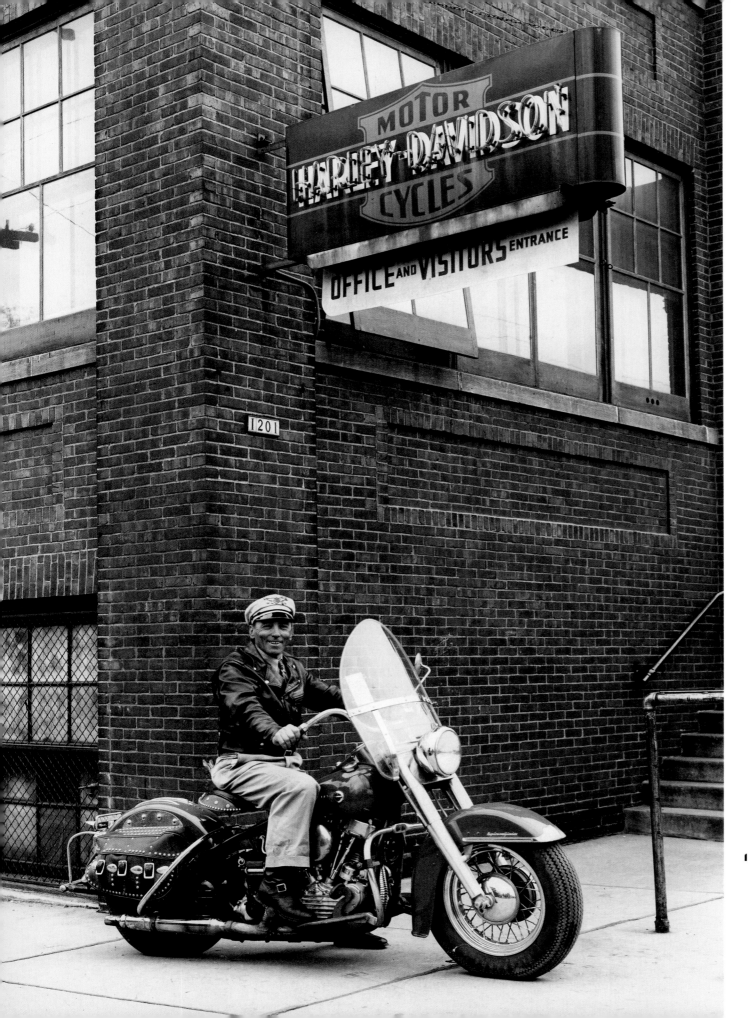

1950 | *An enthusiast on a visit to the*
Harley-Davidson plant.

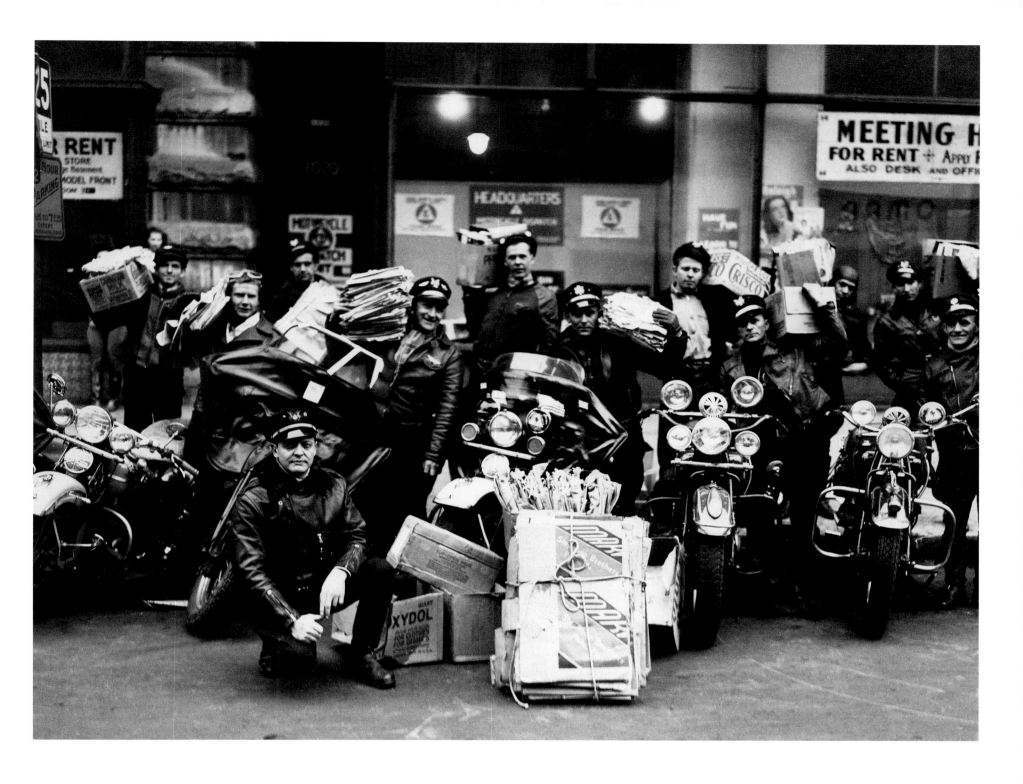

1943 | *Milwaukee's Motorcycle Civil Defense Dispatch Unit conducting a paper drive during World War II. Both Harley-Davidson and Indian motorcycles are shown in this photo.*

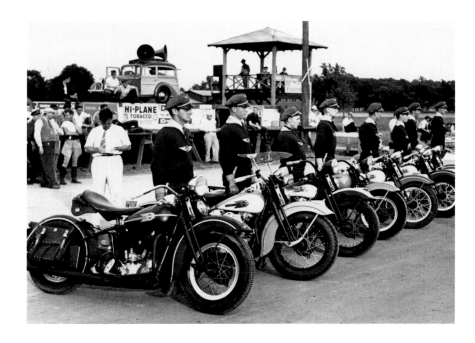

1939 | *A club lines up for the "best uniform and cleanest bike" contest at a rally in Richmond, Virginia.*

1949 | *The breeches and high boots with a short, zippered motorcyclist jacket worn by these Baltimore Ramblers displays a combination of pre– and post–World War II club attire.*

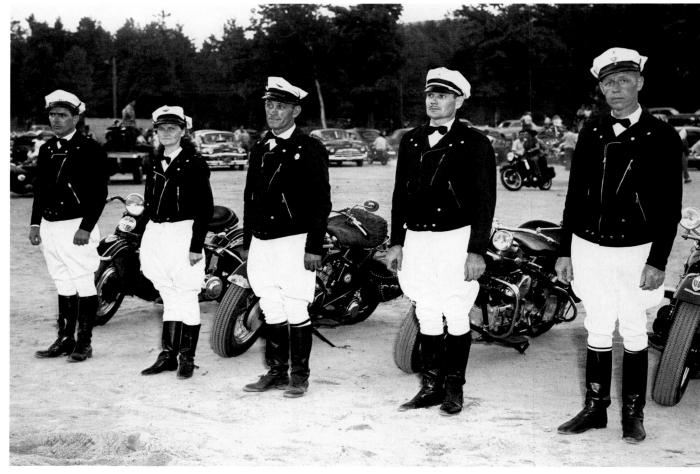

1948 Motorcycle club members and their children pose beside their beloved FL model.

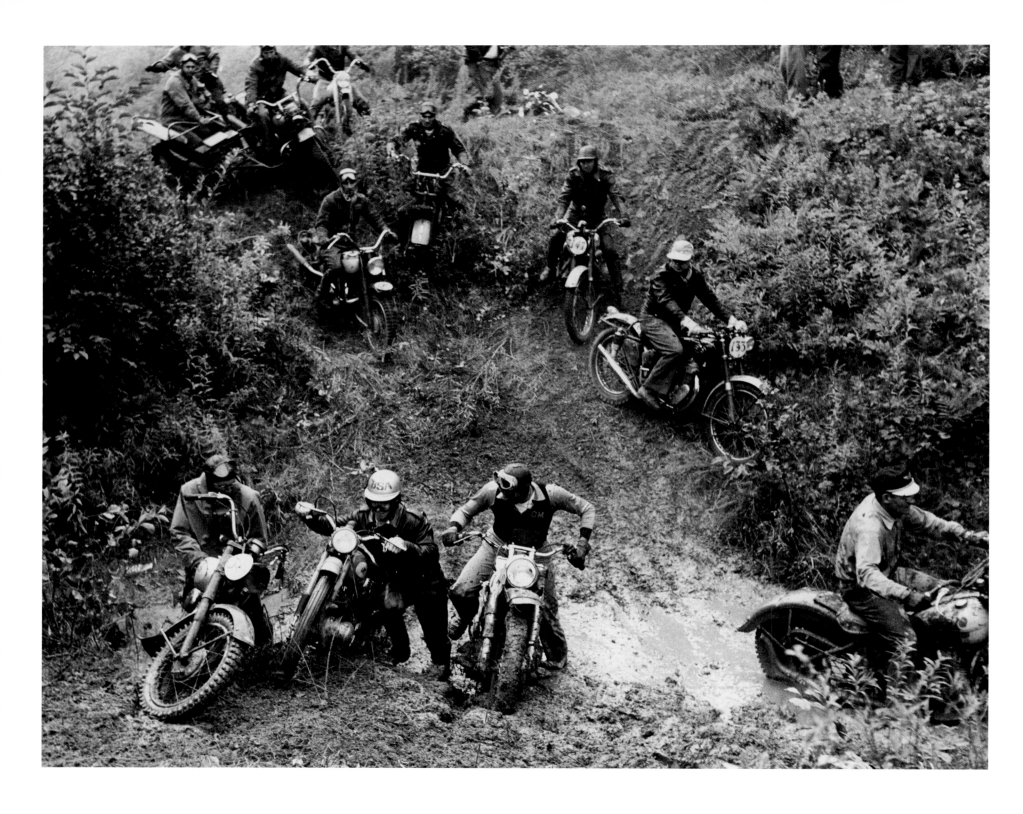

1951 | *Mud holes and steep slopes were purposely laid out in the Jack Pine Enduro to bunch contestants together and cause confusion.*

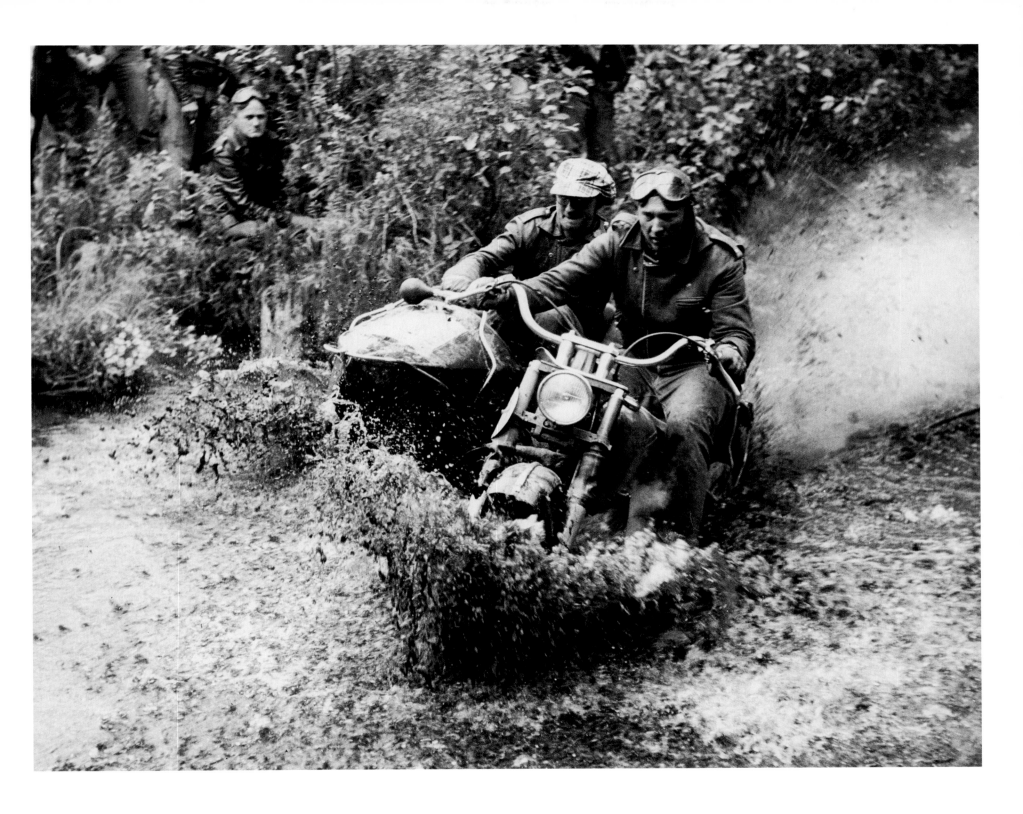

1953 | *This dramatic crossing of the Tobacco River during the Jack Pine Enduro demonstrates the extreme nature of such contests.*

Clubs & H.O.G.

When out riding Harley-Davidson bikes or attending special events and rallies, camaraderie with fellow enthusiasts is an important part of the experience. Our brand has attracted loyal followers from day one. In order to provide a way for more people to share this common interest, Harley-Davidson developed the Harley Owners Group (H.O.G.) in 1983. Today over 640,000 riders enjoy their membership in H.O.G.

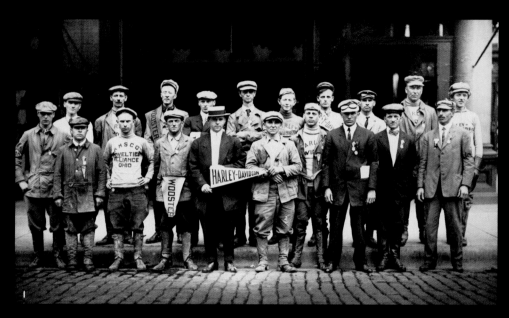

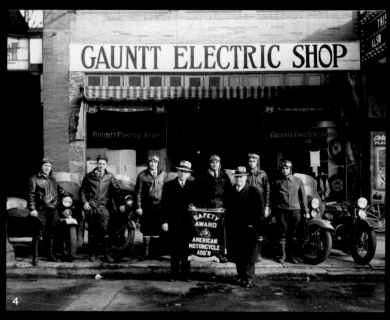

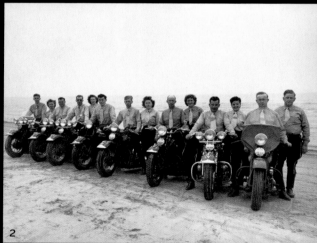

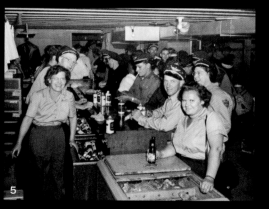

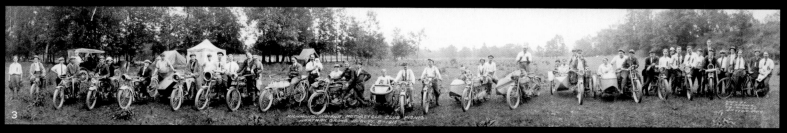

3

4

5

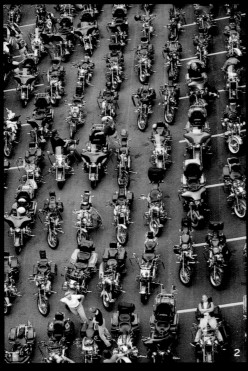

2

OPPOSITE PAGE
(1) The Rosencranz family tour group in 1912 (2) The Power Cit
on the beach in 1948 (3) A panoramic shot of a 1915 club (4) Th
Wheel Cycle Club (5) A club social scene in 1948.

THIS PAGE
(1) A 1941 trick-riding club (2) Annual H.O.G. rally in 2000 (3) S
patches from years of H.O.G. events (4) A rider takes a break fr

I'M CONVINCED THAT THERE'S

A LITTLE OUTLAW IN ALL OF US.

AND BACK THEN, AS NOW,

A LOT OF PEOPLE

WANTED TO

BREAK AWAY FROM THE NORM

FROM TIME TO TIME.

THE DAYS FOLLOWING WORLD WAR II SIGNALED A CHANGE in motorcycle culture—and in Harley-Davidson's business. Our shift back into civilian manufacturing after years of producing for the

military was difficult. We had to struggle to meet the new demand. Lots of riders had returned from the war and were eager to get back on two wheels and to great times with friends. Many of these were GIs who learned to ride on WLAs during the war effort. When they got home, they were anxious to buy bikes and hit the road.

The economy was growing, people were earning discretionary income, and a lot of them were spending it on motorcycles. As with any community, though, there was a handful of riders out there—hell-raisers— eager to have too much fun. These riders were the kind who made a little more noise and let off a little more steam than anyone else. This was a very small fraction of the overall riding population. Because they were flamboyant and rode extreme motorcycles, they at- tracted attention. And as we've seen time and again at Harley-Davidson, a small handful can create a look that soon gets copied.

Around this time, some of these riders started using their motorcycles to express themselves and stand out from the crowd. To make their bikes lighter and faster, they started removing parts, such as front fenders and front brakes. They would replace the heavy front tire with a 21-inch rim and 3-inch tire. Small seats were mounted directly to the frames. Rear fenders were shortened or "bobbed," which is where the nickname "bobber" came from.

When these riders rode together on their loud and fast machines in their black leather jackets—many military-style, held over from the war—they created a scene that was hard to ignore. They were rebels who didn't adhere to the rules, and they continued to raise more and more hell. They would ride through Small- town, U.S.A., get speeding tickets, and spend a few nights in jail. Nothing they did would generate even a tiny blip on today's national radar. But at Harley-

Davidson there was a quiet concern that the image of motorcycling was being threatened by growing awareness of this antisocial behavior.

In the summer of 1947, a disturbance at a three-day Fourth of July motorcycle gathering in tiny Hollister, California, set off a media frenzy. A bunch of riders from California (the media claimed there were 4,000, though those who were there say 400) came to enjoy

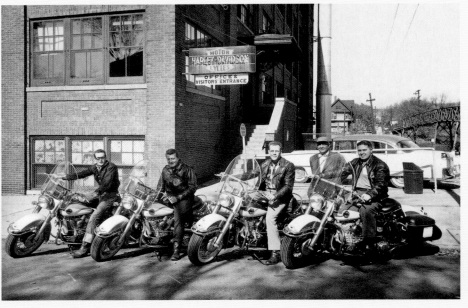

Riders at the front entrance of the Juneau Avenue facility demonstrate the evolving look of post–World War II enthusiasts.

the racing and camaraderie. Well, some noise was made and some booze was consumed. Some of the riders got a little crazy, a few fists were thrown, and police made arrests. Things got out of hand but certainly didn't warrant the massive media exposure that would ensue.

A photo of a tough-looking guy holding a beer bottle in each hand, sitting on a Harley with dozens of broken bottles in the foreground, found its way into the pages of *Life* magazine. Hollister was depicted as a

large-scale riot. The caption added to the hype: "Racing their vehicles down Main Street and through traffic lights, they rammed into restaurants and bars, breaking furniture and mirrors." *Life* hit a nerve. Newspapers far and wide were running headlines like HAVOC IN HOLLISTER and RIOTS—CYCLISTS TAKE OVER TOWN.

Bring a few hundred people into any small town for a three-day party, mix in a little booze, and something is likely to happen. In this case, though, the fact that the people in question were motorcyclists made for great national drama.

There were no reports of any townspeople being injured in Hollister. In fact, the infamous photo was later proven to be a setup. (The man on the bike wasn't even a motorcyclist!) But the damage was done. An aura of menace surrounded motorcyclists, especially those who rode in groups. They now inspired fear.

This was before the days of instant, blanket television coverage of big, visual events. The press hungered for photo ops. If you look at it from their perspective, you couldn't ask for more dramatic material, since motorcycles and the people who rode them made for interesting photos. Post–Hollister motorcycle gatherings tended to attract media. The outlaw coverage was unprecedented. The general public was becoming increasingly conditioned to view such gatherings and their participants with fear.

A few years later, in 1954, Hollywood added to the hype with *The Wild One*, a hugely popular movie starring Marlon Brando and Lee Marvin and based partly on Hollister. In a world where people have always been

fascinated by the good guy/bad guy formula, motorcyclists represented the perfect bad guys for Hollywood. The film reinforced the stereotypes, and public resentment toward "bikers" grew.

There was serious concern at Harley-Davidson about our future. Things were snowballing. A *Saturday Evening Post* writer noted in 1954 that "Nobody, except another cyclist, likes a man on a motorcycle."

But even the very worst situation can create some positives. The Hollister event and the rising visibility of outlaw riders were either horrendous or magnetically attractive, depending on your point of view. I'm convinced that there's a little outlaw in all of us. And back then, as now, a lot of people wanted to break away from the norm from time to time. Well, for those people, riding a Harley-Davidson was (and still is) a means to do that. Thanks to all the media and Hollywood attention, everybody on the planet recognized that. So those seeking a certain level of thrill in their lives, at a higher level of intensity, had their opportunity to "escape."

I was always attracted to the hardware the "outlaws" rode. While I wasn't interested in getting involved in the whole scene, it fascinated me because everything about it was so extreme. Think of the hardtails—motorcycles with no rear suspension. These were the modified Softails of their era, the coolest of the customs. The seats featured suspended sprung posts to cushion the rider. The chopper crowd removed those and mounted the seats low on the frame. It's a great look. Rider comfort on hardtails, though, was minimal.

People were riding to declare their rebel status and to prove just how tough they were. The word "outlaw"

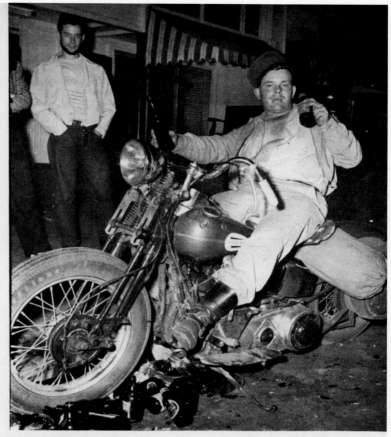

CYCLIST'S HOLIDAY

He and friends terrorize a town

On the Fourth of July weekend 4,000 members of a motorcycle club roared into Hollister, Calif. for a three-day convention. They quickly tired of ordinary motorcycle thrills and turned to more exciting stunts. Racing their vehicles down the main street and through traffic lights, they rammed into restaurants and bars, breaking furniture and mir- rors. Some rested awhile by the curb (*above*). Oth- ers hardly paused. Police arrested many for drunk- enness and indecent exposure but could not restore order. Finally, after two days, the cyclists left with a brazen explanation. "We like to show off. It's just a lot of fun." But Hollister's police chief took a dif- ferent view. Wailed he, "It's just one hell of a mess."

31

has been around forever. Think of the Wild West. Outlaws are enthusiasts, but they're wilder. The Hells Angels was the most prominent motorcycle club, among many, to spring up and grow in the outlaw era of motorcycling, especially during the 1960s. These clubs could immediately empty out a bar just by showing up on Harley motorcycles with patches on their vests. And whatever they did, wherever they went, there were always onlookers who felt obligated to exaggerate what they'd seen.

This staged photo was taken during the Hollister rally and appeared in a 1947 issue of Life *magazine.*

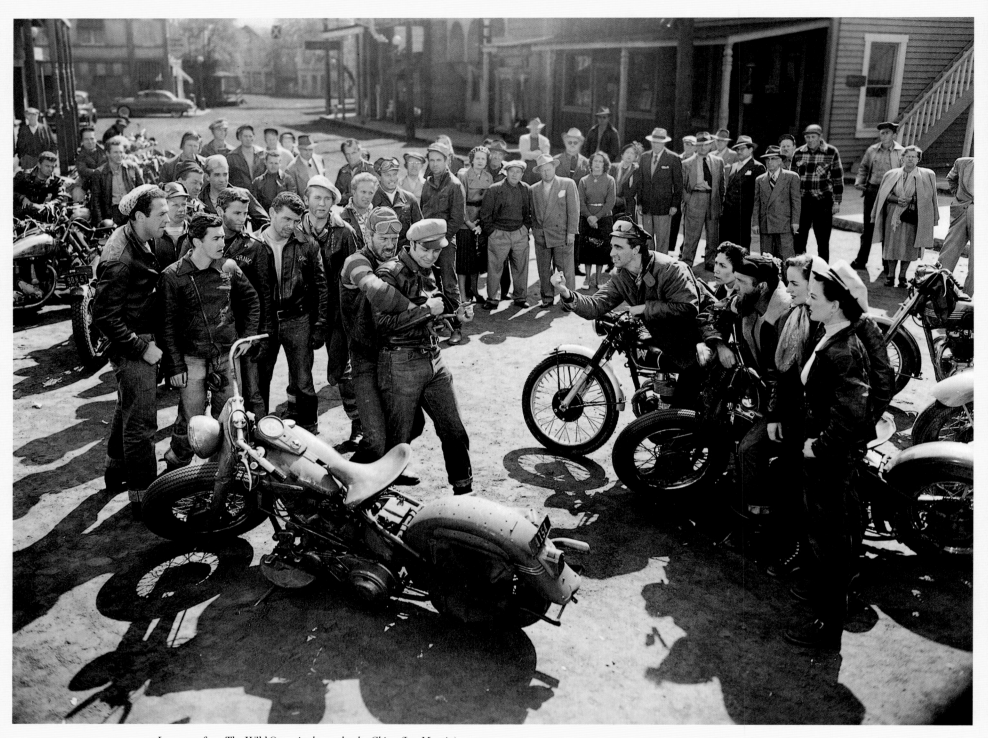

In a scene from The Wild One, *rival gang leader Chino (Lee Marvin) tussles with Johnny (Marlon Brando) as a crowd gathers to watch.*

Over the years, I've met outlaw club members. They are people who love motorcycling. They, like all enthusiasts, seemed to have respect for our longevity and what our brand represents. The Harley-Davidson brand is a common denominator, attracting a great variety of people from all walks of life: police officers, outlaws, the rich and famous, pleasure riders. This was notable at the grand opening of the Harley-Davidson

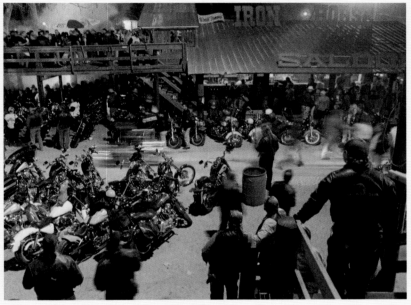

Café in New York City in 1993. There were famous people there like Donald Trump with his bodyguards, plus a whole group of Hells Angels and lots of other motorcycle enthusiasts.

Many of the outlaw clubs are still around today, but the media has moved on. With today's instant-saturation coverage of just about everything, people have taken on more of a "I have to see it to believe it" stance. If people don't witness motorcyclists doing bad things,

maybe we aren't such bad people after all. The explosion of interest in motorcycling over the past dozen or so years has been accompanied by very positive media coverage of Harley-Davidson.

Still, if you take a look around at any motorcycle rally these days, much of what you'll see—custom bikes, black leather, tattoos— stems from the era of the late forties through the sixties. And check out all those Softails! You can talk all you want about the bad-boy reputation of that era, but it didn't prevent us from getting where we are today.

WOULD YOU SELL AN UNRELIABLE MOTORCYCLE TO THESE GUYS?

A 1988 Harley-Davidson advertisement played off of the biker image of an earlier era.

Far left: Riders congregate at the Iron Horse Saloon.

1948 | FL (PANHEAD)

The simplicity of the 1948 FL is very appealing. A lot of collectors have a great love affair with the Panhead motor, which first appeared in 1948. The name refers to the top of the engine, because it looks like an upside-down kitchen pan.

Many other aspects of the FL stand out visually. It has the look of its time, and yet it's not outdated. We've gone back to this bike more than once for its styling. The FL has a hardtail frame, which was used on motorcycles prior to rear suspension. We recreated the visual effect of this frame on the '84 Softail model. Draw a straight line along the frame from the fork pivot to the rear axle and you have a hardtail.

We recreated the FL fork for the '88 Springer Softail. With its exposed springs, thin front leg and thicker, rigid back leg, this fork is easy to spot. Until then, the '48 FL was the last Harley-Davidson to use that fork.

We went deeper into the FL legacy when we designed the '97 Heritage Springer. That bike was tailored to resemble the '48 FL, using the fork, the 16-inch front wheel, the early-style front fender and running light, and the tombstone taillight that are representative of that model.

To kick off the dealer launch of the Heritage Springer, Harley-Davidson made a film about its links with the '48 FL. I was shown riding the '48 FL, and my son Bill was riding the '97 Heritage Springer. Here we were, fifty years out, and the FL elements were still a part of our style and identity.

POWERTRAIN
Engine: 45-degree, overhead-valve V-Twin with aluminum heads and hydraulic lifters
Displacement: 74 cubic inches
Transmission: Four-speed, hand shift
Primary drive: Double-row chain, oil-mist lubricated
Secondary drive: Single-row chain
Brakes: Drum and shoe (front and rear)
Ignition: Battery and coil

CHASSIS
Frame: Steel, double downtube
Suspension: Springer leading-link (front)
Wheelbase: 59 inches
Gas tank: 3.75 gallons
Oil: I gallon
Tires: I6 x 5 inches (front and rear)
Colors: Azure Blue; Flight Red; Black

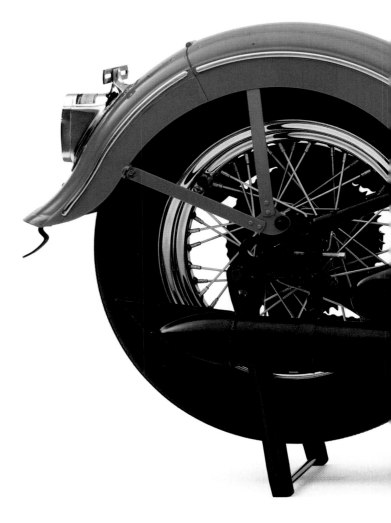

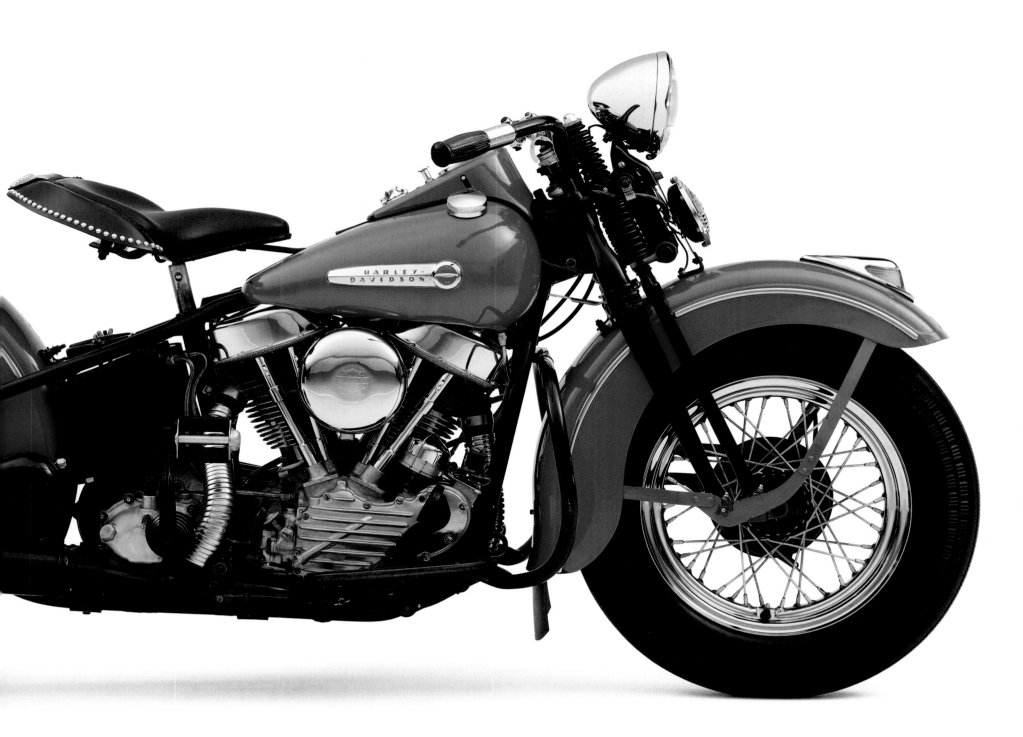

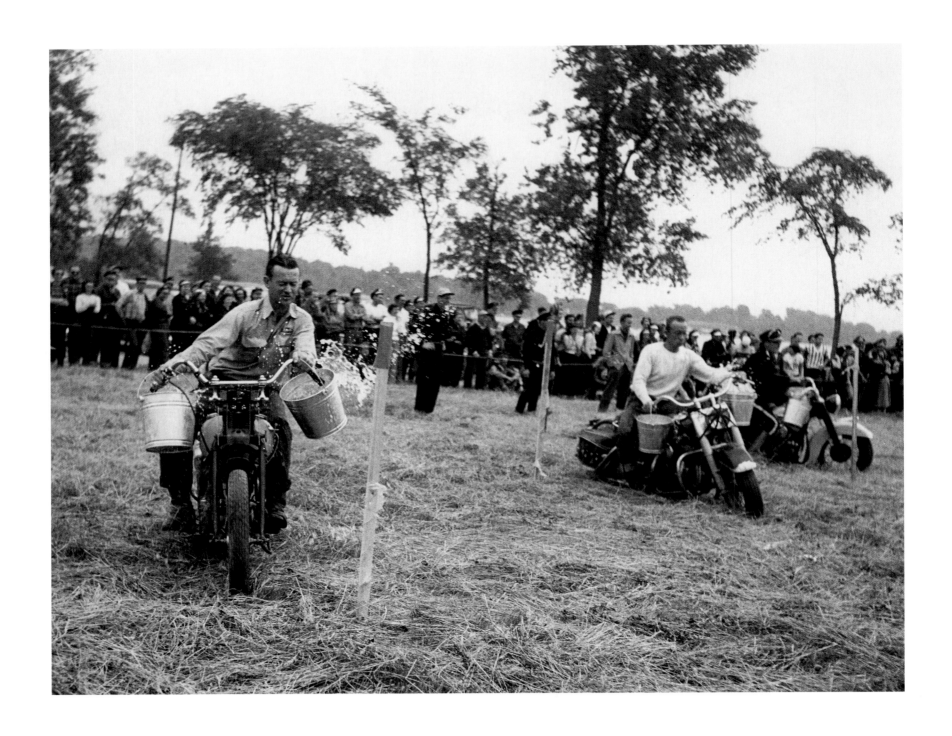

1951 In the bucket contest, riders had to maneuver through a twisting course while spilling as little water as possible.

1954 *Boy-on-bike-meets-girl was the theme of this advertisement for the KH model.*

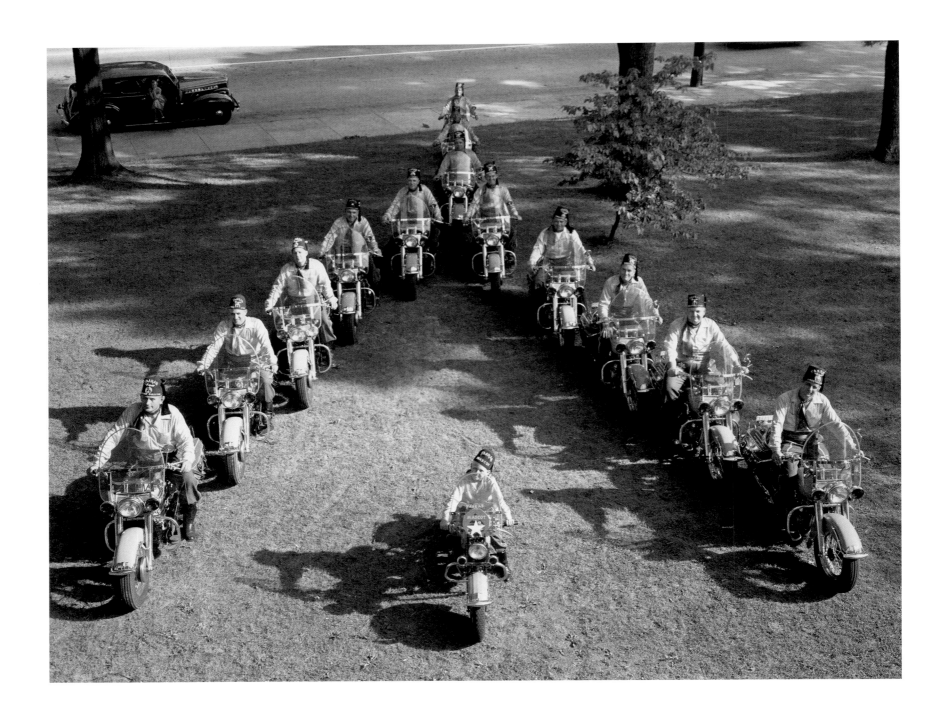

1952 | *The Shriners have long favored the Harley-Davidson Big Twin motorcycle for formation riding. This lodge hails from Atlanta, Georgia.*

1954 | *South Milwaukee's Black Panther Motorcycle Club beneath the marquee of a downtown theater.*

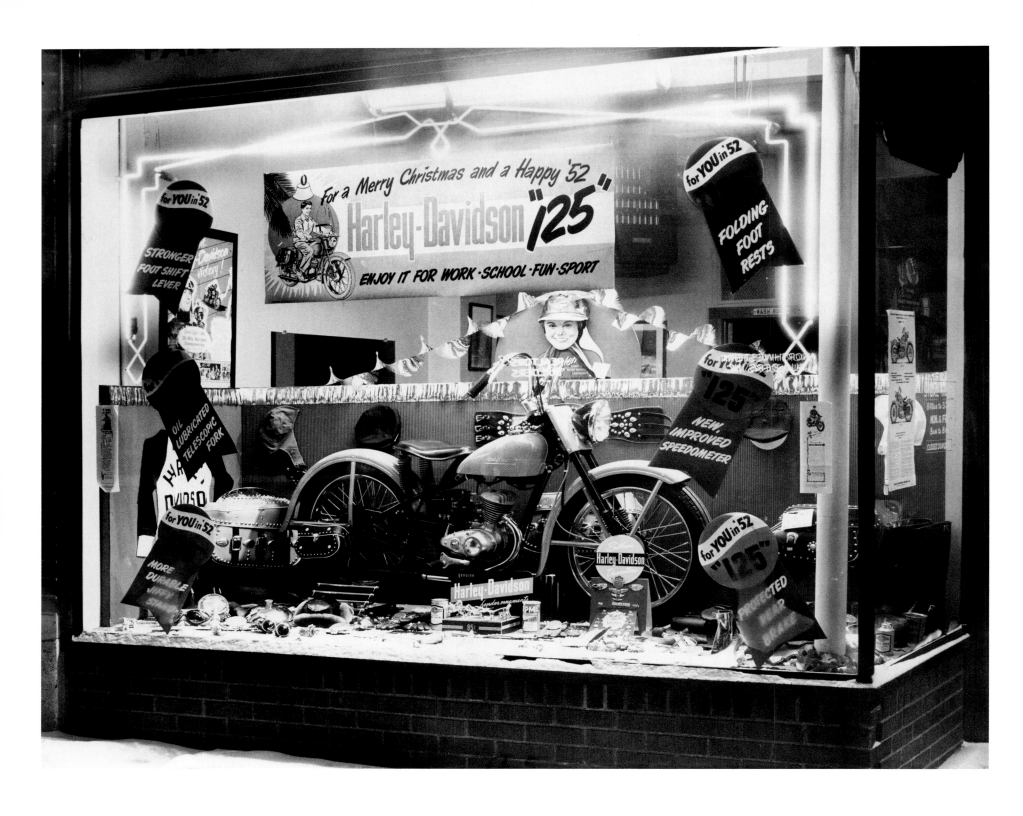

1951 | *A Christmas display in Milwaukee dealer Bill Knuth's northside store.*

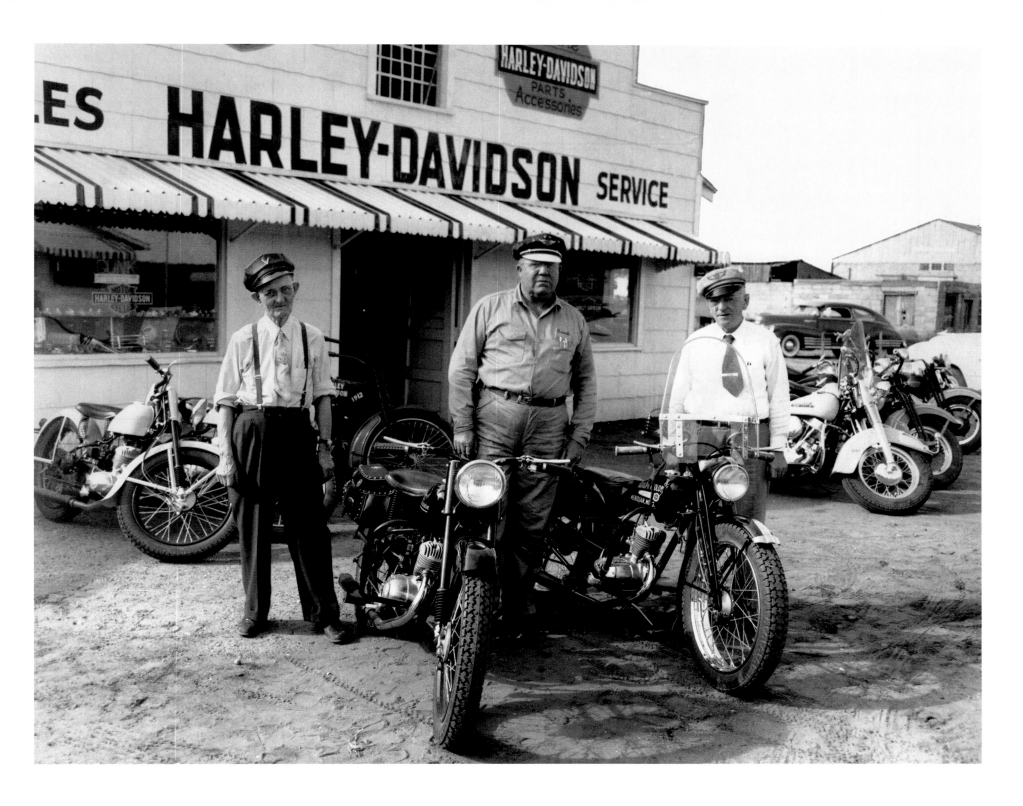

1951 | *Meridian, Mississippi, dealer Frank Burriss stands in between two lightweight 125cc models and a pair of customers.*

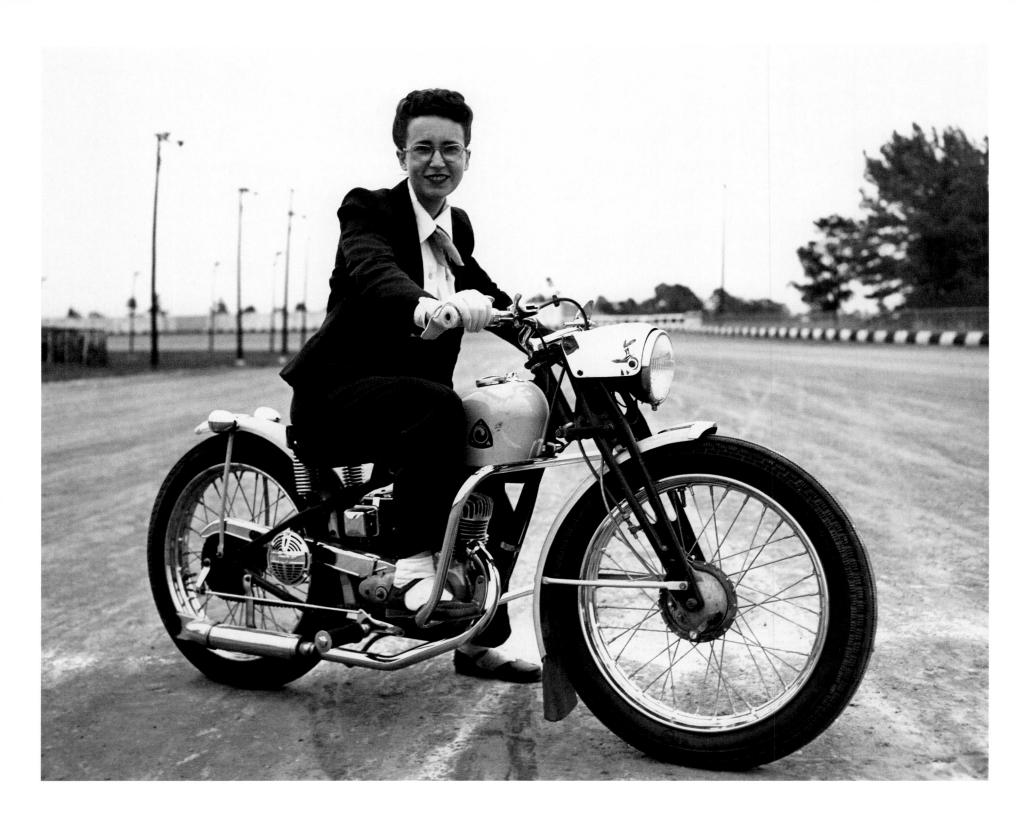

1950 | *This lightweight 125 model with bobbed fenders and extra chrome was introduced in 1948.*

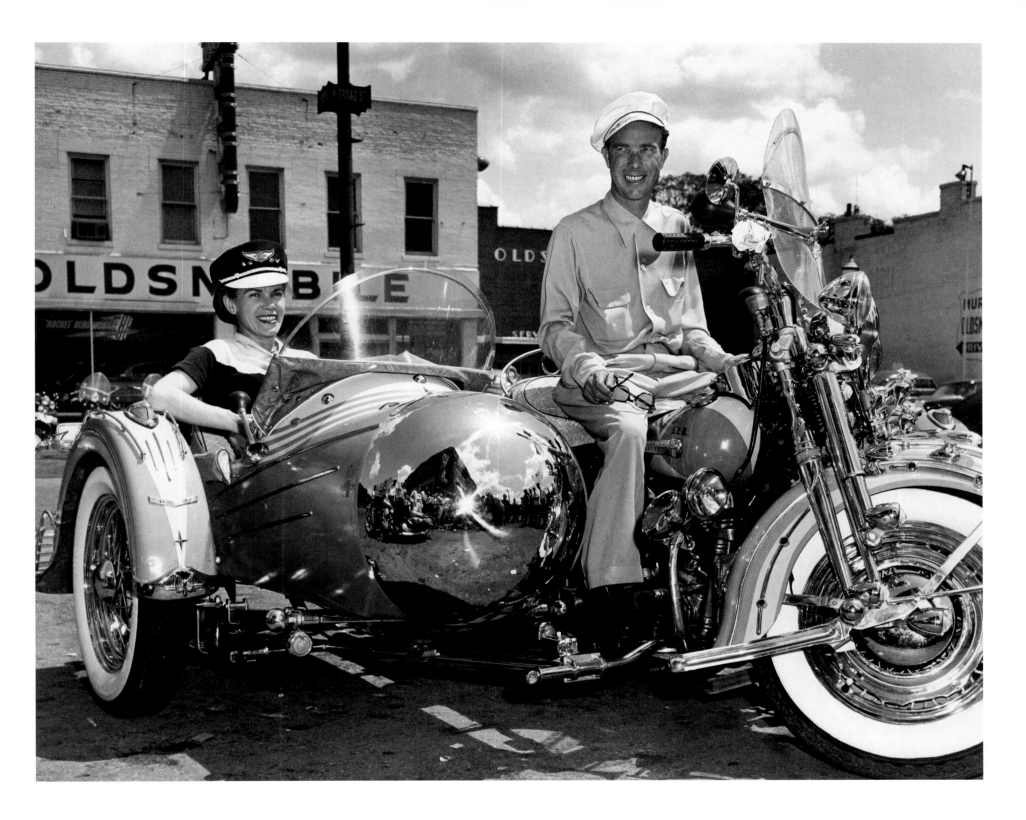

1951 | *Customizing took off in the 1950s as this heavily chromed,*
highly accessorized motorcycle with sidecar demonstrates.

THERE WAS NO FORMAL

DESIGN DEPARTMENT

AT THE TIME,

WHICH MADE THE OPPORTUNITY

TO SET UP THE COMPANY'S

FIRST FORMAL STYLING DEPARTMENT

VERY ATTRACTIVE.

SO I PACKED UP MY BOX OF CRAYONS

AND SAID,

"I'LL BE RIGHT OVER."

I N THE EARLY NINETIES, OUR AD PEOPLE DID A PIECE THAT featured a baby wearing Harley-Davidson pajamas and the tag line: "When did it start for you?" I know from personal experience that the fascination with motorcycles can start quite young. Riders are often asked when they first got interested in riding. Given my own family's history, I was exposed to the brand practically from birth.

Being surrounded by parents and friends, photos, films, and clothing that reflected Harley-Davidson's history really influenced me. When I was old enough to hold a crayon, I started to draw. Shape, form, and color intrigued me. I had an early interest in design, but I didn't get into styling and customization until my teen years. My involvement with designing and customizing in many ways mirrors the evolution of the whole custom movement. I've been happy to be a contributor.

I knew something about motorcycles before my first riding experience. My dad rode motorcycles every day. Growing up, I would always run to the window with great excitement when he came home from work. I was fascinated by his vehicles, so I went out to the garage with him as often as he'd let me. I'd sit on the bike and get familiar with the throttle and the brakes and so on. Just by being around my father, and hearing about the company during family discussions at the dinner table, I became submerged in motorcycle lore. So by the time I got my first motorcycle, I knew what everything was and how to ride to a certain extent.

My first ride, under the watchful eyes of my dad, was on a 1948 125cc single-cylinder S Model when I was fifteen. We went to a neighborhood back street. After a few miles on the shiny new 125, I was hooked. This was mine. I had dreamed about this, and now my dream was real.

Fifteen-year-old Willie G. is pictured here on his first bike, a 1948 125cc S Model.

Brothers John and Willie G. as teenagers pose for a photo on their K Models in 1952.

Nineteen forty-eight was the first year for the S Model. This model was unique in its girder-style front fork and parallelogram-movement front suspension displaying very large rubber bands. I'll always remember that. The company produced the S Model after the war to appeal to a younger market and widen the spectrum of riders. This vehicle was smaller than others offered at the time.

History often repeats itself. In the early twenties, we developed a single-cylinder transportation motorcycle. We ran a big billboard about getting to and from work at a very economical number of miles per gallon, a campaign to attract a new type of rider and broaden the market. We took the same approach with the 1948 S Model. Its role was similar to that of today's Buell Blast—learning how to ride on a smaller motorcycle that isn't intimidating.

By the time I was a senior in high school, I was riding a 165 Model that had a slightly larger engine (165cc as opposed to 125cc). I made my first modifications to a bike during that time—a unique two-tone paint scheme, some chrome plating, and a shortened and flared rear fender. These were my early years with bikes, and I was already starting to change them.

While I was still in high school, I started participating in endurance runs organized and advertised by local dealers. I was able to compete in these off-road competitions fairly close to home because urban sprawl had not yet occurred. My younger brother, John, and I would go over with friends to Bill Knuth's Harley-Davidson dealership in Milwaukee, where we would pick up what we needed—map, schedule card, directions—before heading out to participate. We were riding hard all the time and having fun. Usually we'd end up at some gathering place like a tavern or roadhouse after the event, telling everybody how many times we fell off, had to push the bike through the mud, that kind of stuff. It was neat. And I even picked up a few trophies in some locally sanctioned Enduros. Those are great memories.

Following my 165 Model, I graduated to the new 45-cubic-inch model for Harley-Davidson, the K. It was a full-size bike. At the time, I was interested in many facets of motorcycling, though I had two passions: one was to ride off-road, which beat up the bike; the other was to customize the bike. But I didn't have the luxury of owning several vehicles, so I went back and forth between riding my K in Enduros and customizing it.

My high school heroes were the hot-rod and custom-bike guys. Other kids admired football players and movie stars, but these enthusiasts were the epitome of cool to me. I was drawn in by the unique hardware. It's hard to explain how powerful the attrac-

tion was. You have to remember that back in late-forties and early-fifties America, it was a big deal for a high school kid to have his own motorcycle or car. To have a hot rod or a custom bike and a leather jacket was an even bigger deal.

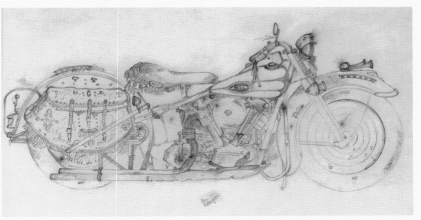

These guys had powerful modified engines that were faster and louder than stock. Middle America was still a bland place, so modified vehicles were special. There were only a few guys in my school who had motorcycles like this. To see a beautiful early Knuckle-head with bobbed fenders parked next to a shaved and decked '39 Ford was magnetic. I spent my lunch hours outside just staring at them.

The custom-bike guys were gearheads. They didn't get their parts and ideas from 700-page after-market catalogs, because there were none. A quick hop over to the parts store or dealership wasn't an option. They had to design, build, and modify their bikes themselves in back-alley garages. They could form metal in a rudimentary way and had hands-on knowledge learned from doing. It was and still is very impressive to me.

Tailoring a bike to one's vision is among the purest forms of self-expression.

These guys who adapted their motorcycles drew me in with their engine mods, exhaust, paint, and detailing. During homeroom, when I probably should have been studying, I was always drawing artistically converted bikes and hot rods. And I had my face in every kind of enthusiast magazine available. But from these sketches came my first very own custom. My K Model was painted in a red-and-white diamond design that rolled over the top of the tank. For that time period, it was very distinctive. The bike had minimal aluminum fenders, an aluminum tail light, and a compact headlight.

After-school and weekend hours were spent with friends, riding and thinking about modified motorcycles as minimal, elegant, and tasteful—the qualities

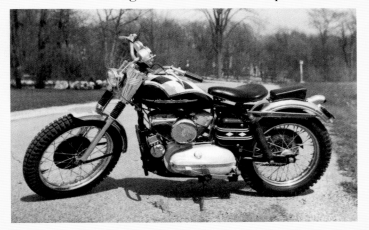

I admire most even now. I was always talking about future custom vehicles. Without knowing it, I'd more or less pointed my compass in the direction I'd follow later in life.

A 1947 drawing by Willie G. of an EL (Knucklehead) model demonstrates his early fascination with art and custom motorcycles.

Bottom: Willie G.'s customized K Model, with a red-and-white diamond paint scheme, one-off proto-type short aluminum fenders, small solo saddle, and rear racing pillion.

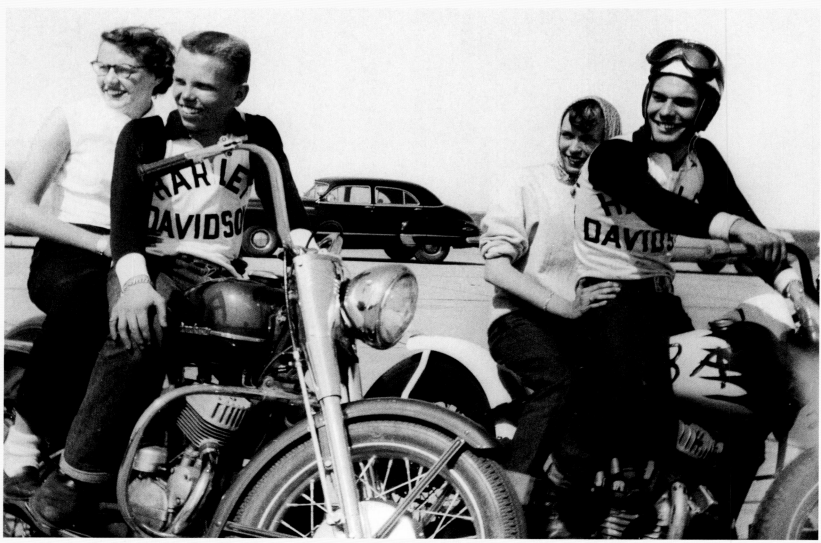

Willie G. and his future wife, Nancy (at left), on a K Model in 1952 with friends at the drag strip in Half Day, Illinois.

Another influence was journeying to a drag strip in Half Day, Illinois. Some pals and I—including my girl-friend, Nancy (who's now my wife), and my brother, John—would ride down and race. There were no high-dollar teams with semis and huge trailers. It was mostly a bunch of homebuilt hot rods and motorcycles—frames, wheels, motors, and a pair of goggles. Again, the rule was simplicity—and, of course, to have fun.

More and more, racing captivated me, and making my own adaptations was right up there, too. But professional racing wasn't in the cards as a career path, and customizing bikes was basically a hobby. It was time to go to college, and I'd made my decision about where to go and what to study. I loved my art courses in high school and also enjoyed photography, so I enrolled at the University of Wisconsin at Madison and took art courses there. But UW had no programs in industrial design, which was a new discipline then.

Around this time, I read a story in *Post* magazine that changed the course of my life. It was about dream cars created by students at the Art Center College of Design in Los Angeles. The pictures showed students doing exactly what I wanted to do—combining their interests in art and vehicles. I realized this was the place

for me and convinced my parents to support my plan to go there.

My classwork there focused on automotive design, and I learned about proportion, form, and stance—essentially, how a vehicle sits on the ground—and how the pieces fit together to determine image. I also learned to see things from a designer's perspective, and how to draw and build clay models. Eventually, I began to include motorcycles in my project work.

As busy as I was with school, I still needed to stay plugged in to the motorcycle scene. Sometimes on weekends I'd borrow a bike from a local dealer and head out to the races, or ride up Highway 1 to hang out with friends in San Francisco and northern California. The custom-bike scene there, which was in its infancy in the early fifties, was still far more vibrant and colorful than it was back in Milwaukee. Choppers were the mainstay, mostly with bobbed fenders, custom paint, and detailing.

One night after the races in Ascot, I saw something that I will always remember. I stopped to fill my tank at a gas station, and in rode a guy on a bike with a springer front end and a skinny front wheel. I distinctly remember that 21-inch front wheel with a 3-inch cross-section tire on a Big Twin. It was a striking design element that really changed the character of the motorcycle. What I'm describing is common today. As a young student in 1953, I had not seen a Big Twin with that styling approach. It illustrated to me how a wheel and tire change can dramatically affect the look of a motorcycle. To understand this, consider what solid wheels do to the look of our Fat Boy model.

While enthusiasts were enjoying riding stock machines, a movement was afoot to modify stock motorcycles. After seeing that springer, I started noticing more and more inspired motorcycles, stretching further and further away from stock. I came to think of this as customization art. It influenced me. Every self-tailored bike is an opportunity for people to make a personal statement.

At graduation time I wasn't sure that I wanted to

In the late sixties, Willie G. works with a 1/4-scale, scratch-built FL model used for developing styling concepts.

live away from Milwaukee and, especially, Nancy. Fortunately, Brooks Stevens Industrial Design, a company that had a consulting relationship with Harley-Davidson, was headquartered in the Milwaukee area. Brooks hired me, and I was able to cut my professional teeth doing design work on everything from furniture to outboard motors. This included work on automotive projects like Studebaker and Willys. On the two-wheel

Willie G. is at work in the Juneau Avenue Styling Department in the late sixties, before he "blossomed" and lost the tie.

side, I did design work on Cushman scooters. I also moonlighted for Harley-Davidson.

I talked about my design projects over many lunches with my dad. After a while, he started to discuss the Motor Company's need for an industrial designer. He recognized my design abilities and training, and opened up the opportunity for me to join the company. He wasn't the kind of person to put my name on the door at Harley-Davidson if it didn't deserve to be there. I had to earn the chance, and once earned, the decision to join would need to be my own. There was no formal design department at the time, which made the opportunity to set up the company's first styling department very attractive. So I packed up my box of crayons and said, "I'll be right over."

I didn't immediately start designing custom vehicles. I had to get my feet wet first. At the time, our priority was big bikes. But I got the chance to stretch myself and work on things like golf cars, lightweights, and scooters.

We had learned over the years that one of the things Harley-Davidson owners most appreciate about our hardware is its familiarity. My new department stayed true to the company's core identity and concentrated on refinements and improvements to the existing product lines. We improved products but were always careful with the imagery. We added features while appreciating that there's a critical look about a Harley-Davidson; the motorcycle itself changes, but its design is still familiar.

The first important new product I was involved with was the Electra Glide, introduced in 1965. The Electra Glide exudes familiarity; it was major because it was the first time we used an electric starter on one of our pleasure motorcycles, and the styling was revolutionary. Look up the word "motorcycle" in a dictionary, and in my mind, you should see a picture of an Electra Glide, possibly a police version. This is the bike that from any distance is unmistakably a Harley-Davidson. It continues to be a very popular motorcycle for a range of riders.

By the sixties, the custom movement had gained a lot of momentum. I remember being in Daytona around then and watching a group of riders pull out of a drive-in. A guy made his way onto the street with an extreme long-raked, pushed-out front end. It was the first time I had seen an extended front fork.

Motorcycles have always been dramatic. They're not for everybody and never will be. This is a product that people can take to an extreme as a means of self-expression. Combine this with what was happening in America in the late sixties, and you have

all the elements for a custom-bike culture.

I think of people who adapt motorcycle designs as folk artists. The vast majority are self-taught, using their own inspiration to craft their visions. Experimentation is a crucial part of the process. Look at how the basic anatomy of motorcycles has evolved over the years: wheels, fenders, forks, chassis, handlebars, seats, and a multitude of unique accessories. Changes to any one of them can radically alter the look of a motorcycle. The possibilities are limited only by the imaginations of the artists.

At Harley-Davidson we were well aware of the fact that many of our riders were customizing their vehicles. We have always tried to stay in tune with motorcycle culture. I felt it was time to become an active part of the custom movement. As an experiment, I built a mockup that would become the Super Glide model, and we were on our way. In relatively short order, factory customs would become synonymous with Harley-Davidson. The Super Glide. Low Rider. The entire Softail line. Now the V-Rod. They are beautiful customs straight from the factory.

We've provided the parts, accessories, inspiration, and the talent of our dealer network, and individual customization has become a large part of owning a Harley-Davidson. Custom-bike owners are forever experimenting. It's the same approach we have used in the styling department at Harley-Davidson since I brought my box of crayons in, in 1963. We're always searching for that special look.

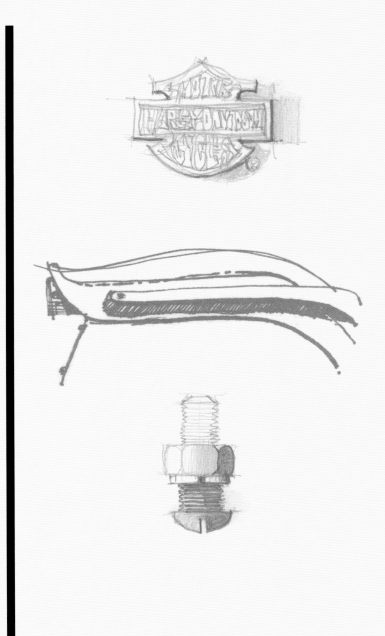

1957 | XL SPORTSTER®

The Sportster era began in 1957, when we introduced an overhead-valve, 55-cubic-inch engine. Before that, our motorcycles were side-valves (Flatheads), referred to as the K-Models. In 1957, we added the overhead-valve cylinder heads, which gave the motorcycle increased horsepower and performance. Today there are many iterations of the Sportster, but this was the beginning.

This motorcycle was king of the street. Stoplight to stoplight, the Sportster had a lot of power compared to other motorcycles of the time. As a higher-performance sport model, the Sportster was not loaded down with saddlebags, luggage racks, or extra lights. Many of them were as you see here, light and nimble, which added to the performance image.

I put a lot of miles on Sportsters as a young man and owned the '57 XL. It was my bike of choice. What's more, just out of design school, I was moonlighting for Harley-Davidson when I designed the circular tank emblem used on the 1957 and 1958 Sportster models. It's one of the first production jobs I ever did for the Motor Company.

POWERTRAIN

Engine: 45-degree, overhead-valve V-Twin

Displacement: 55 cubic inches

Transmission: Four-speed, four-shift, single-unit construction with engine

Primary drive: Triple-row chain, oil bath

Secondary drive: Single-row chain

Brakes: Drum and shoe (front and rear)

Ignition: Battery and coil

CHASSIS

Frame: Steel

Suspension: Telescopic forks (front); swinging arm, hydraulic shocks (rear)

Wheelbase: 57 inches

Gas tank: 4.4 gallons

Oil: 3 quarts

Tires: 18 x 3.5 inches (front and rear)

Colors: Pepper Red with Black; Skyline Blue with White; White with Black; Black with Pepper Red

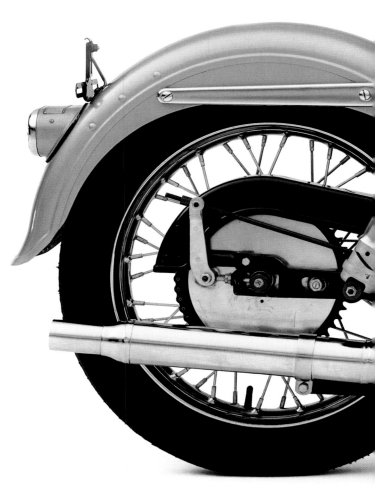

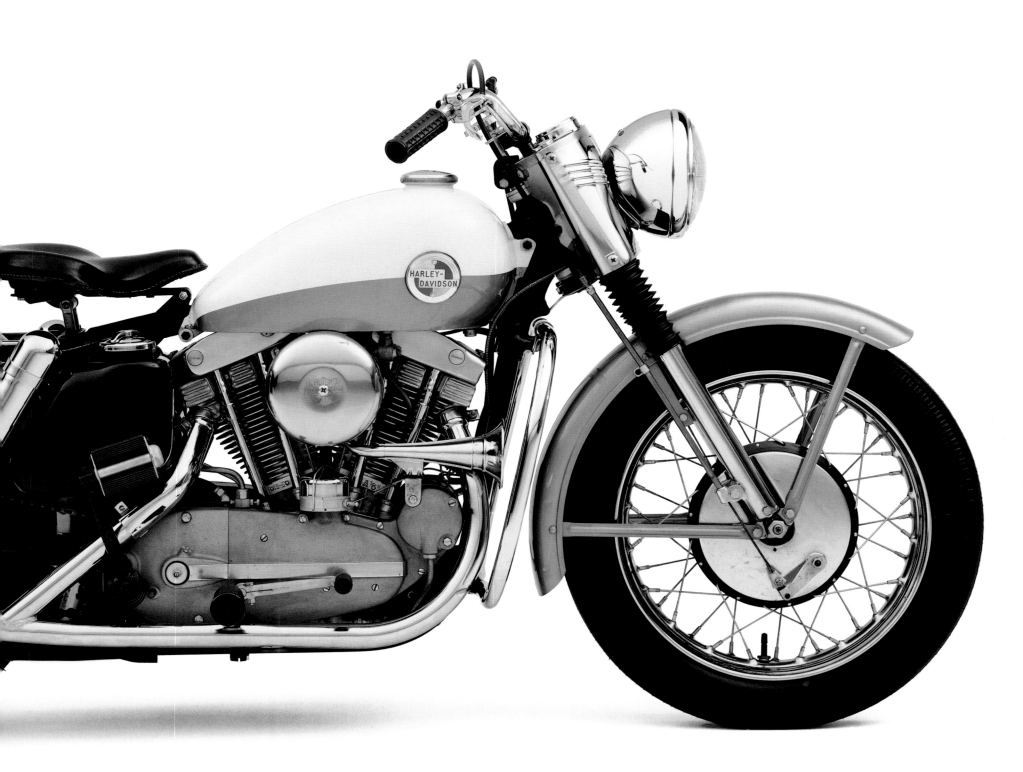

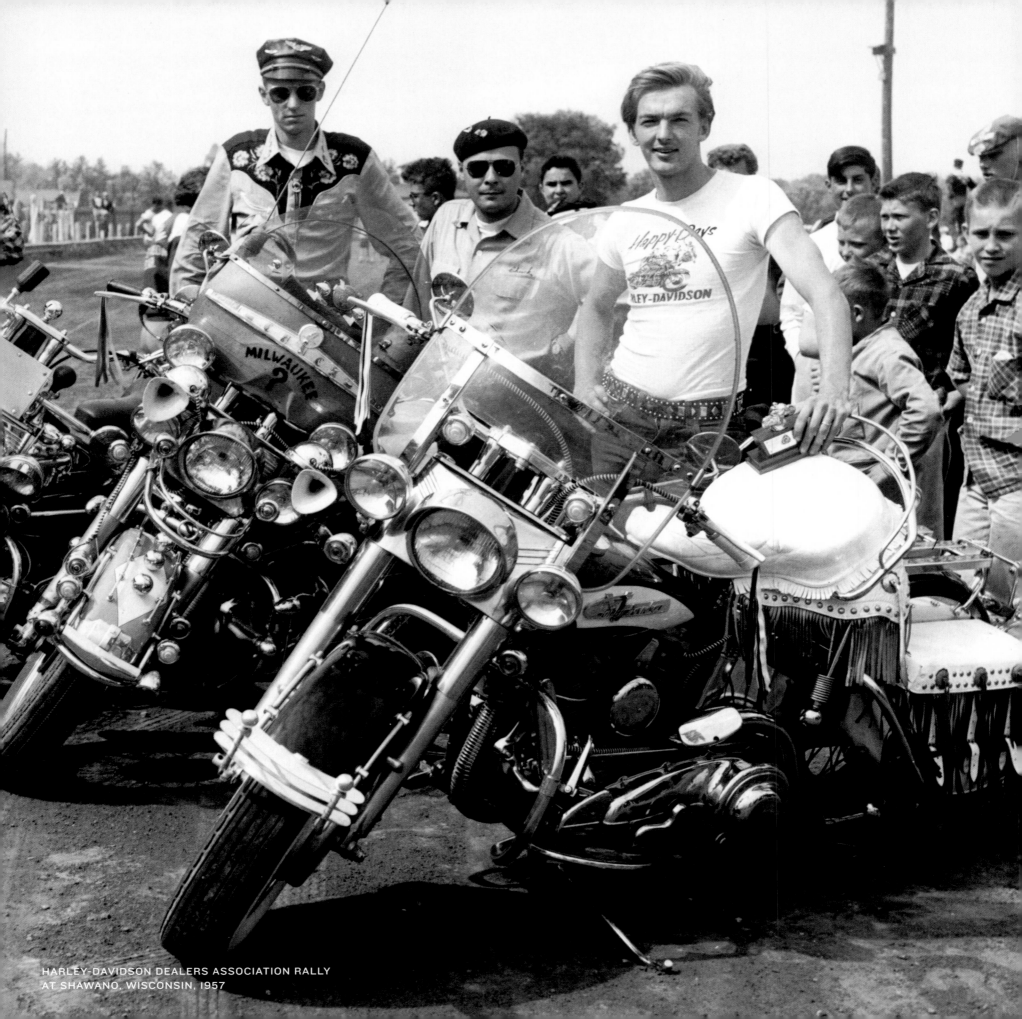

HARLEY-DAVIDSON DEALERS ASSOCIATION RALLY
AT SHAWANO, WISCONSIN, 1957

1956

CULTURE AND COMPETITION

1970

BIKES ARE BACKED UP TO THE CURB,

HANDLEBAR TO HANDLEBAR,

FOR BLOCKS.

THOUSANDS AND THOUSANDS OF THEM,

THEIR LICENSE PLATES

A PATCHWORK QUILT OF COLORS

REPRESENTING EVERY STATE.

I N 1978, I TRAVELED TO STURGIS FOR THE FIRST TIME AS A rider. It was much less corporate and commercial in the seventies than it is now. There were fewer motorcycles by a large number, you could still camp at City Park, and it was much wilder. The Deadwood and Sturgis of the seventies was a Wild West scene of outlaws and all kinds of motorcycle characters.

Things have certainly changed. Because of the great expansion of the rally, Deadwood has restrictions about where you can park your motorcycle, and camping at City Park is no longer allowed. But I'm happy to have experienced the Sturgis of yesterday and today.

Riding to Sturgis for more than 20 years has been such a blast for me because I'm always with friends and family. In the evening hours at Sturgis, we reminisce about our travels and the weather we journeyed through on the trip. Of course there's a story or two for each year, and retelling them is part of what makes the experience unique. One particular year on the ride to Sturgis, we hit road construction right after a rain. I'll never forget it. We nicknamed the journey the "Mud Ride," because the section of road under repair had six to eight inches of wet, watery mud on it. Cars were sliding all over; it was a real challenge just to ride through it, but we did. However, we needed to clean off right afterward, so we rode into a spray-and-wash car wash and stayed right on our bikes. Everything was full of mud—us, our helmets, you name it. We took turns spraying each other with water wands to free ourselves and our bikes of mud. It ranks as one of my favorite memories of the journey to the Sturgis rally.

A rider gets the thumbs-up sign from a group of kids in Sturgis during the 1990 rally.

Traveling from Milwaukee to Sturgis is a lot like watching a movie on a big screen. It starts out with the lush green farmlands of Wisconsin, then you cross the Mississippi into Minnesota. Eventually you come upon massive stretches of the Great Plains, which are as flat

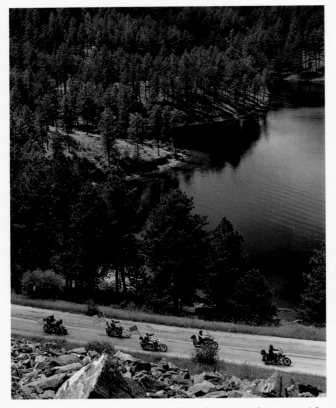

Some riders break away from Sturgis to enjoy a tour of the Black Hills in 1999.

Far right: This watercolor painting by Willie G. was inspired by countless rides through the Great Plains on the way to Sturgis.

as you can imagine. It's one of my favorite places to ride for a number of reasons. Foremost is the way light plays on the open fields and how it breaks through the clouds. The sheer size of the Plains against the horizon in the distance makes you feel minimal.

But the Plains are also a subtle landscape. You'll travel past a house that has been abandoned and know that somebody, at some time, was trying to farm the surrounding land. It begs the questions: Who lived there? What did they do? Where are they now? It's what I think about when I blow across the Plains—it's something I look forward to every year. As a collector of Native American artifacts, I can almost see the early tribes on this landscape. I believe that we're also a kind of a tribe, on bikes, moving across the Plains.

As you ride to Sturgis, the landscape goes from lush green to open plains. Soon, you start to see cattle, cross the Missouri River, then enter South Dakota. You notice the outcroppings of the Black Hills. The terrain starts to undulate. All of these elements are distinct pictures in my mind. And experiencing them on a motorcycle is one of the great benefits of riding.

The conditions you ride through on the journey makes Sturgis more of a special place once you arrive, but the area doesn't need any embellishing. The early rally organizers knew all along that the Black Hills near Sturgis were the perfect setting for motorcycle riding. With Wyoming state parks and Yellowstone National Park nearby, and all the great roads and little towns surrounding Sturgis, it's a place like no other.

For those who haven't experienced what happens after the ride, I'll paint a picture: It's mid-afternoon

on an early August day. You and your wife find yourselves standing on Main Street in the small Black Hills town of Sturgis, South Dakota. For years you've heard stories about the legendary motorcycle rally known simply as "Sturgis," one of the largest annual motorcycle gatherings and a must for Harley-

Davidson owners. You've wondered, Is it really possible for more than a quarter of a million riders to be in the same place at the same time? You rode your bike all the way from home to see for yourself.

There are endless streams of motorcycles as far as you can see. You're trying to look at the bikes because each is different. The city is alive with the sound of Harley-Davidson V-Twins. You can't see any open spaces anywhere along the street. Bikes are backed up to the

curb, handlebar to handlebar, for blocks. Thousands and thousands of them, their license plates a patchwork quilt of colors representing every state.

The sidewalks are packed with T-shirt-clad humanity, flowing in and out of storefronts and between bikes. You peer in through a shopwindow and see people trying on jackets and chaps. Through another window, you see an artist with a customer getting tattooed.

You're in an extremely big crowd, but there's a very friendly atmosphere.

You wander into an alleyway packed with stalls selling every conceivable motorcycle-related product,

from T-shirts, belt buckles, sunglasses, leather belts to saddlebags, chrome parts, and decals. You smell the smoky aroma of frying buffalo meat, sausages, and onions coming from food stands.

Right about here you start to realize that Sturgis is a thrill. You then pull out your camera and try to find a shot, any shot, that will somehow capture this for friends and family back home.

Before the week is up, you will have ridden hundreds of miles through the beautiful Black Hills, read in the local paper that indeed more than a quarter of a million motorcyclists are here, watched the sun go down behind Mount Rushmore, taken demo rides on brand-new Harley-Davidson motorcycles, heard hundreds of great road stories, attended informational seminars, seen a couple of bands that you thought were pretty good, spent a few hours in Harley-Davidson's massive display area, made new friends, bought some raffle tickets to help raise money for the Muscular Dystrophy Association, got an oil change, lost money gambling in Deadwood, spent a wild night at the racetrack, and bought so many souvenirs that you had to ship them home. Finally, you hit the road for home, hoping the return trip will be just as much fun as the ride here. And it will be.

Once home, you'll do what millions of other riders have done over

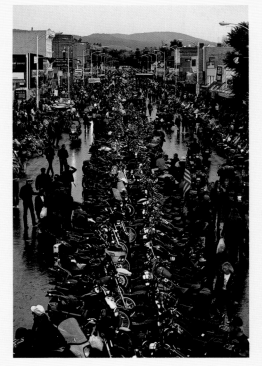

For many, the rally experience includes nights spent on the campground among friends, as this Iowa scene shows.

Bottom: Even a rainy day in 1990 won't discourage the crowds from gathering on Main Street in Sturgis.

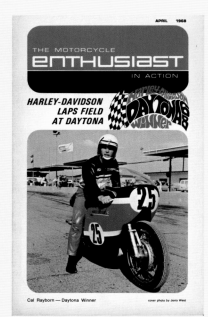

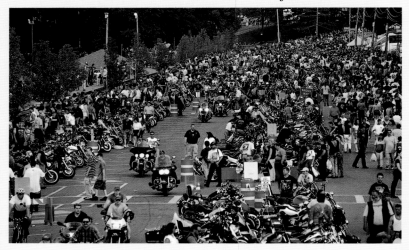

This April 1968 cover of The Enthusiast *celebrates a Harley-Davidson victory in the Daytona 200.*

Far right: Wier's Beach is a popular spot for riders to congregate at the annual Laconia Rally in New Hampshire.

the last 60-odd years. You'll tell anyone who will listen where you've been, what you did, and what a super time you had. You'll tell your Harley riding friends they missed the time of their lives and encourage them to join you next year. The stories—the legends—will grow. And next year's gathering will be larger.

We love rallies. Nancy and I have been to several hundred, big and small, and we never tire of them. Events like Sturgis; Bike Week in Daytona Beach, Florida; and Motorcycle Week in Laconia, New Hampshire, are among the greatest, and certainly most visible. Although the big three draw the largest crowds and are the best known, every weekend of every year, somewhere in the world, rallies are taking place, bringing riders together and generating excitement.

Almost since the days when motorcycles first appeared, enthusiasts have been coming together to enjoy the spirit of community. Even during the most trying times in our nation's history, motorcyclists have gathered to share their passion, trade road stories, compare hardware, laugh and ride together—and simply escape from the everyday world for a while.

As a boy, I remember hearing my dad tell stories about the fun he and my uncles had at Daytona. I saw the pictures in motorcycle magazines and couldn't wait to go myself. For a racing fan like me, Daytona was a dream destination because of the Daytona 200, where some of the top racers in the world competed. The thought of being on the beach with thousands of bikes

and riders while there was still snow on the ground in Wisconsin seemed so awesome.

On the night at the dinner table when my dad told me he was going to take me on the journey south, I was elated. This was back in the early fifties, and the Daytona scene was nowhere near today's massive scale, but the event was still spectacular.

It was all there, even beyond what I'd dreamed about. Beautiful custom bikes were everywhere. There were a few representatives of the emerging chopper crowd, with their lean bikes and black leather jackets.

There were club riders in their pilot-like uniforms, with pressed shirts, knee-high boots, jodhpur pants, and white-brimmed hats. The motorcycle community was still relatively small at that time, so to see this many bikes in the same place, and how cool everybody looked, and how much fun they were having, just blew my mind.

Then there was the racing. The races were actually held on the beach, on hard-packed sand that was

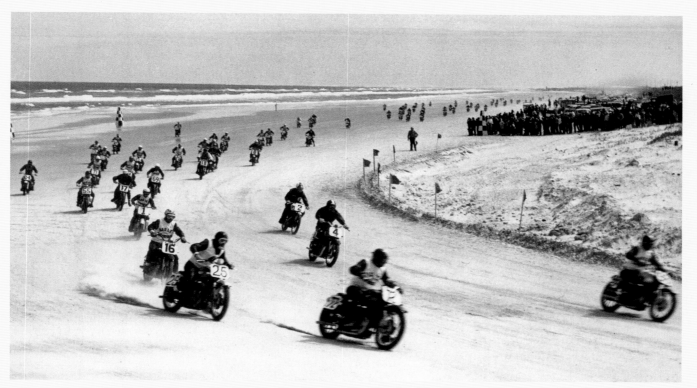

The annual races at Daytona were once partially held on the hard-packed sand. In 1961, the races were moved to the Daytona Speedway.

smooth as glass. As the tide came in, the long straightaway would narrow, which gave the racers less room and added to the drama. With the waves in the background and crowds of cheering fans, a mass of Harley-Davidson KRs—along with Indians, British bikes, and some older Harley WR tank shifters—would come roaring down the beach.

As the bikes reached the end of the long sand straightaway, they'd have to slow and make a tricky, tight turn onto the back straightaway, which was a paved but bumpy road. They moved so fast on that rough back stretch that they needed special knee grips on their bikes to lock themselves on. No pictures could ever do it justice. You needed to be there.

These memories are very special to me. And I love to talk about them. When we do this, we're keeping the legends alive.

Motorcycle rallies are a lot like tribal gatherings. They allow a community of people to share in a culture and celebrate it. This is a tradition worth protecting and perpetuating. And that's what we're doing at Sturgis, Laconia, Daytona, and everywhere else riders gather together.

1966 | FL (SHOVELHEAD)

Historically, our engines have been street named. Three familiar names are Knucklehead, Panhead, and Shovelhead. We discontinued the Panhead in 1965 and introduced the Shovelhead in 1966. The Shovelhead engine had a long life. It ran until we introduced the first Evolution engine in 1984.

The FL motorcycle with Shovelhead engine was one of the first to have Harley-Davidson fiberglass saddlebags. The acquisition of a fiberglass manufacturer in Wisconsin in 1962 allowed us the flexibility of tooling and manufacturing small production runs of custom fiberglass shapes. From a styling standpoint, the ability to work with this material was an important development. Though fiberglass saddlebags have been used on many of our motorcycles since, the side profile shape has always referenced the one used on the first Shovelhead. It remains a recognizable form that is a defining part of our big touring bikes.

A feature you see on the FL (Shovelhead) pictured here is the sprung seat post. This was a two-up seat, on which riders sat at a higher position than they would today. The last seat-post model was offered in 1981, and we mounted the seat rigid to the frame in 1982.

POWERTRAIN

Engine: 45-degree, overhead-valve V-Twin Shovelhead
Displacement: 74 cubic inches
Compression: 8:1
Transmission: 4-speed foot-shift or hand-shift
Primary drive: Double-row chain
Secondary drive: Chain
Brakes: Drum and shoe
Ignition: Battery and coil

CHASSIS

Frame: Double downtube, cradle type
Suspension: Telescopic forks (front),
 hydraulic shocks (rear)
Wheelbase: 60 inches
Gas tank: 5 gallons
Oil: 4 quarts
Tires: 16 x 5 inches (front and rear)
Colors: Black with White; Indigo Metallic with White

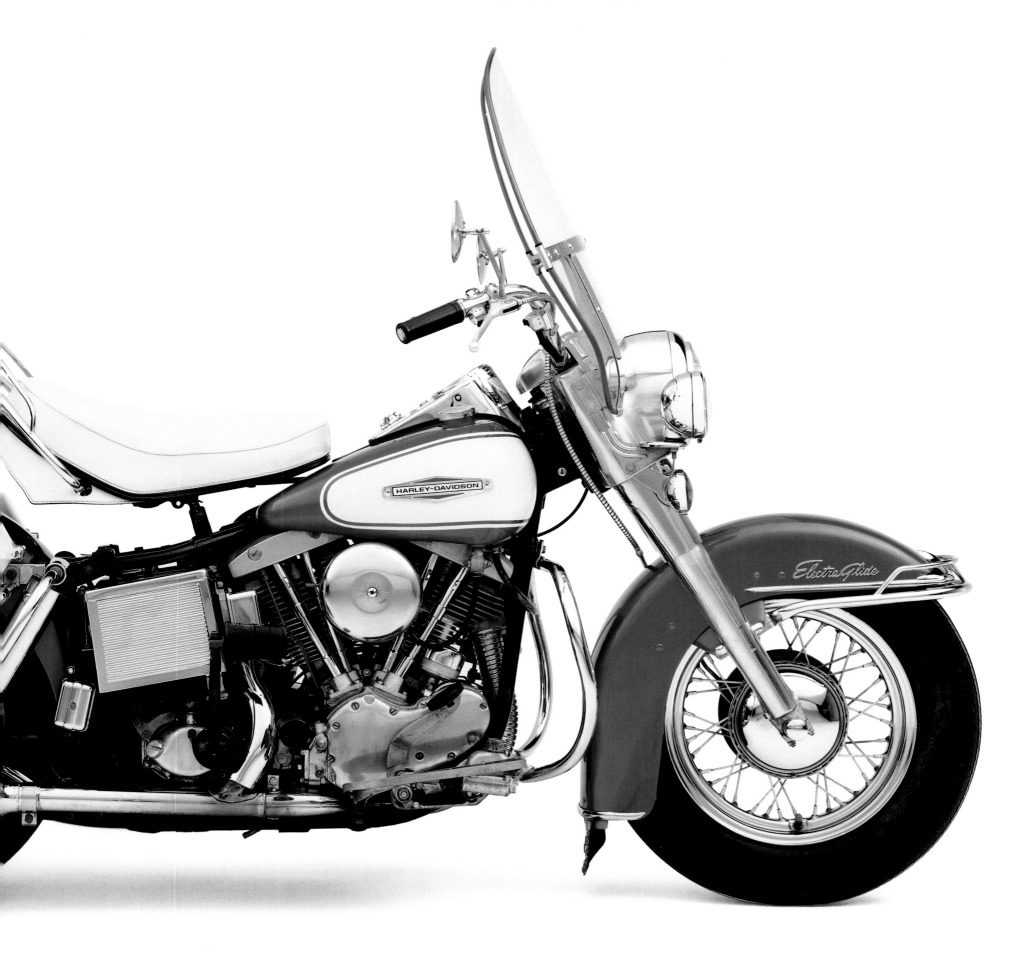

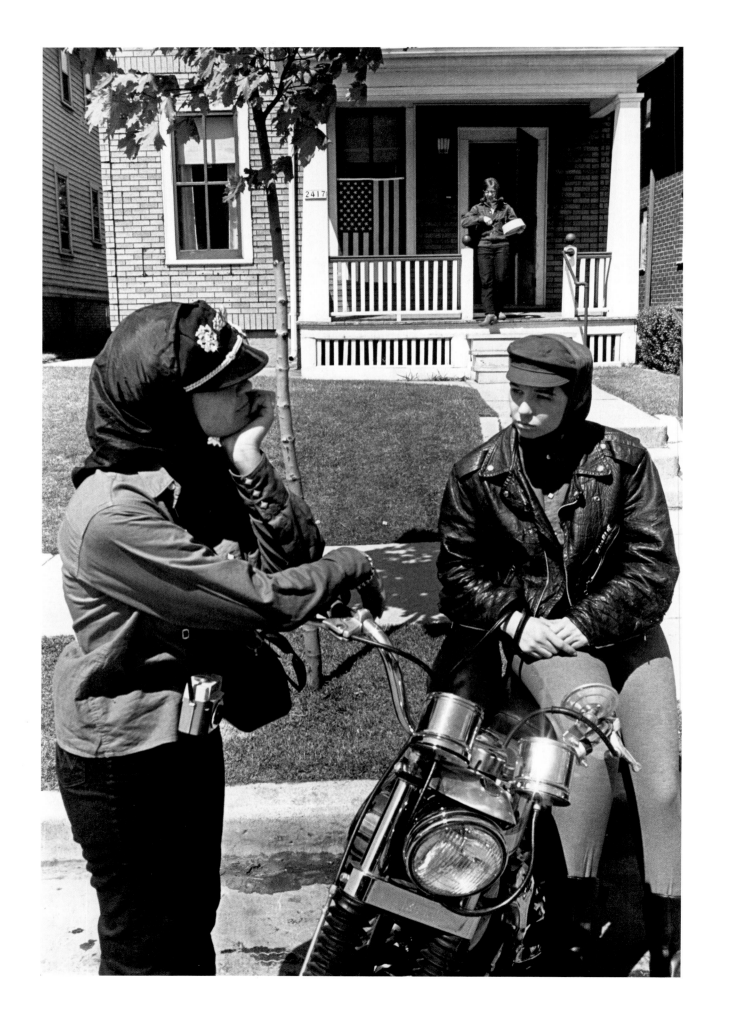

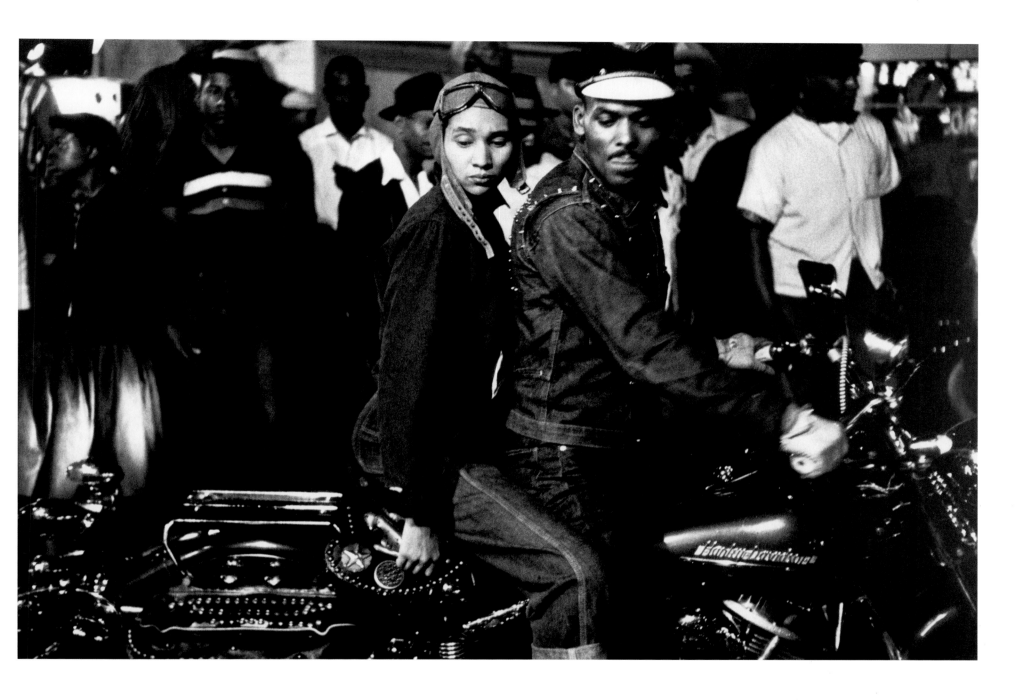

1966 | *Memorial Day Run, Milwaukee.* **1955-56** | *Riders at a rally in Indianapolis.*

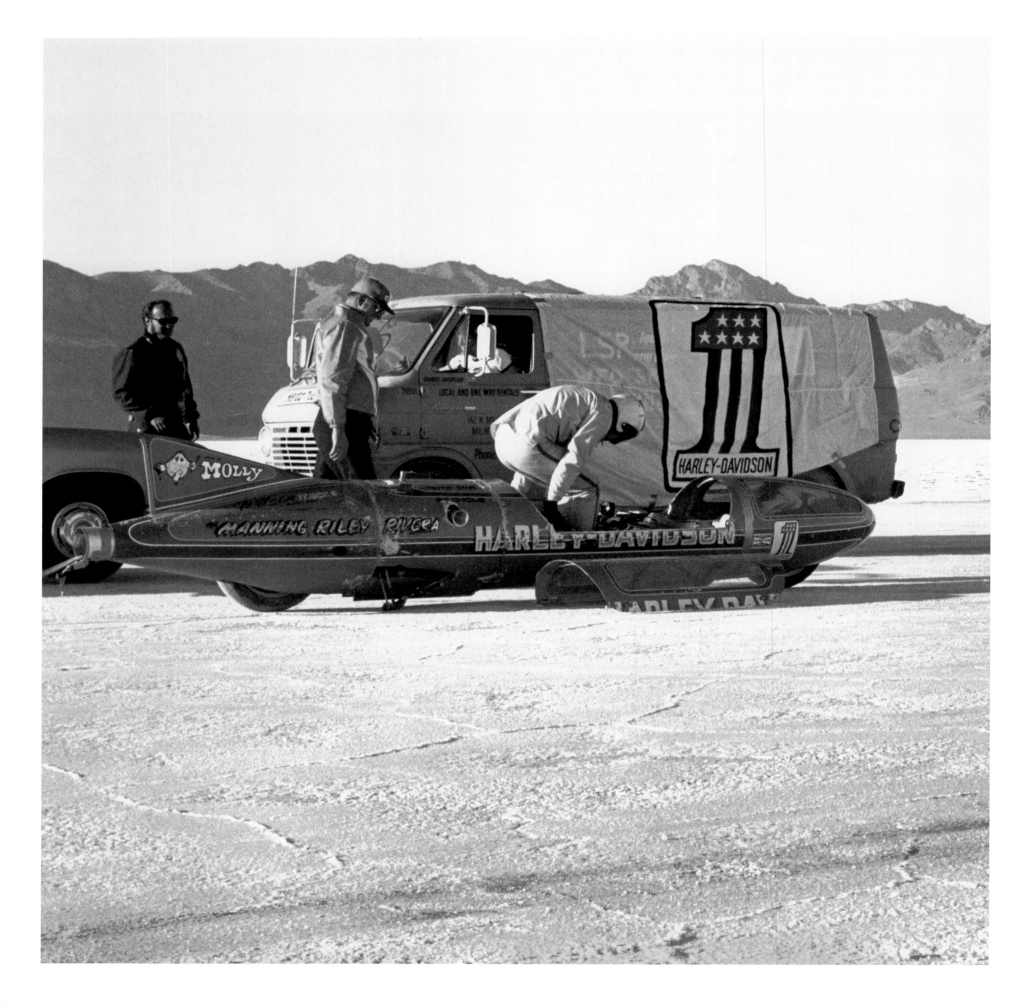

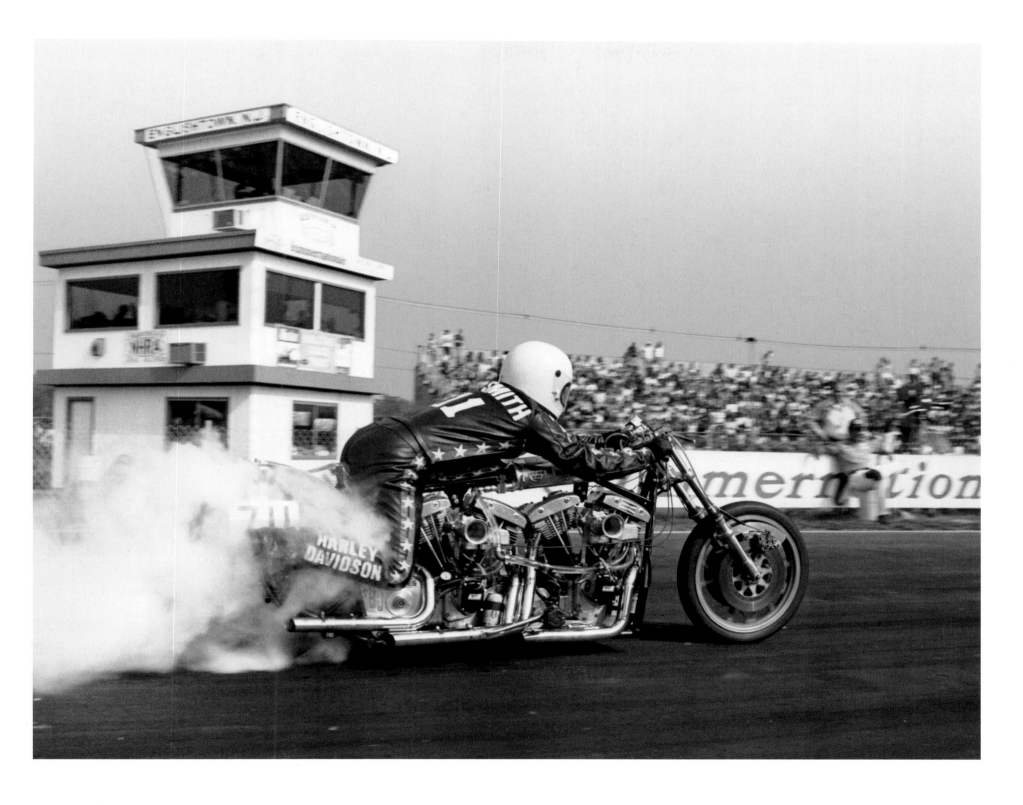

1970 | *Factory racer Cal Rayborn set a new land speed record of 265.492 mph in a streamliner on the Bonneville Salt flats.*

1970 | *Joe Smith broke the nine-second barrier for the quarter mile on a double-engine, Harley-Davidson dragster .*

1967 | *Harley-Davidson motorcycles line the curb on High Street in San Francisco, California, during the "Summer of Love."*

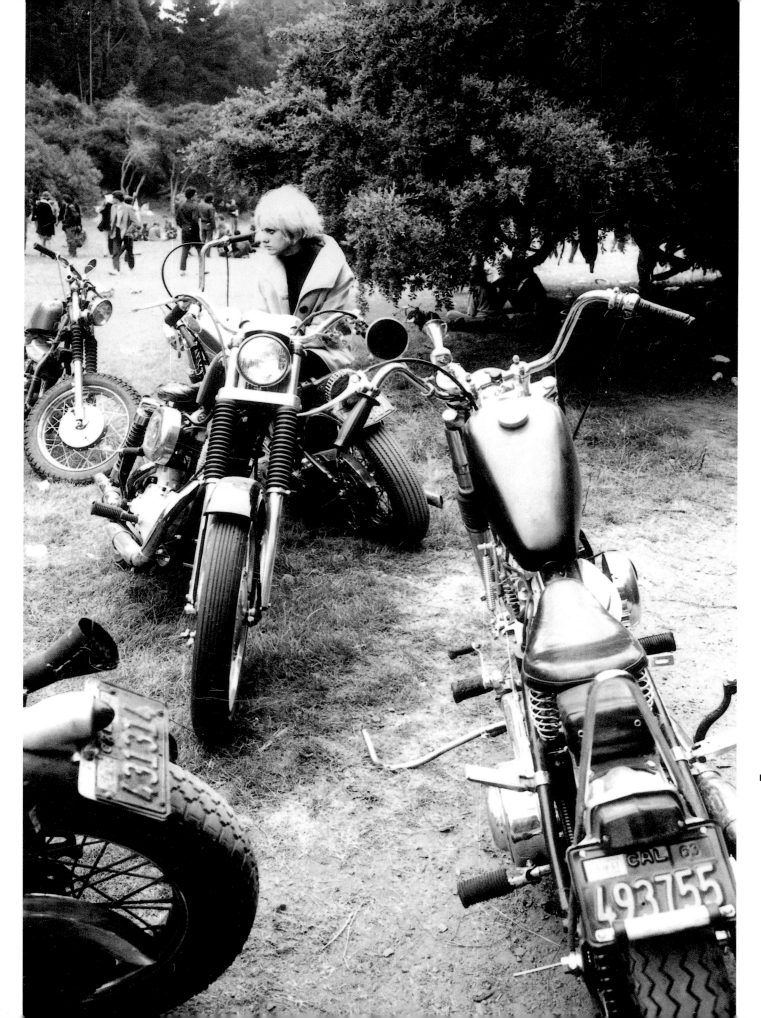

1967 Golden Gate Park in San Francisco, California, is the setting for this display of choppers. Extended forks, high bars (or long sissy bars), and small tanks were popular modifications in the sixties.

153

Dealers

I've always said that dealers are on the firing line. They interact daily—one-on-one—with our customers. The Motor Company is nothing without a great, worldwide dealer organization. Dealers are our most important business partners, and their spectacular new stores truly are a commitment to a great future.

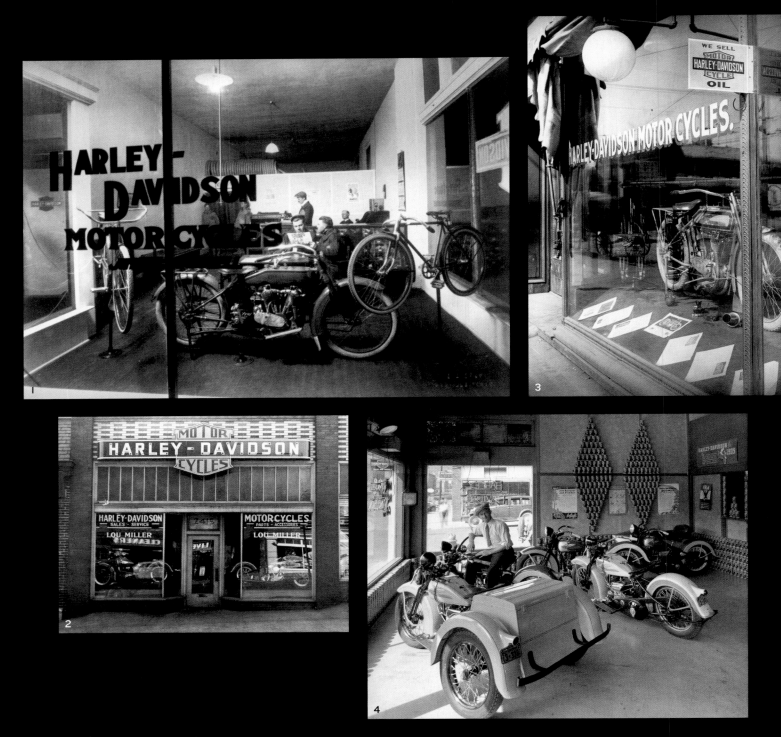

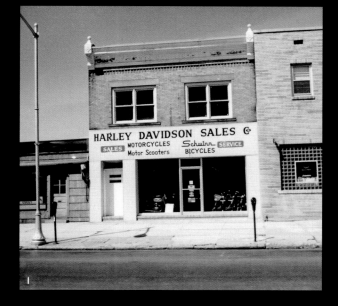

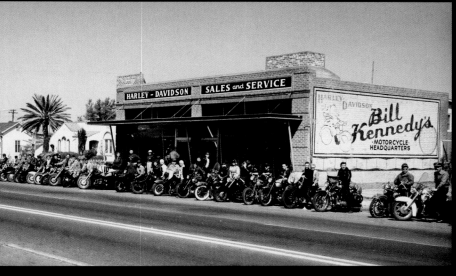

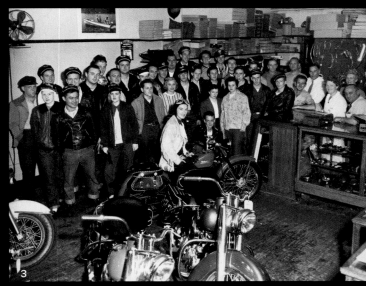

OPPOSITE PAGE
(1) Harley-Davidson produced a line of bicycles until the early 1920s
(2) Omaha dealership in 1937 (3) A new two-speed (4) A Servi-Car model
on display in a dealer showroom.

THIS PAGE
(1) This dealer sold Harley-Davidson models and Schwinns in 1967
(2) The Gypsy Tour getting ready to depart from Bill Kennedy's dealership
in 1951 (3) A 1951 group shot (4) A contemporary Harley-Davidson dealer
storefront (5) The larger interiors of today's dealerships allow for more
room to showcase Harley-Davidson merchandise.

MY DAD WANTED TO KEEP

THE COMPANY AS IT WAS.

THE IDEA OF

GIVING UP

CONTROL OF HARLEY-DAVIDSON

TO A COMPANY

HE WAS CONVINCED

COULD NEVER TRULY UNDERSTAND US

WAS SOMETHING

HE DID NOT AGREE WITH.

J UST HEARING THE WORDS "LATE SIXTIES" EVOKES VIVID memories and imagery for me, as I'm sure it does for anyone who was around then. I can't think of another time that had as many

dramatic contrasts, both in the culture and at Harley-Davidson. The events of this era had a major effect on me and anyone involved with our motorcycles.

The anti-war movement and hippie lifestyle were blossoming. Televised scenes of Vietnam violence appeared in our living rooms every night. Some of the greatest rock and roll ever made was being recorded, and it captured the way young people in particular were feeling. Our motorcycles, too, reflected the spirit of the times.

Riders were building increasingly creative bikes that expressed their growing distaste for the status quo, and stressed their individuality and passion for freedom. The influence of tie-dyed shirts, beaded jewelry, and psychedelic art began showing up in custom paint, accessories, and clothing. These details, combined with long front forks and coffin tanks, made bikes look more and more extreme.

Then the film *Easy Rider* appeared. I don't think anyone could have predicted it would succeed the way it did. I remember how exciting it was to see those two

guys riding beautiful custom bikes, inspired by Harley-Davidson, across the country. I can still see the sun reflecting off the spokes. The movie triggered so many feelings—and still does. I personally liked *Easy Rider*

Billy (Dennis Hopper) and Wyatt (Peter Fonda) ride the open road in the 1969 film Easy Rider.

very much. But others at the time reacted differently. And more pressing factors were commanding our attention at Harley-Davidson.

Honda and other overseas competitors were cranking out more and more bikes, selling them at good prices, and gaining market share here in the U.S. Harley-Davidson wasn't as nimble as it once was. Our lightweight motorcycle line had grown larger over the past several years. We were spread thin. But aside from these problems, there was something else we absolutely didn't see coming.

Until 1969, I don't think I'd ever heard the term "hostile takeover." But suddenly the phenomenon was spreading through the business world, as strong companies or investor groups seized publicly owned companies by buying controlling interests in their stock. Since Harley-Davidson was a company with major cash-generating potential, it became a takeover target. A manufacturing group called Bangor-Punta approached our executives, major shareholders, and many of our dealers, offering to buy stock. Most of our dealers weren't impressed by the offers. But, given the way things were going at the company, some of the executives and shareholders were.

The board of directors and executive leaders held several heated meetings. To people not accustomed to such offers, selling seemed like a viable action. Some felt it would be in their best interest not to have all of their personal wealth tied to Harley-Davidson. My dad wanted to keep the company as it was. The idea of giving up control of Harley-Davidson to a company he was convinced could never truly understand us was something he did not agree with.

It became apparent that the only way to avoid the Bangor-Punta deal would be to find a buyer capable of understanding and perpetuating our business—cash-rich enough to make that happen. So we looked for a white knight and found one in the form of a major conglomerate. American Machine and Foundry, known to the world as AMF, made everything from food- and tobacco-processing machinery to boats and bowling equipment. We figured that, with AMF's reputation for leisure products, strong engineering emphasis, and deep pockets, Harley-Davidson would benefit. We would avoid a hostile takeover and remain intact. The acquisition was completed in January 1969.

AMF soon made its presence known. I've always viewed our name on the fuel tanks as hallowed ground. But not long after the merger, I was informed that AMF's logo would also appear on our fuel tanks, directly to the left of our name. I was stunned. Didn't AMF realize that the words "Harley-Davidson" evoked positive reactions and feelings? What did AMF evoke?

It hit me that the new corporate ownership would soon have an impact on our product planning and development. AMF wanted Harley-Davidson to

become the next high-volume producer. But we weren't built for that.

I tried my best to stay focused on design. I was able to retain my creative freedom. I was actually starting to feel good about some of the cool stuff we were working on, like the #1 logo.

A great racer, Mert Lawwill, won the AMA #1 plate for Harley-Davidson dirt-track racing, and I wanted to mark the occasion with something extra special. The numbers on dirt track number plates have an aggressive angle to them. I designed a logo that incorporated a large, angled number one. I also wanted a sense of Americana, so I included a hint of the flag and our name across the bottom. It quickly became a well-known logo for us, and I'm very proud of it.

A new motorcycle of the AMF era, the Super Glide, wore that logo and is a design milestone. We married a Sportster fork and front-wheel assembly to our FL—or touring—chassis and gave it a dramatic red, white, and blue paint scheme. But what was radical was the tail section, nicknamed the "boat tail." It was bullet-shaped, with a recessed tail lamp.

Probably because the Super Glide looked so different, it became the subject of a great deal of debate and wasn't a big seller. But this model was important, because it established us as a custom manufacturer. It was the seed of a new family of custom motorcycles, the popular FX series.

Fortunately for me and everyone else who rides our bikes, I gained a new colleague around this time— Louie Netz, a talented young designer who joined the company in 1974 and became my partner and friend. He's a true motorcycle enthusiast, excellent designer, and company leader.

Our next successful iteration in the FX family was the 1977 Low Rider. A classic roll-type fender replaced the boat tail of 1971. Lowering the seat so it stood only 27 inches from the ground gave it a custom look. We used drag-style handlebars and a black treatment on the cylinders and heads, and we polished the outer fin edges for contrast. The outer engine covers, the tank, and the fenders were painted silver. The logo's red lettering was inspired by an early style dating back to our 1917 race bikes. The tank was topped with a unique speedometer/tachometer console. We were enthusiastic about what we'd created, but unsure whether it would stand up to the scrutiny of riders at Daytona.

In March 1977, Louie and I picked up two Low Riders at Harley-Davidson's motorcycle assembly facility in York, Pennsylvania—a retrofitted AMF facility—and hit the road. We could tell by the way riders on the highway were reacting to the bikes' low seat height, drag bars, and overall look that we were in for favorable reviews when we hit Daytona. We were right. The stares, thumbs-ups, and enthusiastic

This Willie G. drawing of a wheel and front fairing from the late sixties is a design concept sketch.

Far left: The Harley-Davidson #1 logo, designed by Willie G., was among the most popular in Motor Company history.

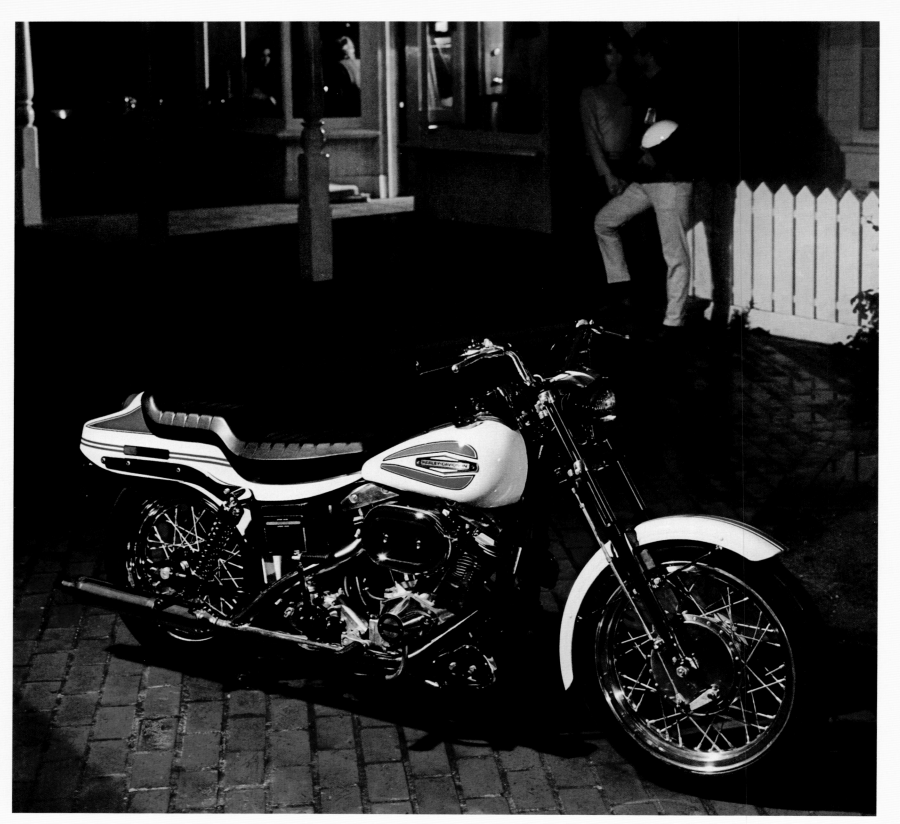

The Super Glide, pictured in this seventies advertisement, was later nick-named the "Night Train," after a popular song at the time.

comments seemed contagious. When it became apparent that everyone thought the bikes were one-offs rather than factory-built, we knew we were on to something. We didn't need focus groups or surveys. Positive reaction from our customers told us what we needed to know.

The dealer launch of the Low Rider was a hit right out of the gate—just when we and our dealers needed one. At the time, showroom traffic was down, as low-priced Japanese motorcycles were winning more new customers than we were. Our dealers were happy to see a great-looking motorcycle.

But the Low Rider wasn't the only new model introduced in 1977. Our highly modified—and, ultimately, controversial—Sportster, the XLCR Café Racer, was announced that year. The Café Racer was built to make a distinct visual statement. My partner in the prototype process was Jim Haubert, an excellent fabricator who previously worked in our racing department. We designed the motorcycle as a racer-looking vehicle. We modified the frame, created a new fuel tank, new tail section and seat, and a quarter fairing up front. We took it further with cast wheels, which were new at the time, and a unique all-black exhaust system. It was the first blacked-out motorcycle and had a sinister XR road-racer look.

After all the excitement and effort, the XLCR model did not generate major sales. One school of thought has it that timing was off, since we delayed production for a full year in order to get quality in line. When people get emotionally wrapped up in the visuals and the excitement of a product, they want to buy it right now. The delay killed the buzz, and people lost interest. But the XLCR eventually connected with them, as evidenced by the demand and prices in today's collector market. Without question, it's one of my favorites, and to this day I have retained serial number one. This experience taught us some valuable lessons.

Shortly after AMF assumed control of Harley-Davidson, their corporate logo appeared on the gas tank. Pictured here is a tank from the 1977 Low Rider model.

Far left: Harley-Davidson introduced a line of golf cars in the early sixties. By the end of the decade, under AMF, Harley-Davidson accounted for a third of the U.S. golf car business.

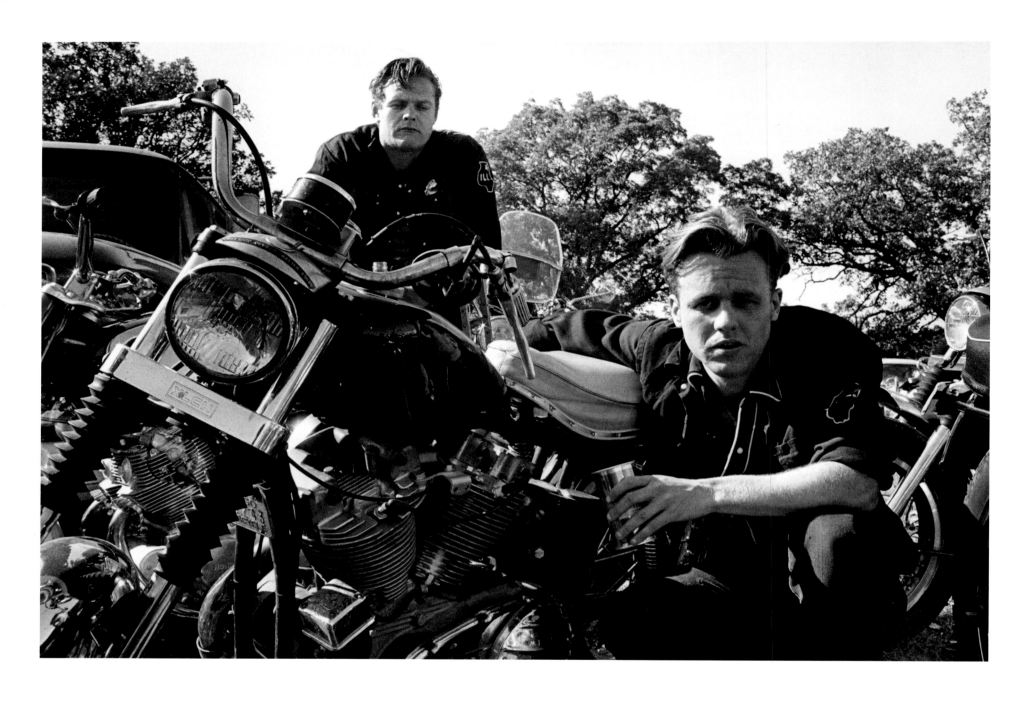

1966 | *Brucie, his CH, and Crazy Charlie, McHenry, Illinois.*

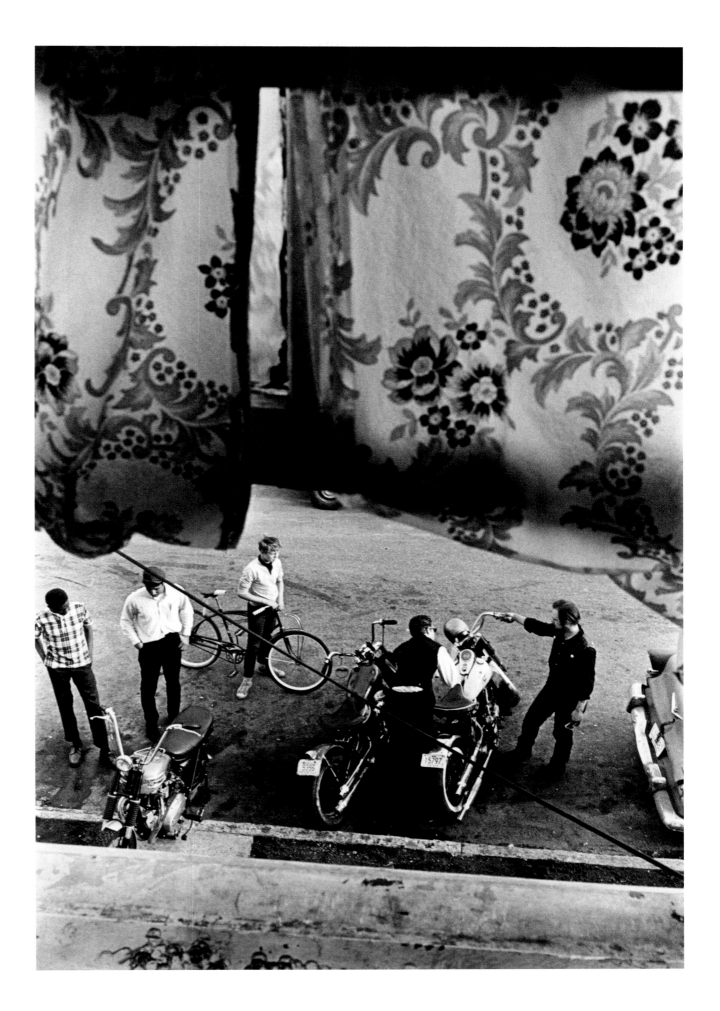

1966 | *From Lindsey's room, Louisville.*

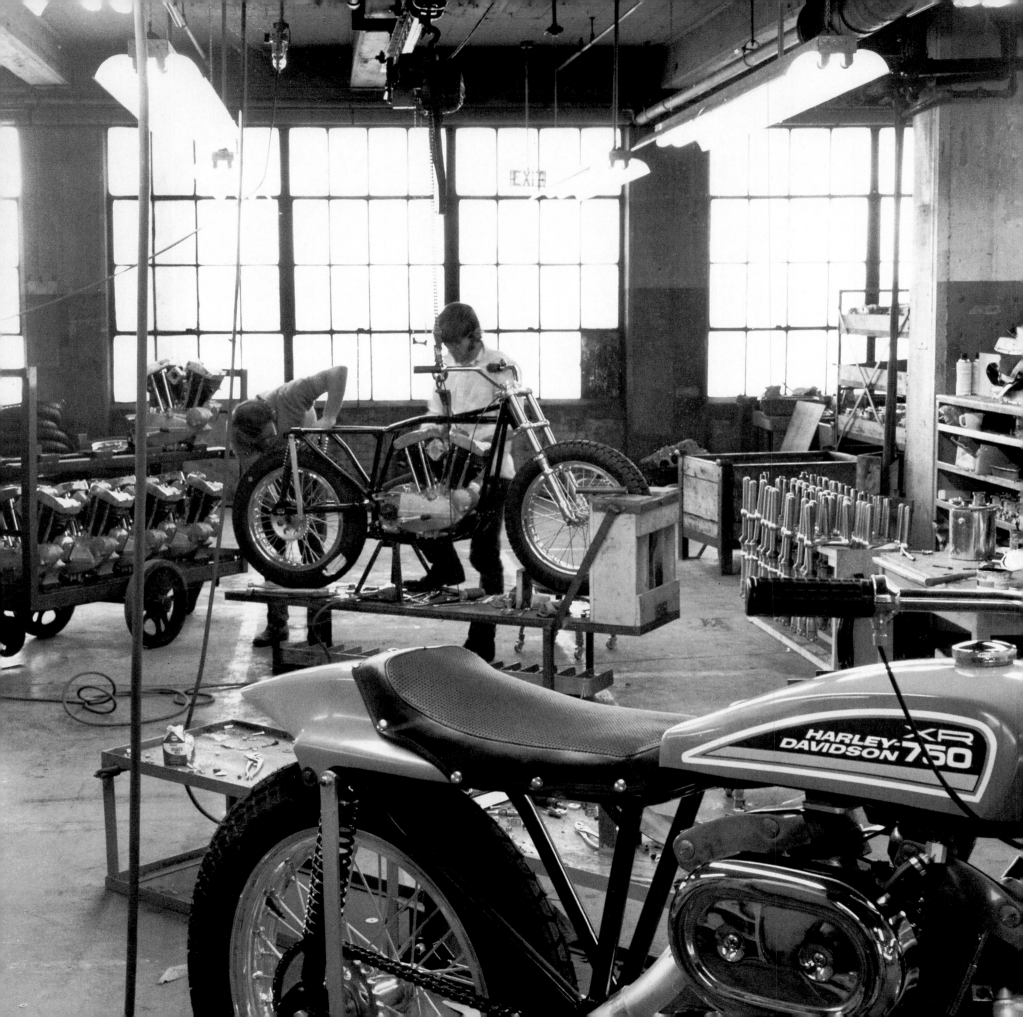

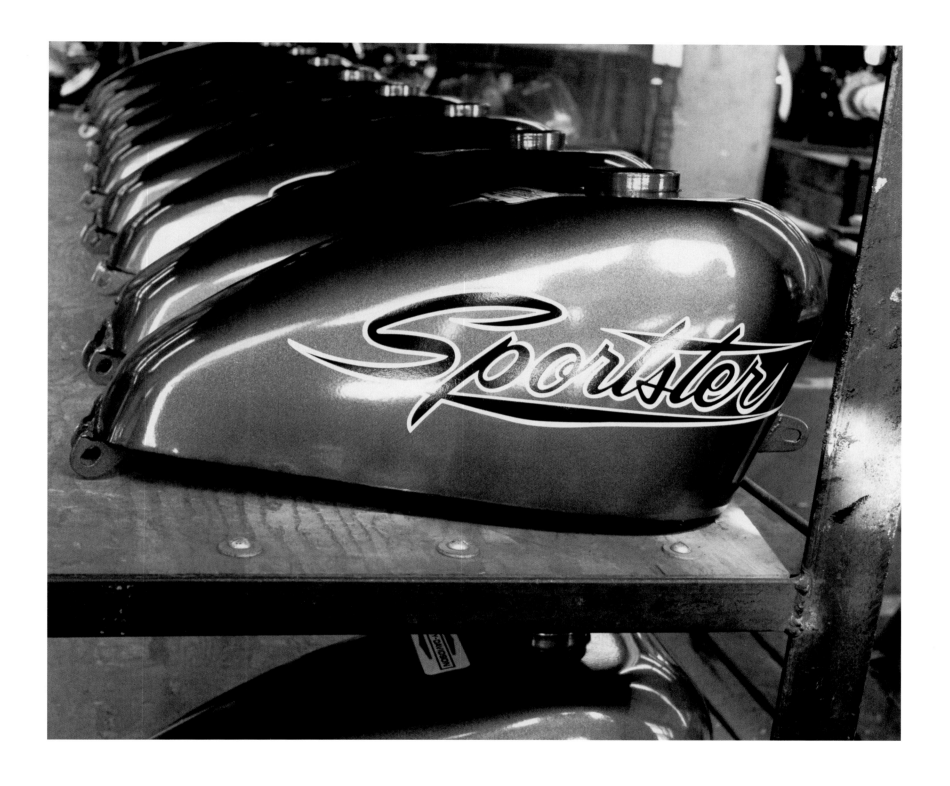

1970 | *These racing models were assembled and tuned in the XR750 racing shop.*

1970 | *The famous Sportster script and peanut tank.*

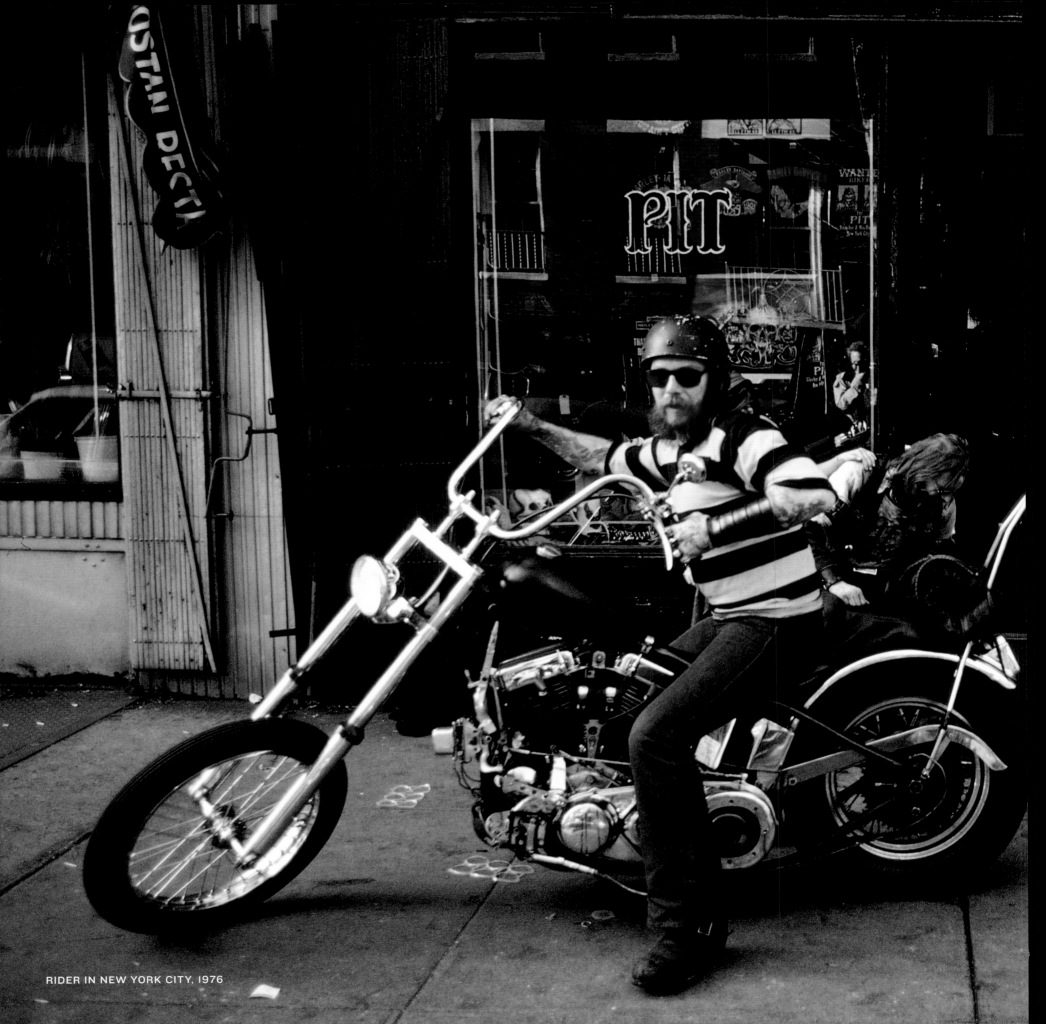

RIDER IN NEW YORK CITY, 1976

1971

DARK DAYS REVISITED

1983

I LEARNED AT A VERY YOUNG AGE

HOW IMPORTANT IT IS

TO UNDERSTAND THE ATTACHMENT

SO MANY PEOPLE HAVE TO

OUR COMPANY

AND TO

OUR NAME.

THE WORLD IS FILLED WITH FAMILY NAMES, EACH SPECIAL IN its own way. Simple names like "Harley" and "Davidson," when associated with our products and our brand, have become more than stand-alone family names; they carry an emotional weight for millions of people.

"Harley-Davidson" is located on the most prominent part of the motorcycle—the tank. It's embroidered across jackets and displayed on many of our other MotorClothes products. Worn as a tattoo, it demonstrates a personal level of loyalty.

Our brand conjures the experiences of riding—rallies, camaraderie, and freedom. Harley-Davidson employees are involved with the sport, which means connecting with our customers. We attend rallies and special events as riders and enthusiasts. I firmly believe that to fully understand motorcycle design, you have to be immersed in the sport. It's one of the reasons we're successful.

The four founders subscribed to this same philosophy, though it hadn't been formalized. They knew the value in something as simple as a handshake and a road story or two shared with a customer. Throughout the history of the company, our management people have enjoyed the sport. In back issues of *The Enthusiast*, the world's oldest, continuously published motorcycle publication, you will find lots of stories telling of management's fascination with riding over the years. Walter Davidson won some of those early endurance runs. And the second generation crossed the country on their motorcycles in their teens. My dad competed in the 1930 Jack Pine Enduro with William J. Harley riding alongside him. Somehow my dad's watch got damaged, which was serious since the event was a time-distance race. William J. gave his watch to my dad, who went on to win the event with 997 points over two days. From these stories and more like them, I understand it was a hands-on deal from the beginning.

My dad believed strongly in our dealer organization and the dealers' role in promoting and protecting the

William H. Davidson addresses dealers during the launch of the K Model in 1951.

Far right: A toddler gets a Willie G. welcome at a Harley Owners Group rally.

brand. As president, Dad always gave the keynote address at the dealer shows. He was good at it, probably because he enjoyed it. He was a dedicated man who recognized dealers as crucial parts of the whole.

Harley-Davidson products don't come from some invisible, faceless corporation. Our visibility as passionate participants in our sport, whether we're Motor Company employees, dealers, or dealer employees, sends a clear message: we ride and we do it because we love it, and we're enthused by the pride that comes from all the people who support our brand. I'm very grateful to my family, especially Nancy, for being so supportive throughout these weekends when we're away from home. We're together in this; it's been a major part of our lives. Our children have gotten more and more active at events, which is terrific, because it illustrates the continuation of a family tradition.

I've had many moving conversations with riders. Lots of people have come up to me and said that their experience with Harley-Davidson has changed their lives. They're talking about a positive change that's a result of being involved in activities—riding their bikes on memorable trips and meeting people, often lifelong friends and sometimes significant others.

When a Harley-Davidson rider has a chance to talk to a "factory person"—one of our engineers, H.O.G. staff, or employees from the assembly line—they make a powerful connection. The bond between a rider and his motorcycle becomes stronger when there's a human face behind the machine. On our end, it helps to learn more about the customers' expectations. It's why Harley-Davidson places such a premium on mixing it up with our customers.

I learned at a very early age how important it is to understand the attachment so many people have to our company and to our name. I'm fortunate to be a direct

descendant of one of the founders of this company I love so much. I've never taken the brand lightly, nor do my wife, my sons, or my daughter. We have tremendous respect for our heritage, and we hold it very close to our hearts.

One of my contributions to protecting the brand is through design. My artistic interests in Harley-

Davidson motorcycles and custom-vehicle design are long-standing. I can't say enough about my influences in high school, when I was drawn to custom vehicles and spent a lot of time with the motorcycle and hot-rod crowd. In 1963, I joined Harley-Davidson as a designer and took note of the product lineup. There were dressed-out baggers, which had their own beauty. And there was the Sportster, a muscle bike from the late fifties and early sixties. Though these were significant models, there was a missing piece. Through involvement in our sport and closeness to our customers, I realized riders had a growing desire for a factory custom.

As detailed earlier, I took it upon myself to put together a prototype that was extreme for its time. Other than the rear fender section, it was a marriage of existing parts. To emphasize the custom look that was taking hold among riders, I put a Sportster front fork and front-wheel assembly on the Big Twin chassis, which emphasized the Big Twin engine and rear wheel. To further distinguish the back of the vehicle, I created what I call a "racerly" boat tail, with a streamlined look. I recessed a Chevrolet taillight in the boat tail. We utilized a dramatic red, white, and blue paint scheme and the new #1 logo on top of the fuel tank.

The first photos of this FX were planted in *Motorcycle Sport Book* magazine. We purposely didn't indicate that it was a Harley-Davidson prototype. We

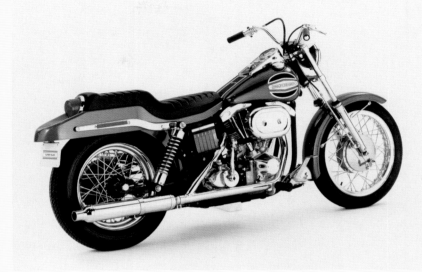

hoped to get a response that would tell us whether we had touched a nerve in the custom market. As it turned out, there wasn't enough to suggest that we should create an original-equipment motorcycle like this. But company management believed in the prototype and was willing to fly with the model as a test. So we built it as a production bike.

The production motorcycle was featured on the cover of *Cycle* magazine with the editor standing on the seat. I named this the Super Glide FX—for "Factory Experimental." The FX was intended to be in the line for a long time.

In all honesty, the Super Glide was not a great commercial success. I believe the tail section was probably too extreme. But there was value in creating this model. It was a seed that eventually blossomed into an entire line of custom FX motorcycles, and the current collector market has shown an interest in the Super Glide. Today the word "custom" is essential to our overall model lineup. Creating that motorcycle will always be a bright light in my past.

A prototype of the 1971 Super Glide is shown here with a dark green color scheme. The final model was produced with a red, white, and blue paint job.

Far left: This May 1972 cover of The Enthusiast *promotes "The Great Stars and Handlebars Road Race Revival," which was designed to stimulate sales.*

Willie G. worked with editor Bob Greene to plant these prototype photos of the Super Glide in the 1969 fourth annual edition of Motorcycle Sport Book.

These early days brought many memorable changes. When I joined the company, I did so as Bill Davidson. But as can happen when two members of a family with the same name work in the same location, there was confusion between my father, William H. Davidson, and me, William G. Davidson, both known as Bill. Just as it is today, our work environment was casual and friendly. Eventually, people started calling me Willie G., which helped to reduce confusion. Like most nicknames, it wasn't planned, but it fits: I'm an informal type of person.

Customers were first introduced to my nickname in 1976, when our marketing department created an ad to support the launch of the XLCR Café Racer. Because the XLCR was so unique, marketing focused on differentiating our motorcycle design process. This model was created by a "skunkworks"—a creative group located off campus. The guy we worked with was Jim Haubert. Louie Netz also came on board around this time. The ad agency came up with the idea to feature the non-committee design, using "Willie G." to symbolize it. The design was a dream of mine. Working with Jim and Louie, we put the bike together. And that motorcycle was some-thing people liked to talk about. Today the Café Racer is a highly collectible vehicle with an enthusiastic cult following.

At rallies or events after the ad ran, more and more people approached me to talk, calling me Willie G. Our sport has always attracted fun people from all walks of life, and of course they ride great motorcycles. I go to the rallies to be part of the happening. If you do this for a number of years, as Nancy and I have, you make lots of friends who are riders. Going to these events is our chance to see these people. The autograph thing is a by-product, and though it can sometimes get a little intense, I'm not the type of person who's going to say no if I can help it. I'm happy to sign my name. It's really a two-way street—I enjoy it, and the riders seem to appreciate it.

Over the years, I've seen some things that amazed me. I've seen my likeness airbrushed on a fairing, and—believe it or not—tattooed on a person's leg. I once signed a man's arm, and he had my signature tattooed. A lot of riders are aware that I've been in the design game for a long time, but I think the reason they request my autograph goes beyond this. It has to do with having the family name on the tank.

The Davidson family takes a break in New Orleans (L to R): Bill,
Michael, Nancy, Willie G., and Karen.

1971 | FX SUPER GLIDE®

The Super Glide was the first Harley-Davidson motorcycle created for the custom market. We had big touring bikes and the nimble Sportster, but we didn't have a custom. I knew that riders wanted unique variations of our Big Twins so we gave them the Super Glide model.

It's extreme, and it was meant to be. The goal was to achieve a dragster look: big rear tire and big engine with a lighter, smaller-looking front fork wheel assembly. To get that look, we used the FL chassis from the fork neck rearward and the engine from our Big Twin. The lighter front end—front fork, wheel, and headlight—came from our Sportster.

To add to the dramatic presentation, I gave the seat, taillight, and rear section a strong, long appearance. The tank graphic is an extended version of the Bar & Shield. On top of the tank, there's a red, white, and blue logo of the number '1.' I designed this logo initially for a poster that celebrated a winning AMA championship and it became the inspiration for the bike's paint scheme.

The FX Super Glide was considered very extreme for its time, but it has become a significant part of our identity. The Super Glide would be the beginning of many FX custom Harley-Davidson motorcycles to come.

POWERTRAIN

Engine: 45-degree, overhead-valve V-Twin

Displacement: 74 cubic inches

Transmission: Four-speed, constant mesh, foot-shift

Primary drive: Duplex chain

Secondary drive: Chain

Brakes: Drum and shoe (front and rear)

Ignition: Battery and coil

CHASSIS

Frame: Steel, double downtube, cradle type

Suspension: Telescopic fork (front); swingarm with exposed hydraulic shocks (rear)

Wheelbase: 62.75 inches

Gas tank: 3.5 gallons

Oil: 1 gallon

Tires: 19 x 16 inches (front and rear)

Colors: Sparkling America (red, white, and blue)

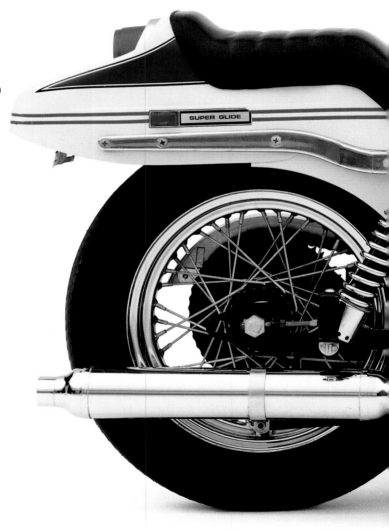

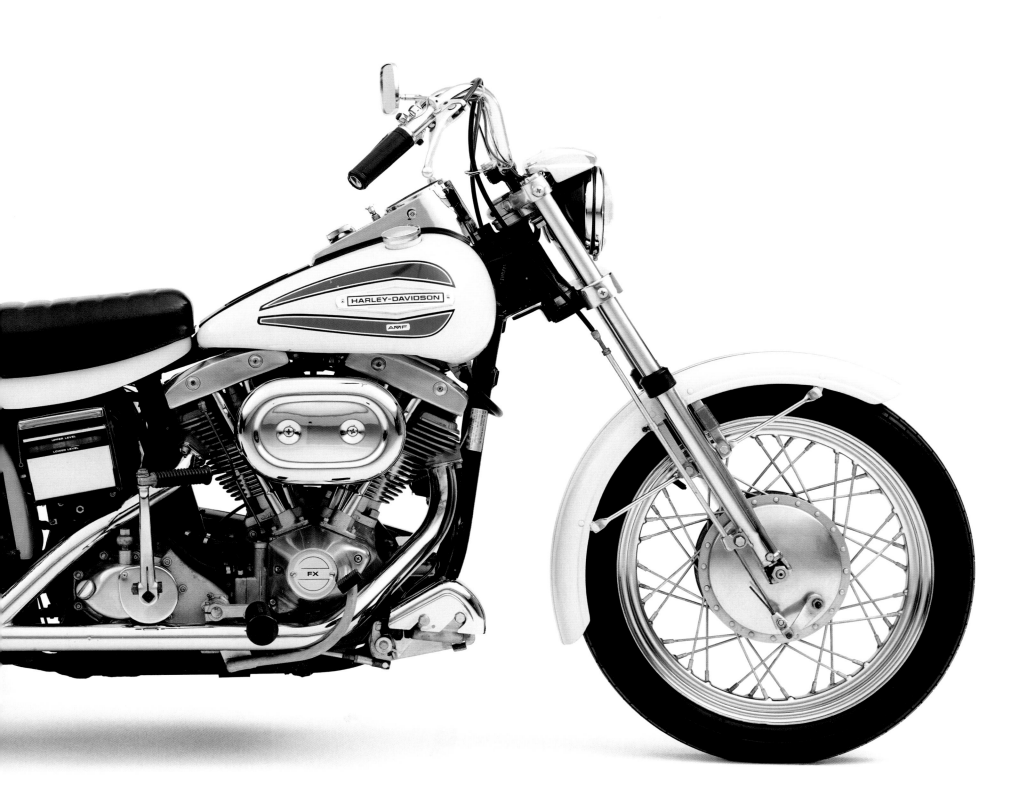

1972 | XR750

The all-alloy XR750 is a legendary racer that dominates the dirt track to this day. Dirt-track racing, especially on the one-mile track, is second to none for excitement. Great dirt-track riders like the Springsteens and the Parkers of the world are my heroes. Their racing fame started with this model, which has lasted through many iterations.

The XR750's performance originates in the alloy engine, developed under Dick O'Brien. Dick was the head of our racing department then. The advances he made in the engine design were significant. The lighter weight and better cooling of the aluminum alloy improved the engine's performance. The design of the combustion chamber and the valve angles also increased horsepower. While we have changed the XR750 somewhat over time, we've had thirty years of great racing from this motor.

The XR750 is a functional motorcycle—all business. You can compare its beauty to that of an 8-Valve. You see its performance characteristics in its minimal fuel tank, its very short fender, two carburetors with pronounced air cleaners, and its unique cylinders, heads, and rocker covers.

The relationship between the 750 and the Sportster shows up in the name: "X" for Sportster and "R" for racing. Like the Sportster, the XR750 combines power, weight, performance, and handling, but in a more extreme way.

On the XR750, I designed the tank using the classic Harley-Davidson orange and black with white trim. The character of this color scheme is reflected in today's 883R.

POWERTRAIN

Engine: 45-degree, overhead-valve V-Twin
Displacement: 750 cubic inches
Transmission: Four-speed, foot-shift
Primary drive: Triple-row chain
Secondary drive: Chain
Brakes: None
Ignition: Magneto

CHASSIS

Frame: Double downtube
Suspension: Telescopic forks (front); hydraulic shocks (rear)
Wheelbase: 56.25 inches
Weight: 295 pounds
Gas tank: 2.5 gallons
Oil: 3 quarts
Tires: 19 x 4 inches (front and rear)
Color: Jet Fire Orange

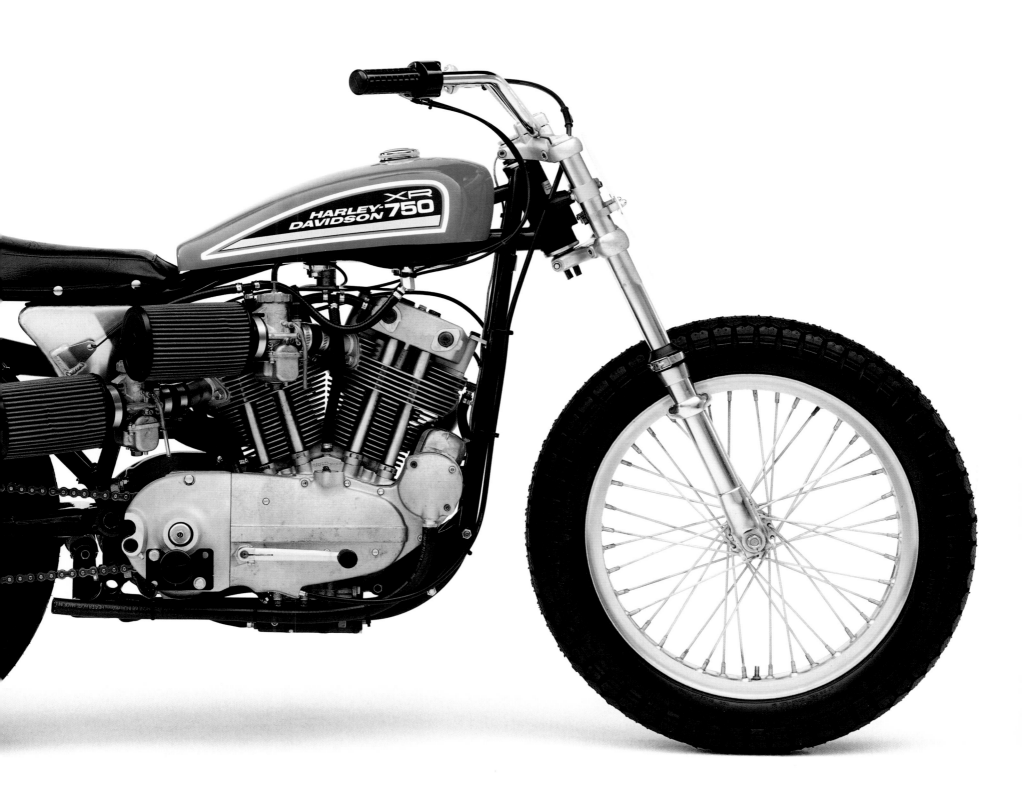

Racing

Racing motorcycles are stripped down to the bare essentials, and this equates to beautiful sculpture in my mind. Observing them in hot competition is sheer excitement. The sights, sounds, and smells are all part of the emotional experience of being at the races.

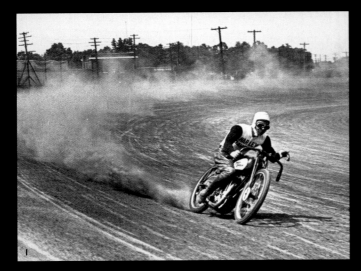

1

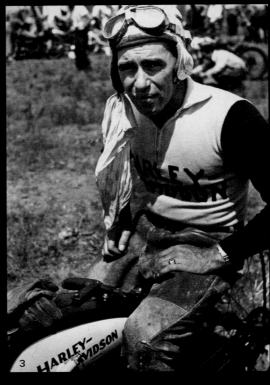

3

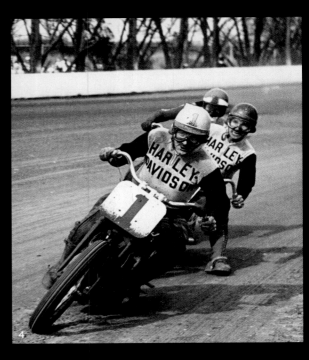

4

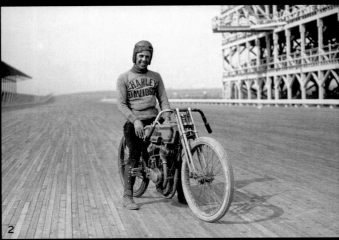

2

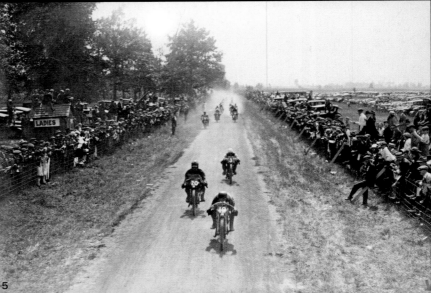

5

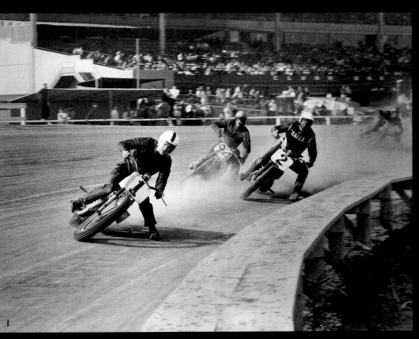

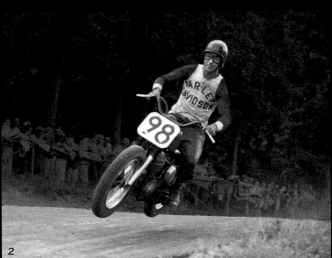

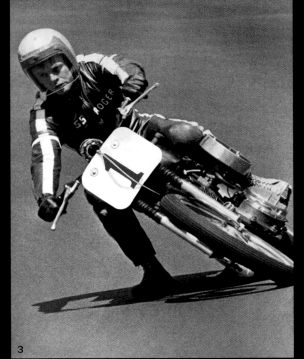

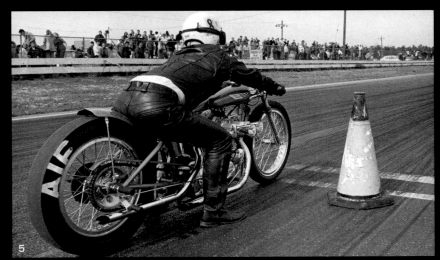

OPPOSITE PAGE
(1) Joe Petrali on the dirt track in 1937 (2) Portait on the board track
(3) A 1936 portrait of Joe Petrali (4) A 1948 dirt track race (5) An early-
twenties race.

There are many faces of racing today—road tracks, dirt tracks, and drag strips. My family and I have spent endless weekends enjoying this aspect of our sport, and the participants are truly heroes to me. Dirt track events are usually very close, tight races. Many times the final lap will have several riders approaching the finish line in a virtual dead heat.

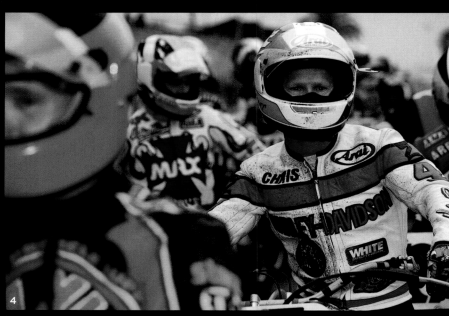

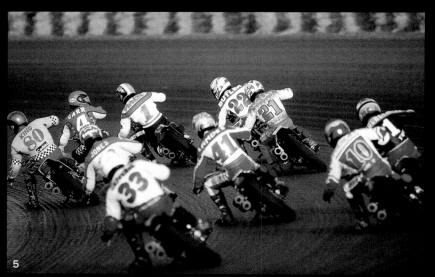

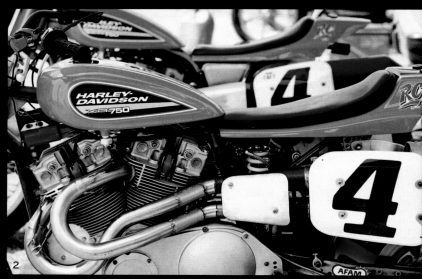

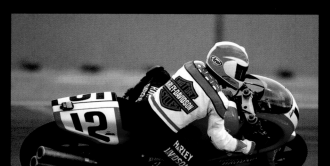

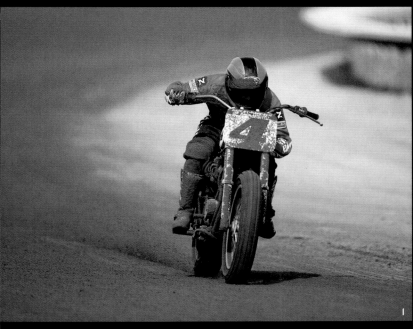

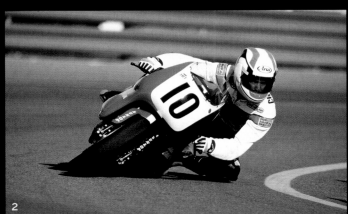

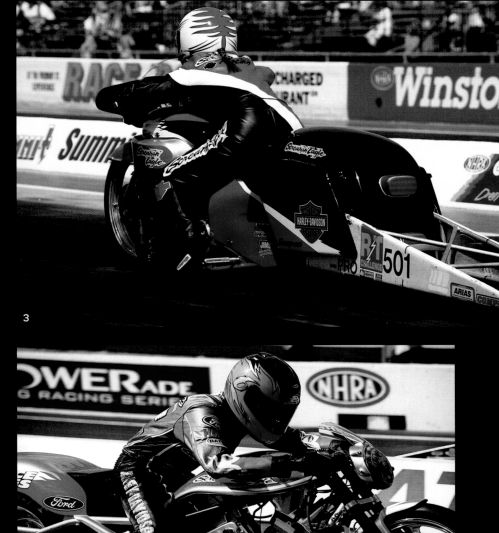

OPPOSITE PAGE
(1) Scott Parker with the Number 1 plate (2) A pair of XRs at the track
(3) Chris Carr on a VR1000 (4) Chris Carr at the starting line (5) Scott
Parker leads the pack.

THIS PAGE
(1) Chris Carr heads to the finish line (2) Racer Chris Chandler
leans into a turn (3) Former Harley-Davidson drag racer Lori Francis
(4) G.T. Tonglet, rider of the Screamin' Eagle/Vance & Hines NHRA
pro-stock bike.

1977 | XLCR CAFÉ RACER

The term "café racer" originated in England. These motorcycles looked like road racers, but were street legal. In 1974, I had an idea to build a Sportster motorcycle in a racerly mode. The Sportster bore the closest resemblance to performance vehicles like our famous XR dirt track racer. Although the engines differ in many ways, they're still cousins. The Café Racer has that stripped-down, lean and mean look of the XR, especially in the tail section.

I'm always looking for dramatic ways to pull these bikes together by adding finishes that do not appear to be too flamboyant. The Café Racer is entirely blacked-out, with the simple, gold-toned Bar & Shield on the fuel tank. We played with different finishes of black. We used wrinkle black on the gear cover and flat black on the exhaust system. The air cleaner uses gloss black.

The Café Racer featured cast alloy wheels, which was a first for us. We continued with a very tight-fitting, minimal front fender and short, drag-style bars. A small quarter-fairing surrounds the headlight and includes a dash panel around the speedometer and tachometer.

Though the style of the Café Racer was well received, I don't believe that the market was quite ready for it. However, the bike is now a highly collectible motorcycle with a strong cult following.

POWERTRAIN

Engine: 45-degree, overhead-valve V-Twin

Displacement: 61 cubic inches

Transmission: Four-speed, foot-shift

Primary drive: Triple-row chain

Secondary drive: Single-row chain

Brakes: Double-disc (front); single-disc (rear)

Ignition: Battery and coil

CHASSIS

Frame: Steel, double downtube

Suspension: Telescopic forks (front); box-selection swingarm and hydraulic shocks (rear)

Wheelbase: 58.5 inches

Gas tank: 3.75 gallons

Oil: 3 quarts

Tires: 19 x 18 inches (front and rear)

Color: Black on Black

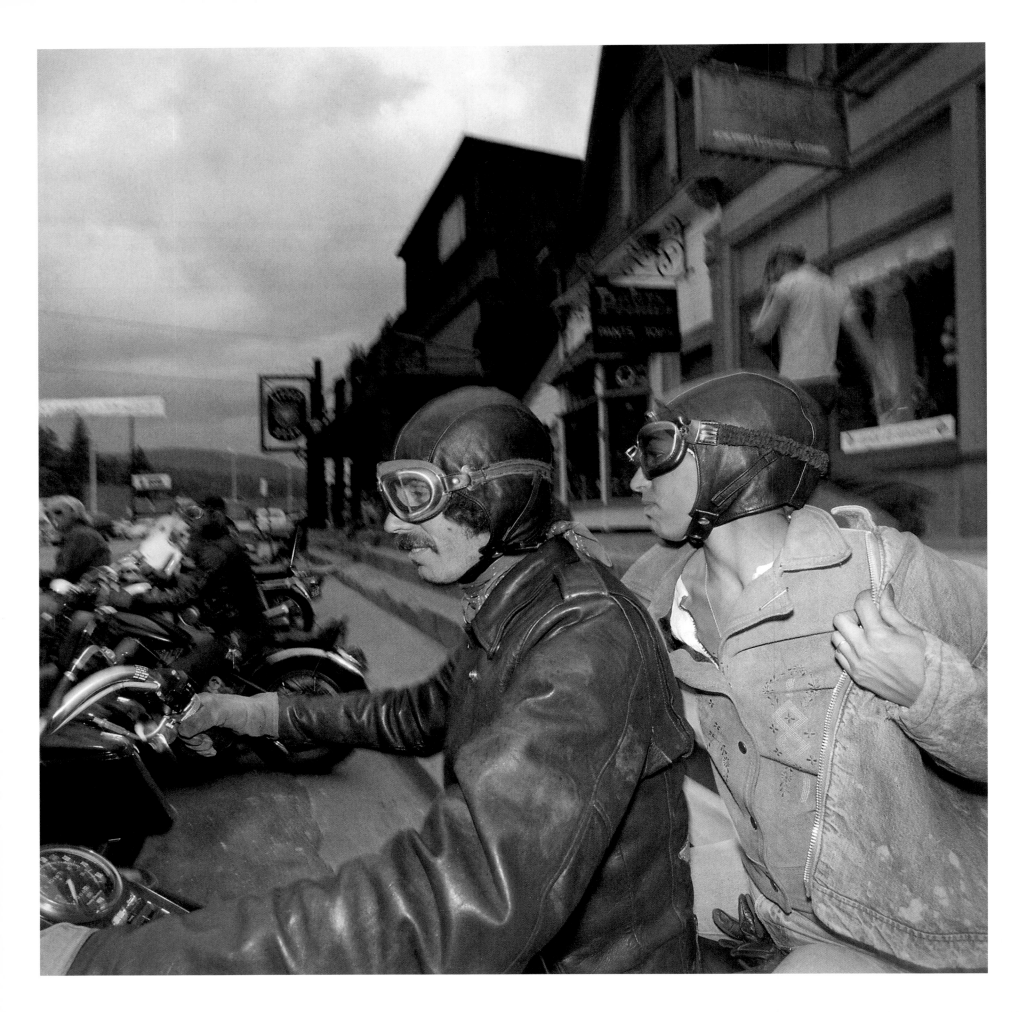

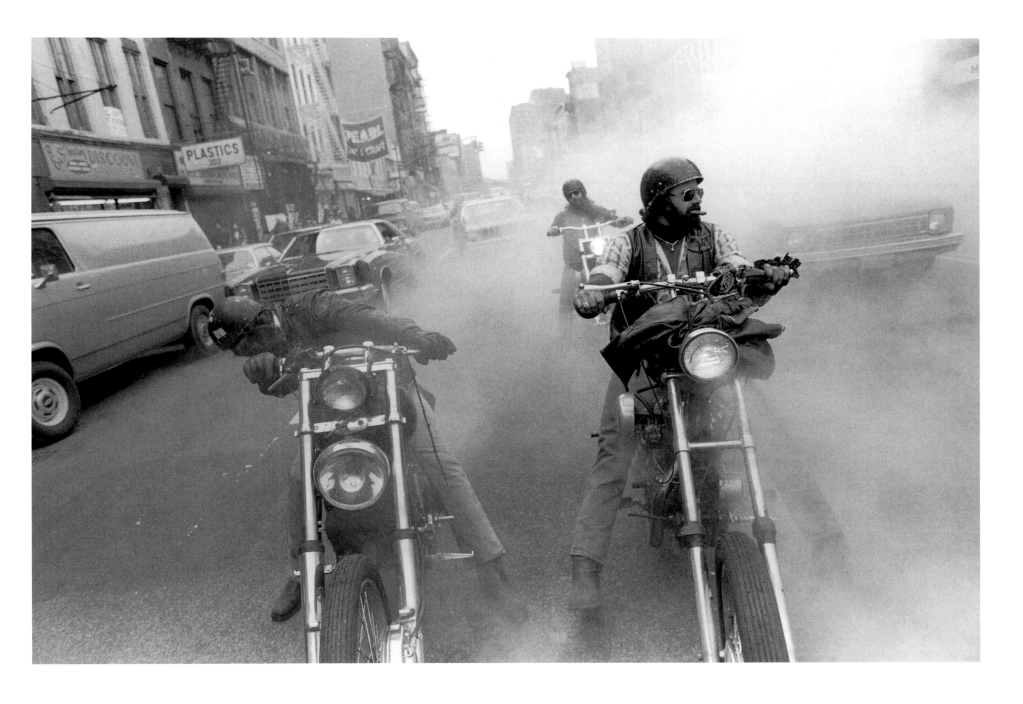

1980 | *Newlyweds "Sportster" John and Arlene in Evergreen, Colorado.*

1981 | *A New York City motorcycle club makes its way through city traffic.*

1981 | *Sunrise at a campsite outside Sturgis.*

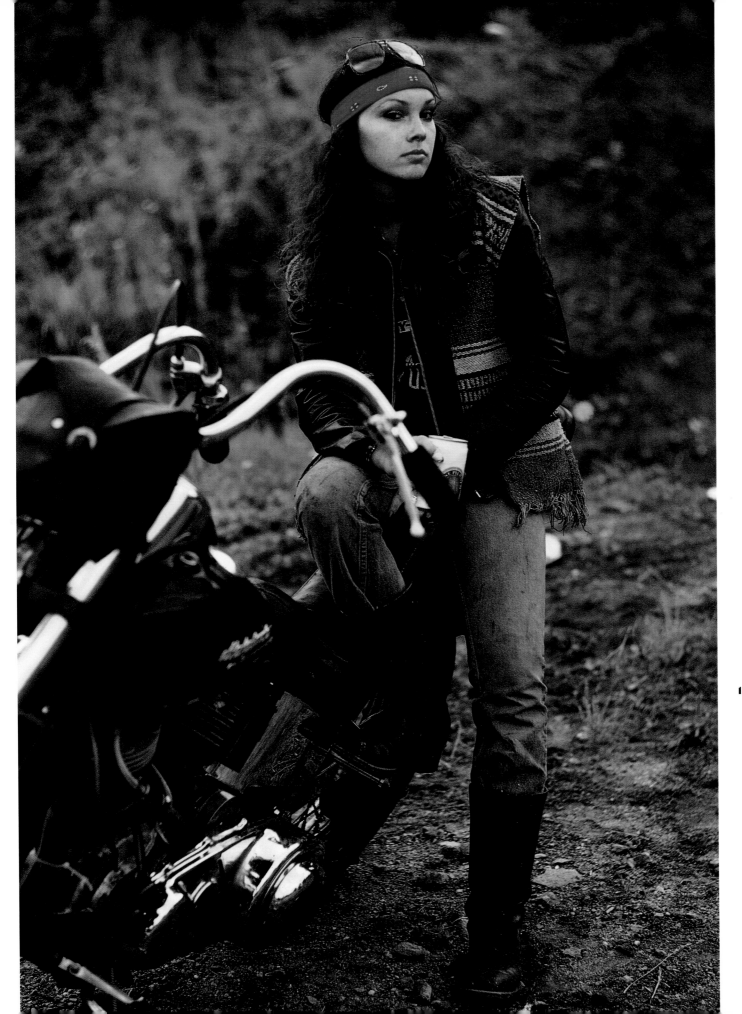

1982 | *End of the day, Sturgis.*

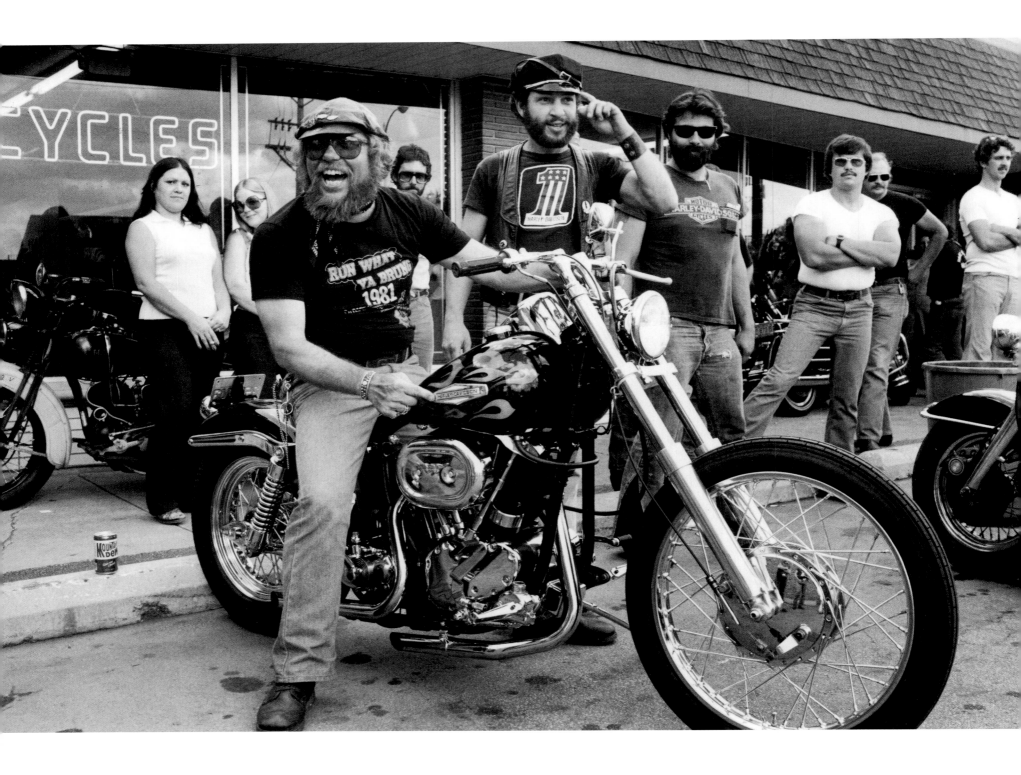

1981 | *Willie G. points excitedly at the Harley-Davidson logo on his gas tank during the Buy-Back ride, which celebrated the new ownership of the company.*

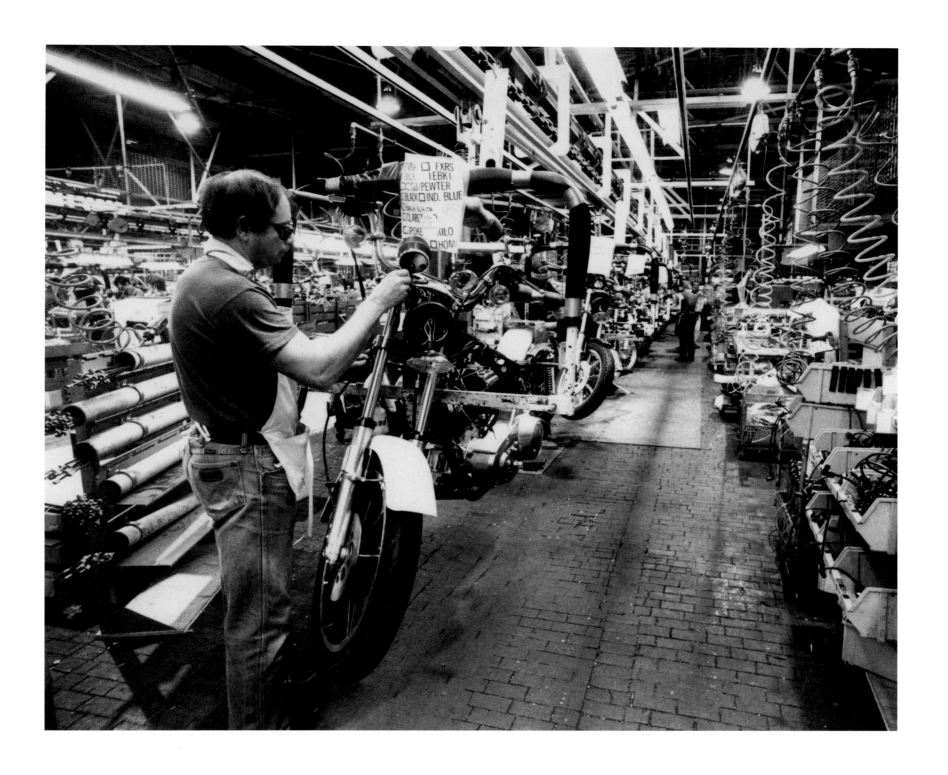

1983 Renewed energy and dedication marked the post-buyback
years at the York Final Assembly Plant.

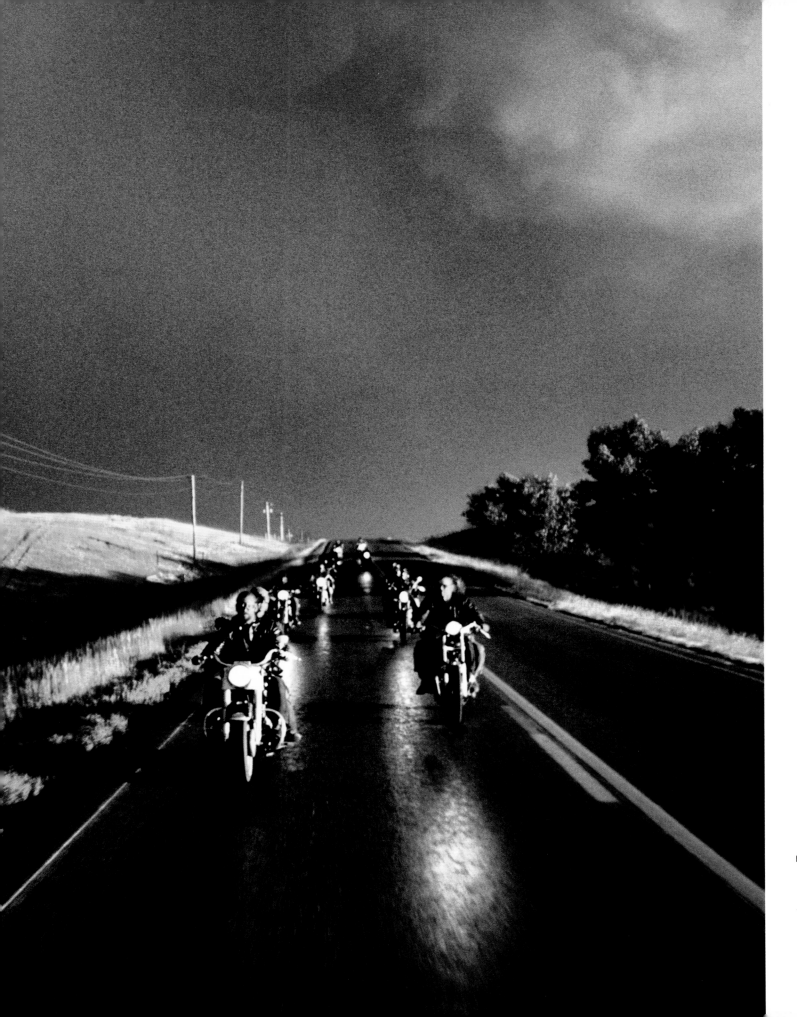

1980 | *Leaving Sturgis en route to the drag strip at Belle Fourche, South Dakota.*

1977 | **FXS LOW RIDER**®

The '77 Low Rider was a later iteration of the '71 Super Glide model—our first foray into the custom market. The Super Glide had an extravagant paint job and a pronounced, sculptural rear seating area (boat tail). You either loved it or hated it. The Low Rider had more popular appeal. It was a volume seller that established us in the custom market. If the Super Glide was the seed for Harley-Davidson customs, the Low Rider was the flower.

The Low Rider represented a milestone in the use of certain design elements, some of which are still active today. For the first time, we painted and highlighted the engine using a monochromatic paint scheme. We blacked out cylinder heads and highlighted the fins. We painted the rocker boxes, timer cover, and outer primary silver.

Note the bike's exhaust system—the way the rear cylinder exhaust swings forward, wraps around the timer cover, then joins the large collector-style muffler and gives it a performance look.

The low seat height—27 inches—was a significant change. When you sit low, you feel like you're wearing the motorcycle. The handlebars are an extension of your hands and the footpegs and rear brake lever are an extension of your feet. You're out in the open. How you feel and look on that bike is important to your sense of pleasure and confidence. The Low Rider is all about that. It not only looks good parked, it feels great on the road.

POWERTRAIN

Engine: 45-degree, overhead-valve V-Twin
Displacement: 74 cubic inches
Transmission: Four-speed, foot-shift
Primary drive: Double-row chain
Secondary drive: Single-row chain
Brakes: Double disc (front); single disc (rear)
Ignition: Battery and coil

CHASSIS

Frame: Double downtube
Suspension: Telescopic forks (front); swinging-arm and springs (rear)
Wheelbase: 58.5 inches
Gas tank: 3.5 gallons
Oil: 4.5 quarts
Tires: 19 x 16 inches (front and rear)
Color: Charcoal Silver Metallic

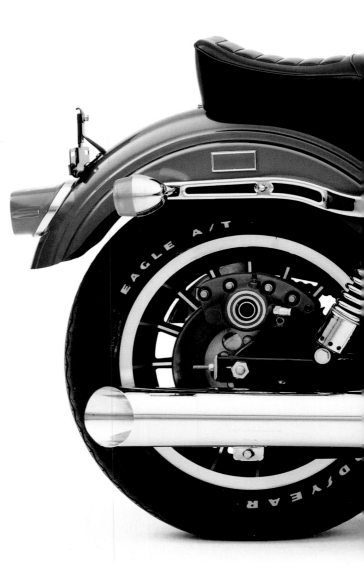

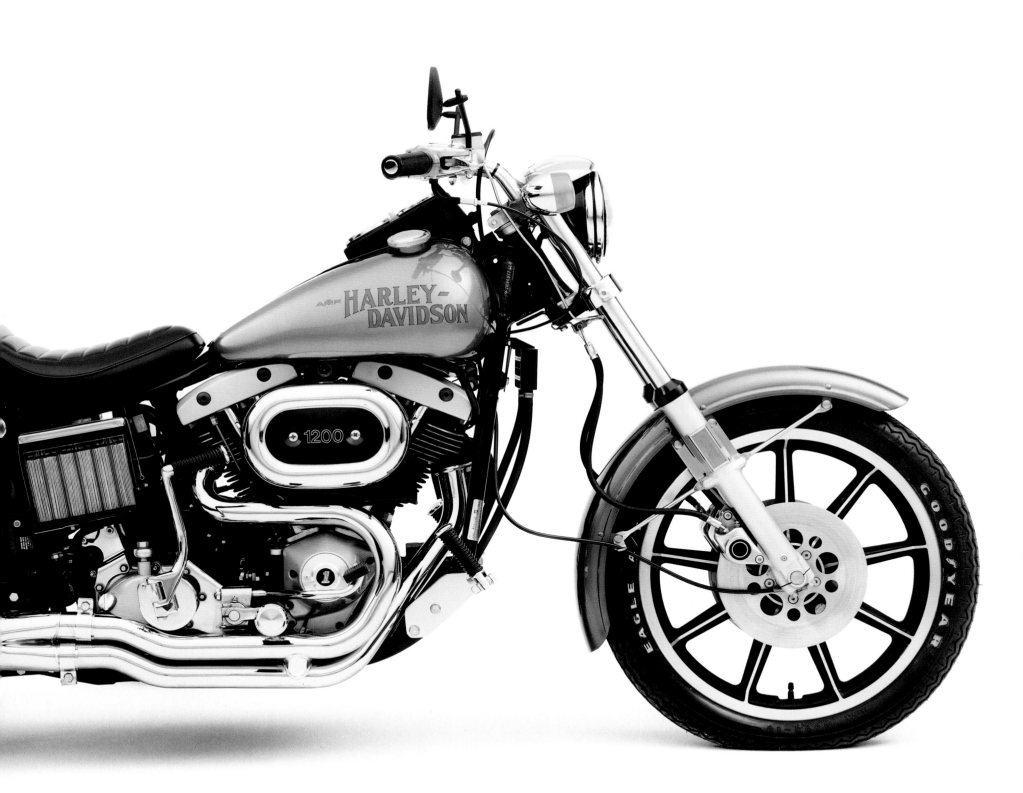

1980 | FXWG WIDE GLIDE®

The FXWG Wide Glide motorcycle was our answer to the classic chopper. "Wide Glide" refers to the distance between the fork legs. The bike uses a classic 21-inch front wheel. The color scheme—orange and black with white trim—is very recognizably Harley-Davidson and fondly referred to as the "flamed Wide Glide." It was the first of our motorcycle products to feature tank flames inspired by early motorcycles and hot rods.

The flame paint job was one of our most complicated production paint jobs. It took several masking operations to create the white outline and the flames themselves range from yellow to orange. The paint was applied wet on wet, which means that the flames were fogged, only adding to the challenge of achieving a high-quality paint job across high volume in a production environment.

Good-looking flames should have an interesting variation and flow in the pointed areas of the design. How the designer handles the thick and thin sections and the pockets is critical.

We designed these flames to surround and enhance our legendary Bar & Shield. The flames aren't overdone; they are concentrated for a dramatic, visual impact.

POWERTRAIN
Engine: 45-degree, overhead-valve V-Twin Shovelhead
Displacement: 80 cubic inches
Transmission: Four-speed, foot-shift
Primary drive: Double-row chain
Secondary drive: Chain
Brakes: Dual discs (front); single disc (rear)
Ignition: Electronic

CHASSIS
Frame: Double downtube
Suspension: Telescopic forks (front); hydraulic shocks (rear)
Wheelbase: 65 inches
Gas tank: 5 gallons
Oil: 4.5 quarts
Tires: 21 x 16 inches (front and rear)
Color: Black (with flames)

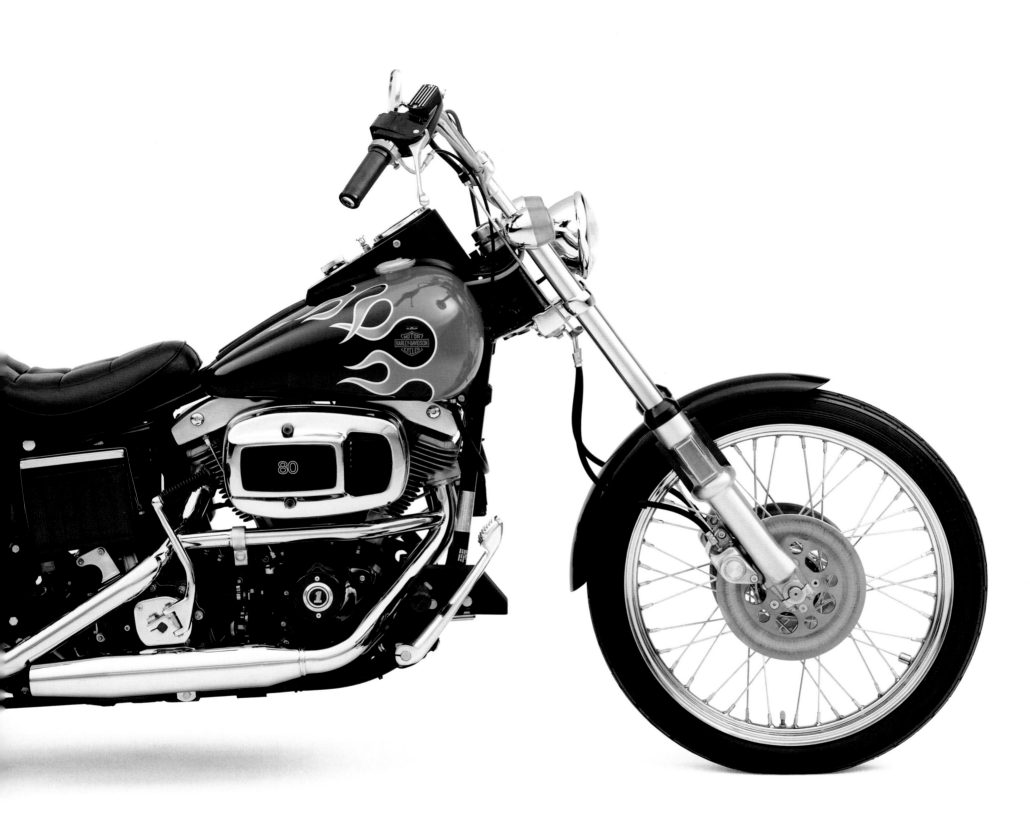

WE WERE A SMALL GROUP OF BELIEVERS

LOOKING TO RAISE ENOUGH MONEY TO

PULL OFF THE DEAL OF A LIFETIME:

A HIGHLY-LEVERAGED, HIGH-RISK BUYOUT OF A

COMPLEX MANUFACTURING COMPANY . . .

I HAVE TO SAY,

A LOT OF PEOPLE

thought we were nuts.

I T WAS FIVE YEARS AFTER HARLEY-DAVIDSON'S MERGER WITH AMF, and our sales still hadn't reached the levels that they'd envisioned, so they weren't allocating a lot of capital for new motorcycle development.

My challenge was to take existing hardware, making the most of available parts, and freshen our product line with new colors, trim, and imagery.

AMF was seeking a rapid return on its huge investment in the York facility and was pushing for record numbers of vehicles to be built and shipped. Unfortunately, evidence was mounting that this corporate-wide emphasis on numbers, and the need to continually drive them higher, was having a negative impact on product quality. Contrary to popular belief, not every one of our motorcycles of the AMF era was of shoddy quality, but the truth remains that many of the bikes we shipped were ones we wish we'd held on to a little while longer.

Our long-standing closeness to customers was diminishing in an effort to make the numbers, and it was becoming painfully obvious that we had a big problem on our hands. Instead of all those great conversations I was used to enjoying at Daytona or Sturgis or other rallies, I was hearing more and more about problems that people were having with their bikes.

Former Augusta, Georgia, dealer Vic Crenshaw escorts Willie G. on the ride out of town during the 75th Anniversary Executive Ride in 1978.

Judging by the letters we received, we were jeopardizing our customers' hard-won loyalty. Though the letters would start out conveying frustrations about the product, I noticed that they always ended with statements like, "We love the company and we're going to

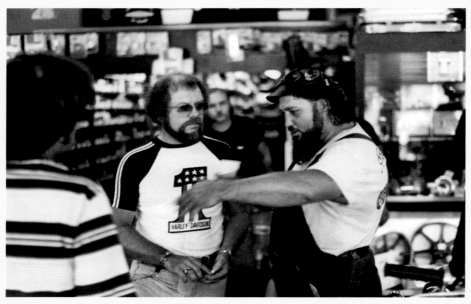

Willie G. listens to product comments during a stop at a dealership on the 75th Anniversary Executive Ride in 1978.

stick with you." You could feel that the person was going to do his or her best to support us. I'll always be thankful to all the riders who did this.

Rather than dwelling on the negatives, we came up with ways to redouble our efforts. Unlike our competitors, we didn't have vaults full of cash to advertise and promote. And even if we had, that approach probably wouldn't have worked, because our riders eventually would have seen through the smokescreen.

For our 75th anniversary in 1978, we organized a series of cross-country group rides, each led by a different member of the management team. We saw it as a way to get out on the road, reconnect with customers and dealers, and have some fun. This idea was driven, in large part, by the group executive of the motorcycle products division, Vaughn Beals, who would become one of the most celebrated figures in our history. Vaughn was pushing hard to get the leadership team out of the office and onto our motorcycles.

Although this wasn't a huge marketing initiative and we didn't draw anywhere near the kinds of crowds

and media coverage such rides do today, several of our dealers planned local events, and groups of riders joined our processions when we rode through their towns. We shook a lot of hands and made new friends wherever we stopped. And we did a lot of listening.

By the time all of the ride routes converged in Louisville for the AMA National Dirt Track Championship Race, our leadership had gotten excited. The conversations with dealers and customers were revelations for those who didn't regularly get out and ride.

With the ride instilling a stronger connection to customers, our improvement efforts took on greater meaning. Vaughn was pushing to get quality back on track. Also, extensive changes in engine and chassis engineering were on the drawing boards, spearheaded by a talented man named Jeff Bleustein, our current CEO.

Vaughn was the kind of leader who commanded your attention. In addition to being a good engineer, he was a true believer. He realized that Harley-Davidson was a gem and was frustrated that we were falling off AMF's radar. He couldn't fathom how a company with our heritage and mystique could be of minimal interest to its parent company. AMF had started out with the expectation that we would become another General Motors, but since we weren't producing that level of profits, they were losing confidence. But there was so much potential.

As the seventies wound down, we were dealt a few very bad hands. The headlines announced an economic recession and interest rates rose into the mid-teens, so discretionary income diminished. Suddenly, fewer people were buying motorcycles, ours or anyone else's.

The market was evaporating. With everything else we were going through, we didn't need this. Resources became even scarcer, and employee morale was at an all-time low.

To make matters worse from a financial standpoint, the environmental movement generated extensive emissions regulations. For motor-vehicle manufacturers, this meant large capital investments for new equipment. This was a rude awakening for AMF. They found that mass-producing motorcycles was a capital-intensive enterprise.

Although Harley-Davidson had many supporters within the AMF ranks, some folks started seeing us as a losing proposition that would never generate the profits they were after. They started taking a hard look at what it would take to get us into fighting shape, both financially and competitively. Those who saw us purely from a profit-and-loss standpoint missed the whole emotional side to Harley-Davidson. AMF put us on the block in 1980. I don't know whether they ever realized that our brand, our relationship with riders and dealer organizations, and the styling—function and emotion—of our motorcycles are what make us so strong. These are truly the reasons why we're around today.

It wasn't exactly a seller's market for a U.S. motorcycle manufacturer whose prime competition came from Japan. And our company required a large amount of capital investment. Not surprisingly, the same factors

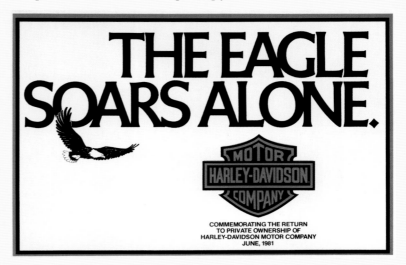

that prompted AMF to sell us turned off potential buyers. Months were passing, the market was sliding deeper, and I couldn't help but feel that if things didn't turn around for us soon, we were in real danger of extinction.

Then, on an afternoon for which I'll forever remain grateful, Vaughn pulled together a meeting. He had come up with the idea of a small group of company leaders buying Harley-Davidson from AMF. He had explored the possibility and the risks involved. This was not an easy sell, but his enthusiasm was infectious. He got us excited about the idea, but each individual had to make a decision based on financial considerations and how the decision might affect his family.

"The Eagle Soars Alone." was the slogan the Motor Company adopted to spread the word about its freedom from corporate parent AMF.

Far left: Harley-Davidson celebrated its independence from AMF in 1981 with a "Buy-Back" ride.

The Buy-Back team completes the deal on June 16, 1981 (standing from left): John Hamilton, Dr. Jeffrey Bleustein, Kurt Woerpel, Christopher Sartalis, and William G. Davidson; (seated from left): James Paterson, Timothy Hoelter, David Lickerman, Peter Profumo, David Caruso, Ralph Swenson, Charles Thompson, and Vaughn Beals.

Thirteen of us decided we wanted in, at various levels of financial commitment. We were a small group of believers looking to raise enough money to pull off the deal of a lifetime: a highly leveraged, high-risk buyout of a complex manufacturing company. On a dollars-and-cents level, we had to face the fact that we might be putting ourselves and our families at risk. I have to say, a lot of people thought we were nuts.

In the winter of 1980–81, with thick legal documents flying back and forth, the proposal fully in motion, and loan contracts being drafted, I went to Nancy and the children and said, "I'm about to take on a major risk. Here's my opportunity, and I am going to take it. There are no guarantees it will work, but I

have faith in Harley-Davidson." It was an emotional moment for me. But for me to do anything other than support this venture just wouldn't have been true to my mind and heart. From every perspective, both past and future, this event had great significance to my family. The loves of my life understood this and gave me their support.

On February 27, 1981, the pending buyback deal was announced. This was an extraordinary time. One of the most memorable events in my life was the ride from York to Daytona that year, on an olive-green 1981 Electra Glide. I borrowed its unusual retro paint scheme from a 1936 model. There was a lot of fringe on the oversize bags, which I refer to as "Big Bertha" bags. I

was at York preparing for the ride when I heard the news that we had achieved the buyback. Before leaving, I took some black tape and crossed out the AMF logo on my fuel tank. When I arrived in Daytona, I parked by

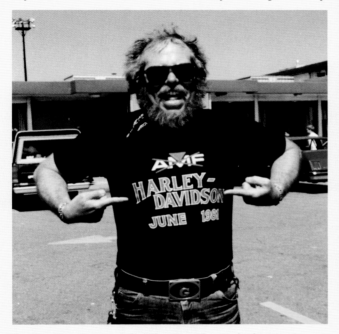

the landmark Boothill Saloon, at the end of Main Street. Riders were wishing us good luck and offering lots of thumbs-up signs. I was elated that Harley-Davidson was going to be back in the hands of enthusiasts. We had done the right thing.

On June 16, 1981, the thirteen of us sat down with lawyers in York, Pennsylvania and signed reams of paper. This was the real deal, and now it was a very done deal. We had a final signing ceremony outside on a platform. Employees celebrated with us, and word spread quickly throughout the motorcycling world that Harley-Davidson now belonged to

Harley-Davidson. If we'd learned anything from our 75th Anniversary Ride, it was that there was only one real way to celebrate our independence. And you know what that is.

Mounting commemorative bikes that I'd embellished with some special trim and striping, we headed back to Milwaukee, making stops at dealerships along the way. We were met with a lot of support. At a dealership in Pittsburgh, an employee climbed the dealership sign and painted "AMF" off. The shirts we wore were printed with a slogan that captured the spirit of the moment beautifully: "The Eagle Soars Alone."

There were question marks ahead of us, but for now we were happy to be out riding motorcycles. Our motorcycles. We were free again.

A Harley-Davidson dealer employee spray paints black over the AMF logo on a dealership sign in 1981.

Far left: Willie G. sports a T-shirt that commemorates Harley-Davidson's newly independent status in 1981.

1980 | FXB STURGIS

I have a lot of passion for this model, which is a variation on the original Low Rider. In the late seventies, the company was at a deciding point on the belt drive. Going from a chain to a belt drive would be a major change. (The belt is on the left side of the motorcycle, not seen here.) Sometimes you need to take these styling changes out to the public to get feedback. So I rode one of the first belt prototypes to Sturgis.

You have time to think when you're on the highway, riding cross-country. On my ride home from the rally, I was thinking about how we would style this bike. When we stopped at a wayside, I said to myself, 'We should do a blacked-out bike with some very subtle orange highlights and name it the Sturgis.' So I pulled a paper bag out of a trash can and wrote down some thoughts: an all-black air cleaner, engine, cylinder heads, rocker covers, blacked-out wheels, and, of course, all-black sheet metal on the fenders and tank. Orange would be used sparingly on the wheels and on the Bar & Shield on the fuel tank. Here and there we would add little pieces of chrome. The bike should have drag-style handlebars and a unique pouch on the back with lacing to give it a handmade look. The "Number 1" logo could be used on the timer.

We went on to build this bike, which is a collectible now. I still have that paper bag in my personal collection.

POWERTRAIN

Engine: 45-degree, overhead-valve V-Twin Shovelhead
Displacement: 80 cubic inches
Transmission: Four-speed, foot-shift
Primary drive: Belt
Secondary drive: Belt
Brakes: Dual discs (front); single disc (rear)
Ignition: Electronic

CHASSIS

Frame: Double downtube
Suspension: Telescopic forks (front); hydraulic shocks (rear)
Wheelbase: 63.5 inches
Gas tank: 3.5 gallons
Oil: 4.5 quarts
Tires: 19 x 16 inches (front and rear)
Color: Black

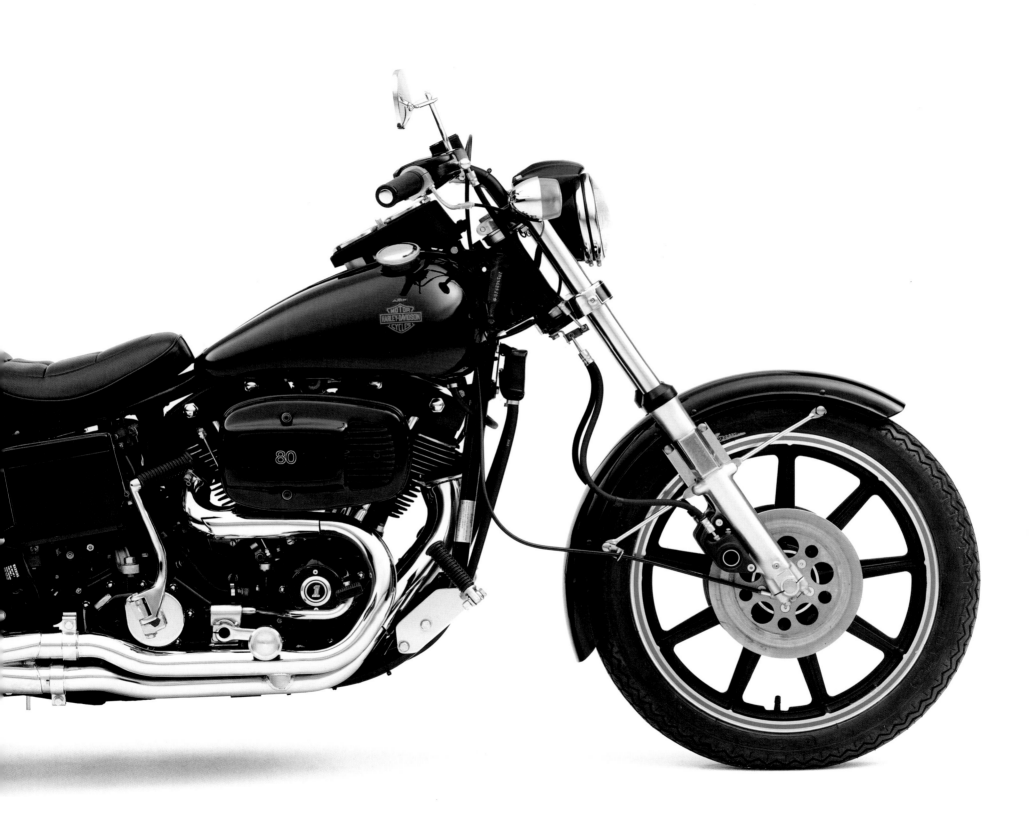

TO BE ABLE TO GET TOGETHER

WITH OUR CUSTOMERS,

HAVE A BLAST

RIDING OUR BIKES,

AND KNOW THAT BY DOING SO

WE'RE HELPING OTHERS,

IS A

GREAT PLACE TO BE.

THE 85TH, 90TH, AND 95TH ANNIVERSARY RIDES HAVE BEEN SOME of my, and my family's, most memorable experiences. The festivities kicked off with parties on the coasts, and from there, several rides made their way home to Milwaukee for the birthday celebrations. We invited enthusiasts to join us along the way.

My family's starting point has always been on the West Coast, and we've taken many memorable cross-country rides just getting out there.

Once we're on the official company rides, we set certain mileage requirements to meet each day. We stop in cities to meet with press and media, and we attended local parties and auctions. We also did a lot of storytelling—sharing of the day's road experiences, whether you were riding in sunshine, rain, or wind, and what you observed along the way.

It's easy to make friends on these rides, because you're all participating in the same activity. Conversation flows easily. Of course, everyone's excitement grew as we neared Milwaukee. The group changed as we rode, shrinking or growing based on personal schedules. Some rode for a short way, while others opted to join us for the whole distance.

And there was a big parade to look forward to when we arrived in Milwaukee, with the freeway closed for the event. All lanes were jammed with thousands of Harley-Davidson motorcycles, six across, in staggered formation—for miles.

The sides of the freeway, all the overpasses, and the sidewalks lining the city's main street were packed with cheering spectators. Many were holding handmade signs saying WELCOME HOME, waving American flags, and sharing thumbs-ups signs with the riders, who looked like heroes returning from some far-off victory. Numerous riders wore Harley Owners Group (H.O.G.) chapter patches on their vests, with Harley-

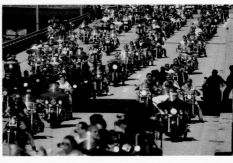

Loyal Harley-Davidson riders jam the freeway entering Milwaukee for the 90th Anniversary celebration in 1993.

Davidson pendants and American flags jury-rigged to the backs of their bikes. The license plates were from all over the United States, and some bikes were even shipped here from overseas. Vanity plates had all kinds of clever, creative names.

Television helicopters hovered overhead, and

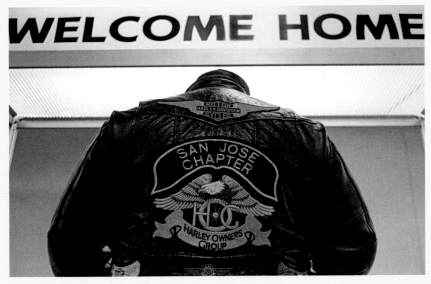

A Harley Owners Group (H.O.G.) member from the San Jose chapter checks in at a local event.

cameras were everywhere. The enormity of the event and the outpouring of warmth from the crowd overcame many of the riders. Sometimes you saw a few tears sliding from under sunglasses. Many riders commented on the fact that emotions welled up during the parade. Everyone was affected, even the most grizzled, well-traveled attendees.

Tens of thousands of motorcycles were parked in endless rows at the city's beautiful festival grounds on the shores of Lake Michigan. There, riders spent the entire day being entertained by top-name performers and motorcycle drill-and-stunt teams, feasting on food

and world-famous Milwaukee beer, participating in charity auctions for Harley-Davidson memorabilia and collectibles, shopping in massive dealer and vendor tents, checking out rare motorcycles from our collection, and generally having the time of their lives. Many riders broke away in the afternoon to tour Harley-Davidson manufacturing facilities or take demo rides on our newest models, returning for the evening festivities.

Everything built up to the final night, when everyone joined thousands of Harley-Davidson employees, the company's leaders, children afflicted with muscular dystrophy, and celebrity emcees in singing "Happy Birthday." It was a remarkable feeling to be onstage there with my family. I'm always excited and a little nervous at this point, recognizing the responsibility. It's tough to express my feelings to the enthusiasts in a few short sentences and accentuate the importance of the moment.

What sticks out in my mind is how anxious people were to talk afterward. It's always intense, which reinforces how vital these people are to the company's folklore. It comes from a unique quality of loyalty in our motorcycle family.

Events like this happen only in Harley-Davidson's hometown of Milwaukee. The city leaders, business owners, residents, and, of course, our employees and local dealers roll out the red carpet anytime we invite the family home to celebrate with us. The hospitality is a key component of the sharing that goes on. Everybody has a good time, riders and non-riders alike.

Some of the greatest emotional highs I've ever ex-

perienced have come from these kinds of events, helping lead the rides along with Nancy, my family, and members of our leadership team, and sharing stories with customers. Such events are monumental undertakings, saved for special occasions. They give all of us the opportunity to participate in an experience that shows the world what we're about.

We rarely need a reason to ride. As soon as some free time presents itself, we're up on two wheels. Most Harley riders are adventurous people. We just want to get out on our bikes, alone or with friends, escape from reality for a while, explore, and have fun—plain and simple. But when the call goes out for a group ride, local H.O.G. chapter rides, parades, or dealer-sponsored rides, it's about camaraderie and shared passion.

Group rides always have a planned destination and some sort of gathering awaiting their arrival. When you hear people describe owning and riding a Harley-Davidson motorcycle as a "lifestyle experience," this is a big part of what they're talking about. The riding, along with this social element, make for an unforgettable combination.

Over the years, I've participated in numerous rides from Milwaukee to Daytona or Sturgis, cross-country anniversary rides and H.O.G.-sponsored rides, and countless parade runs through the towns that have hosted H.O.G. events. Whether there are 500 bikes or 50, I've loved them all.

Many of the company-sponsored rides are fund-raisers for the Muscular Dystrophy Association, a cause that is close to our hearts at Harley-Davidson. To be able to get together with our customers, have a blast riding our bikes, and know that in doing so we're helping others, is a great place to be. Over the last 20 years, these rides have helped the Harley-Davidson family raise nearly $40 million for the fight against neuromuscular diseases.

From very early on, whenever Harley-Davidson employees and customers have gotten together to ride, we've had a special time. These fund-raising rides have been a fairly recent addition to our heritage. But the benefits to us, our customers, and those less fortunate can't be measured. Relationships with family and friends are basic elements of our lives that I treasure. Harley-Davidson brings people together and hopefully adds another dimension to their lives.

I've had a lot of riders come up to me and say that since they purchased their Harley-Davidson motorcycle and got involved, their lives have changed for the better. They always have something positive to look back on or something on their calendar to look forward to. They've discovered how significant it is to get out and have fun with friends, and to make new ones. If you travel 1,000 miles with a group of riders, you're almost certain to establish some bonds—and you'll hear from them again, whether it's a note or a

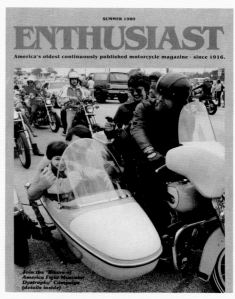

The summer 1980 Enthusiast *cover details Harley-Davidson's involvement with the Muscular Dystrophy Association. Willie G. and Nancy are shown here with former MDA National Poster Child Rocky Arizzio.*

Far left: The Harley-Davidson 95th Anniversary celebration was held at Milwaukee's Summerfest Grounds in 1998.

phone call or a big hug at some distant rally.

As mentioned earlier, our first noteworthy anniversary ride occurred in 1978, to mark our 75th year. This was during our time under AMF. Vaughn Beals championed the idea of our leadership team getting out and riding with dealers and customers, so we organized a series of cross-country rides, each led by members of the management team, culminating at the AMA National Championship race in Louisville, Kentucky.

We had to plan our rides in the same flexible way customer groups planned theirs. We might be riding in the rain some days, arriving late on others, and changing plans midstream. We also learned quickly that events of this magnitude require a tremendous amount of planning and logistics. We relied on our own common sense as riders and the expertise of road captains to show us the way. Event planning has become a critical part of what we do at Harley-Davidson. The people who run H.O.G., those who are involved in planning birthday celebrations, and many more have a huge assignment, and they do it well.

While modest by today's standards, our executive-led 75th Anniversary ride held some of the atmosphere that is common now. Dealers were actively involved in events at our ride stops, where we'd have a little party and the chance to talk with our riders. I remember what an eye-opener it was for some of the AMF management, especially those who were new to the motorcycle business, to see customers asking me to autograph their motorcycles. One of them said he couldn't imagine someone asking to have his car signed by a representative of the manufacturer. Prior to this ride, many of these folks didn't realize the strength of our riders' loyalty and how symbolic our heritage was to them.

I think the most valuable discovery that management made on this ride was the importance of being accessible to our customers, to listen to them, and participate in the sport the same way they do. In this way, we would create an emotional connection, allowing our customers to express their loyalty to our products. This wasn't news to me, since I'd been out riding with customers and visiting with dealers my whole life. It became obvious that we should be doing more of it, and slowly but surely, these rides became a part of our culture.

After our management-led buyout from AMF in 1981, we celebrated our independence with a group ride from York, Pennsylvania, back to Milwaukee, with numerous dealer stops along the way. Soon after that, I started leading Muscular Dystrophy Association fundraising pledge rides to Daytona each March. We were making a more concerted effort to stay involved with our riders.

Times were still challenging. The buyback team was in deep debt, and the company was suffering from an economic downturn. We were in creative survival mode, in need of ideas that would accentuate our value. Here was this terrific community of riders who shared our passion for Harley-Davidson motorcycles. We thought, "What better way to tell our story than by riding?" So in

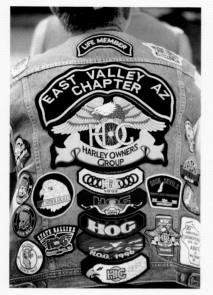

1983 we formed a company-spon-sored riding club, the Harley Owners Group.

We started H.O.G. as a way to bring people into the riding experience, but nobody could have predicted that it would grow the way it has. From around 30,000 members in its first year, H.O.G. ranks have swelled to over 640,000 members in 115 countries, with 1,200 chapters around the world.

Every weekend, all over the world, H.O.G. members are gathering somewhere and having an awesome time, whether it's a group ride to a local state park, or a weekend-long state rally, or maybe one of the club's mega-national or international events.

Nearly every Harley-Davidson dealership world-wide sponsors a local H.O.G. chapter, which meets anywhere from once a month to once a week. The meetings are often at the dealerships, which have always been popular local hangouts. As a part of their affiliation with H.O.G., many dealers have built special meeting rooms for their chapters. The focus is on having fun. H.O.G. chapter-event calendars are filled with rides, rider training, maintenance seminars, and parties. And nearly every chapter sponsors fund-raising events for local causes, such as the MDA. Because club members frequent their sponsoring dealership, dealers and their personnel naturally develop stronger relationships with their local customers, and vice versa.

To me, the real beauty of H.O.G. is in the riders, who have made it what it is today. Although the H.O.G. staff in Milwaukee provides guidance and training, local chapters and state events, which can attract thousands of riders, are entirely volunteer-run. A lot of people put a lot of time and effort into H.O.G.

Harley owners can now choose among hundreds of company, dealer-sponsored, H.O.G.-sponsored, or private club events at the local, regional, national, and even international levels. And that's in addition to the classic rallies like Sturgis, Daytona, and Laconia. The size and scale of many of these events has increased dramatically over the years. But at their most basic level, they reflect the same passion that brought our riders, dealers, and company leaders together in the earliest days.

I recall being in the 95th Anniversary parade through Milwaukee. As the procession went down Wisconsin Avenue, I could hear the roar of the engines echoing off the buildings and all the cheering people. I was in awe.

Patches cover the back of this H.O.G. member's riding jacket. They mark everything from events attended to the length of H.O.G. membership.

Below: Founded in conjunction with the birth of H.O.G. in 1983, H.O.G. Tales magazine is devoted to chapter members and their activities around the world.

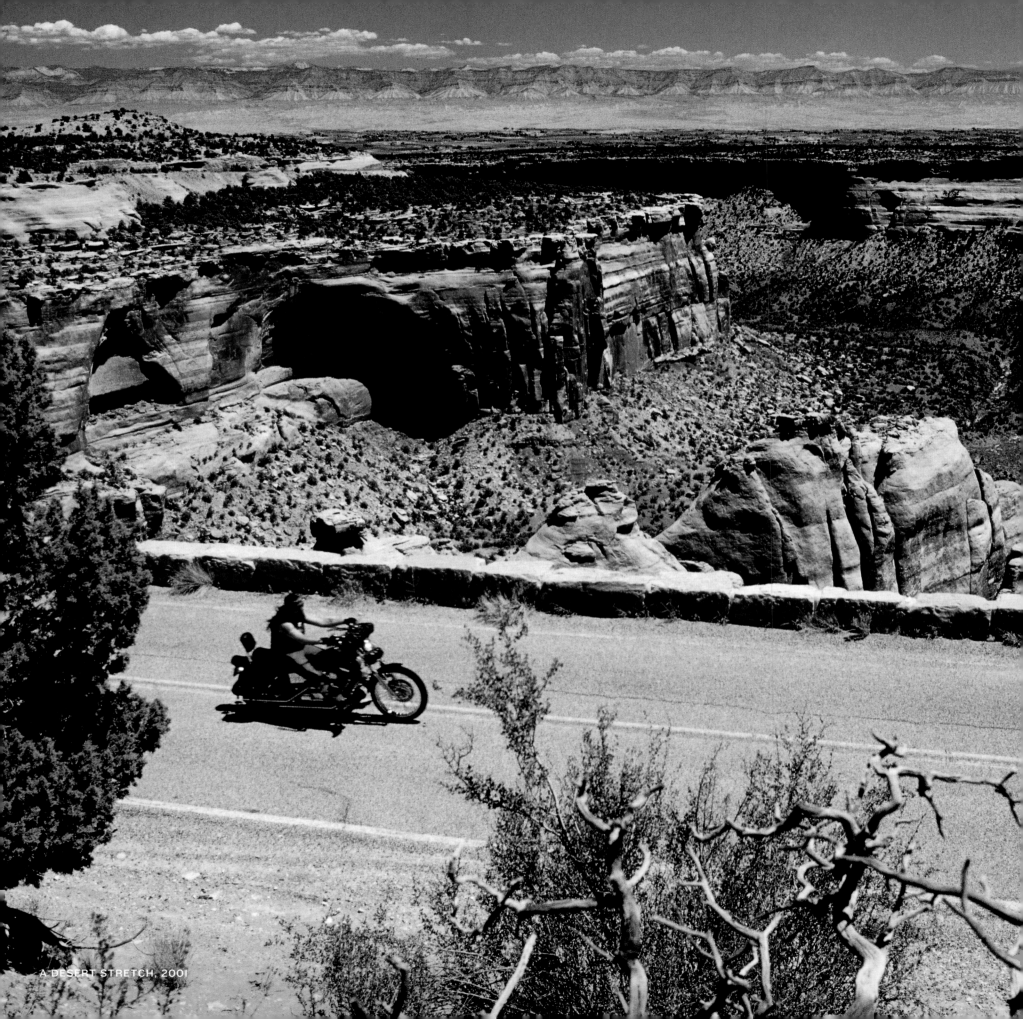

A DESERT STRETCH, 2001

1984

RISING TO THE CHALLENGE

2003

THE RESPONSE WAS

IMMEDIATE AND POSITIVE.

EVERYTHING ABOUT THE SOFTAIL JUST SEEMED TO WORK.

THERE'S NOTHING LIKE

HITTING A HOME RUN

WHEN YOU

REALLY NEED ONE.

W

HEN IT COMES TO DESIGN, EVERYONE'S FAMILIAR with the phrase "Form follows function." But at Harley-Davidson, we've realized over the years that to continue engaging our

customers and attracting new ones, form must follow *emotion* as well as function. We know that the shapes and forms we use, and their familiarity, can ultimately determine how successful a new vehicle will be. We could build a motorcycle that meets all performance criteria in an efficient way, but if it lacks the magic of proportion and style, and if it doesn't have the right rider-to-vehicle-to-ground relationship, the market won't accept it.

In recent years, this "American Look"—which is industry lingo for "the Harley-Davidson Look"—has taken center stage with the U.S. cruising-motorcycle community. Many of the shapes and forms we and our customers hold dear have been copied or slightly modified by other manufacturers. While we're somewhat flattered by the attention, I can't help but wonder how exciting it would be if these same manufacturers expanded upon their own traditional looks to evoke emotional responses from their riders.

A chopped Harley-Davidson hardtail motorcycle from the forties or fifties is representative of why our Softail line has been such a huge success. Hardtails are a vital part of our history: they are just plain beautiful— the rawest of the raw when it comes to pure custom motorcycles. They represent an era of customization and personalization when less was more.

Look at a hardtail frame and the first thing you notice is the spare profile. There's nothing beyond what is absolutely necessary. There's no rear suspension, so the frame is extremely low, which gives it the side profile that so perfectly lends itself to customization. The top frame forms a continuous line from the fork pivot to the rear axle. The rear fender is mounted close to the tire. The early years of customization saw hand-shift bikes modified, a suicide clutch, an open primary, high bars and

The 1957 FLH model marked the end of the hardtail (no rear suspension) era. The Duo Glide was introduced in 1958 with a suspension system located under the seat.

Just released. The Harley-Davidson Bad Boy.

shotgun pipes added. It is a piece of art, a wholly American look with raw mechanical appeal.

But anyone who's ever been on an early hardtail will tell you that it's not the most comfortable ride. I've always said that you don't really ride a hardtail, you wear it. That rough tail section bounces over bumps in the pavement without allowing the bike to absorb the shock. Roll over a wet match and you feel it. The only cure for the harshness was to compensate for the tail section with seat suspension. For the chopper crowd, the lower the better, which usually meant a wafer-thin seat mounted to the frame. There was a spartan look about these choppers that added to their appeal.

I'd always loved the idea of hardtails but couldn't reconcile the lack of rider comfort. So I figured their days were long gone. But out of the blue one day, in the midst of some of our roughest times in the late seventies, a rider who would change all that came into our Milwaukee headquarters. Bill Davis, a knowledgeable craftsperson and designer with a passion for motorcycling, said he had something to show us.

Bill showed us a motorcycle that resembled a hardtail, but its modified frame had suspension hidden under the seat—it was a suspended motorcycle with the look of an old hardtail. Unfortunately, we were so

involved with trying to keep Harley-Davidson afloat, and so heavily entrenched in the Evolution motor project, that we didn't have the resources to jump into a new chassis. The idea went dormant but never disappeared from our consciousness.

A few years later, just after our buyback from AMF when we were mired in our darkest hours, we knew we were in need of a home run to kick-start our market again. Jeff Bleustein (who was at that time head of engineering) said, "Hey, Willie, let's get Bill Davis back in here and look at that frame again," and the internal interest snowballed from there. He and Vaughn Beals, himself an engineer, saw great potential in it and were very supportive. We met with Bill several times, and eventually the styling department mocked up a modified version of his idea, putting the spring shock combination underneath the transmission, so that it was completely invisible. Soon we found ourselves developing our hardtail-look chassis in concert with the Evolution engine, so the timing couldn't have been better. Bill became a trusted partner we would work with for many, many years.

In 1984, we stepped up to the plate, introduced our FXST Softail, and surprised everyone. Up front was a classic 21-inch laced front wheel married to a minimal fender and an increased rake angle that gave the motorcycle a long look. Its bobbed rear fender exposed more of the laced rear wheel than traditional fenders. The minimal hardtail-like frame, staggered dual exhaust, and the 1340cc Evolution engine created an extremely handsome look that combined history with an inventive platform. That platform enabled us to introduce

many iterations of the Softail platform over the years. It also had a lot to do with our ability to keep our doors open in the eighties. The response was immediate and positive. Everything about the Softail just seemed to work. There's nothing like hitting a home run when you really need one.

Although we were pleased with the success of the launch, we weren't entirely surprised by it. The Evolution motor, with its belt drive, lit a fire under the market and signaled our return to competitiveness. Blending the hardtail look into the Softail worked so well for us because it was perfectly natural. The challenge was to design exciting iterations on the Softail platform.

We followed the first Softail model with the FLST Heritage Softail, incorporating the hardtail look with an FL-style motorcycle, clearly reminiscent of our 1949 Hydra-Glide. With its telescopic front forks and full FL-style fender over the 16-inch laced front wheel, plus floorboards instead of pegs, it was a near dead ringer for the classic fifties-era hardtails and an immediate success. Two years later, we added a black-and-chrome powertrain, two-tone paint scheme, windshield, passing lamps, studded leather saddlebags, and passenger seat and backrest, and christened it the FLSTC, the Heritage Softail Classic—a bike that was as much at home cruising the boulevard as it was touring the freeway. The proportions were right; all the parts fit together perfectly.

IT'S SPRING TIME, AGAIN.

THE NEW SPRINGER SOFTAIL. HISTORIC STYLE. MODERN-DAY RIDE.

We marked the next year, 1988, our 85th anniversary, with another modification on the Softail, this time focusing almost exclusively on the front end. The FXSTS Springer Softail paid homage to our Springer front ends, which largely disappeared from our product line in 1948. Recreating the look of the exposed chrome springs and forks while staying true to the original form was itself a huge task. But to do so while also providing comfortable levels of front-end suspension required engineering expertise. As you're going down the road on a Springer, there's a lot of visual excitement going on. The front leg and the front springs are moving up and down relative to road surface. It's "kinetically" exciting to watch the chrome motion reflected in the head-lamp shell. It really defines the bike and is part of the reason why Springers have long been favorites of customizers.

There are certain trigger points that motorcycle designers zero in on. For example, the wheels can have maximum styling impact. Think of the visual effect you

This 1989 poster features the new FXSTS Springer Softail in front of its grandparent, an early Springer model.

Far left: The Spring 1986 Enthusiast *introduced the* FLST Heritage Softail *by referencing the new model's styling connection to the* 1949 Hydra-Glide *(inset).*

can create on a motorcycle by going all the way from laced, traditional wheels to solid cast-disc wheels. That's an instant, night-to-day change without altering your chassis or sheet metal. Then change the trim, seat, and exhaust system and paint and accessorize the entire package and you've created a fresh look.

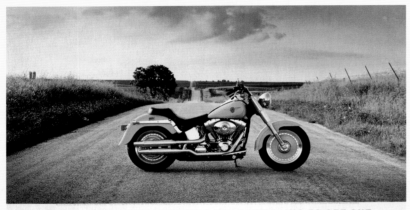

INSIDE EVERY MAN THERE'S A FAT BOY TRYING TO GET OUT.

It's you, all right. A Fat Boy. Or a Sportster or Wide Glide or Road King. Chromed steel and perfect paint and when you hit the starter it takes you into the wind where it's all good. Well, don't let too much more life slip by before you let it out. In this model, view you miss is time you don't get back. 1-800-443-2153 or www.harley-davidson.com. **The Legend Rolls On.**

Now plug yourself in to our design department back at the end of the eighties. We were working on a Softail model for our 1990 product line that would incorporate disc wheels, an FL front end with a minimal front fender, and a monochromatic silver paint scheme. As it came together, I felt that it needed something to increase its potency—color accents. When it comes to creating impact, few colors are as powerful as yellow, so we added some to our trim pieces like the derby and timer covers, instrument panel, rocker box spacers, and tank graphic. With these simple touches, we gave the model some extra character.

I rode the bike to Daytona, and its look was well received. In August 1989, we introduced a motorcycle that would eventually become one of our best-selling models of the nineties, the FLSTF Fat Boy.

You're probably wondering how we came up with a name like "Fat Boy," and I've heard a lot of tales about this, nearly all of which are untrue. Here's the real story: it's tough to come up with names that will be popular on the street, given the number of products our customers have nicknamed over the years (Knucklehead, Panhead, Shovelhead, hardtail—you get the idea). We always have to ask ourselves, "What's the street going to name this?" and work from there. We were looking for something unusual and maybe even a little irreverent, because there's something sort of cool about poking fun at your products from time to time. To me, and to a lot of other insiders who'd seen it, the bike had a massive "fat" look. So the folks in marketing came up with the name "Fat Boy"—and the street picked it up.

Another Softail iteration came in our 1997 model-year lineup with the FLSTS Heritage Softail Springer, a vehicle that takes our Springer theme to a completely different level. While the FXSTS Springer replicates the front end of early choppers, the Heritage Springer is reminiscent of our 1948 FL. It has a laced 16-inch front wheel mated to an all-new fender that replicates the '48 model; a massive, chromed springer front end; crossover dual fishtail exhaust, passing lamps, fringed bags and seat, a tombstone taillight, and a chrome passenger grab rail. Even the horn cover was designed to match the '48 model. In designing this bike, we wanted to make a statement. It has so many intricate visual details that riding it is like having your own parade.

For those riders who prefer a simpler, clean-looking vehicle, we created the FXSTB Night Train, introduced in 1999. We've always liked monochromatic, low-contrast, minimalist motorcycles because they look so tight. The black-on-black look is at once subtle and severe. We used different types of black—wrinkle, flat, and gloss—to give the vehicle texture and degrees of reflection and to create visual interest.

We know only too well that not everybody likes blacked-out motorcycles. There is a basic philosophy behind product design that we follow when broadening the line—there is no such thing as a motorcycle for everybody. Controversy, in my mind, is positive. Without it, you would have a bland product line. No one would want to talk about the changes. I think all of our product designs should generate some degree of debate—it's healthy.

As we began planning for the 2000 model year, we took a hard look at the Softail line. By now, the Softail had been in the lineup for well over a dozen years, so it made sense to review the various pieces of hardware with an eye toward reinvigoration. But questions always surfaced: "How much change is too much, and is this the right time to do it?" With the pending introduction of the dual counterbalanced Twin Cam 88B engine, the timing part of the equation seemed logical. "How much" posed our greatest challenge, but we were eager to push the envelope.

From front to back, our new-generation Softail was going to get a complete makeover, without sacrificing our traditional look. We updated the front end with bottle-shaped chrome lower-fork legs; hid the fasteners

The Harley-Davidson styling team astride a 1984 FXST Softail: (from left to right) Dan Matre, Gene Ikeler, Willie G. Davidson, Louie Netz, and Vern Hunt.

that mounted the front fender; resculpted the triple trees; and added a stunning stretched fuel tank with a chrome instrument panel. Out back, we added a seventeen-inch solid-disc rear wheel with a 160 rear tire. We used a minimal new fender with sculpturally clean fender supports and a simple frenched taillight. Bottom line? We dramatically changed the image of our original Softail, and the 2000 FXSTD Softail Deuce was one of the best-received vehicle introductions ever. The media called it the most handsome Softail vehicle we'd ever created, and the model won several awards from major motorcycle magazines.

We're entering our 100th year of business with seven models in our Softail platform, and each of them has a unique character. They all stem from the original. I'm proud of these significant iterations. My design team is always working on the "next" vehicle, and they're the best damn design team in the industry. My partner Louie Netz and I have a small group of dedicated, highly creative enthusiasts who challenge one another and explore future products. I know that we'll continue to surprise our riders.

1984 | FXST SOFTAIL®

This model marks a very significant milestone. As a trend-setting custom, the 1984 Softail model introduced two major features: the Evolution engine and the new Softail frame. The frame is unique in that visually it has the simple straight lines of a classic hardtail.

Yet through its pivoting rear section, the frame allows for hidden rear wheel suspension—the rear shocks are underneath the transmission. This structure has allowed us to have the flexibility to create many Softail iterations, each with its own distinct look.

Coupled with the contemporary styling version of the hardtail were a horseshoe wraparound oil tank, the bob tail rear fender, a deep pocket seat, and 21-inch front wheel. The tank identity is our most important symbol: the Bar & Shield.

When I think back to the timing of this model (we were struggling new owners), and its impact on the market, I realize how critical this great new engine and chassis were to our survival. The Softail line has been a perennial best-seller for us and a favorite among motorcyclists. It successfully blends the past with current technology and appeals to Harley riders everywhere. It was a modern bike with roots in our heritage.

POWERTRAIN
Engine: 45-degree, overhead-valve V-Twin Evolution®
Displacement: 80 cubic inches
Transmission: Five-speed foot-shift
Primary drive: Double-row chain
Secondary drive: Chain
Brakes: Single disc (front and rear)
Ignition: Electronic

CHASSIS
Frame: Double downtube
Suspension: Telescopic forks (front); horizontal
 gas-charged shocks (rear)
Wheelbase: 66.3 inches
Gas tank: 5 gallons
Oil: 3 quarts
Tires: 21 x 16 inches (front and rear)
Colors: Vivid Black; Candy Red

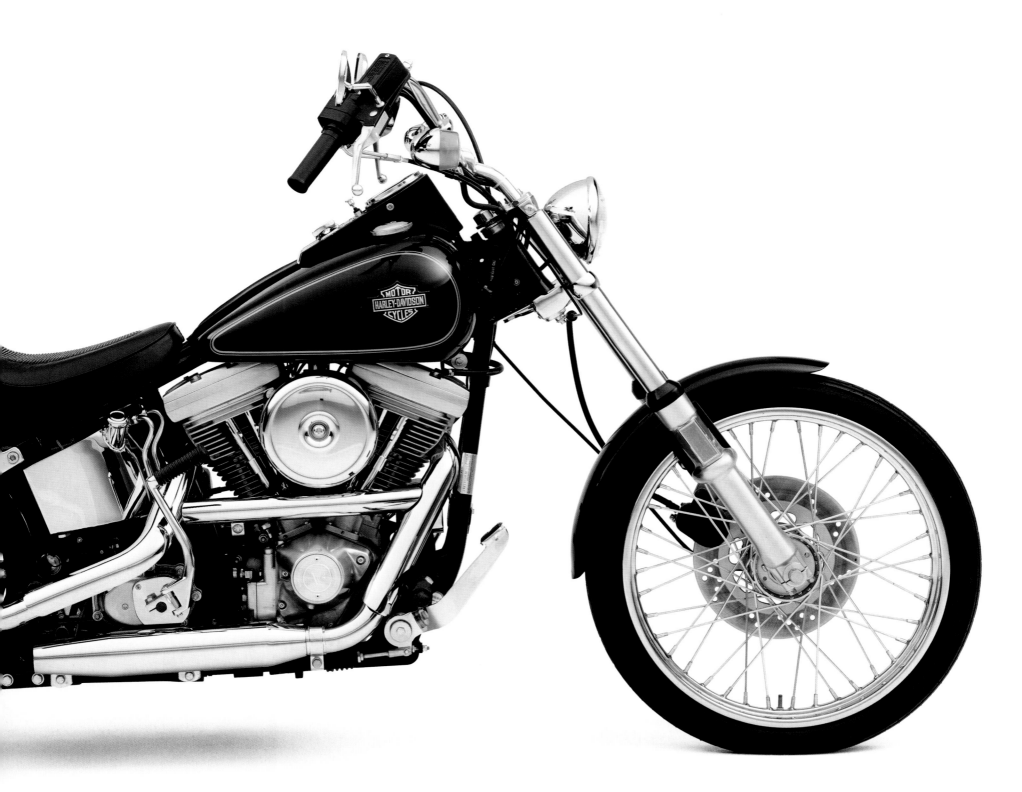

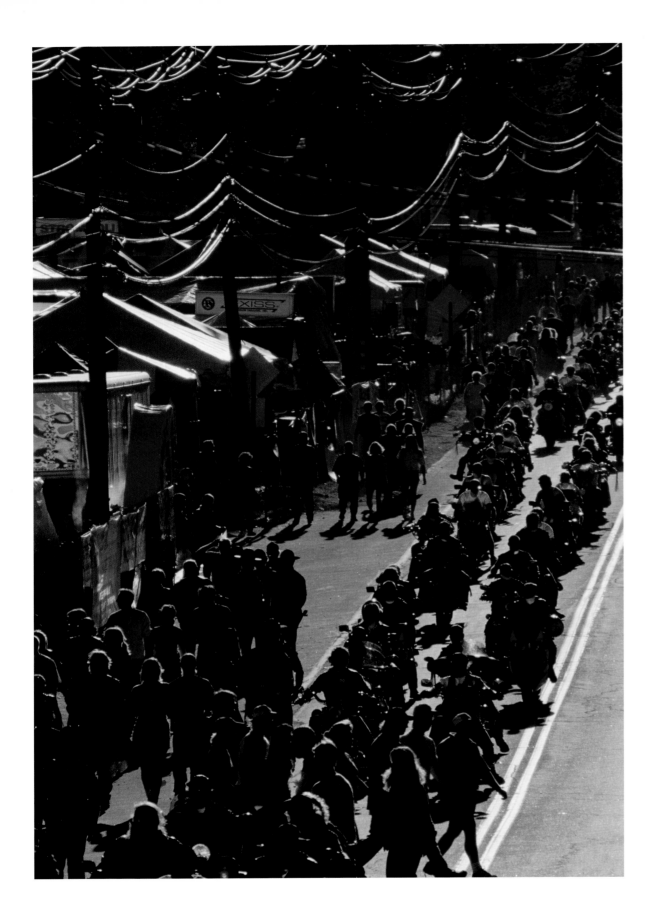

1997 | *The faithful at an annual gathering in Laconia,*
New Hampshire.

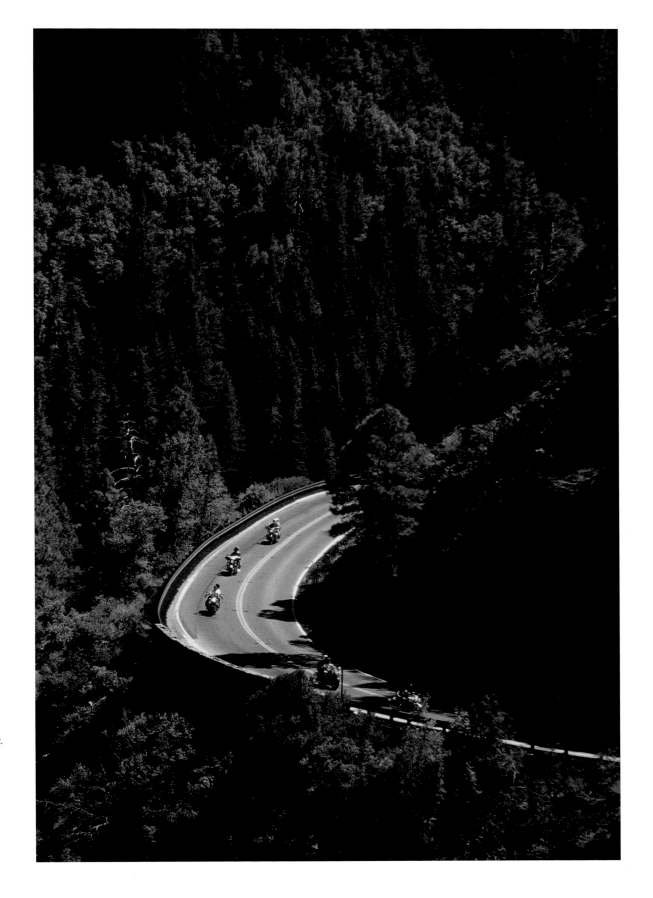

1996 | *This stretch of the ride winds through Flagstaff, Arizona.*

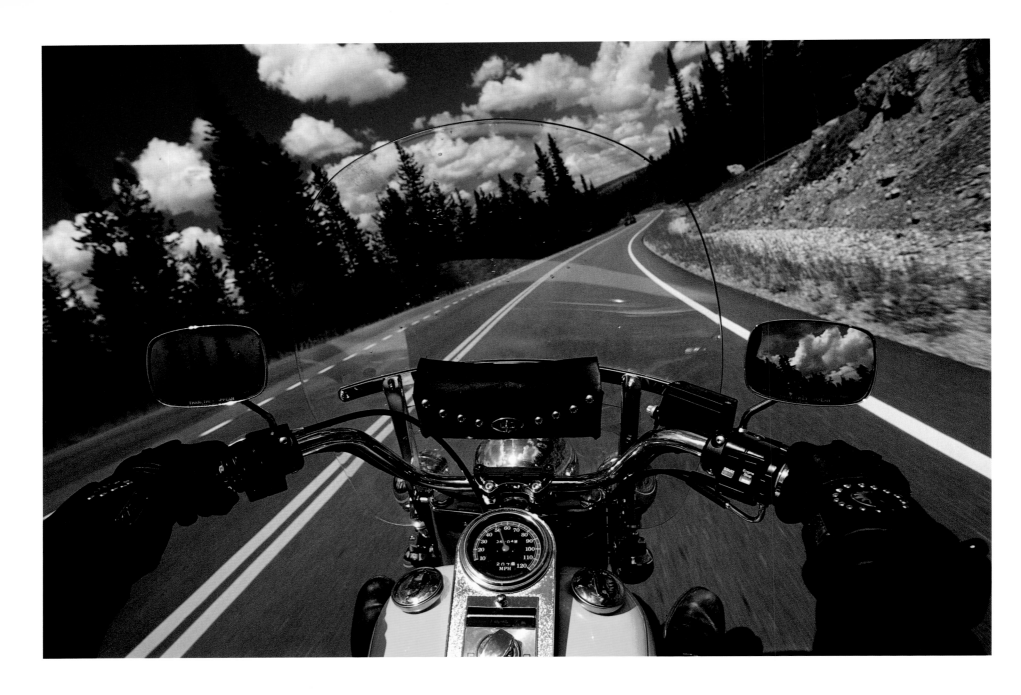

1990 | *Nothing compares with the road ahead, seen over the console of a Harley-Davidson motorcycle.*

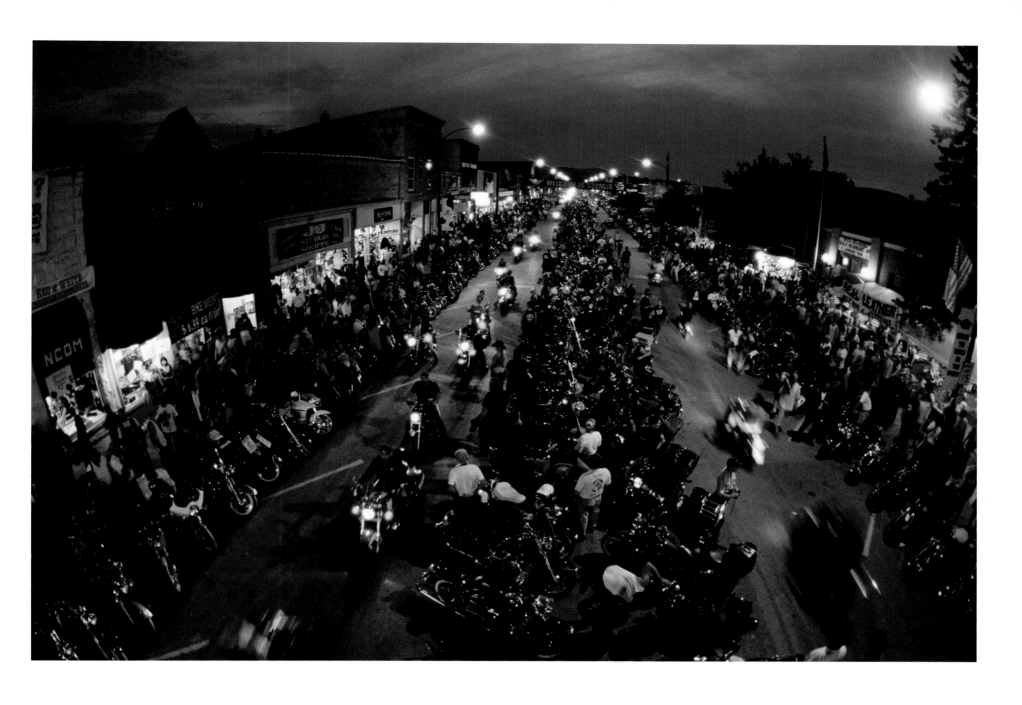

1998 | *There's barely enough room to admire all the bikes parked along Main Street during Bike Week at Sturgis.*

1984 | *Enthusiasts find many ways to express their passion for the brand.*

1994 | *A trio of German riders compare their tattoos at a rally in Spain.*

1993 | *During the 90th Anniversary celebrations in Milwaukee, enthusiasts from all over the world showed off their ride and rally patches.*

1992 | *Harley-Davidson patches make an unique statement.*

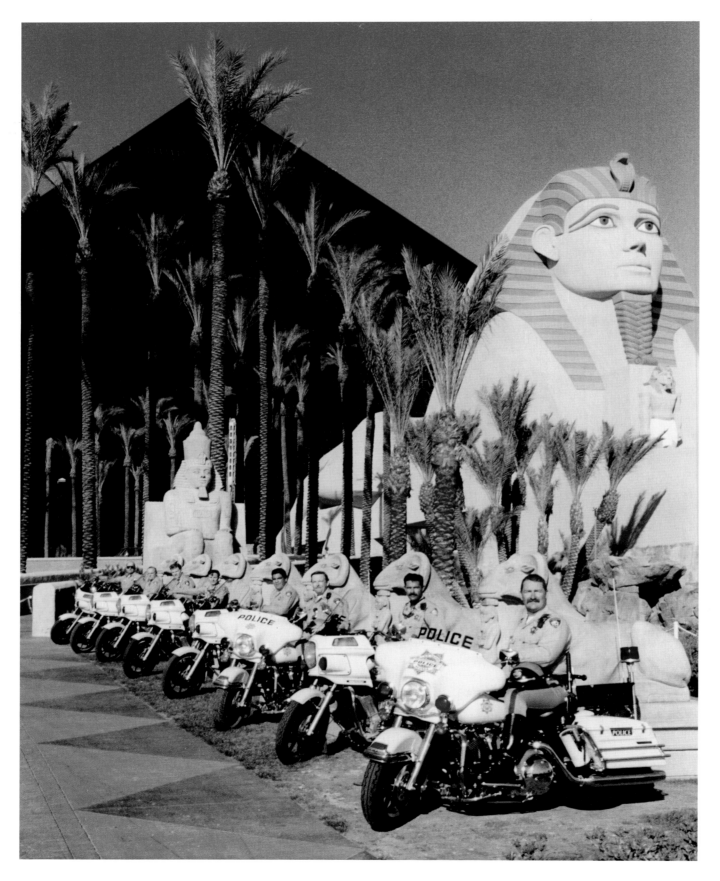

1994 | *The Las Vegas Metropolitan Police Department poses in front of the Luxor hotel.*

1991 | *During the 50th Annual Sturgis Rally, Malcolm Forbes launched a hot-air balloon in the shape of a Harley-Davidson Heritage Softail motorcycle.*

1986 | XLH SPORTSTER®

In 1986, we introduced the Evolution heads and engine to the Sportster model. It was a major development for this motorcycle. The Evolution engine castings are aluminum, making it a more efficient engine than the so-called "Iron-head" on previous Sportster motorcycles. The Evolution is unit constructed, which means that the transmission is an integral part of the crank-case, whereas our Big Twins have a separate crankcase and transmission. With its Evolution engine configuration, the Sportster has remained in production to this day and represents approximately 20 percent of Harley-Davidson sales.

Visually, the character of the Sportster comes across in minimalist and unique ways. If you take a quick view—looking down on the bike—the Sportster is very narrow relative to our other models. The fuel tank, fondly referred to as the peanut tank, is a strong visual cue in identifying this motorcycle. And there isn't a console on this fuel tank, just a fuel cap. The speedometer and tachometer instrumentation is on the handlebars. The profile shows a triangulated oil tank under the seat, the racetrack-shaped air cleaner, and the shorty duals. Another major identifier on the lower half of the engine is the cam cover. And, like all Sportster models, the 1986 XLH has a small headlight.

POWERTRAIN

Engine: 45-degree, overhead-valve V-Twin Evolution®
Displacement: 1100 cubic centimeters
Transmission: Four-speed, foot-shift,
 unit construction with engine
Primary drive: Triple-row chain, oil-bath lubrication
Secondary drive: Single-row chain
Brakes: Single disc (front and rear)
Ignition: Electronic

CHASSIS

Frame: Steel, double downtube
Suspension: Telescopic fork (front);
 dual shocks (rear)
Wheelbase: 59.3 inches
Gas tank: 2.25 gallons
Oil: 3 quarts
Tires: 19 x 16 inches (front and rear)
Colors: Vivid Black; Signal Red/Slate; Candy Blue;
 Candy Burgundy/Slate; Candy Purple/Silver;
 Liberty Edition

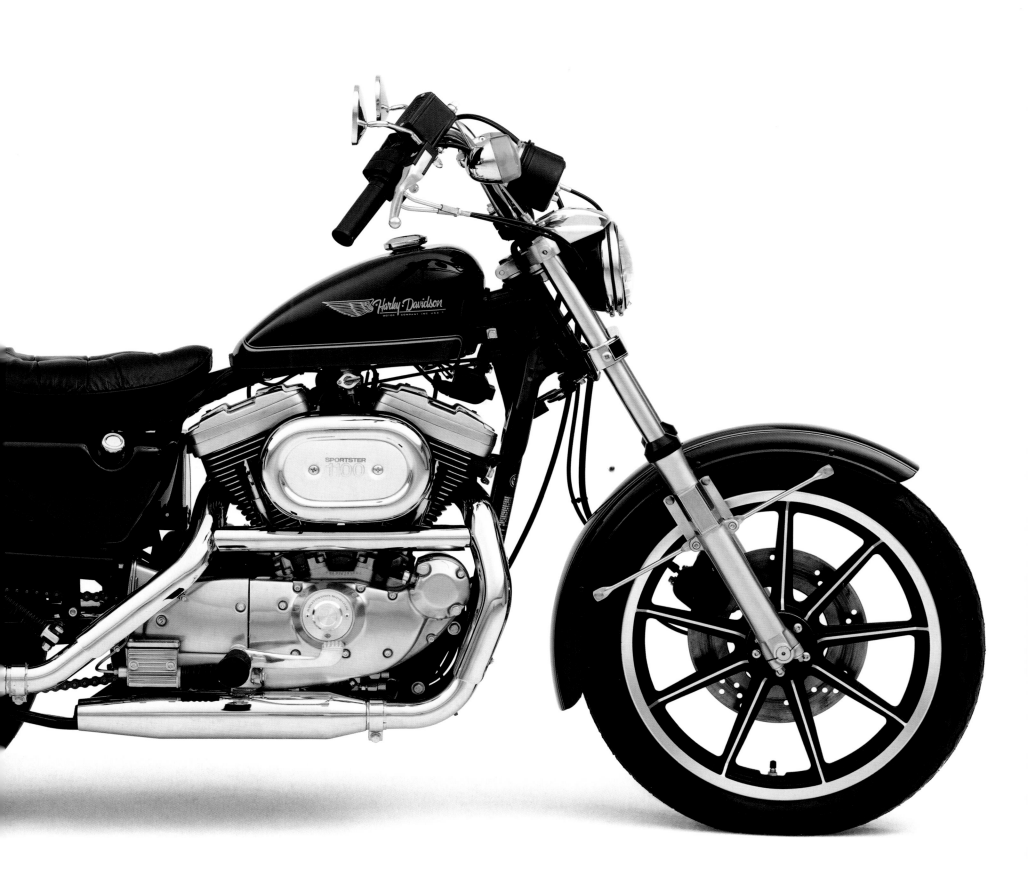

I, AND MANY OTHERS, BELIEVED THAT

THE COMPANY WOULD SURVIVE

THANKS TO THE INTRINSIC VALUE OF OUR BRAND

AND THE

LOYALTY

OF THE RIDERS, DEALERS, AND EMPLOYEES.

HARLEY-DAVIDSON WAS DOWN

BUT NOT OUT.

I WISH I COULD SAY THAT THE THRILL OF OUR BUYBACK FROM AMF was enough to carry us through our first years as an independent company. The truth of the matter was that we almost immediately found ourselves bogged down in a huge, complicated mess that would eventually put the very existence of Harley-Davidson into jeopardy.

In the span of a few years, an economic recession had dragged the entire motorcycle industry to its knees. High unemployment and interest rates greatly reduced the demand for motorcycles. Those factors, along with intense competition from Japan, were killing us. Our sales volumes were plummeting, and we hit our all-time low U.S. market share in 1983. We had been bleeding red ink.

We responded with belt-tightening measures such as huge budget cuts and extended payment schedules for our nervous suppliers. But it wasn't enough. To keep the doors open and cover our debts, we had no choice but to lay off employees. We were on such shaky financial ground that we would eventually need to ask 40 percent of our workforce to leave.

The pain of seeing people I'd known and worked with for years, people who had remained loyal to Harley-Davidson after all we'd been through, carrying boxes out the door and taking the bad news home to their families was devastating. Though our dealers were justifiably worried about whether they'd survive, they stood by us; the leadership group and employees were in survival mode. However, the glass was half full, not half empty. In other words, yeah, it was tough, but we were on a course. I, and many others, believed that the company would survive thanks to the intrinsic value of our brand and the loyalty of the riders, dealers, and employees. Harley-Davidson was down but not out.

The difficulties were far from over; even though we'd taken these painful steps to cut expenses, our Japanese competitors seemed to take a different view of the U.S.'s economic situation. Rather than cutting back as the market sank, they continued to export

motorcycles at the same volume. So their dealerships were bulging with more inventory than they could possibly sell. The only way for dealers to unload the bikes was through ridiculously low pricing, against which there was no way we could compete. When an imported heavyweight motorcycle sold for considerably less than a Harley-Davidson motorcycle, it created an unfair market advantage. We felt defeated.

Desperate, we approached the International Trade Commission (ITC), the federal watchdog for international competition. We made the case that an uneven playing field threatened not only our company but an entire American industry. We knew it was a long shot, since other industries had asked for government protection and received none. Several newspapers predicted that we'd soon be finished.

Maybe it was the bags of letters from our dealers, customers, and employees that arrived every day at the White House and the ITC. Or maybe it was just a feeling that a great American company, making some major efforts to revitalize itself, was dying. Whatever it was, in early 1983, the ITC recommended to President Ronald Reagan that he impose taxes on imported heavyweight motorcycles to protect American jobs and help us complete our revitalization efforts. Reagan agreed on April 1, and gave us five years of protection to ensure a level playing field.

The tariff announcement gave us a tremendous lift

It's Called the "E-Head"

V²

Evolution Power Launched

The 1984 introduction of the V² Evolution engine marked the first radically new Harley-Davidson motor since the 1966 Shovelhead engine.

and sent a message to the marketplace that Harley-Davidson wasn't going down without a fight. We got some positive media exposure, too, which boosted employee morale. In spite of the skeptics, we could see that a lot of people out there were rooting for us. That felt good.

The next challenges were to bring rider confidence back to Harley-Davidson and soothe our bankers, who were becoming increasingly impatient. It was a critical test for us. Thankfully, the new owners were determined to survive this crisis. Under Vaughn Beals' leadership, Harley-Davidson was becoming lean, tight, and focused. We were instituting groundbreaking programs for employee involvement, extensive quality improvement, and "just in time" inventory control. Employees were rallying behind these ideas and generating success. All of which was reassuring, but it was understood that we couldn't make any big mistakes or we'd never pull ourselves out.

We also knew that the Evolution motor project that Jeff Bleustein had been leading was about to launch. And we had high hopes for the Softail motorcycle. But funds were tight. We didn't have the money to develop some of the other vehicles we had on the drawing board, so we did as much as possible with existing models—creating different nameplates, instrument consoles, handlebars, paint, seats, exhaust systems, and wheels. As challenging as this was, it motivated my team and me. Our leaders understood the value of styling and that raised morale. Still, we were under continuous financial pressure.

With the 1984 model-year product launch came our

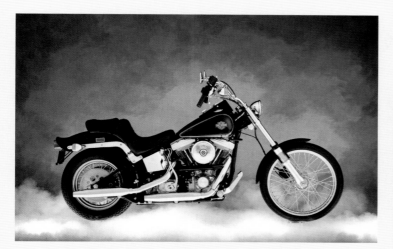

1340cc V² Evolution motor. It was an instant hit with the motorcycle press. They called it our greatest engineering effort to date. It was our first major engine project in nearly 20 years and was stronger as well as more reliable and fuel-efficient than anything we'd ever built. We powered five models with the V² Evolution that year. The new FXST Softail had a time-honored "hardtail" look with concealed rear suspension. It raised the styling bar and gave customers a "canvas" for customizing creativity. It's still an important vehicle for us. The Softail chassis served as a springboard for significant model variations.

Word of mouth in the marketplace was slowly starting to shift, and we could see some light at the end of the tunnel. We were spending more time with our customers than ever before, thanks in large part to the growing ranks of the Harley Owners Group. I'm convinced that this growing closeness with our customers was absolutely vital to rebuilding the trust we'd lost over the years. Even though the quality of our motorcycles was much improved, the sour taste of recent years lingered. We were learning that the only real way to regenerate trust was face-to-face, one customer at a time. So we were looking for opportunities to ride with

our customers—and, of course, to recruit new ones.

You'd probably never dream of buying a car without a test drive. Well, for years, test rides didn't exist in the motorcycle industry. We were so eager to put riders on our current bikes that we experimented with a demo-ride program. By loading new motorcycles onto trucks and hauling them to events and dealerships around the country, we showed riders both the equipment and our commitment to them. The program was an immediate success and would soon become an industry standard.

Through discussions with riders and employees, including management, we were gaining a practical

sense of what customers wanted and expected from Harley-Davidson. We were starting to move in the right direction, and our sales data reflected it. We got a shot in the arm when the California Highway Patrol awarded us a sizable contract in 1984. This endorsement reinforced the positive perception spreading in the marketplace. But we still faced financial challenges. We were far from being out of the woods.

In August 1985, we introduced another motorcycle

The 1984 FXST Softail was one of five models to feature the new V² Evolution engine, which gave riders more torque and improved reliability.

Below: The overwhelming popularity of the H.O.G. (Harley Owners Group) provided a new outlet for loyal riders.

Harley-Davidson pioneered the concept of demo rides, which offered would-be customers test rides on different models.

Far right: Executives and friends make a stop on the 1986 Liberty Ride.

that would be very well received—the FLST Heritage Softail. This bike had the classic look of a fifties-era Harley-Davidson, and its wide front fender and Softail rear suspension brought to mind the early Hydra-Glides.

In the fall of that year, an opportunity presented itself. The restoration of the Statue of Liberty was being widely reported in the media. We decided to run two simultaneous cross-country fund-raising rides for the Statue. Vaughn led a customer group on the west-to-east route across the northern U.S., while I led the southern route. We rode limited-edition Liberty motorcycles with a unique paint scheme and Statue of Liberty graphics. We built 1,750 of them and promised to donate a hundred dollars for each one sold.

For some of us, this ride was a first—getting our feet wet on a cross-country journey, inviting riders, stopping in cities, visiting dealerships for special events, the whole deal. More and more riders joined us along the way. Meanwhile, the press was starting to warm to us. They obviously enjoyed the spectacle of a large group of motorcyclists riding these beautiful machines. It was a welcome change to be interviewed by reporters who were starting to understand what we were all about and wanted to see us succeed.

When we reached the Statue of Liberty, Vaughn presented a check for $250,000, raised through the sale of the limited-edition motorcycles and other pledges received from customers. The media coverage gave the general public a sense of how exciting it would be to join a cross-country ride.

Sales and market share continued their upward trend. In fact, virtually every productivity measure was improving, and it looked like we were going to close the year on a high note.

But then a bomb went off that put us hours from

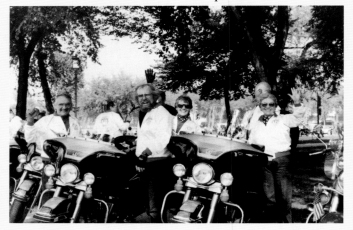

insolvency. In October, our lead lender announced that they were going to discontinue overadvance financing (lending above a borrower's credit line limit) to Harley-Davidson because they thought we were too risky. The part I remember clearly is being called into a meeting as an investor (one of thirteen) and owner of the company to hear that the bank was

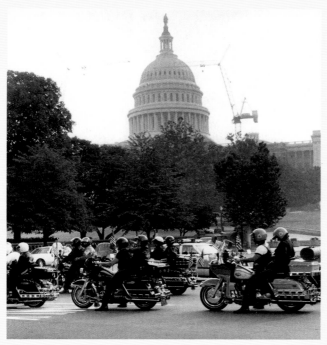

pulling the plug and we might have to file for bankruptcy. We were in shock. Here's this national treasure, Harley-Davidson, and you're given this news. It's your whole life, and you absolutely don't know what to do. Then you have to go home and tell your wife and family that, hey, maybe this company isn't going to make it. It's gut-wrenching, much stronger than words can express.

Vaughn Beals and then-chief financial officer Rich Teerlink went up and down Wall Street, trying to beg, borrow, or steal financing. They were getting beaten down and rejected by some of the biggest names on the Street. Words like "bankruptcy" and "Chapter 11" started floating through the halls. The buyback group met with the lawyers. It became painfully clear that if a new financing deal wasn't struck by December 31, we'd be filing for Chapter 11 protection in January 1986.

What better time than the holidays for good news? Vaughn and Rich teamed with Steve Deli of Dean

Witter's Chicago office and found a lender who offered a verbal commitment to finance us. We had hope.

But the story doesn't end there.

On the afternoon of December 31, Rich received the devastating news that the lender couldn't possibly gather the needed signatures and transfer funds before banks closed for the holiday. I'm not sure how Rich did it, but he convinced the lender to keep the office open a little longer and literally ran from desk to desk to obtain the necessary signatures. The paperwork went through, and money was transferred with only minutes to spare. Harley-Davidson would be open for business in 1986.

I knew all along, going back to the early buyback discussions, that we were taking a big risk in buying Harley-Davidson. But I believed then, as I do now, that our name—our brand—is a gem. And I knew there were a lot of people out there who agreed. Harley-Davidson survived, and today we are where we once imagined we could be.

The 1985 Liberty Ride helped fund the Statue of Liberty renovation. Harley-Davidson's contribution to the effort came from the sales of special Liberty Edition motorcycles.

1986 | FLST HERITAGE SOFTAIL®

I was out riding the Heritage Softail motorcycle just after it launched in 1986. When I stopped at a filling station, a man said to me, "Nice restoration." I told him that this was no restoration—it was a brand-new motorcycle.

The Heritage Softail, which is the second major iteration of the Softail frame, has a look that reflects styling elements of the 1949 Hydra-Glide. While the first Softail models had a narrow, small front tire with a 21-inch rim and a 3-inch cross-section tire, the Heritage Softail has a big 16-inch front tire rim and a traditional large touring-style fender, coupled with a substantial headlight and front fork mechanism. You can see the Hydra-Glide styling clearly in that fork assembly. It's classic Harley-Davidson. The laced front wheels with the big chrome hubcap also come from Hydra-Glide styling.

These design elements were popular in the fifties, and their application to the Heritage Softail remains popular to this day. It's a basic look, which is why our customers like it.

POWERTRAIN

Engine: 45-degree, overhead-valve V-Twin Evolution®
Displacement: 80 cubic inches
Transmission: Five-speed foot-shift
Primary drive: Double-row chain
Secondary drive: Belt
Brakes: Single disc (front and rear)
Ignition: Electronic

CHASSIS

Frame: double downtube
Suspension: Telescopic forks (front); horizontal gas-charged shocks (rear)
Wheelbase: 62.5 inches
Gas tank: 3.5 gallons
Oil: 3 quarts
Tires: 16 inches (front and rear)
Colors: Signal Red/Cream

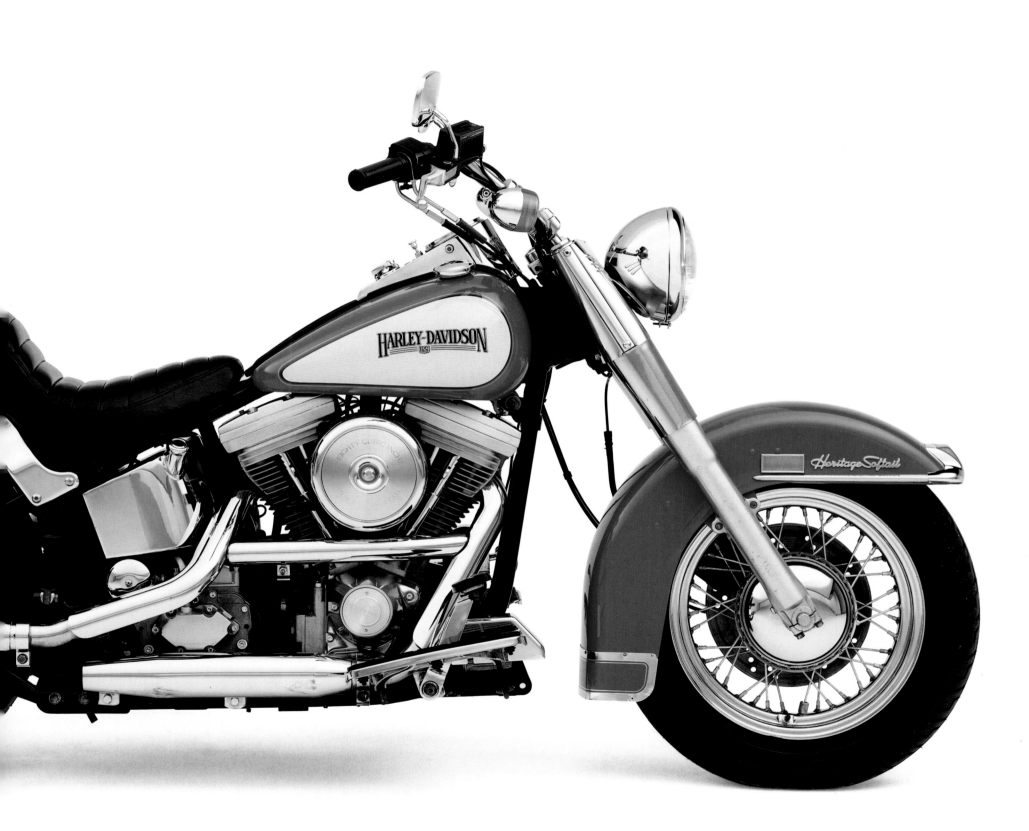

PRESIDENT REAGAN PRAISED OUR EMPLOYEES

FOR THEIR EFFORTS AND SAID

HARLEY-DAVIDSON HAD SHOWN

THAT AMERICAN BUSINESS,

GIVEN THE OPPORTUNITY TO COMPETE FAIRLY,

COULD TAKE ON THE GREATEST COMPETITION IN THE WORLD.

**EVERYONE CHEERED,
FLAGS WAVED, TEARS FLOWED.**

GOD BLESS AMERICA.

AT HARLEY-DAVIDSON, WE'RE IN THE BUSINESS OF HAVING fun. But that doesn't mean we'll ever forget how it felt to get knocked down during the mid-eighties. In the latter half of the decade, we were starting to move in a positive direction. Good times were starting to roll in the marketplace, and we were getting a strong sense of this back at headquarters.

After Vaughn Beals and Rich Teerlink secured our future with some financial wizardry in late 1985 to keep the doors open, we entered 1986 with renewed energy and spirit. I guess we figured that after all the headaches, heartbreaks, disappointments, and damn hard work—and the shocking fact that we came within a few hours of disaster—we were long overdue for a little sunshine. We were winning back riders and attracting new customers to the brand.

This was a wonderful time for Harley-Davidson employees to be out with riders. We got the message that our customers, especially those who'd been with us through our dark period, were pumped up. Their support and loyalty, then and now, is crucial. After some admittedly uncomfortable years, it was nice to get slaps on the back and thumbs-up signs.

The non-motorcycling world also saw that we were getting our act together: some of the country's most influential manufacturing publications began showcasing our innovative business techniques. Our public relations people showed these write-ups to national newspapers and encouraged them to publicize our efforts. The word "turnaround" started appearing in connection with the name Harley-Davidson. Fortune 100 companies sent teams to study our manufacturing methodologies.

Given our run of financial trouble, it might not have seemed like the ideal time for a public stock offering, but Rich and Vaughn saw it as a realistic way to raise capital and reduce our massive debt. They did a super job of convincing Wall Street we were a safe bet. When our stock was offered on the American Stock Exchange

in June 1986, brokers found that there was more demand than there were available shares. This, of course, is what drives stock prices up.

For two years beginning in 1986, Harley-Davidson offered a rebate for the entire purchase price of a Sportster toward a new, larger Harley-Davidson model.

Far right: The New York Times *was quick to note Harley-Davidson's financial recovery after company leader requested that a tariff against large foreign motorcycles be lifted a year early.*

The next day, Vaughn came in my office, shut the door, and put a bottle of champagne on my desk. We had gone from a highly leveraged and risky buyout in 1981 to near bankruptcy in late 1985, and now, just six months later, to a successful stock offering. Since the initial offering, our stock has been one the nation's top performers, which has allowed many thousands of investors to share in our success. And I still have that bottle from Vaughn; it's a little remembrance that will never be opened.

But the year was far from over. Our marketing people devised a brilliant play. Purchasers of new Sportster models could trade them in any time over a two-year period and receive the $3,995 purchase price toward the price of a larger Harley-Davidson motorcycle. This was totally unheard of and conveyed an important message: if Harley-Davidson believed enough in the quality, reliability, and resale value of its motorcycles to buy them back from customers for the full selling price, they must be super bikes.

We received vast amounts of attention for this pro-

gram, and customers took full advantage. The timing was perfect, too, since we had just launched some pivotal motorcycles, in particular the Heritage Softail and the Low Rider Custom, both of which became big sellers for us.

The Heritage Softail was a significant bike in the Softail lineup and was a contemporary throwback to the '49 Hydra-Glide, so that's why we named it "Heritage." It was a stylish combination of a period look with our current engine.

The FXLR Low Rider Custom was the second generation of the 1977 Low Rider. The 1987 version had a rubber-isolated engine, which meant greatly reduced vibration. We also added a five-speed transmission, so the package required a brand-new frame design.

Late in the year, fueled by all the positive marketplace momentum, we achieved the number one market-share position for

Harley Asks End to Tariff Aid

Continued on Page 33

651cc and above in the U.S. market. We were becoming a product people talked about and dreamed of owning. We had a much better holiday season than the year before!

Nineteen eighty-six was a banner year for us, but 1987 was even better. We'd been looking at the tariff situation very closely. After the International Trade

Commission and President Reagan levied the increased tariffs on imported heavyweight motorcycles for a five-year period back in 1983, our competitors started finding imaginative ways to sidestep them. Because the tariffs applied to bikes 700cc and above, they imported motorcycles with engine configurations just below 700cc. Knowing that there was only one year left under the tariff provisions, and feeling confident about our status in the marketplace, we made an epic decision.

In March, in a room filled with government officials and national media, Harley-Davidson told the world that it no longer needed tariff protection to be competitive, and requested that the tariffs be lifted. Essentially, the announcement said we were strong enough to take on the best competition in the world. This tactic was unprecedented, and within 24 hours, the story was everywhere. The press was now hailing Harley-David-son's turnaround as an "American success story."

We were on the map. Our turnaround was the kind of story that made people feel good. Other American companies that had struggled to survive against foreign competition took some inspiration from us. Our brightest moment, though, was still to come.

We sent a letter to President Reagan, who at that time was drumming up support for his administration's initiatives to strengthen America's businesses in the

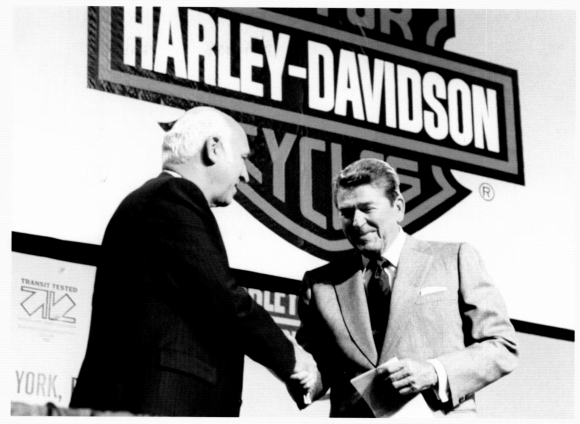

global marketplace. Since he'd been so supportive of Harley-Davidson, we thought he might be interested in joining us for a celebration. After a few weeks, the call came in from the White House: the president wanted to pay a visit to our York manufacturing facility.

When I got to York several days later, the first thing I saw were a dozen or so of our beautiful orange and black semi trailers tightly positioned, nose to end, across the entire edge of our property that faced the freeway. I was proud to see this. I had originally designed the truck graphics to create a rolling billboard with our orange and black colors, alongside the bar and shield. With the positioning of the trucks, nobody could possibly get through. The plant was fortressed behind a wall of our trucks! It was a marvelous display of American muscle.

In May, 1987, President Ronald Reagan visited the Harley-Davidson York Final Assembly Plant in Pennsylvania to congratulate employees on the company's recent turnaround. Then-chairman Vaughn Beals is at left.

Secret Service agents and dogs were everywhere, checking everyone and everything. They even had snipers in towers around the place. They went through

The Harley-Davidson trailer truck is a rolling sign of the Motor Company's dedication to its riders.

Far right: A proud threesome monitors the ticker tape on the day Harley-Davidson was first listed on the American Stock Exchange in 1986: (from left) Former Motor Company C.E.O. Rich Teerlink, former chairman and C.E.O. Vaughn Beals, and Dean Witter's Steve Deli.

the plant, and wherever there was a small opening in the floor, they filled it; they didn't want anyone having access to a hidden spot. Some of the event pictures show cardboard shipping crates with our logo. The crates had a disguised opening that could serve as an emergency escape route for the president if it was needed.

Employees were invited to hear the president's speech. The agents led them into one of the warehouse spaces, in the plant itself, where he would speak. They were excited. It was their day. They had earned this.

In the early afternoon, we could tell by the way the Secret Service agents were acting that it was getting close to show time. Way off in the distance, we spotted a helicopter. As the rotors slowed, the door dropped open and out came the White House press corps. But no president. One of the Secret Service agents told me the first helicopter was a decoy. A few minutes later, an

identical helicopter floated into view and landed. The president slowly walked down the steps, made his familiar salute, and jumped into the limo, which drove into the plant. The president of the United States of America was in our house. And all those TV cameras meant that everyone in the world was watching.

Reagan attended a roundtable discussion with our corporate and union leaders, along with a few lucky employees, before delivering an inspiring speech to our workers. I was delighted to present him with a Harley-Davidson jacket on this momentous occasion.

President Reagan praised our employees for their efforts and said Harley-Davidson had shown that American business, given the opportunity to compete fairly, could take on the greatest competition in the world. Everyone cheered, flags waved, tears flowed. God bless America.

After the president and his entourage left, we scrambled to watch the national news to see how it all played out. It was an emotional high point to see our logo on the screen behind the network anchors, and Reagan touring our plant and congratulating our employees. When the president of the United States tells the world that Harley-Davidson is a great company building superior products, you feel honored.

There were so many factors that contributed to brand recognition and stronger media attention, and the president's visit was one of them. The local press started to cover motorcycle rallies. Hollywood was approaching us to use our motorcycles in movies and music videos. All of the positive exposure was driving people into our dealerships.

A few months later we announced our move from the American Stock Exchange to the larger New York Stock Exchange and marked the event with a motorcycle parade down Wall Street. Nothing grabs the attention of Wall Street (and media crews) like several dozen Harley-Davidson motorcycles pulling up in front of the Stock Exchange.

We were about to usher in our 85th Anniversary. It was time to plan a customer celebration. In the summer of 1988, our leadership team led cross-country rides from ten North American cities, all headed for Milwaukee, where we enjoyed a day of music and entertainment. One of the benefits of the rides was that we were fund-raising for the Muscular Dystrophy Association. I can't think of a better way to celebrate your birthday and say thank you than to get on your motorcycle and ride with a bunch of customers across this great nation. As I stood next to a monstrously large birthday cake at the party, listening to thousands of customers sing "Happy Birthday Harley-Davidson," I was bursting with pride. We had made it!

Bill Davidson waves the Harley-Davidson flag at one of the 85th Anniversary celebrations in 1988.

1988 | FXSTS SPRINGER® SOFTAIL®

Harley-Davidson discontinued the original Springer on solo FL models in 1948. In the eighties I kept in the back of my mind the idea that someday we should resurrect the Springer fork. That fork is a defining part for a Harley-Davidson. If you look at the front fork, all of its visual excitement is in the chrome springs and the two legs of the fork. In the mid-eighties, a collaboration between many departments at Harley-Davidson, including Engineering, Marketing, and Styling, brought an improved version of the Springer fork back on the market.

It was a dramatic direction to take because today motorcycle front forks are basically all internal hydraulic. The Springer fork is exposed. Reviving this front fork style after all these years was a major departure from industry norms and took a lot of people by surprise. We brought it back because it's classic Harley-Davidson.

We had a lot to celebrate when we launched this bike in 1988. Manufacturing went the extra mile for this model. You'll notice how the rigid leg tapers in a faithful reproduction of the original fork. We could have done it in a much less expensive way, but we wanted to be true to the original, even though chrome plating the Springer was difficult because of its intricacies.

The tank profiles a unique eagle graphic with a large wing shape that flows out of the Harley-Davidson Bar & Shield. It's a version of the graphic used for our 85th Anniversary bikes.

POWERTRAIN

Engine: 45-degree, overhead-valve V-Twin Evolution®

Displacement: 80 cubic inches

Transmission: Five-speed, foot-shift

Primary drive: Double-row chain

Secondary drive: Belt

Brakes: Disc (front and rear)

Ignition: CDI

CHASSIS

Frame: Steel, double downtube

Suspension: Springer fork (front); horizontal gas-charged shocks (rear)

Wheelbase: 64.5 inches

Gas tank: 4.2 gallons

Oil: 3 quarts

Tires: 21 x 16 inches (front and rear)

Color: Vivid Black

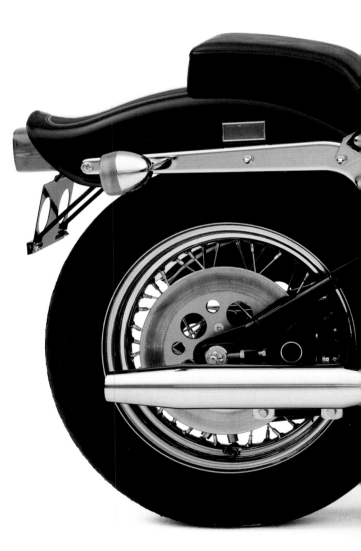

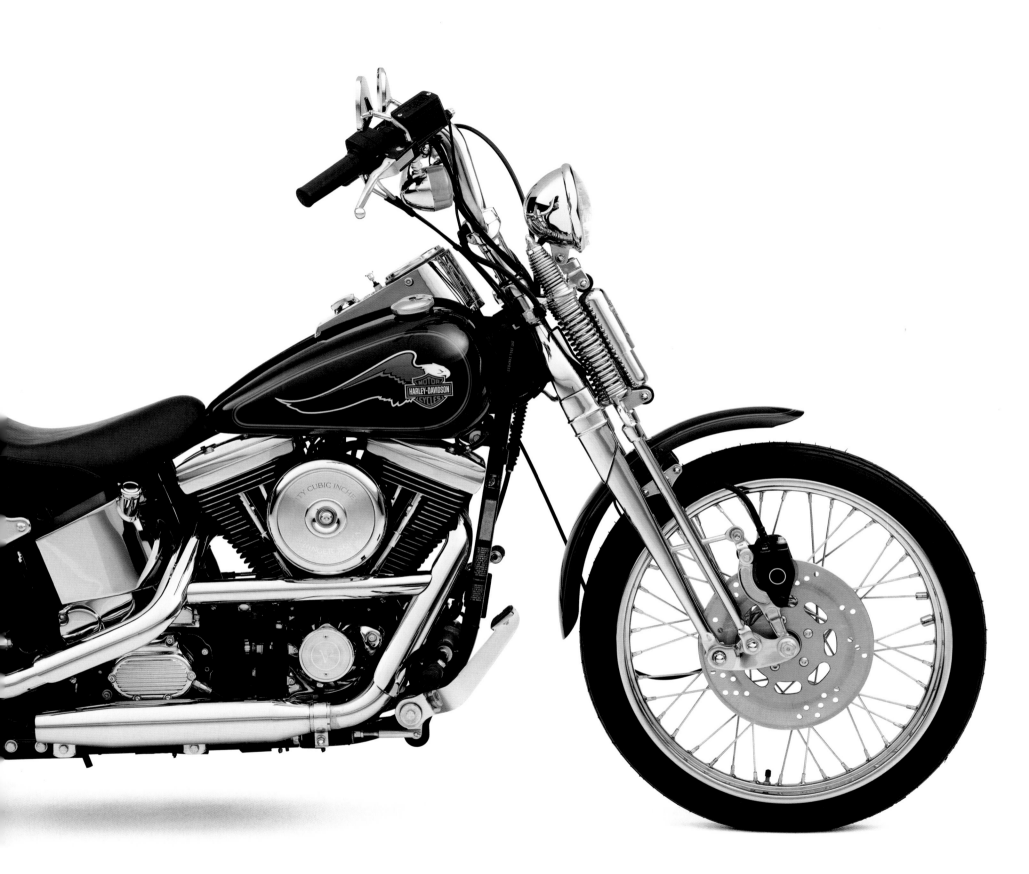

Rallies

Rallies are a way of life, and the journey to get to one is magnetic. I don't know of many riders who don't have some kind of a mark on their calendars for a road trip that more than likely ends up at a rally. There's no better way to see the world's beauty than from the seat of a Harley-Davidson motorcycle. At the end of the trip, there are always shared stories among friends, both old and new.

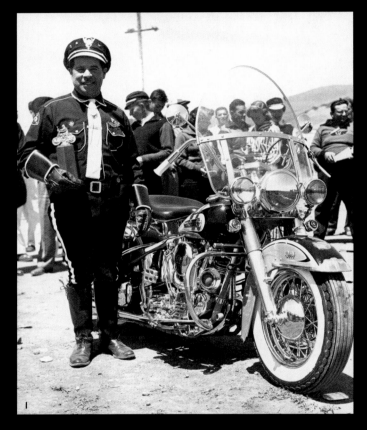

1

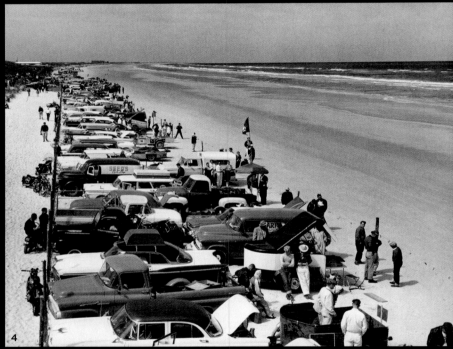

4

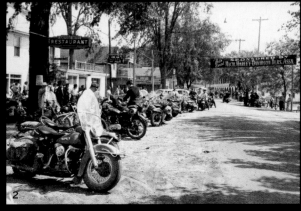

2

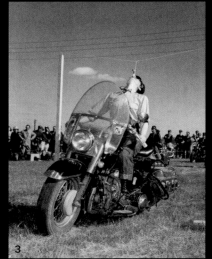

3

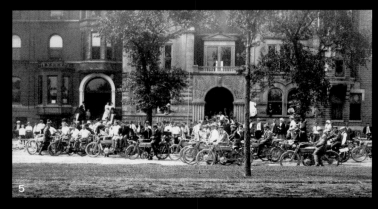

5

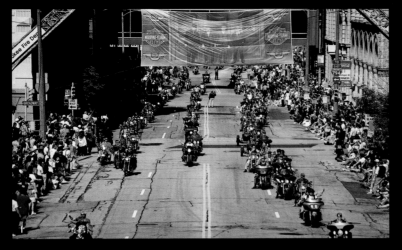

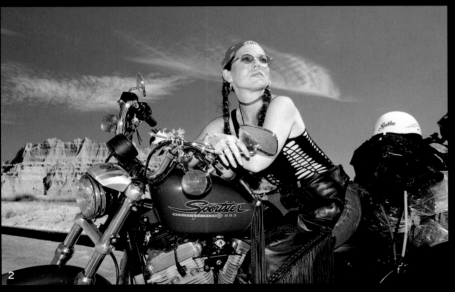

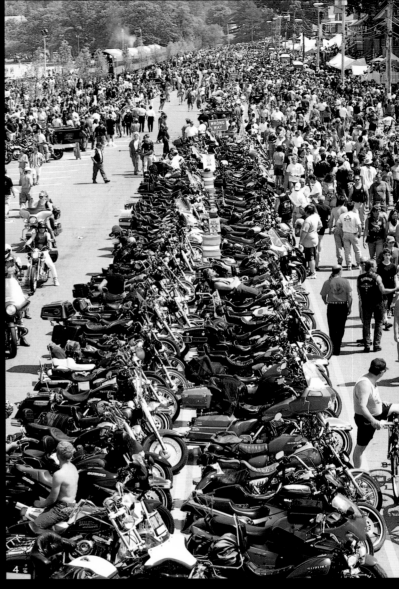

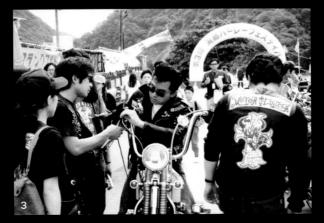

OPPOSITE PAGE
(1) Best dressed rider, 1956 (2) Gypsy Tour in Crystal Lake, Michigan, 1955 (3) Game time at the rally (4) Daytona Beach pit area, 1959 (5) Chicago Motor Club picnic in 1912.

THIS PAGE
(1) Ninety-fifth Anniversary parade through Milwaukee (2) Taking a break from the day's ride (3) Rallies throughout the world allow riders to gather and talk about their bikes (4) A gathering at Weirs Beach, Laconia, New Hampshire, in 1997.

1990 | FLSTF FAT BOY®

This Softail frame allows for many variations on fender, wheel, and fork treatments. On the 1990 Fat Boy model, the wheels are the defining characteristic. The idea was to create a distinctive look using solid-cast disc wheels.

We pushed this distinction further with a silver monochromatic paint job and silver powder-coated frame. Since the entire bike was silver, we needed something bright to set it off. I added yellow trim to the rocker boxes, the derby cover, the timer cover, and the ignition switch.

I've always been intrigued with the handmade look. On the seat, the valance has the trademark Fat Boy edge lacing with six eyelets; the lacing is also found on the fuel tank trim strip. We laced rawhide to give it a hand-sewn look, which is reminiscent of our jacket and vest designs. We have retained this element through all production years of the Fat Boy.

Another interesting element on this model is the tank logo, which I designed for the Fat Boy. It's one I'm very proud of. The star, the U.S.A. on the base, and the circular Harley-Davidson with the contemporary wing shape can be found on every Fat Boy tank from 1990 through today, with only slight tweaking. It's part of the impact of this bike— it's patriotic and nostalgic.

Today's version, with the balanced engine and its great look is one of our most popular models worldwide.

POWERTRAIN

Engine: 45-degree, overhead-valve V-Twin Evolution®
Displacement: 80 cubic inches
Transmission: Constant mesh, foot-shift, five-speed
Primary drive: Duplex chain
Secondary drive: Belt
Brakes: Disc (front and rear)
Ignition: CDI

CHASSIS

Frame: Double downtube
Suspension: Telescopic forks (front); horizontal gas-charged shocks (rear)
Wheelbase: 62.5 inches
Gas tank: 4.2 gallons
Oil: 3 quarts
Tires: 16 inches (front and rear)
Color: Fine Silver Metallic

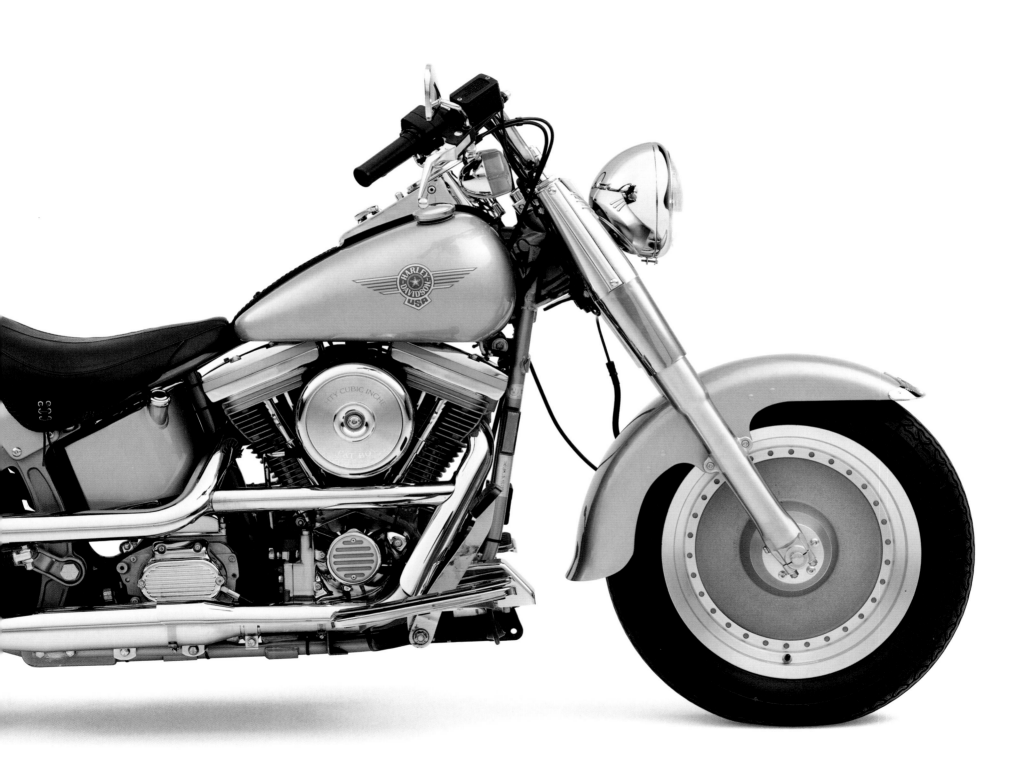

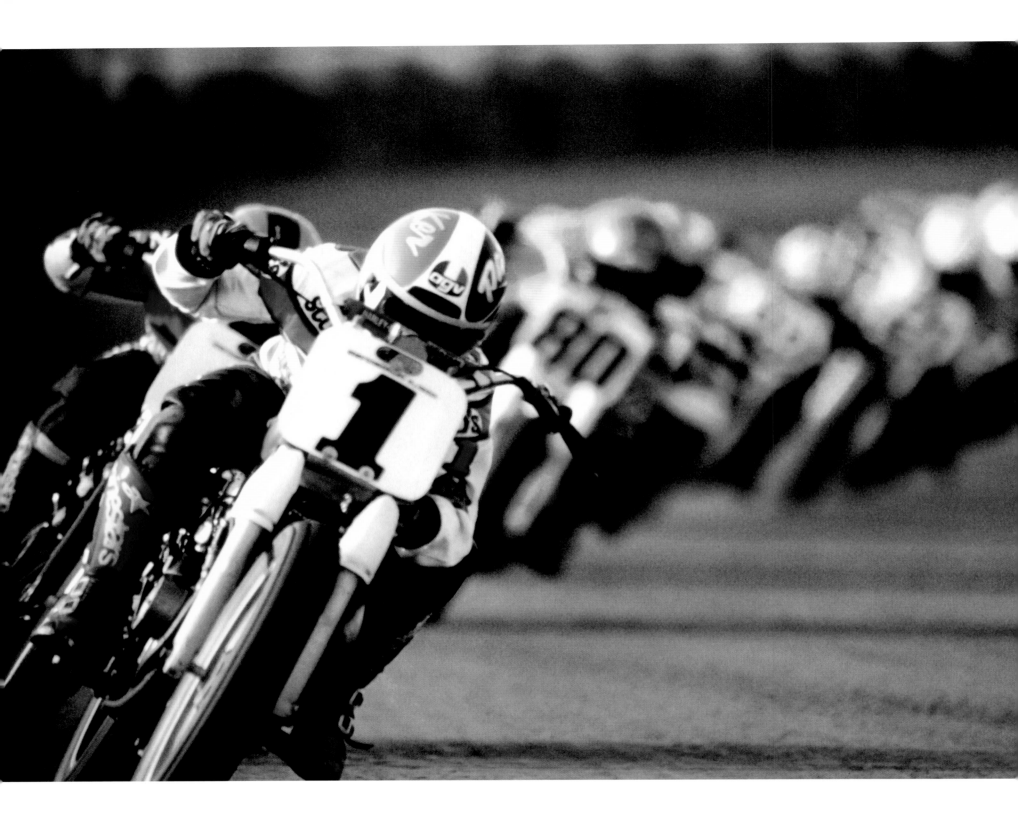

1998 Scott Parker, displaying his No. 1 plate, was the AMA Grand National Championship title winner at Springfield, Illinois, for the Hall of Fame Race.

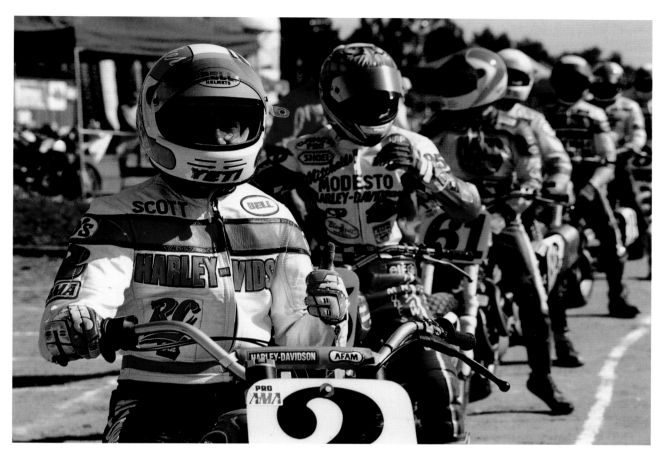

1993 | *Scott Parker is the winningest racer in history with five consecutive Grand National Championship victories. In total, he won nine Grand National Championships.*

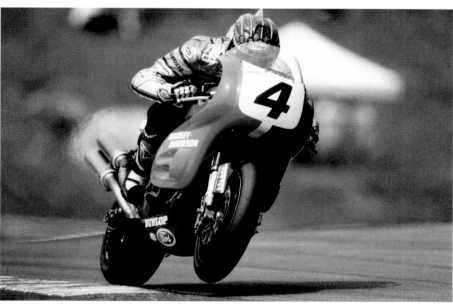

2000 | *Harley-Davidson reentered the Superbike category with the VR1000.*

1996 | *A Harley-Davidson employee at the York Final Assembly plant in Pennsylvania crafts a forged gas tank.*

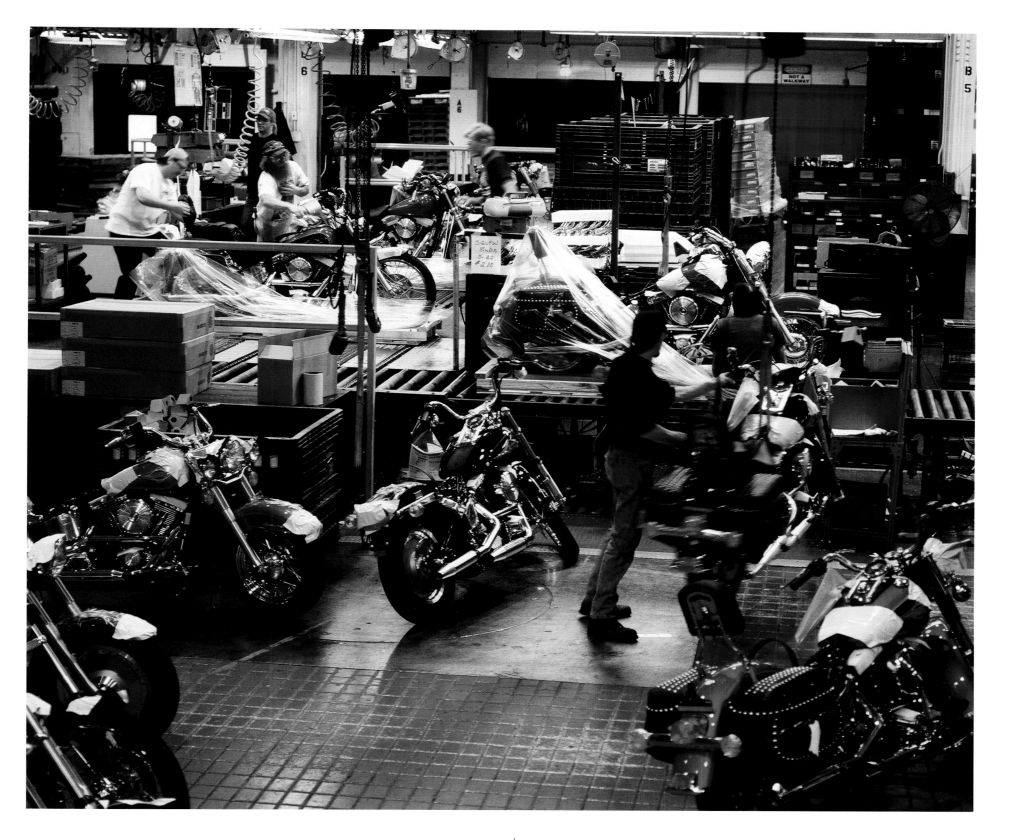

1997 *When a Harley-Davidson model comes off the assembly line at the York, Pennsylvania, factory, it is carefully inspected and wrapped for delivery.*

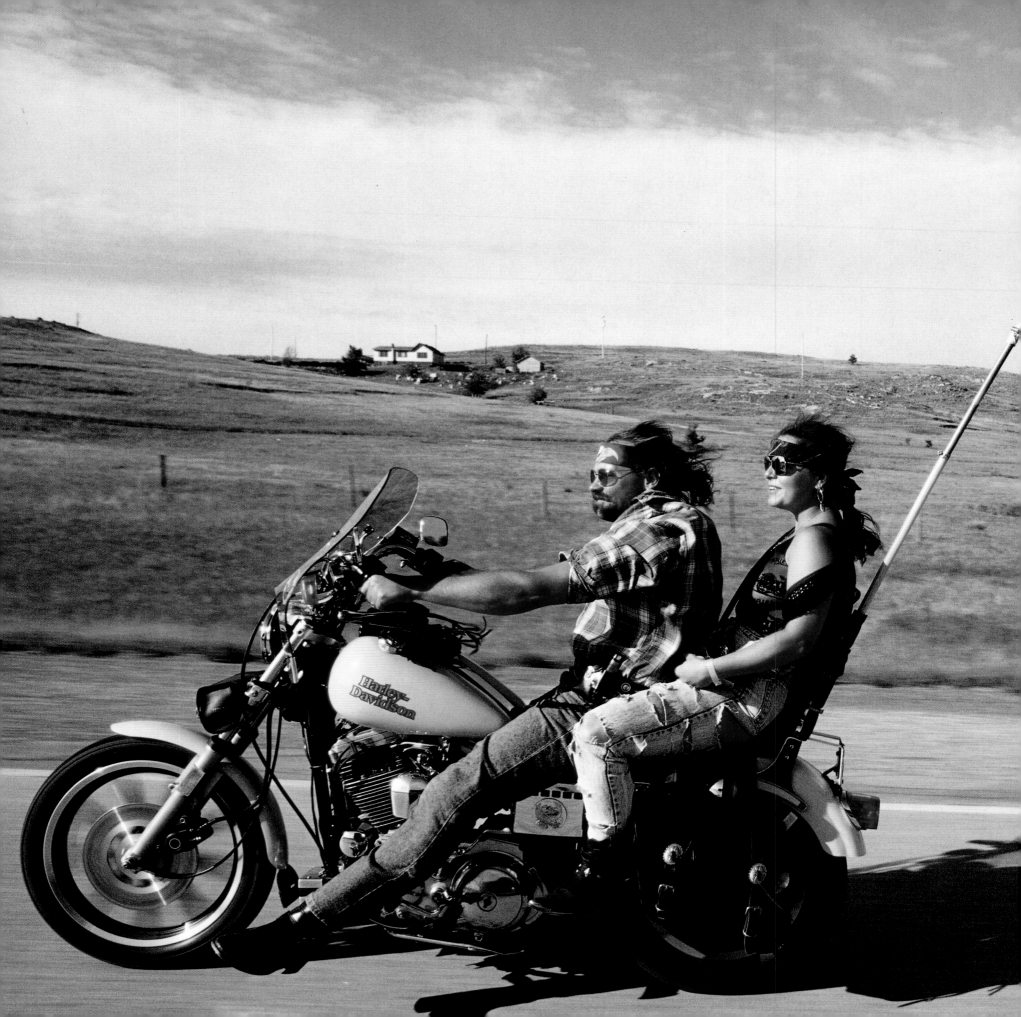

│ *A rider takes a break on the Big Dam Tour.*

1994 │ *A proud pair of riders fly the flag on the road between Sturgis and Rapid City, South Dakota.*

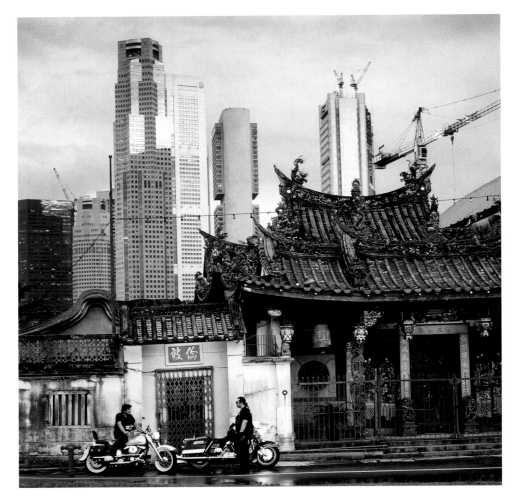

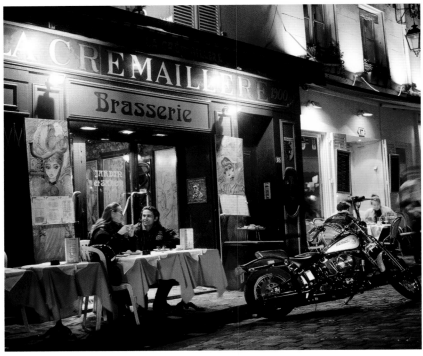

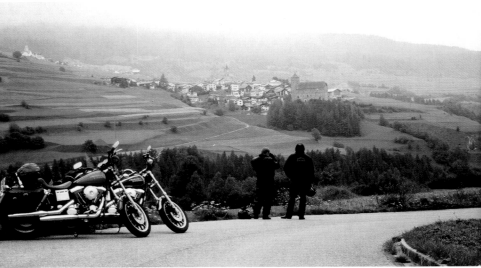

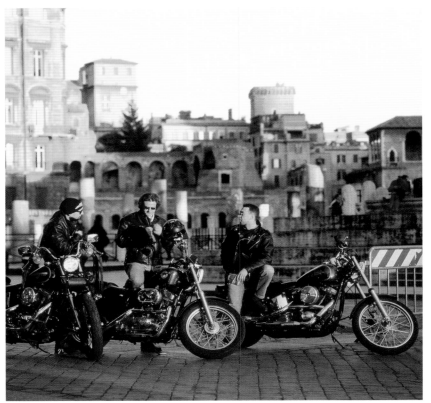

1994–2000 | *Enthusiasm for Harley-Davidson motorcycles knows no boundaries. Clockwise from top left: Downtown Singapore; Paris, France; Italian street scene; Swiss Alps.*

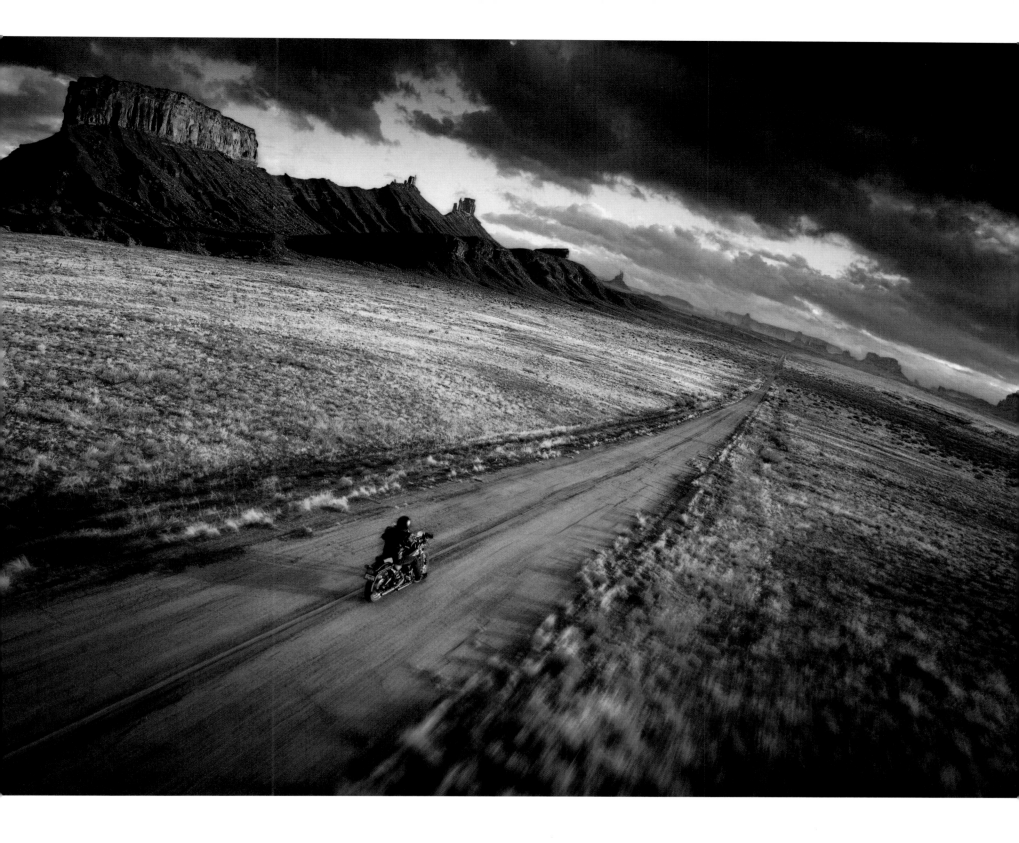

1998 | *Created as an advertisement for Harley-Davidson, this image romances nothing but wide-open road ahead.*

1994 | FLHR ROAD KING®

When we introduced the Road King model in 1994, we broadened the market for our FL chassis and created a motorcycle that works equally well in both the touring and custom categories.

The 1960 headlamp nacelle enclosure is the defining shape of this motorcycle. It also uses a windshield rather than the full "batwing" fairing used on our Ultra Classic FLs. The result is a lighter, nostalgic look. Another classic element is the vibration-dampened, rubber-mounted engine drivetrain, which dates back to the original 1980 FLT.

At Harley-Davidson, we continuously create new models and innovate going forward, but we are always looking in the rearview mirror out of respect for our history—the '94 Road King is an example of this. A few years later the Road King Classic took this thinking a step further when we offered covered hard bags with the nostalgic look of leather.

Depending on how the motorcycle is accessorized, the appearance of the Road King could be looked upon as either contemporary or historic. A large variety of Genuine Harley-Davidson Parts & Accessories add-ons help to accomplish this, but the rider creates the desired look. Because of this, the Road King continues to be one of our most popular sellers.

POWERTRAIN

Engine: 45-degree, overhead-valve V-Twin Evolution®
Displacement: 80 cubic inches
Transmission: Five-speed, foot-shift
Primary drive: Double-row chain
Secondary drive: Belt
Brakes: Double disc (front); single disc (rear)
Ignition: Electronic

CHASSIS

Frame: Double downtube
Suspension: Telescopic forks (front); swingarm and shocks (rear)
Wheelbase: 62.94 inches
Gas tank: 5 gallons
Oil: 4 quarts
Tires: 16 inches (front and rear)
Colors: Aqua Pearl/Silver; Black/Silver

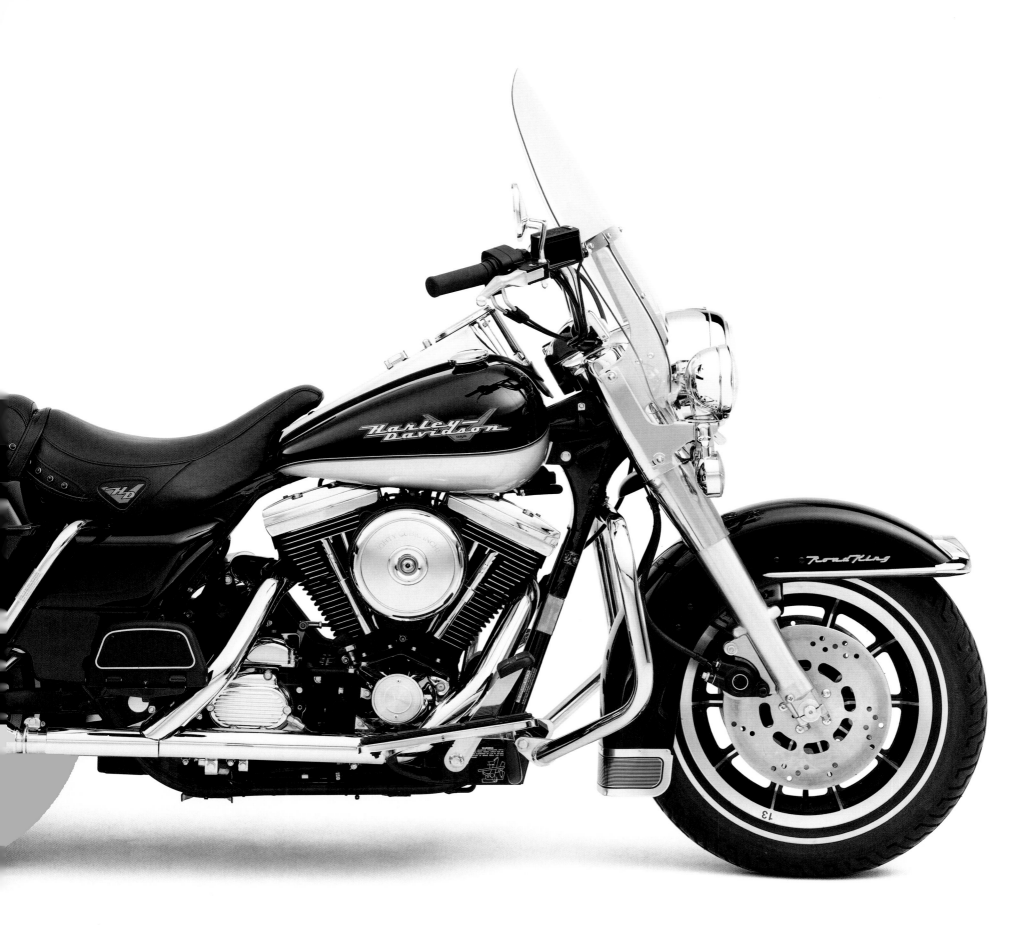

Celebrity

The Harley-Davidson motorcycle is as famous as some of the celebrities who have ridden. The image of Clark Gable on a Knucklehead (below) is from the cover of a 1941 *Enthusiast*—a copy of which is in my personal collection; they're two timeless celebrities.

1

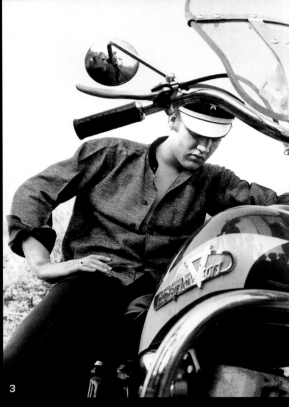

3

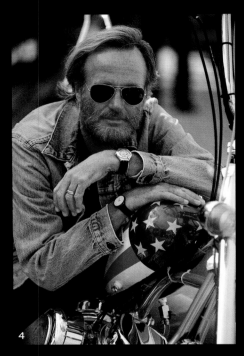

4

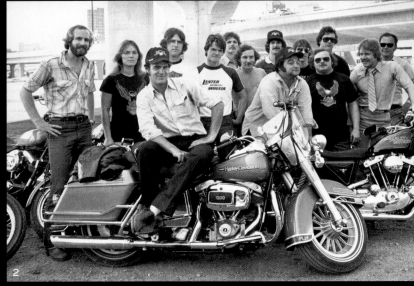

2

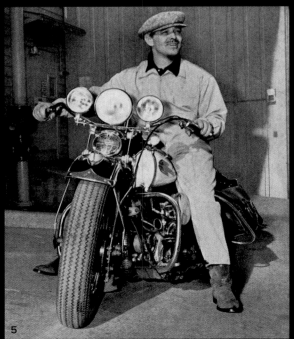

5

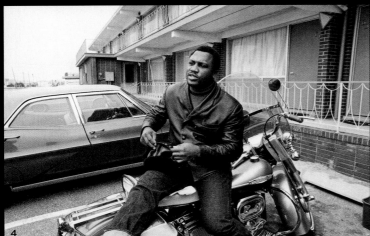

OPPOSITE PAGE
(1) Jayne Mansfield (2) Dan Aykroyd and John Belushi with
the Blues Brothers Band (3) Elvis Presley (4) Peter Fonda
(5) Clark Gable.

THIS PAGE
(1) Jay Leno (2) Cher (3) Mickey Rourke (4) Joe Frazier
(5) Bruce Willis in *Pulp Fiction* (6) Liz Taylor and Malcolm Forbes
(left, in background) with the Sportster motorcycle nicknamed "Passion."

Our touring bikes have a strong visual impact. Our first electric-start Big Twin touring model, the Electra Glide, was introduced in 1965. Thirty years later, it continues to be popular and is considered a benchmark. Riders have really embraced the look of this bike, so when we upgraded it to celebrate the model's thirtieth year, we made subtle styling changes, introduced fuel injection, and trimmed the motorcycle in gold. Gold was also used for the air cleaner insert, an insert in the timer cover, the wheels, and in the striping that accentuates the paint and tank logo.

When you look at this motorcycle, it says "touring" loud and clear. From the front, our bat-wing fairing, headlight, and spotlights are very distinctive. The various fiberglass pieces on the rear of the motorcycle—the tour box, saddlebag, and side covers—are defining elements, and classic Harley-Davidson.

The front nameplate says "Ultra Classic Electra Glide." "Ultra" is appropriate because this bike is loaded. There's major storage capacity, an excellent sound system, and a CB radio. The lowers provide protection from the elements. The backrest in combination with the large, comfortable seat make for enjoyable cross-country touring for two-up riding. This 1995 Anniversary edition also marked the advent of fuel injection, a major development in Electra Glide history. When you add it all together, you have a truly great touring motorcycle.

POWERTRAIN
Engine: 45-degree, overhead-valve V-Twin Evolution®
Displacement: 80 cubic inches
Transmission: Five-speed, foot-shift
Primary drive: Double-row chain
Secondary drive: Belt
Brakes: Dual discs (front); single disc (rear)
Ignition: Electronic

CHASSIS
Frame: Double downtube
Suspension: Telescopic forks (front); hydraulic shocks (rear)
Wheelbase: 62.88 inches
Gas tank: 5 gallons
Oil: 4 quarts
Tires: 16 inches (front and rear)
Color: Burgundy Pearl/Vivid Black

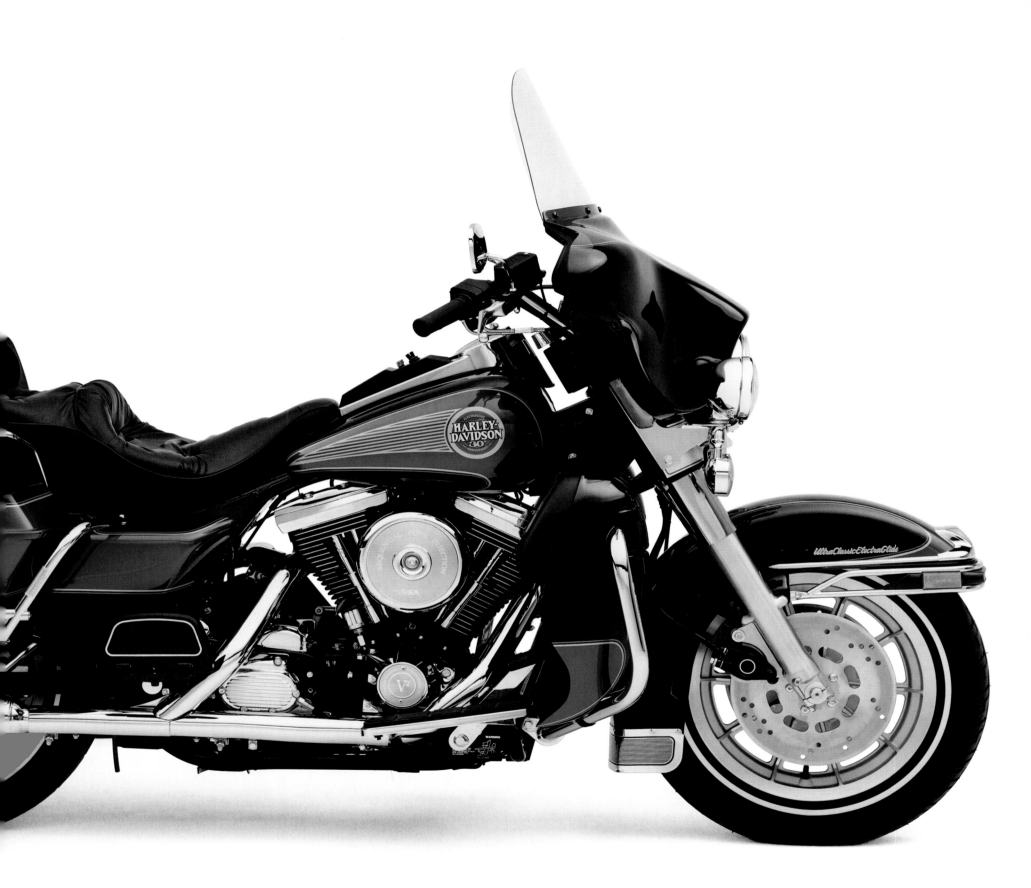

WE HAD TO DELIVER THAT PERFORMANCE

IN ORDER TO CREATE

A NEW RIDING EXPERIENCE.

WE WERE TRYING TO

DESIGN A BIKE

THAT WOULDN'T BE A COPY OF ANYTHING;

IT WOULD BE IN A CLASS OF ONE;

IT WOULD BE OURS.

LAKE GENEVA, WISCONSIN: MAY 1995. CORE HARLEY-Davidson people from the styling, engineering, manufacturing, purchasing, and marketing departments are gathered at a confidential offsite product-planning meeting to discuss what we call a "build direction" for a new vehicle. This is a crucial stage to getting a totally original platform off the ground.

Initial development work for this platform dates back to 1988, when our engineering department began running data on a high-performance, liquid-cooled motor that would be a radical departure from our traditional air-cooled V-Twin designs. It was our entry into superbike racing. We debuted the liquid-cooled, fuel-injected V-Twin with dual overhead camshafts on our VR1000 Superbike in 1994.

Going in, we knew competition against top superbike teams would be a challenge. They'd been in this for a long time, and we were the new kids on the block. We were coming in with a lot to learn in a short period of time. Cutting-edge technology and the world's best riders and support teams are expensive. But we were in this to learn and to give our customers something to cheer about. The VR program was helping us develop and refine technologies, such as Harley-Davidson's approach to liquid cooling and electronic fuel injection. It was also exposing our people to different ways of looking at our motorcycles.

We had developed this engine for racing. Now we were going to take it to the streets. Our experiences racing the engine and gaining a better understanding of its applications eventually led us to the 1995 meeting in Lake Geneva, where the product-planning committee was brainstorming our future.

There were some major questions: could we design and engineer this motorcycle to perform in a way that would speak of Harley-Davidson and entice customers? Was this something we could build, market, profit from—and sustain?

We wanted to give riders a high-performance experience. We were talking about a performance custom,

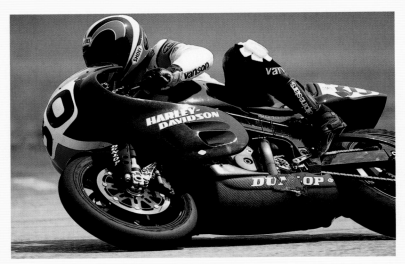

Harley-Davidson entered the Superbike racing circuit in 1994 with a new water-cooled engine.

which was a nonexistent market segment at that time. On the performance side, we set a goal of creating an acceleration feel of one G. Acceleration is a forward thrust created by engine torque. It's one of the most endearing aspects of Harley-Davidson motorcycles and has been for many years. Our low-end torque is what a lot of riders feel (and love) in our motorcycles. Riders talk about the Harley-Davidson Look, Sound, Feel—well, that Feel is embedded in our low-end torque. It's a positive force designed into an engine characteristic. Horsepower peaks at different levels of rpm. There are engines that have a lot of horsepower, but that doesn't mean they have low-end pull. We emphasize torque. In the new engine platform, torque was an essential spec, since it would determine horsepower, drive chassis stiffness, and handling characteristics, all of which would have a sizeable impact on our styling and feasibility decisions.

We had to deliver that performance in order to create a new riding experience. We were trying to design a bike that wouldn't be a copy of anything. It would be in a class of one; it would be ours.

One of our challenges was to maintain the image:

The motorcycle had to be recognizable as a Harley-Davidson product. The V-Twin achieved this, preserving the long lineage of our great V-Twins, the heart of a Harley-Davidson motorcycle. We also needed a strong identity that would make a visual statement with its finishes and shapes.

By the time we left Lake Geneva, we were determined to go forward with the platform, though we knew the costs and risks would be high. Harley-Davidson designed the VR1000 water-cooled racing engine. But our engineering department was also in the middle of developing the Twin Cam 88 engine and the Softail Deuce model. These were significant projects, which meant that we didn't have adequate manpower to work on a street-legal version. So our engineers partnered with Porsche Engineering Services, providing the VR1000 water-cooled racing engine, and a collaboration began to design the technology for what would become the Revolution engine. Together with Porsche, we'd make Harley-Davidson's first water-cooled engine ready for the street.

Styling was another key component in the design of this vehicle. We had actually tried a few iterations with the VR motor in some of our traditional vehicles, but they didn't work. Instead, we decided to create a high-tech visual from the frame up, which would require starting from scratch with the chassis and sheet metal. We knew we wanted this vehicle to be low and long, with an extended front end, like a dragster. Dragsters have always had a pure performance look—minimal sheet metal, long front ends, and massive rear wheels. As it had so many times throughout our

history, racing would give us our cues.

We were starting to envision this dragster-inspired machine with a fast-looking air box, a massive engine, and a sleek exhaust system. And we knew we wanted it to look aggressive standing still. We just didn't know how to get there yet. We code-named the project "Digger," in homage to its drag-racing roots.

The design team was spending a lot of time brain-storming, sketching, and looking at shapes and forms, and it didn't take long to figure out that the task was going to be more complicated than we'd envisioned. Designing a wholly new model is a slow and sometimes painful process. Even though this was our first design project to extensively use the best available computer-aided industrial design technology, we still wanted to rely on our tried-and-true methods. When the styling team would start to get comfortable with a specific

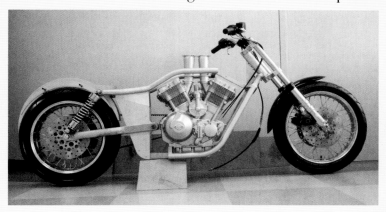

direction, we'd have a full-size, three-dimensional clay model built, so we could gather everyone around and critique it the way a potential customer would.

This practice is crucial to design at Harley-David-son. I'm often singled out for credit on our motorcycles'

great style, which is always flattering but not usually accurate. Much of what we've produced since I began my watch in 1963 reflects the work of those who

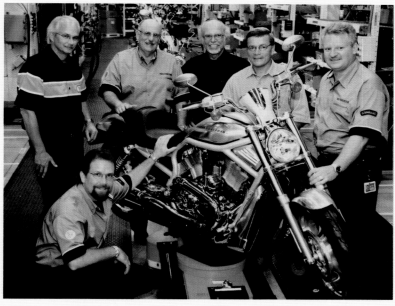

came before me. The story behind their efforts—and the inspiration it gives me and my design team today—is remarkable.

And teamwork is what styling is really about. Each member of the team contributes in a characteristic fashion. Louie Netz, our director of styling, has been with us for more than 25 years. His background in racing (he competed on ice and the short track) is invaluable, and he's a natural design leader. Our con-stant partners are the folks in engineering and marketing. Without their cooperation, we'd never get further than clay models. Other central members of the styling group include Ray Drea, the department man-ager, an accomplished artist who works on graphics,

The first V-Rod comes off the assembly line at Vehicle and Powertrain Operation in Kansas City (from left to right): Bill Davidson (kneeling), Louie Netz, Jeff Bleustein, Willie G., Carl Eberle, and Earl Werner.

Far left: This chassis consists of steel tubes and fabricated parts configured to the desired motor position, wheelbase, and fork angle. The powertrain is machined plastic and represents internal components with no styled covers.

new model upgrades, and paint schemes and who was a pivotal contributor to the Road King Classic model. Brian Nelson has excellent two-dimensional rendering abilities. Earl Golden is our department's 3-D model

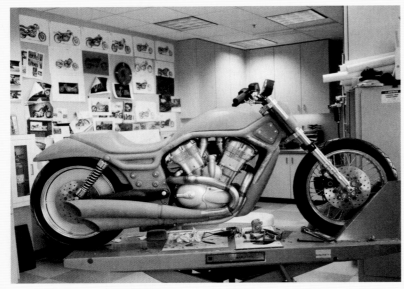

After numerous critiques of the clay model, the overall gesture of the V-Rod begins to emerge. Note the 2-D concept sketches and competitive analysis on the back wall.

maker, and Doug Clarkson is our hands-on craftsman who redefined the model shop and works with computer-aided design. Kirk Rasmussen, our chief computer pilot, came on board with the V-Rod project; and Frank Savage, a skilled craftsman with form and shape work, has excellent sculptural abilities. Christine Eggert tracks our schedules, keeps us on time, and is our gatekeeper. Most importantly, we're all riders.

Our first major decision on the V-Rod had to do with its frame. We knew we wanted it to have an uncluttered look, showcasing the jewel: our V-Twin. The frame would need to be strong and handsome. To frame the engine, we used a process called "hydroforming," which uses liquid under intense pressure to form com-

plex frame bends and shapes. The long swing arm is a visual identifier with an attractive sculptural shape.

In keeping with our styling philosophy—that function, properly designed, can be beautiful—we spent a lot of time conceiving engine shapes, covers, fasteners, and finishes. There's an inherent elegance to the V-Twin, which is entirely exposed; the styling department's job was to make sure the engine was a work of art. All the elements had to work together visually, of course, but the engine also had to meet high performance requirements.

One of our styling challenges was designing the air intake area. To meet our one-G goal, the engine would have to move a lot of air, which would require a massive air box and exhaust system. But locating an air box on the right side of this engine, our traditional approach, would hide the cylinders. So we put the air box above the engine, where the fuel tank would ordinarily be, and moved the tank under the seat.

The necessity of the large exhaust system presented another styling hurdle. We needed to provide adequate exhaust volume in order to achieve horsepower goals while meeting sound regulations. We had to get very creative with exhaust shapes. The curved forms we designed looked terrific—and also disguised major volume.

Our next test with liquid cooling had to do with the radiator. With high-rpm performance motors, air alone can't dissipate the heat; thus the necessity for radiators. But there was no way we were going to hang an ugly black box on the front-frame down tubes. The radiator is a classic example of a functional necessity that we felt should be turned into good-looking hard-

ware. The area behind the front wheel has poor airflow. We designed air intakes to the right and left of the frame center that pick up clean air for adequate cooling; instead of hiding the radiator, we accentuated it. We wanted to make it look like it belonged to the motorcycle, rather than an afterthought.

The 38-degree raked front end was an early visual decision. This feature creates an aggressive side elevation. In other words, it looks like it's moving when it's standing still. A combination of a 34-degree frame head angle with the 38-degree fork angle gave us the handling characteristics we were after. This, paired with a dramatic rear shock angle, accentuated the horizontal long, low look.

To create front-end identity, we designed a unique headlamp with an angle that emphasized the dragster look. We paired the headlamp with a sleek, high-tech instrument panel.

We have a strong reputation in the industry for the quality and appearance of our paint applications. When you think of mechanical beauty, what comes to mind? Metal. Pure, monochromatic, metallic silver. So we did a 180 and didn't paint it at all. The bodywork would be brushed, anodized aluminum. This sophisticated look alludes to performance. It reminds me of aircraft and race cars.

Design and engineering worked hand in hand for more than five years in order to get this vehicle right. Each time we walked around the clay model or built another prototype, we felt that more changes were necessary. It was time-consuming, but this is the process of design.

I vividly remember the test track in Texas. It was in March 1998. A group of us traveled down to test-ride an early prototype, along with some competitive vehicles. I walked into a garage that was full of other manufacturers' bikes, along with our all-black (disguised for confidentiality purposes) prototype. The dramatic rear shock and front fork angles, plus the overall proportion (even in its unsightly finish) created a presence that was startling. When I test-rode the vehicle, I knew we were near completion.

Right up until launch time, close-to-finished prototypes were being tested on tracks in Germany as well as in the U.S. To ensure that our water-cooled Revolution motor could stand up to even the most extreme condi-

Computer modeling and rapid prototyping techniques were among those employed in the design of the V-Rod headlight. Shown here is a sintered nylon prototype of the V-Rod headlight assembly.

Far left: Preliminary clay concepts begin to take shape. The styling effort on the powertrain became a priority over the chassis and body parts due to the critical timing required for engine development between H-D and Porsche.

tions, we left models idling in a shed in the Arizona sun. They were closely monitored. This would be our most extensively tested motorcycle in history.

In June 2001, six years after the Lake Geneva meeting, we were ready to unleash this performance custom, which we'd named the VRSCA V-Rod—"VR" to tie in to its VR1000 lineage, and "SC" for street custom. The V-Rod was very different from what people expected. We knew some people would be downright shocked by what they saw.

Our first task was presenting the V-Rod to the international motorcycle press—the industry's toughest critics and the folks who had seen it all. Rumors had been flying that a water-cooled vehicle was coming from Harley-Davidson. When we invited reporters to this special meeting, they suspected that they were about to see it. I knew they were in for a bigger surprise than they could've imagined.

The meeting was held July 9, 2000, at the Motor Speedway in Irwindale, California. My son Bill, my design partner, Louie Netz, and I had the pleasure of kicking off this bike launch. We each made presentations. It was the defining moment. You've worked on this motorcycle for a number of years, and here you are in front of media from around the world. The model is under a cover. This is the end of the project, and your adrenaline is running strong. I described the philosophy behind the vehicle. When that cover came off, for the first time in my life I heard a collective gasp

The V-Rod's liquid-cooled engine and radical styling caught the motorcycle press by surprise, as demonstrated by this Motorcyclist *cover from October 2001.*

Far right: This Summer 2001 cover of The Enthusiast *took a more subdued approach to the V-Rod's introduction than its unsuspecting motorcycle magazine counterparts.*

from the motorcycle press. We'd succeeded in shocking the press. When they finally were able to speak, their comments were positive.

The next day, we started a series of demo rides for the writers at a nearby drag strip. That was a smart move: the first time these editors rode a V-Rod was with the front wheel pointing down a straightaway. These were the near-first production vehicles, and they were getting ridden hard and fast. Burnouts, speed-shifting, the whole deal. In all the passes down the strip, none of the vehicles required any work. After the reporters rode on the drag strip, they then took the bikes for a ride up into the foothills of the San Gabriel Mountains. We were demonstrating different types of usage. It was obvious to everyone that our relentless testing had paid off.

We then staged our announcement show with the dealers in Los Angeles at the Summer Dealer Meeting. Several thousand dealers from around the world were there. Jeff Bleustein, our leader, gave us an intro. My son Bill and I rode the V-Rod motorcycles from opposite sides of the stage to the center, then dismounted and hugged each other. It was very emotional for me. I think the dealers felt that. It was the culmination of a supreme effort involving many people. It had a lot to do with our family, my son, and this extreme motorcycle. Our company's success in these years had allowed us to do this. We relished that

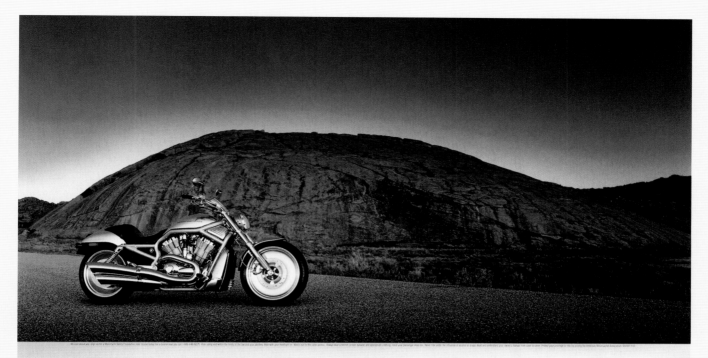

99 YEARS OF WIND CAN CHANGE THE FACE OF ROCK, BUT IT'S STILL ROCK.

The world spins. Time marches on. But as always, we use the bedrock of tradition to push our designs. Take a look at our latest: the Harley-Davidson V-Rod motorcycle. Traffic-stopping style. Long, raked-out front end.

And at the center, the sculpted mass of the torque-laden Revolution V-Twin. Just the way our old friend the wind likes it. 1-800-443-2153 or www.harley-davidson.com. **The Legend Rolls On.**

This 2002 advertisement for the VRSCA V-Rod points out the obvious.

defining moment of emotion and shared it with all those people.

By the time we got to Sturgis, word had spread that the V-Rod was hot. The buzz was amazing. It wasn't unanimous love at first sight, but we definitely struck an emotional chord. Everyone was talking about the V-Rod, arguing pros and cons, which was exactly the reaction we'd expected. The magazines, both domestic and international, were featuring the V-Rod on their covers. The amount of print coverage this bike generated was staggering.

As exciting as the V-Rod is, it is in no way a replacement for any model in our product line. It's another branch on our family tree, intended to broaden our market by appealing to riders who want a different style of motorcycle. We are here celebrating our 100th birthday because of these air-cooled motorcycles, and we will continue developing them in the future.

Will the V-Rod be a home run? I think so, and am anxious to pick mine up at the local dealership. Memories of the '52 K Model I rode in high school still occupy a special place in my heart. Hopefully, the V-Rod will inspire similar love affairs for the next generation of riders.

2000 | FXSTD SOFTAIL® DEUCE™

Certain classic forms are important to the Harley-Davidson design philosophy.

The Deuce walks a fine line. People know right away that they're looking at a Harley-Davidson motorcycle, yet its new shapes make a very modern design statement.

The Deuce is a new iteration of the famous Softail platform. If you trace the Softail through its many variations, it has always been the ultimate custom motorcycle. We modified many pieces of the Softail to give the Deuce a contemporary custom appearance. A balanced Twin Cam 88 motor with improved performance, coupled with sheet metal changes make this motorcycle important to the custom market.

When I look at the Deuce, my eye travels from the front of the fuel tank along the bike to the smooth rear fender supports and the sculptural, fast-looking rear fender with a flush, somewhat recessed—or "frenched-in"—taillight. The custom fuel tank and narrow console give the motorcycle length. So does the exhaust system—it's a classic shotgun style. The back of the vehicle is finished off with a 17-inch rear wheel with a wide 160 tire.

The front of the Deuce also adds to its fast, classic look. Fender brackets are hidden inside of the fork legs. The lower legs—the sliders—on the fork have a simple bottle shape with a small fin at their base. The triple trees and handlebar risers are very sculptural forgings.

The Deuce combined dramatic visuals with the new 88-cubic-inch balanced engine, which greatly reduced vibration, further making this Softail model very desirable. It's a motorcycle that has won high design marks from motorcycle publications.

POWERTRAIN

Engine: 45-degree, overhead-valve Twin Cam 88B™
Displacement: 88 cubic inches
Transmission: Five-speed, foot-shift
Primary drive: Double-row chain
Secondary drive: Belt
Brakes: Single disc (front and rear)
Ignition: Electronic

CHASSIS

Frame: Double downtube
Suspension: Telescopic forks (front); horizontal gas-charged shocks (rear)
Wheelbase: 66.75 inches
Gas tanks: 5 gallons
Oil: 3.5 quarts
Tires: 21 x 17 inches (front and rear)
Colors: Vivid Black; Diamond Ice Pearl; Aztec Orange Pearl; Sinister Blue Pearl; Luxury Rich Red Pearl; Concord Purple Pearl; Sinister Blue/Diamond Ice; Aztec Orange/Diamond Ice; Luxury Rich Red/Black

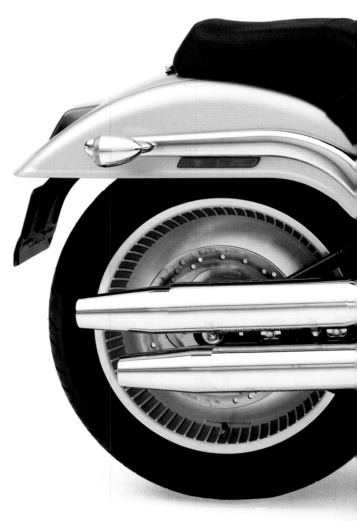

Fashion

Early on, Harley-Davidson developed functional clothing for riding comfort, and through that process, a distinct fashion statement evolved. Cultures around the world have unique decorative dress—everything from military jackets with ribbons and pins, to a hand-sewn tribal piece. Harley-Davidson is also a culture, where form follows function, and the result is a unique type of beauty.

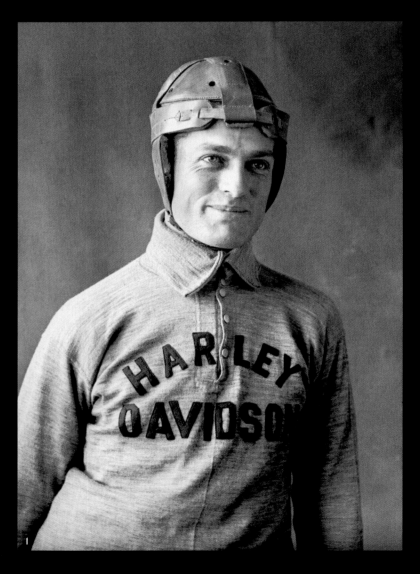

OPPOSITE PAGE
(1) Alva Stratton in 1914 racing garb (2) A 1917 riding uniform with
puttees (3) Gauntlet gloves were worn as early as the twenties
(4) Early forties shearling bomber jacket.

THIS PAGE
(1) Harley-Davidson MotorClothes, functional riding apparel in
action (2) Never too young to gear up with H-D style (3) Harley-Davidson

2002 | VRSCA V-ROD®

Our challenge with creating the V-Rod was to maintain a distinct Harley-Davidson image and create a radically new bike. The V-Twin engine achieves this. It has always been the jewel of our motorcycles and the V-Rod model is an extension of this principle.

For styling inspiration, we turned to what has always given us cues throughout our history: Racing. We knew we wanted this vehicle to be low and long, with a very dramatic, extended front end, like a dragster. It would have to feature minimal sheet metal, and a massive rear wheel. We started to envision a bike with a fast-looking air box, a large engine, and a sensuous exhaust system.

We wanted it to look aggressive standing still. The frame has a minimal, uncluttered look, yet is strong and handsome. The long swing arm is a definite visual indentifier with a sculptural shape. Instead of hiding the radiator, we accentuated it. The 38-degree raked front end was an early styling decision. Paired with a dramatic rear shock angle, it helps to accentuate the horizontal long, low look.

We have a reputation in the motorcycle industry for our strong paint applications, quality, and appearance. But when you think of mechanical beauty, what comes to mind is metal. Pure, monochromatic, metallic silver. The body work on the V-Rod is brushed, anodized aluminum.

We set out to give riders a high-performance experience, but without sacrificing the Harley-Davidson "Look" they'd expect. The result is a first for us and the market: a performance custom.

POWERTRAIN

Engine: 60-degree, dual overhead cam, liquid-cooled V-Twin Revolution™
Displacement: 1,130 cubic centimeters
Transmission: Five-speed, foot-shift
Primary drive: High contact ratio spur gear
Secondary drive: Belt
Brakes: Dual disc (front); single disc (rear)
Ignition: Electronic

CHASSIS

Frame: Hydroformed perimeter type
Suspension: Telescopic forks (front); hydraulic shocks (rear)
Wheelbase: 67.5 inches
Gas tank: 4 gallons
Oil: 4 quarts
Tires: 19 x 18 inches (front and rear)
Color: Anodized aluminum

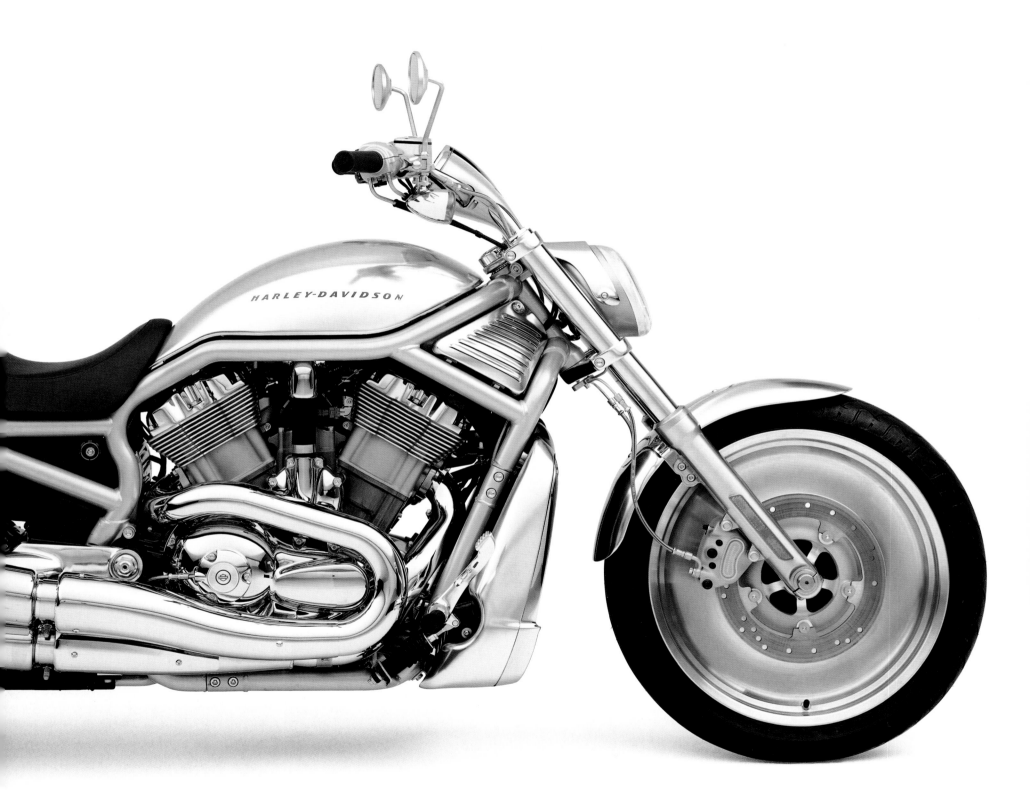

WE'VE BUILT

OUR ENTIRE BUSINESS

ON A MISSION STATEMENT

THAT BEGINS WITH THREE WORDS.

IT ACCURATELY DESCRIBES

WHO WE ARE AND WHAT WE DO:

WE FULFILL DREAMS.

O

UR SIMPLE PHILOSOPHY OF STAYING TRUE TO THE Harley-Davidson basics, while always adding value to them, has allowed us to keep growing and reach this 100th Anniversary milestone.

Look at our motorcycle line and you can't help but notice the consistency from year to year. Our customers want this and have come to expect it. But examine them more closely and you'll see the improvements, some as subtle as a slight bend in a support bracket, and the surprises, like the first Softail or the V-Rod, and you'll start to better understand what makes Harley-Davidson so unique—and what will keep it going. Over the next several years, people will be excited by the changes and surprises that are in the product-development pipeline. I can't tell you what's coming, but it's perfectly okay for you to dream a little.

I can honestly say that the view from where I'm standing today is inspiring and positive. Reaching the century mark in any business is a rare achievement, so all of us here are extremely proud of that. But we're even more proud that we reached this mountaintop on very sound footing, with our gaze trained on the next summit.

Demand for our products remains strong worldwide, and we've continued our steady growth, despite some hurdles that we've faced internally and those that are confronting the global business community. We've enjoyed the kind of success that most companies never do, and we're well aware of that. Today Harley-Davidson is one of the most admired companies in the world.

Reaching our 100th birthday is one thing, but no one could have possibly predicted that the road from our 85th to our 100th would be paved with such incredible success. Growth, managed well, is its own reward. Just ask any of the tens of thousands of riders who've joined the ranks in recent years, or any of the thousands of employees who've

The never-before-seen show-car brilliance of the Sterling Silver paint is the key ingredient in this 100th Anniversary Dyna Wide Glide model.

joined our company. Or, if you want to see a totally different kind of smile, ask anyone who invested in us back then and stayed with us through the years.

But managing growth well is a huge challenge, and I think the way we've done it is what's put us on those "most admired" lists and earned the loyalty of our riders. What many people don't realize is how dramatically size changes everything. It took all of our resources to build about 50,000 motorcycles in our 85th year. We'll soon surpass 250,000 motorcycles per year, with our highest-ever levels of quality. We had about 85,000 H.O.G. members then, versus 640,000 now. Our parts and accessories book was only about 80 pages long then, and now it's over 700 pages.

Since 1990, we've invested over $1 billion in new manufacturing facilities and equipment to keep the product flow running smoothly. Construction crews are at work again to give us more space. The Willie G. Davidson Product Development Center was completed back in 1997. Now construction crews are pouring concrete to greatly expand its size.

Successfully guiding all this development while focusing on our basic business and keeping the flame burning isn't easy. Thankfully, we have amazing employees—less than 2,000 back in 1985, and more than 9,000 today. Our people hold themselves to high standards and have tackled many trials while also planning, executing, and participating in customer events. All of this says a lot about the quality of our employees and the culture our leadership group has nurtured over the years.

While many of the obstacles have been invisible to people outside our doors, our most glaring one was the wide gap between demand for our motorcycles and our production capacity. Despite our significant investments and steady increases in annual production, there simply weren't enough Harley-Davidson motorcycles to go around in recent years.

While most businesspeople would think rampant demand is a dream come true, it creates tough problems for a company like ours that cares so deeply about customers. Sometimes the demand/supply imbalance has resulted in long waits, which creates very understandable

frustration for people who want to ride with us. So over the past 15 years, we have done everything possible internally to increase production output without sacrificing quality.

Our steady increases in production also means more motorcycles for our dealers to maintain. The majority of our dealers have substantially expanded their facilities and staff to better serve their customers. Their investments are paying off in improved service operations and higher levels of customer satisfaction.

We want our customers to be able to visit a dealership, sit on a variety of bikes, pick out the one they want, and buy it. Local demand may spike and alter this situation from time to time, but I'm confident we'll achieve a workable balance. Lead time on some of our models today has been considerably shortened.

We're already deep into planning and execution for the future. The 100th Anniversary is more of a checkpoint for us than an end point. It's a once-in-a-lifetime deal, but the truth is, all the activities, celebrations, and special products will probably just fan the flames at Harley-Davidson, and we'll be running harder when it's over than we are now.

We also have to avoid saying our 100th is just the beginning. That devalues all the incredible things that have happened up to this point, which we're not willing

to sweep under the rug. The founders working in that shed in my great-grandparents' backyard, all those beautiful motorcycles, the racing, the war years, the economic roller coaster, the turnaround, anniversary rides and rallies, H.O.G., worldwide growth, and millions of faces that have come and gone. All these experiences, events, and people are like great chapters in a book that will never end.

What makes me so certain Harley-Davidson will endure? Consider this simple fact: no matter the era, the drama, the hardware, the people involved, or the enormity of change we've witnessed, there's one constant that has carried us forward from Serial Number One and will doubtless be with us through our next

Harley-Davidson launched its next-generation Screamin' Eagle/Vance & Hines NHRA pro-stock drag racing motorcycle in 2002.

Far left: Forbes *magazine recognized Harley-Davidson as its "Company of the Year" in its 2001 survey of best big companies. Pictured on the cover is C.E.O Bleustein with a V-Rod.*

This 100th Anniversary Electra Glide Standard, in Vivid Black, has a broad band across its gas tank with a subtle repeating pattern of the word "Harley-Davidson."

century. It is the experience of riding a motorcycle, which has always been and always will be exciting and fun. Period. Explain riding any way you want, but it all comes down to two wheels propelled by an engine. It's leaning during cornering. It's the exhilaration of the wind, the powerful sound, and the total joy we feel every time we swing a leg over one of these beauties and blast into the unknown. That experience will never die.

Add to that the power of Harley-Davidson's heritage, the imagery and emotions it evokes, the feeling that lodges in our hearts and inspires our dreams, and you've got one strong package. This won't change. Our task is to build on the trust we have with our current riders so coming generations can enjoy the same kinds of experiences that we're having and share in the Harley-Davidson mystique.

We know that the percentage of people in the world who say they'd love to own a Harley-Davidson motorcycle is very large. If we continue to do things right,

we'll be here when the time comes for them to join our family. Once you get the desire to own a Harley-Davidson, it never goes away. In fact, it grows stronger over time. As you see people riding, read about Harley-Davidson in motorcycle magazines, hear stories from friends, visit dealerships to look around, and take a training course, you gradually become an enthusiast. Maybe it's a Buell Blast or a Sportster to build confidence and get comfortable with riding. And maybe, when the time is right, you trade up for a bigger model. The 100th-Anniversary celebration alone will probably kick-start enough dreams to keep us cranking for years to come .

Here's another reason our story won't be ending anytime soon: the world is getting more and more complex. Some of the technologies—communication networks and those damned cell phones—that were supposedly created to free up time for us to enjoy life have had the opposite effect. People are working harder and experiencing higher levels of stress. So, more than ever, we need to break free and escape from time to time on our motorcycles.

It's no accident that I use the word "dream" so much. It's one of the most important words in our vocabulary at Harley-Davidson. We've built our entire business on a mission statement that begins with three words. It accurately describes who we are and what we do: we fulfill dreams. We're here to put people on two wheels and smiles on faces. That's what this amazing brand is all about. As long as we continue to follow that mission—and we will—our future will be bright.

Today, as I'm writing this, I'm getting ready to leave

for Daytona for the umpteenth time. The honest-to-God truth is, I'm very excited about it and have been thinking about it constantly. I'm in my sixties and I've been riding forever, and I still get this thrill when I know I'm about to hit the road. I can't wait to go home, pack up the gear, then get on my bike and ride the back roads all day long with my friend Louie Netz and a bunch of our pals. Upon arrival in Daytona, I'll park my motorcycle and watch as a crowd gathers. That's all the proof I need that we're doing the right things, and that the riding experience is still exhilarating and always will be.

This is as true for me now as it was for the founders way back when. Our motorcycles may look different as a result of evolutionary improvements, but the feeling of riding has never changed, and that's what makes all of this sensible in my mind. I know that the excitement I feel in my heart is the same excitement they felt. They, too, were out riding Harley-Davidson models, or dreaming about their next ride, or what their next bike would look like. How could they not feel the same way I do? My wife and kids are no strangers to this feeling. Eventually, my granddaughter and all future generations of Davidsons will know it. And so will everybody else who rides a Harley-Davidson.

We *do* fulfill dreams.

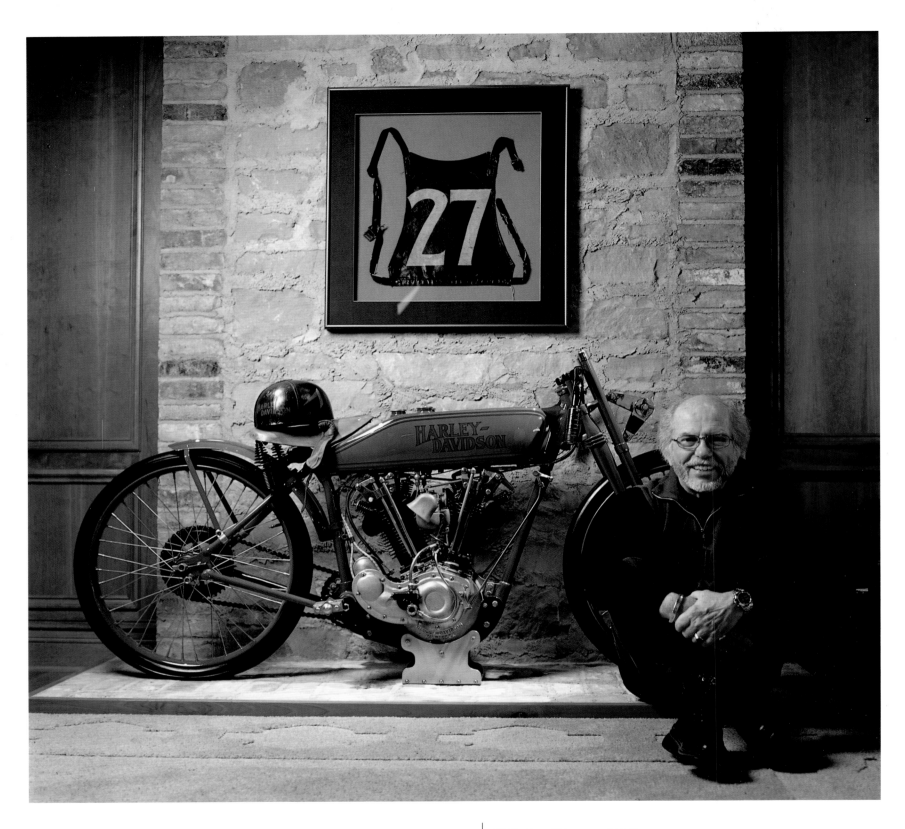

2002 | *Willie G. and his restored 8-Valve racer.*

Opposite: Three generations of Davidsons and family, left to right:
Cara, Callie, Bill, Michael, Karen, Scott, Willie G., and Nancy.